T0228218

A NEW ANTIQUITY

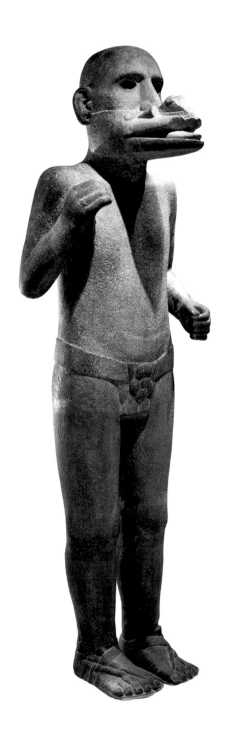

# A New Antiquity

ART AND HUMANITY AS UNIVERSAL, 1400–1600

*Alessandra Russo*

THE PENNSYLVANIA STATE UNIVERSITY PRESS
UNIVERSITY PARK, PENNSYLVANIA

Library of Congress Cataloging-in-Publication Data

Names: Russo, Alessandra, 1972– author.
Title: A new antiquity : art and humanity as universal, 1400–1600 / Alessandra Russo.
Other titles: Art and humanity as universal, 1400–1600
Description: University Park, Pennsylvania : The Pennsylvania State University Press,
　　[2024] | Includes bibliographical references and index.
Summary: "Examines how the subtlety, variety, and inventiveness of American, Asian,
　　and African creations and techniques encountered in the context of sixteenth
　　century Iberian colonization challenged and revolutionized the definitions of what
　　art is and what it means to be human"—Provided by publisher.
Identifiers: LCCN 2023047085 | ISBN 9780271095691 (cloth)
Subjects: LCSH: Indian art—Appreciation—Europe—History—To 1500. | Indian
　　art—Appreciation—Europe—History—16th century. | Art—Philosophy. |
　　Europe—Civilization—Indian influences.
Classification: LCC E59.A7 R87 2024 | DDC 700.1/04—dc23/eng/20231018
LC record available at https://lccn.loc.gov/2023047085

The Pennsylvania State University Press is a member of the Association of University
Presses.
It is the policy of The Pennsylvania State University Press to use acid-free paper.
Publications on uncoated stock satisfy the minimum requirements of American
National Standard for Information Sciences—Permanence of Paper for Printed Library
Material, ANSI Z39.48–1992.

Frontispiece: Quetzalcoatl-Ehecatl, Mexica, late postclassic, ca. 1500 (fig. 42).

To Leonardo,

*figlio adorato.*

# Contents

# Illustrations

*Acknowledgments*

Retracing the genealogy of the people, moments, and places that shape this book revealed an impossible task; lineages always brought me farther away, in space and time. A sound and leading question by a freshman in my class. A supportive remark by my sister-in-law while hiking. A present received in my late teens—a museum reproduction of a gold Tairona pendant figurine. The long years lived in Mexico and a brief visit to Ecuador, where I experienced in situ the finesse of pre-Columbian art and architecture. The moment I glimpsed the pyramids at Giza, while landing in sandy Cairo. Reading the description of the Great Wall in Fernão Mendes Pinto's sixteenth-century *Peregrinaçao* and then retracing his path during my trip to China. The emotion I felt at the Biblioteca Nacional de España when I opened Francisco de Holanda's *De aetatibus mundi imagines* and spent an entire day with the painted manuscript on my desk.

Ellie Goodman's spirited and determined support for my project has been a compass through the years. Josué Chavez's indefatigable and critical reading of many versions of the chapters made me clarify what I meant. Ken Kitayama, Jeremy Ceballo, and Zoé de Bretagne helped me, with great dedication, to attain books from the library and to complete the bibliographical information.

Among the scholars who most inspired this inquiry is the late Robert Williams, to whom I had the courage to write, sharing some work in progress. Bob responded with surprise and enthusiasm, welcoming an unexpected dialogue. Serge Gruzinski encouraged me, in many ways, to write and then *finish* this book. He invited me to present its nascent theses as a visiting professor at the École des Hautes Études en Sciences Sociales in Paris and closely followed the book's development through the years. My look at the arts still owes much to the perspectives of three great women mentors and friends. Vera Fortunati always supported my desire to study the impact of non-European artifacts on European thought in other terms than exoticism—and introduced me to the pioneer book by Adalgisa Lugli. And Laura Laurencich Minelli and Dúrdica Ségota—both of whom I will miss forever—introduced me to the pre-Columbian artistic worlds. I am thankful to the precise recommendations offered by the two peer reviewers, one of

whom then revealed himself—Peter N. Miller—as well as the twenty-one single-spaced pages of comments offered by the second reviewer, which prompted me to rework parts of the manuscript and improve it in crucial ways.

My students and colleagues at Columbia University, especially at the Department of Latin American and Iberian Cultures, always responded to my ideas with curiosity and respect. I am grateful to the undergraduate students of my global course "Artistic Humanity" for embracing the challenges of the readings and for discussing them with me, in English and in Spanish, uncompromisingly. The graduate students who studied with me the evolving contents of my seminar "Theories of Art in the Iberian Worlds" through the years know how long the path through scholarship can be. Sylvie Deswarte-Rosa, Rosario Nava Román, Francesco Pellizzi, Carlos Alonso, Alexander Nagel, Alexander Marr, Jesús R. Velasco, Michael Cole, Seth Kimmel, James Delbourgo, Patricia Grieve, Orlando Bentancor, Pamela Smith, Karla Jasso, Anna More, Annemarie Jordan Gschwend, Décio Guzmán, Jesús Escobar, Claudia Swan, Rebecca Zorach, Diana Fane, Anna Blume, Cocò Alcalá, Iris Montero-Sobrevilla, Graciela Montaldo, Bruno Bosteels, Stéphane Toussaint, Ángela Jesuino, Patricia Falguières, Christopher Wood, Romy Golan, Giuseppe Olmi, Pier Mattia Tommasino, Joanna Ostapkowicz, Davide Domenici, Jérémie Koering, Gerhard Wolf, and, most recently, Fernando António Baptista Pereira and Salvatore Settis have been fundamental interlocutors to *A New Antiquity*. Special acknowledgments go to the librarians and curators who gave me access to their treasures and spent time with me for discussion. In particular, I thank Irene Pintado-Casas and Isabel Ortega García at the Biblioteca Nacional de España, Alexandra Markl at the Museu de Arte Antiga of Lisbon, the staff of the Real Academia de la Historia in Madrid, and Joanne Pillsbury at the Metropolitan Museum of New York. From the Templo Mayor of Mexico, Leonardo López-Luján always offered prompt responses to my queries, bringing me closer to the art objects even from afar. I also thank the teams in charge of images rights—at a panoply of institutions—for helping with the authorizations in record time. At Penn State University Press, the editorial team shepherded the realization of this book through two years: special thanks are due to Annika Fisher for finely copy editing my manuscript, with dialectic dedication and intelligence, and to Maddie Caso, Alex Ramos, Brian Beer, and Jennifer Norton for taking great care of the book's production.

At the inception of the project, in 2012/13, I was invited to the Wissenschaftskolleg-zu-Berlin with an unforgettable cohort of fellows. I am particularly grateful to Gastón Burucúa, Ussama Makdisi, Kelly Aschew, and Carlo Ginzburg for conversing with me on my project. During the writing of this book, a Connecting Art History Getty Grant funded the research group that I codirect with Michael Cole. The themes of these parallel projects came to intersect in many ways, and I thank my fellow participants, especially Bianca de Divitiis and Lia Markey, for our discussions on the circulation of artifacts, people, and ideas between Spanish Italy and the Iberian Americas. For the decisive final steps

of this editorial journey, I have been supported by a generous Provost Grant at Columbia University. I am grateful to Dean Sarah Cole for believing in the importance of my project for the humanities.

A previous version of chapter 1 appeared in the *Art Bulletin* (2020), and chapter 5 revises some materials discussed in my essays for *Art History in the Wake of the Global Turn* (2013), *Images Take Flight* (2015), and *Art History Before English* (2021). My thanks to the editors of those publications—in particular, Milette Gaifman, Lillian Tseng, Aruna D'Souza, Jill Casid, and Robert Brennan, for their continuous encouragement. Through the years, I presented my work in progress in lectures and at symposia. I particularly benefited from the comments received from Youzhuang Geng at Renmin University in Beijing, at the University of Cambridge for "America in the Making of Early Modern Ingenuity," at the Metropolitan Museum of Art for "Making Marvels," at the Bard Graduate Center for "Prudence, Techné, and the Practice of Good Governance in the Early Modern Kunstkammer," at the Universidad Iberoamericana—Mexico City for "Machina—Medium—Apparatus," at the Sorbonne in Paris for the conference "La Renaissance des Origines," as well as at the Rewald Lecture at the CUNY Graduate Center and the Warnock Lecture at Northwestern University. While I was finishing this book, Zoltán Biedermann invited me to the University of London; Maria Lumbreras, Allison Caplan, and Mark Meadow to the University of California, Santa Cruz; and Gerhard Wolf to the Kunsthisthorishes Institut Florenz, Max-Planck-Institut. The discussions following these virtual sessions, held in the time of COVID, as well as the questions voiced by Carol Paul, Hannah Baader, and Giuseppe Marcocci, came through the screen with clarity. The University of Coimbra gave me a new opportunity to debate in person. Thanks to José Pedro Paiva, Angela Xavier Barreto, Jorge Flores, and Gabriel Rocha for their feedback.

Through the long process of completing this book, my husband, Patrice Giasson, always brought a unique critical, loving, and curatorial eye to my materials, hypotheses, and chapters. Our son, Leonardo, grew from newborn to third-grader while *A New Antiquity* was taking shape. He provided me with several lucky charms (tiny magic wands, a handmade colorful bracelet, a written note) and even lent me his blanket when I needed comfort to advance in my work. He then helped me to number the initial list of illustrations and looked proud of his *mamma* when he saw the first complete, spiral-bound version of the manuscript. Between Italy and Quebec, the *nonni* Alice, Claudia, Thérèse, Sandro, Antonio, and Jacques—all art lovers—and the *bisnonna* schoolteacher Caterina nurtured in many ways the vision that I now offer in this book. Thanks to all my family for always supporting me with great openness.

Finally, I wish to thank the hamlet of Andes, New York, its inhabitants, and its school. My family was kind-heartedly welcomed there during the pandemic upheaval. Andes turned out to be the perfect place where I could write *A New Antiquity* with time and calm.

# Introduction

## A Revolution in Thought

It is the fluvial port of Seville, in the sixteenth century. Since 1493, at least once a year, a multitude of people witness the unloading of the fleets arriving from across the Atlantic, after stopovers in the Azores, Lisbon, Sanlucar, or Palos. The ships are full of "so many and such different pieces and of such refinement, and inventiveness, that have never been seen in the world": musical instruments made of shells and wood; cotton and alpaca textiles and embroideries; polychromatic ceramics; turquoise masks; feather garments and insignia; multimetered accordion-folded manuscripts painted on deerskin, maguey, or bark paper; gold and silver jewelry; vases of all sizes and shapes; tiny figurines of precious stone; and so on (fig. 1).[1] Soon enough, sculptures, images, textiles, jewels, and books mixing American, European, African, and even Asian materials, techniques, and uses also arrive from the "West Indies." An "idol" made in Hispaniola already combines cotton, feathers, and shells of the island with European wood, glass beads, and mirrors, and even African or Asian rhinoceros horn (fig. 2).[2] "A chasuble of white cloth from the Indies," originally made for Pope Clement VII, ends up in the Low Countries in the 1520s.[3] A few years after conquering Mexico-Tenochtitlan, Hernán Cortés sends Charles V "a coiled snake with a greenstone and a pearl in the middle, and a cross on the back with its pendants."[4]

When the House of Trade is established in 1503, this panoply of different objects is carried through the streets of the city to pass through customs, often one item at a time on men's shoulders, *a cargas*. In 1534, the twenty-seven boxes arriving from Peru on the

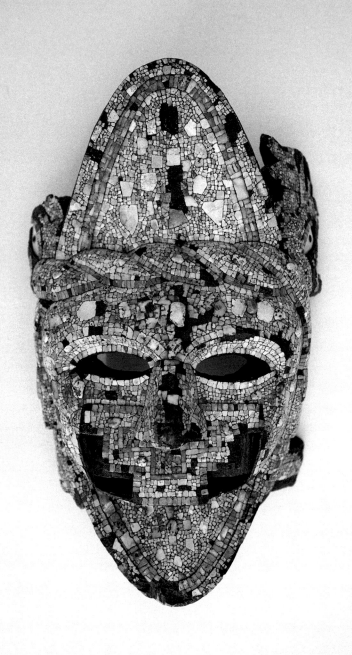

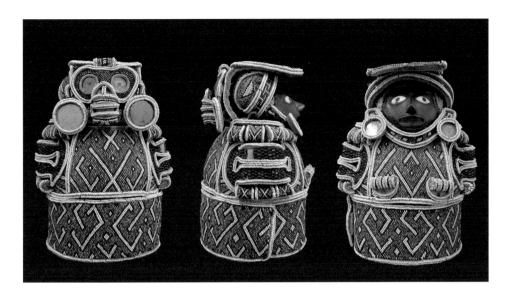

FIGURE 1 | opposite | Mask, Mixtec, Mexico, fifteenth to sixteenth century. Turquoise, spondylus, resin, and mother-of-pearl mosaic on wood, 24 × 15.8 cm. Rome, Museo delle Civiltà, inv. 4213. © Museo delle Civiltà. Photo: Davide Domenici.

FIGURE 2 | Çemi, Hispaniola, fifteenth to sixteenth century. Wood with a mask of rhinoceros horn, green glass, and shell beads, mirror, each figure: 31.5 × 24.5 cm. Rome, Museo delle Civiltà, inv. 4190. © Museo delle Civiltà. Photo: Joanna Ostapkowicz.

vessel *Santa Maria del Campo* are so big and heavy that a cart drawn by two oxen could only transport two of them.[5]

Before crossing the ocean, these objects were observed and described in situ—in Hispaniola, Mexico, Cuzco, Michoacán, Lima, Veracruz, Panama, Nombre de Dios, or Brazil. In fact, they often traveled to Europe accompanied by texts, such as letters, inventories, or chronicles. These were penned while in the Americas by conquistadors, missionaries, and administrators, who narrated how they obtained them—mostly by extreme force, even when presented as gifts or exchanges. The context is that of the violent conquest, colonization, and Christianization of an entire continent.

A vast array of aesthetic experiences elicited by all sorts of "artifacts" (pieces "made with art"), buildings, and monuments unexpectedly filter through these accounts.[6] For instance, the hundreds of gold and silver vases loaded on the *Santa Maria del Campo* were delivered to the Spaniards in Cajamarca by an imprisoned Sapa Inka hoping to be freed. After betraying Atahualpa and brutally murdering him, Francisco Pizarro sent the looted artifacts to Charles V. They arrived in Seville with a copy of the letter that Francisco's brother Hernando, who was also traveling on the ship, had written in response to the judges of the court of Santo Domingo. In this legal document, aimed at legitimizing the sanguinary conquest of the Spaniards, we learn how the ransom was extorted

4

during the war. The document, however, also reports how, since their arrival, the conquistadors were dazzled by the creativity and wit of the Andean populations. Pizarro recalls the dances performed before their eyes, the architecture of the vast ceremonial complexes they visited, and the construction techniques of the ingenious rope bridges they crossed while traveling (and spying) through an extremely elaborate road system. He also points to what he considered to be the different degrees of "art" observed in the Inca provinces, venturing that the inhabitants of the Highlands were particularly gifted: "The lords and people of the mountains possess more art than those living in the plains" (*Estos caciques de la sierra e gente tienen más arte que no los de los llanos*).[7] It is not easy to disentangle what immediately emerges as a paradox, in which artistic sophistication is measured by the arrogance and brutality of those who first lauded and then burned those laced bridges.

In many regards, this is history repeating itself. In 1520, Cortés had enthusiastically described the architectural splendor of Tenochtitlan while strategically planning the final attack on the Mexica city. The line between creation and destruction was extremely fine. Yet, inscribed in that fine line, there are also unexpected clues. When the variety of golden and silver pieces looted in Cajamarca arrived in Seville, for instance, Charles V asked the House of Trade to mint everything except "the most unusual" ones, implying that aesthetic innovation could salvage an artifact from being returned to mere metal.[8] Imperial voracity seems to have been at least limited by those "piezas de las más extrañas" (most unusual pieces).[9] Another clue: it is surprising that the very term *art* popped up in Hernando Pizarro's letter, a legal document justifying colonization. Let us be cautious and assume that, according to its use at the time, the term *art* denoted a human activity ordered according to rational principles. "Ars est recta ratio rerum faciendarum" (art is the way to do things with reason), as Calepino's *Dictionary* points out in a popular edition contemporary to Pizarro's document.[10] Art is defined as a rational and purposeful activity. This is precisely what bears major theoretical implications.

## Subtle "Artistic" Intelligence

After their ports of entry in Spain or Portugal, the extraordinary objects from the New World branch off to destinations across all of Europe, by boat or by land. Offered, gifted, and pirated, they are repacked and unboxed to parade in courts, festivals, and collections.[11] Who will see them and what effect they will have on their onlookers is unpredictable. In March 1493, a nine-year-old named Bartolomé is in Seville when Columbus returns from his first voyage with captives wearing astonishing collars and belts. The boy stares at the "Indians" posing on an arch of the city, having pushed through the crowds to get

a closer view. There, he probably realizes that what he had thought were pearls were, in fact, minute beads of different colors. This young, incredulous observer would eventually mature into the Dominican friar Bartolomé de las Casas, who wrote groundbreaking meditations on the rationality of the American creators, capable of manufacturing aesthetic preciousness with ordinary materials and simple tools.[12] A coeval of Bartolomé's, Columbus's five-year-old son Ferdinand, was also present to see his father's return. The Sevillian library that he gradually gathered throughout his whole life would come to be filled with texts describing objects like those he may have first witnessed that day.[13] Just a few weeks after the navigator's arrival, Columbus moves on to Barcelona, and the city celebrates; its streets are crowded with people eager to see the physical proofs of a new land. Another young man, the fourteen-year-old royal page of Prince Juan, also makes his way to the captives and sees how they are baptized with new names, plausibly still wearing those beautiful parures.[14] The visual effects that those "things" had on the inquisitive adolescent—no less than raw gold and multicolored parrots—will be recalled several decades later by a now-experienced chronicler and naturalist of the Indies, Gonzalo Fernández de Oviedo y Valdés.

Generation after generation, the power of the encounter with previously unimaginable artistry proves galvanizing. When, in summer 1520, a variety of Mexican objects, initially received by Charles V in Spain, travel north and are displayed in the town hall of Brussels, Albrecht Dürer happened to be in the audience. In a passage of his diary that is frequently quoted, he fondly celebrates the outstanding quality of those artifacts, listing them by type and material, even recording their monetary value. But, most important, Dürer pays homage to "the subtle ingenuity of people in foreign lands" (*der subtilen Ingenia der Menschen in fremden Landen* )—to the inventiveness of his past and present fellow artists from the Americas.[15] Dürer's personal conversations with Ferdinand Columbus (Columbus's son) in the Low Countries must have augmented his impressions. In those same years, both Albrecht and Ferdinand were acquainted with Erasmus of Rotterdam.[16] The German artist, the Spanish collector, and the Dutch humanist will all visit the display of New World artifacts that the governor of the Habsburg Netherlands, Margaret of Austria, was assembling in Mechelen.[17] It is tempting to seek clues of these material encounters and exchanges in intellectual circles that have too often been studied as being impermeable to the new artistic realities. If it has been stated until now that Erasmus "hardly let an allusion to the New World pass his pen" and that "there is virtually no impact in Dürer's work of his encounter" with the American objects, can we read between the lines of what has ultimately been reified as "European thought" in search of a different story?[18] And, what, in fact, is this different story? My sense is that it can be a different art history: literally, a different history of what is considered the European concept of art that might actually be rooted in the *piezas más estrañas* and in the *subtilen Ingenia der*

*Menschen in fremden Landen.* How did the unfamiliar objects (as Miguel de Covarrubias pointed out in his *Tesoro* of 1611, *estraño* means "qui ex nostra familia non est" [not from our family]) and the people "of foreign lands" (*fremden*, according to Dürer's language) exert a generative power in the European definition of art?

## Clues Everywhere

All over Europe, artists, historians, collectors, naturalists, kings, popes, nobles, and cardinals received, exchanged, and craved these objects of "unfamiliar" beauty, leaving testimonies of their aesthetic experiences. The phenomenon was immediately polycentric as the artifacts traveled everywhere, quickly, and through the most diverse of networks. For instance, the Italian peninsula was inundated, from north to south, by masterpieces arriving through diplomatic, familial, missionary, and scholarly channels, as well as through piracy.[19] By 1500, the king of Naples, Federico de Aragón, received via Spain a panoply of artworks from the Antilles. In the countryside of Lombardy, in 1521, a gathering of nobles observed several "idols masterfully made with mosaic technique" (*idoli maestrevolmente lavorati di musaico*), which were brought to the Sforza-Bentivoglio court of Pandino by Francesco Chiericati, the papal nuncio in Portugal and patron of Antonio Pigafetta's travel account.[20] In 1535, the pictographic Mexican manuscript known as the Codex Vindobonensis Mexicanus I arrived in Capua as part of the collection of its cardinal, Nicholas Schönberg.[21] In 1569, in the port of Livorno, a Sicilian sea captain, formerly imprisoned by the Turks, got his hands on a distinctive Mexican "painting"—a *ritratto di penne* of Moctezuma (a portrait of the Mexica governor, made with feathers)—and secured it for Prince Francesco de' Medici, continuing to feed a long-standing passion for New World objects in Florence.[22] In 1573, the Calabrese geographer Lorenzo de Anania published in Naples enthusiastic commentaries on the "admirable artifice" of several Mexican objects that he personally saw in the southern parts of Spanish Italy. Scrutinizing a painted manuscript, he compared Mesoamerican pictography to alphabetic writing and saluted the technical innovation obtained with previously unknown botanic species. The Mexicans, he stated, used an oil medium derived from chia (*Salvia hispanica*), which provided both quality and waterproof durability to their pictorial books.[23]

Archival evidence of such thought-stimulating objects spans from hastily handwritten notes (sometimes a single word in an inventory or the marginalia of a book) to an overlooked verse of an epigram by a famous Northern humanist, to a chapter in a best-seller republished over the years, such as Anania's *La universal fabrica del mondo*.

And this is not just a Euro-American story. In the 1560s, a feather painting representing an *Ecce Homo*, which arrived from New Spain to the Spanish Court and was then

given as a gift by Philip II to his young nephew Sebastian of Portugal, was dispatched by the latter's grandmother as a "great present" to the king of Mozambique.[24] In the same years, American objects crossed the Pacific and reached the Moluccas, Japan, China, and the Philippines. Written documents record these journeys. From southeast Africa, a Jesuit saluted the natural twist given to Christian iconography by the plumes of Mexican birds and the subtlety of a unique art piece ("mostrando muy ao natural a imagem do Cristo").[25] From China, an ideographic text accompanying Matteo Ricci's world map published in 1602 praises the pictorial prowess of the Mexicans and the textile finesse of the Brazilians, observed through the marvels that had arrived to the court of Wan Li.[26] Aesthetic refinement is meandering throughout the globe.

## The Question

Though rarely seen in such a broad perspective, the importance that New World artifacts and materials had for the history of collections and for the development of scientific knowledge has been mostly studied through the category of "curiosity."[27] The diverse impacts of their global circulation have been discussed from a broad variety of perspectives and through the aid of various metaphors, like that—particularly compelling—of nomadism.[28] Their political and geographical agency is also largely recognized today, participating in what scholarship has framed as the impact that the New World had on the Old.[29] We also know better today how the New World's artifacts and their circulation were instrumental for shaping a concrete idea of new territories, for promoting a world image of Habsburg domination, and for allowing those rulers, who were not directly involved in the colonization of the Americas, like the Medici, to participate in the symbolic possession of a new continent.[30] Observed under the lens of "pagan objects," their entanglement with the birth of a comparative history of religions has equally borne interesting fruits.[31] Scholars have also studied how their descriptions and display participated in the dawn of ethnography and in the foundations of a "human science," and they have tackled the artifacts' stories in the biographical terms of their "global lives."[32]

However, when one tries to tackle the question from the perspective of art history and, more specifically, of art theory, it becomes increasingly challenging to pose the right question. My book originates from this challenge and asks: what has been the *theoretical* impact of these extraordinary artifacts—art made in lands and by people completely unknown before—on the way we think about the arts?

The predictable answer would be: none. In spite of the variety of aesthetic responses recorded since the fifteenth century—underlined in the pioneering study of George Kubler, the first to study a variety of historical, written interactions with pre-Columbian arts—it

has been posited, until now, that if these artifacts had any conceptual significance in the field of art theory, it is that they contributed to shaping the categories of exoticism, the bizarre, and otherness, before eventually being melted down, dismantled, and lost.[33] Daniela Bleichmar has underscored the misleading attributions and provenances of the artifacts in museums' inventories and catalogue descriptions and tackles the creation of what she defines as "undifferentiated, fungible foreignness."[34] Salvaged, the artifacts have been displayed since the nineteenth century in national museums or forgotten in storage rooms as uncomfortable relics of the incontrovertible atrocities of colonialism.[35] In order to counteract all of the misconceptions they faced through the centuries (mislabeling, oblivion, and so on), it seems that we can only approach these objects by using the double-edged sword of particularism. It is precisely their differences that would need to be cultivated, in a state of isolation from the history of the conquest. Yet, this is the same premise that reinforces the conceptual frontiers between supposedly mutually exclusive worlds: "the West and the rest."[36] Even a groundbreaking work, like Eugenio Battisti's *Antirinascimento*, in which the Italian art historian pointed to the close relationship that European art history has with the artifacts coming from the New World, ends up dividing, in antagonistic terms, the supposed canon of (or the historiographic discourse about) a triumphant Western Renaissance from what had been, internally and externally, the rest.[37]

The answer I propose is radically different. I posit that the subtlety, variety, and inventiveness of a myriad of creations and techniques observed in and coming from the Americas—sculpture, painting, metalwork, mosaic, carving, architecture, masonry, and so forth—actually challenged and revolutionized the definition of both what is art and what it means to be human in the long sixteenth century. The evidence of such singular artifacts made by skillful hands and rational minds, in a previously unthinkable part of the Earth, prompted the redefinition of humanity, precisely as a universal artistic humanity wherever on Earth. This was a veritable revolution in thought, positing that where art is, humans are. My proposal is in dialogue with, and yet distinct from, two fundamental books: David Abulafia's *The Discovery of Mankind* and Surekha Davies's *Renaissance Ethnography and the Invention of the Human*. Abulafia and Davies point to the fact that, in the Renaissance, humans who were found (or "discovered" or "invented," according to each author's lexicon) around the world were sometimes described in chronicles or depicted in maps as object makers. My reasoning goes the other way around: it was precisely the artistic vitality observed all around the world that redefined humanity. In fact, humanity became less inferred from physical features, geographical locations, or particular social, political, and religious customs than from a universal potential—anywhere and at any moment in time—for artistic rationality. It is the artifacts that, ultimately, embody humanity as a possibility. That universal potential is not a homogenizing tool; it does not mean that everywhere and anywhere in the world, people create the same objects or

make the same constructions. On the contrary, the realization of a universal humanity prompted what I call in this book "artifact-based humanism": the study and theorization of a panoply of handmade artifacts, observed on a global scale, defined the purposeful and singular thinking of their creators, prompted groundbreaking comparisons between the uniqueness of distant artificers' modes of creation, demonstrated their equality in terms of a nonprescriptive artistic excellence, and ultimately stimulated a new understanding about a heterogenous, universal humanity at large. This artifact-based humanism differs from the early modern relativism studied by Anthony Pagden as "a far-reaching change in the understanding of human societies" and did not conflate in what Christopher S. Wood perspicaciously identifies as the segregating relativism of modern art history.[38]

During this process—involving observation, recording, and theorizing human artifacts as intentionally handmade—the very category of "art" was also reconceptualized. Though still anchored to the meaning of "manual work," artistic activity became the most tangible demonstration of human thought, encompassing the reasoning preceding and active throughout the material realization of a piece and the "artistic" refinement displayed in that piece. A look at Las Casas's instances of the term *arte* confirms that he uses the word not only to refer to sets of practical know-hows (*arte de marear, arte de la agricultura, arte militar, arte minera, arte de adivinar*, and even *arte del demonio*) but also to specifically describe the enjoyment embedded in making extremely elaborate handmade objects "for recreation"—so not out of need—and the aesthetic pleasure felt by those who experienced them as "a delight to look."[39]

In this way, the subtlety (both technical and imaginative) of the artifacts coming from outside Europe between 1400 and 1600 played a definitive role in what is considered a distinctively European transformation: the redefinition of the frontier between the "mechanical" and the "liberal" arts and, as we will see in chapter 1, the new conception of the figure of the "painter"—the artist.[40] Provocatively, one can say that if in the twenty-first century the splendid pre-Columbian pieces displayed in the Metropolitan Museum of Art's exhibition *Golden Kingdoms* could be presented as artistic pieces and their authors called "artists," this is also due to the complex history of the conquest and its unexpected entanglements with the history of artistic theory in the sixteenth century.[41] The dynamic reflections provoked by the masterpieces observed and described in this contradictory historical context are the theme of this book.

## Made in the Unknown

The precedents and conditions for the "revolution in thought" that I have presented—the articulation of a universal artistic humanity—began in the previous centuries, when

materials and objects circulated in the Old World through an interlocked world system.[42] The Mediterranean context provided a particularly fertile space for aesthetic appreciation.[43] Written and visual sources testified that the refinement of human-made artifacts could break through distances in time, space, and religious or political orientations. It was precisely their intriguing artistic labor—the outstanding quality of the *lavoro*— that, above all, allowed them this mobility.[44] Islamic prayer rugs and oriental carpets, for instance, entered Christian spaces of representation in Renaissance painting. Beyond any easy "iconographic" interpretation (reading them as symbols of religious conflict, thriving commerce, bravura consumerism, and so on), one piece of evidence is particularly telling: most often, fifteenth-century artists, such as Carlo Crivelli and, later, Lorenzo Lotto and Sebastiano del Piombo, painted the oriental carpets "above ground, protected from wear and displayed as works of art" (fig. 3).[45] The immense effort required to render their material characteristics in painting testifies to their aesthetic appeal. In this context, too, contradictory attitudes cohabited. Like the conquistadors lauding and then burning the Inca rope bridges, Renaissance humanists could display in their *studioli* wonderful Mamluk carpets while constructing in their writings the myth of Islam as the enemy and, in particular, the figure of the Turk as the "new barbarian."[46] The inverse is also true: a translation (of a translation) of the Qur'an printed in Venice in 1547 could simultaneously sustain an anti-Islamic rhetoric and sketch a most refined biography of Muhammad.[47]

Throughout the medieval period, the Iberian Peninsula, with its moving frontiers of Al-Andalus, had been a unique space of confrontation and reciprocal transformation among artifacts, techniques, and ideas about art making. It is in the fifteenth century, however, that I locate the most important precedent of a novel conceptualization of humanity through artistry, when refined artworks observed in and coming from sub-Saharan, equatorial, and subequatorial African regions physically reached the Iberian Peninsula, particularly Portugal, and were described in detail.[48] These regions had previously been imagined as existing and yet "unknowable." According to the theory of the five climatic zones, the equatorial zone was impossible to traverse due to extreme heat. Any potential human presence beyond this central area was, therefore, unknowable as well. Since the conquest of Ceuta (Morocco) in 1415, the Portuguese progressively sailed along the entire west coast of Africa, braving geographical frontiers previously considered insurmountable (Cape Bojador in 1434, the Cape of Good Hope in 1488) and demonstrating that the theory of the five climates had no correspondence in reality. The region previously considered torrid was indeed warm but could be traveled and inhabited. In fact, there were people everywhere.[49] Christopher Columbus played a crucial role in demonstrating

FIGURE 3 | Carlo Crivelli, *The Annunciation, with Saint Emidius*, detail, 1486. Egg and oil on canvas, 207 × 146.7 cm. London, The National Gallery. © The National Gallery, London.

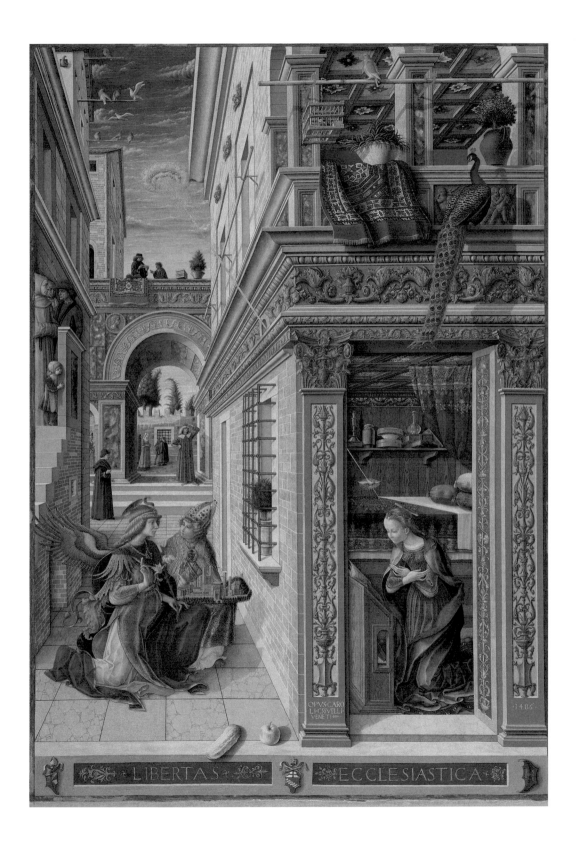

FIGURE 4 | Milanese drawing of a Kongolese textile "di pura bellezza" (of pure beauty), 1664. Modena, Settala Museum, Camp. 338=Gamma.H.1.21, fol. 20r, Biblioteca Estense Universitaria—Raccolta Campori. © Proprietà Comune di Modena, in deposito permanente presso la Biblioteca Estense Universitaria di Modena.

this. As Nicolás Wey-Gómez states, "It was partially against the thesis that the torrid zone generally sustained little or no human life that Columbus would carry out his exploration."[50] Between 1482 and 1485, before sailing toward the "Indies" and while still working for the Portuguese Crown, he had traded along the west coast of Guinea and visited San Jorge da Mina. Writing about Elmina Castle, he says, "[It] is located beneath the equatorial arc and I am a good witness that it is not uninhabitable."[51] In his annotations to Pierre d'Ailly's *Imago Mundi*, Columbus notes that "innumerable peoples" live in sub-Saharan regions. He frequently referred back to his African experience in his later writings.

It is in the 1480s and 1490s that intriguing human-made artifacts coming from equatorial and subequatorial Africa physically or textually arrived in the Iberian Peninsula and beyond. Describing the Portuguese expedition in the Kingdom of Kongo, the royal chronicler Rui de Pina recalls the appearance of "carved ivory items, and many well woven palm cloths of fine colors" brought to Lisbon by the African king, as well as the "very fine embroidered snake" crafted on the cap sported by the ruler of Soyo in 1491, when the Europeans met him.[52] These artifacts were soon compared to the most refined materials. Duarte Pacheco Pereira writes in his *Esmeraldo de Situ Orbis* (1506) that palm-leaf cloth is as soft as and more beautiful than Italian velvet: "In the Kingdom of Kongo they produce cloths from palm fibers with velvet-like pile of such beauty that better ones are not made in Italy."[53] Ivory spoons and raffia textiles from Sierra Leone are described as more artistically carved and woven than in any other place.[54] Comparisons between luxurious European satin and African textiles even sneak into João de Barros's *Asia* (1552), where the author adds that the fabrics include high and low reliefs.[55] One century later, a Kongolese textile with geometric decoration and tassels is celebrated in the Settala Museum of Milan as made with "so great an art that [it] surpasses our puckered silk clothes"; a drawing in the illustrated, handwritten catalogue of the museum attempts to represent its silklike softness, and a comment points to its "pura bellezza" (pure beauty) (fig. 4).[56] In the meantime, the caliber of African artifacts had been considered worth a transatlantic trip. Columbus is said to have reciprocated the beautiful artifacts offered by the Taino chief Guacanagarí in 1492, giving him a tunic "Aphricana arte consutam" (sewn with African artistry).[57] Most likely, this was a textile that he had himself brought from the west coast of Africa, where it had arrived from western Sudan through the Mande trade networks.[58]

The refined artistry coming from previously unknown lands immediately triggered a meditation on the inhabitants' faculties. Around 1507, the Lisbon-based Moravian printer Valentim Fernandes writes, "In Sierra Leone people are very fine, very ingenious, they make ivory artifacts that are marvelous to see, and they can do whatever they are asked to—that is, some make spoons, others saltcellars, others dagger handles, and any other fine thing . . . the men of the country are very talented blacks, [experts] in manual

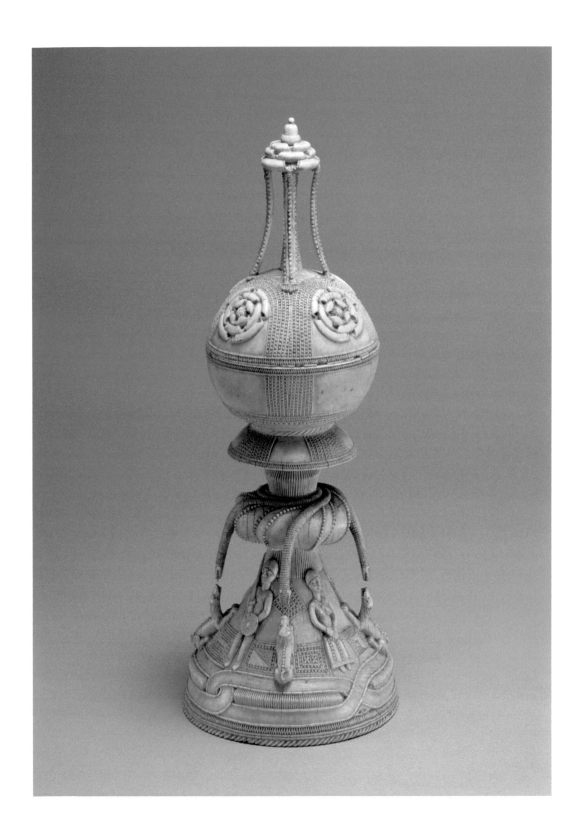

arts . . . they possess infinite ivory teeth from which they make all their gorgeous things [*todas suas obras louçanas*]."[59] In the Upper Guinea coast, Fernandes asserts, there "are people who are very sophisticated in working with their hands, in sewing, weaving, and many other things."[60] Manual dexterity and mental refinement, imitation and invention, could not be separated anymore. The Sapi-Portuguese lidded saltcellar carved in ivory and today displayed at the Metropolitan Museum also tells this story (fig. 5).

## Path Crossing Between Antithetical Universalisms

This book proposes that the artifacts observed in and coming from the Americas brought to extreme consequences those previous reflections on the relationship between artistic gesture and the human nature of Earth's inhabitants. Both anthropology and art history— and even paleontology—are therefore profoundly indebted to the artifacts observed in and traveling through the Mediterranean; sub-Saharan, equatorial, and subequatorial Africa; the Americas; and Asia, as they progressively universalized novel conceptualizations of art and humanity.[61] My use of the term *universalization* and of the adjective and noun *universal* requires definition, as does their distinction from the term *universalism* and the adjective *universalist*.

Universalism can certainly be regarded as a powerful imperial tool of the early modern period. There is no doubt that the hegemonic agenda of conquistadors and missionaries was *universalist* if one understands this term as the impulse "to turn the world into one," notably through the projection, as Emmanuel Wallerstein demonstrates, of supposedly "universal" categories (civilization, progress, and so on).[62] Universalism is, in this sense, a synonym of Europeanization.[63]

It is precisely the antithesis between this sort of European imperial (false) *universalism* and the processes of *universalization* of the concept of art and humanity that I single out in this book. The processes of *universalization* were triggered by the singularity of a myriad of subtle artifacts encountered all over the world. The artistic realities coming from outside Europe prompted a novel conceptualization of the universal: the artifacts coming from, and the artists living in, parts of the world previously thought of as nonexistent or uninhabitable demonstrated how art and humanity are universal, though composed of heterogeneous, singular realities. These objects, in turn, also became *universalizable* in the sense that they could transcend their initial local contexts to enlighten something new about questions that, in principle, were exterior to them. Woodwork observed in

FIGURE 5 | Lidded saltcellar, Sierra Leone, fifteenth to sixteenth century. Ivory, 29.8 × 10.8 cm. New York, The Metropolitan Museum of Art, gift of Paul and Ruth W. Tishman, 1991.435a, b.

Hispaniola could expand the locution "artistically made" and even the meaning of the word *architecture*; golden vases arriving from Cajamarca could prompt a redefinition of the concept of *antiquity*; feather mosaics coming from Mexico could redefine the concept of *painting*.

These antithetical universalisms—European (false) universalism and the process of universalization of artistic and human evidence—interacted in a concrete historical context that we need to keep in mind. Between the fifteenth and seventeenth centuries, the Crowns of Portugal and Spain multiplied expeditions of exploration, conquest, colonization, Christianization, forced labor, and enslavement all around the world. We can roughly sketch this period between the Portuguese conquest of Ceuta (1415) and the aftermath of the Peace of Westphalia, signed in 1648: more than two centuries of wars of conquest and territorial occupation, missionary indoctrination, and exploitation on a global scale, in the Americas, Africa, and Asia.[64] This transcontinental panorama of military aggression and colonization was no less destructive in Europe, where powers continuously confronted one another (often making improbable alliances) through wars, occupation, and destruction. Almost on a yearly basis, treaties (such as Cambrai [1529], Augsburg [1555], Cateau-Cambresis [1559], and Münster [1648]) created periods of relative peace or short truces. But it is perhaps not an exaggeration to say that what defined Europe, at least in these centuries, was precisely an internal antagonistic mode, often on the level of civil war, though masked by the fiction of a common identity within Christendom.[65] That fiction, in turn, provided the ideological unity to overcome internal fights and confront external enemies. One could evoke Aeneas Piccolomini's *Europa*, where the name of the continent ultimately meant a call for an alliance against the Ottomans, after the fall of Constantinople in 1453.[66]

In the middle of this sustained context of confrontation, pillage, and violence, a panoply of novel artistic forms, media, and monuments crossed the paths of not only stormy conquistadors, zealous missionaries, and profit-seeking merchants but also historians, artists, and collectors, who, each from a discrete vantage point, observed and described their most creative aspects. These authors were not only Europeans (Spaniards, Portuguese, Catalans, Basques, Italians, and so on) but also Nahua, Andean, Japanese, and Chinese writers, often urged by Iberian institutions or servants of the Crown of Portugal and Spain to put on paper descriptions of objects and ideas about their creations. This is the reason why, among the richest archival repositories of these artifacts and ideas, there are Inquisitorial processes, missionary inquiries on "idolatries," and geographical descriptions—endeavors in which the local population actively participated to varying degrees. For instance, within the famous *Historia general de las cosas de la Nueva España*, also known as the Florentine Codex, a monumental history of the Mexican world before and after the conquest, directed by the Franciscan Bernardino de Sahagún from the

mid-1550s, we find hundreds of pages, written in Nahuatl, on various artistic techniques with actual art recipes, described in text and illustrated in painting, as well as fascinating thoughts on the conception of color and brilliance. The images of the Codex Magliabechiano (also from the mid-1550s), painted in Mexico to record the "superstitions of the Indians" (*supersticiones de los indios*), are veritable catalogues of the most inventive textile patterns imaginable. In the *Descripción de Tlaxcala* of 1585, a geographic description of the city that allied with the Spaniards, written by the mestizo Diego Muñoz Camargo in response to a questionnaire sent out by Philip II's administration, we read extensive descriptions of monuments, "antiquities," and artistic masteries of the Valley of Mexico.[67]

Asian and African artifacts also entered the realm of ekphrastic practices and visual illustrations, often influenced by the widely circulating descriptions and images of the Americas. The presentation of the architectural splendors of Beijing by the Portuguese Fernão Mendes Pinto in his *Peregrinação* (written before 1583) reminds in many aspects how Cortés had introduced the city of Mexico-Tenochtitlan—just before brutally attacking it—to European readership in 1520. When, at the beginning of the seventeenth century, the Jesuit Joao Rodrigues describes how Japanese calligraphy bears a double nature of painting and writing, his thoughts evoke those of the mendicant missionaries trying to grasp how Mesoamerican pictography actually functioned as a form of writing. Celebrating the music of Angola and Kongo in the 1670s, the Italian Capuchin missionary Antonio Cavazzi openly refers to the *Comentarios Reales de los Incas* (1609 and 1617)— the chronicle on the Andean world written and published by the Cuzco-born mestizo Garcilaso de la Vega el Inca. Cavazzi may have even carried the book along during his trip to Africa.

The historical context of confrontation briefly sketched above had a very concrete impact on how these observations and descriptions took place. After the initial encounter, the artifacts, when transportable, were obtained by force or bartered in an unequal exchange. Some became evidence of supposed idolatry and played a fundamental role in Inquisitorial trials. When unmovable, architecture and monuments were often mutilated or destroyed during the wars of conquest or during the construction of new sites. Other works, portable and made with precious metal, were melted in situ or on their arrival in Europe. And yet, between their creation and their fate, many of these art pieces traveled between continents and sometimes all around the world in physical and textual forms: not only sent and offered as proofs of the new territories, lauded as trophies of conquest, desired and collected as "treasures" but also described, compared, and analyzed in letters, histories, and inventories as tangible forms of human thought.

The material realities of specific artifacts and media (sometimes only fragments and ruins, sometimes masterpieces in perfect condition) prompted audacious revisions of historical, art-historical, and geographical narratives. They triggered, for instance, the most

improbable yet vivid conjectures about prior contacts between populations. Pictographic books found in Mexico were interpreted as the missing link between Egypt's vertical hieroglyphic and horizontal alphabetic writing; exquisite bas-reliefs discovered in Cambodia were used as material proofs of a previously unknown Roman conquest; American Indians were believed to have Jewish origins or Muslim ties based on their use of specific artistic media or architectural features. Objects and monuments also encouraged bold comparisons with surprising results: the magnificence, quantity, and monumentality of Andean and Mexican temples eclipsed the fineness of Greek, Roman, Jewish, or Egyptian shrines; gold vases (*aquillas*) used in Peruvian ceremonies surpassed the richness of those described in the Temple of Jerusalem; "paintings" made with feathers in New Spain were celebrated as on a par with and even superior to oil paintings. Monuments like the Elephanta rock caves of Mumbai, the Great Wall of China, the Aztec Great Temple, or the Great Buddha of Kamakura were measured, sketched, and studied in situ and from afar. Their novelty (in plan, size, and so on) was compared to well-known architecture. All around a sphere that could now be mentally embraced, not only carved temples, monumental cities, painted manuscripts, and intricate sculptures but also body painting, gold *byobu*, turquoise masks, feather mosaics, fish-bone necklaces, and ivory spoons deeply challenged conceptual boundaries, such as those between civilized and barbarian, center and periphery, beautiful and frightening, idol and art, classic and modern, ancient and new.

The stunning variety of human creativity visible all around the Earth stimulated a veritable revolution in thought that can be related to the Copernican one. At the same time that the Earth lost its fixed position at the center of the cosmos, the Earth's constitution was completely reassessed. Its inhabitants were, in fact, as diverse as they were kin. A universal feature of this circumnavigated humanity was, precisely, creativity. For several thinkers, artistic evidence even became the most compelling reason to halt the violence of the conquest and to avoid becoming barbarians, in turn.

## "Antigo Não é Velho": A New Antiquity

In this specific historical, anthropological, and artistic context, the notion of antiquity underwent a profound transformation. Paradigmatic of this transformation is a statement by the Portuguese painter and art theorist Francisco de Holanda: "Ancient does not mean old" (*antigo não é velho*). Writing in the late 1540s, under the impact of those new artifacts arriving in Europe from all over the world, such as the gold and silver vases looted in Peru, Holanda's brief sentence severed the association between antiquity and the past tense. In the Renaissance, the notion of antiquity already embraced more than

Greek or Roman artworks; Byzantine icons were also considered to be ancient.[68] But Holanda advanced this conceptual shift to the limit. To him, antiquity now alluded to a subtle and inventive creation that could be found anytime and anywhere. In Holanda's conceptualization, antiquity became a synonym of artistic excellence, one that the Greeks and the Romans had formally achieved but that any great artist could—and should— achieve anywhere and anytime: Apelles in Greece, Michelangelo in Italy, the Peruvians in their *aquillas*, or the Chinese in their pagodas.

This radical temporal and spatial redefinition of what antiquity could mean had art-historical, philosophical, and anthropological implications. People living on the other side of the world could be "ancient" artists—excellent artists; their humanity could be precisely inferred from their ingenious artistry. Conversely, mediocre art made in the past, even if produced at the core of an empire, could merely be thought of as old: incapable of outlasting its immediate time and its narrow locale.

Inspired by Holanda's passage, I call the novel concept that came out of the intensive observation and description of unexpected artistic forms and of the acute reflections about the hands and minds that stood beyond them a "new antiquity," which gives this book its title. The oxymoron dialogues with and yet deliberately forces the meaning that the term *antiquity* has had in the important scholarship on antiquarianism. In 1950, Arnaldo Momigliano demonstrated that in the fifteenth and sixteenth centuries the term *antiquitates* referred to "the ancient traditions and remains," which were studied and collected in their inevitably fragmentary condition. Although they were not historians, antiquarians untiringly pieced together and interpreted those fragments, especially epigraphical evidence.[69] Since Momigliano, the breadth and finesse of scholarship on antiquarianisms, today considered from transhistorical and global perspectives, has continued to unveil a myriad of discrete approaches to the study of "the ancient traditions and remains," to the multiple antiquities from around the world.[70] Yet, the term remains associated, in all these studies, with the past tense.

Holanda's crystal-clear statement that "ancient does not mean old" encourages us to think of the term anew—freed from an attachment to the remnants of a bygone time. As we will see in chapter 1, according to Sylvie Deswarte-Rosa, the term *antigo* in Holanda is rather a synonym of *priscum*, a quality of pristine perfection that is embedded and remains active in humanity, albeit silently.[71] In fact, this pristine antiquity, this pristine artistic potential, is revealed rather discontinuously. This is why Holanda clarifies: "antigo não é velho."[72] Not each remnant from the past is worth being understood as ancient, and antiquity—as *priscum*—not only can but, by definition, must transcend the past. The theoretical shift is therefore from thinking of antiquity as any fragmentary evidence of particular traditions from the past to considering it an active human potential of artistic perfection, not only freed from time and space but also freed from complying to a stable

canon. The "new antiquity" unveiled during the contact with the artifacts made in unexpected parts of the globe had, in fact, a meaning that transcended local cities, regions, or empires.

Title and subtitle of this book—*A New Antiquity*: *Art and Humanity as Universal (1400–1600)*—follow in a logical sequence. My proposal is that the concept of "a new antiquity" as a universal artistic potential—a realization that emerged through contact with novel fine artifacts made by people living in parts of the world previously unknown—provided the conceptual basis for a revolution in thought, one that posited that where art is, humans are. Holanda's motto becomes the conceptual thread of the authors studied in this book. In fact, with him, a myriad of other sources clearly record the highly conceptual impact of those never-before-seen artistries. Driven by them, authors as diverse as chroniclers, artists, collectors, missionaries, and even Inquisitors participated in lively debates about how to redefine aesthetic excellence, often putting aside the supposed falsity of the things represented (myths, fables, gods, and so on). The artifacts ultimately demonstrated that art is a form of thought—one of the greatest forms of thought of which humanity is capable. Novel linguistic and conceptual vocabularies, object illustrations, and collecting and curatorial practices participated in the reflection on this new universal, artistic humanity.

The first three chapters of the book trace how the subtlety of artifacts and monuments not only observed in person but also described or experienced through written and oral accounts became the material proof of humanity's refined thought for three specific authors. I inquire into the theoretical and historical relationships between Francisco de Holanda, Pietro Martire d'Anghiera, and Bartolomé de las Casas. Chapter 1, "Lights on the Antipodes," addresses the evidence that people living in parts of the globe previously considered unreachable, uninhabitable, or completely unknown were capable of striking artistry. The chapter moves from cartography to art theory and philosophy through the fascinating work of the Portuguese artist and theorist Holanda. I particularly analyze how the concept of the antipodes, especially the somewhat anachronic concept of American antipodes, was transformed by Holanda's geography of art into a theoretical turning point to define artistic intelligence as the common potential of a universal humanity. In Holanda's theorization and in Michelangelo's words in *Da pintura antiga* (On ancient painting; 1548), the previously unknown people of the New World undo any claim of imperial transmission of artistic excellence. The "origins" of art are also redefined: they become potentially universal in space and time. Artistic inception and artistic excellence can be located anytime and anywhere, which does not mean that they happen always and everywhere. In this way, art becomes a potential—and a horizon—of the human.

Chapter 2, "Acuity Through Art," addresses the linguistic and philosophical precision of the vocabulary employed to describe the artifacts observed in, or arriving from,

the New World. In particular, I study how the concepts of *ars* (art), *acumen* (acuity), *ingenium* (ingenuity), and *industria* (purposeful labor) were theorized in novel ways. The attention given to the intricate making of objects, to their techne, is paradoxically what contributes to define their evidentiary role in demonstrating the ethical nature of their makers. The crucial figure here is that of Anghiera, the Italian chronicler at the Spanish court. Between 1493 and 1526, Anghiera played a key role in setting up a specific theoretical lexicon to address the objects coming from the Americas. This lexicon was certainly indebted to a very specific and recognizable rhetorical tradition of ekphrasis. It was also, however, powerfully novel in describing the specificities of never-before-seen objects. Anghiera was also the first to argue that the creative finesse of those human-made things is evidence of the ethical and political qualities of the populations that produced them. What is at stake in this chapter is to position these concepts as originating both within the new fifteenth-century culture of humanism with its classical heritage *and* because of the encounter with new artifacts that impacted and shaped that culture. The intersection between the two generated what I call "artifact-based humanism."

After exploring the philosophical lexicon of artistic description, chapter 3, "An Indestructible 'Indian' Universe of Artists," focuses on Las Casas's work and his juridical definition of the human. I propose that the groundbreaking meditations of this author on the artistic activities observed in the Americas (several long chapters of his *Apologética historia sumaria* were completed after confronting Ginés de Sepúlveda in the famous Valladolid Debate) can be regarded as one of the most refined theorizations on human, artistic rationality. Las Casas implies a definition of the American populations not as living in a natural state of innocence, as scholarship had previously proposed, nor as destroyed for good, as his work was promoted since his lifetime, but precisely based on their artistic prowess. This prowess, inscribed in the materiality, is not mechanical—it is, in fact, intellectual. A key argument for this demonstration is the scarcity of tools employed to obtain such marvelous results—hence, their artistic finesse cannot but be the product of elevated mental qualities. Previously relegated to the notion of mechanical and servile, these artistic expressions became a full demonstration of the unbounded ("liberal") potential of thought. Las Casas redefines humanity through the artistic gesture. The arts and artists from previously unknown territories contributed to the revolutionary transformation of the conception of creativity.

After the first three chapters, the book addresses the unexpected short circuits between the agenda of the project of Christianization and colonization, from one side, and the aesthetic evidence of shapes and media never seen before, from the other. Chapter 4, "The Sublime Art of the Idol," studies the instabilities of the category of *idol* in the context of the Iberian expansion and its contributions to the modern concept of art. Conquistadors, missionaries, and travelers clearly present the manufacture of idols as an

artistically elevated effort—even though aimed at worshiping the wrong "gods." In this way, they put the error and the beauty of the idol in productive tension. It is precisely through its human-made nature that the term *idol* becomes a qualifier for artifact and art piece. The transformation of the notion of the idol can be traced through a variety of texts written in the Americas, Asia, and Africa. These texts span from Inquisitorial processes to chronicles and inventories that address the observation of idols as a subjective aesthetic experience. The description of their shape and beauty—and what the sources call, literally, their *sublime* character—becomes a crucial step to theorize the independence of the artistic object from its worshiping purposes. The appreciation of the art of the idol allows the objects to shift from a forensic context (the verdicts in Inquisitorial trials) into the terrain of aesthetic judgment. Along with the term *idol*, many other terms participated in the same delicate disentangling of religion and artistic object. Some of these terms, like the Quechua *huaca* or the supposedly Taino *çemi*, were Indigenous; others, like the Afro-Portuguese *fetisso*, were pidgin terms evolving from European medieval contexts (Lat. *facticium*, Port. *feitiço*). But all helped to portray the people found in the furthest corners of the globe as artifact makers, and all contributed to a reconceptualization of where artistry resides. Among the chapter's key points of analysis are the Inquisitorial trial of the cacique of Texcoco, Mexico, in 1539, which included the "chasing" of idols, their description, and their display, and the pages that, around 1585, the Portuguese Jesuit Luis Frois devotes to describe the pleasure of walking among the one thousand statues of the temple of Sanjūsangen-dō in Kyoto. The chapter also addresses a fascinating image (dated to the mid-1570s) from the Florentine Codex representing "idol making" in New Spain, where a Mexica idol is represented in contrapposto position. Going beyond the apparent anachronism—pre-Hispanic sculpture was obviously not carved in contrapposto—I propose that this is a theoretical choice made by the *tlacuiloque*, the painters of the Florentine Codex, in order to present pre-Hispanic sculpture as comparable (namely, in a point of potential equality) to Greco-Roman and Renaissance sculpture. The representation of idol making becomes the paradoxical representation of Mexica artistic excellence.

The last chapter of the book addresses the relevance of the artifacts seen or arriving from the Americas, Africa, and Asia, for the history and geography of art—and for the concept of the Renaissance itself. Chapter 5, "Novel Territories of Painting," reflects on how three treatises on art, written in the mid-sixteenth century, envisioned the "rebirth" of the arts through a subtle interplay between a protonational history of art and the global panorama of human creativity. If in his famous *Lives* (published in 1550 and, in a second edition, in 1568) Giorgio Vasari preferred a biographical model restrained in time and space, the Portuguese Holanda—as seen in chapter 1—and the Spanish Felipe de Guevara broadened their critical lens to novel spaces and times. Grounding reflections on

specific artifacts, such as feather paintings and painted manuscripts from New Spain, Guevara identified unexpected territories of the Renaissance, implying that the rebirth of the arts could come from the outside. The chapter then studies the arrival of feather mosaics in Beijing and Prague: simultaneously at the courts of Wan Li and of Rudolph II, where these novel forms of painting triggered linguistic and painterly reactions that illuminate their profound agency in nonexotic terms.

After synthetizing the proposals of the book and their potential implications for rethinking the history of art history, the conclusion, titled "A New Artistic World," takes a step further the analysis of the roles played by the antipodean objects in early modern times. Many of the artifacts discussed in this book were eventually displayed in the first museums, like those of the Bolognese Ulisse Aldrovandi and Ferdinando Cospi, during the late sixteenth and seventeenth centuries. There, they were presented in courageously close proximity to objects or references from the Old World, from classical antiquities to contemporary local arts. I contend that the displays of these museums may have originated precisely in the previous experiments of the authors studied in this book—not only the European chroniclers, missionaries, and artists, but also Indigenous painters and writers who produced similar "montages" or even proto-Warburgian juxtapositions between discrete art pieces, in their pictorial and textual works. The conclusion ultimately addresses how, between 1400 and 1600, through novel material, visual, and textual displays, the heterogeneity of human creativity found throughout the entire world came to be thought of, represented by, and physically displayed as "comparable," in the sense of being in a relationship of artistic equality. That comparison was not a juxtaposition—what could be thought of as the dawn of a world art history made of discrete, autonomous regionalisms—nor was it the premise of the world museum in vogue today. It was, on the contrary, a creative intertwining between myriad artworks, always guided by one specific point of comparability between multiple evidences of human creativity: their always unique and yet intelligible artistic excellence. By the late seventeenth century, however, this dynamic vision started regressing into a gradual disconnection. Albeit written from the perspective of supposedly universalist values, modern political philosophy often reinforced—probably even generated—the epistemological divisions that we have inherited.[73] Modern disciplines, like art history and ethnography, partitioned further their objects with endless internal divisions: high arts versus minor crafts, people with writing versus those supposedly without it, complex versus simple kinship systems, and so on.

Yet, evidence of a universal artistic humanity did, in early modern times, revolutionize the definition of art itself. In spite of all the conscious and unconscious efforts to stifle that revolution, it happened. It is up to us to reconnect with that groundbreaking process and to invent today original scholarly practices for studying and teaching. In

this regard, the book engages with conversations about how to renew the curriculum of a discipline that often perceives itself as uniquely rooted in Europe. The answer, for me, is not an "inclusive" art history: an art history rewritten with the best intentions of decolonizing the discipline but ultimately made of self-standing parts—chapters and special issues that one may easily skip (or that one could read in isolation, which produces the same results: leaving things unchanged).[74] The answer is to historically demonstrate, in our daily practice, the generative power of the "artifacts of the antipodes" in the theoretical reflections about art and humanity. Without taking them into account, there cannot be today *any* art history.

# Lights on the Antipodes
## "Made Throughout the Entire World"

*The precepts of ancient painting already disseminated*
*throughout the entire world, even to the antipodes.*
—Francisco de Holanda, *Da pintura antiga*

When the painter and theorist Francisco de Holanda (1517–1584) wrote these words in his treatise on painting around the 1540s, he meant something revolutionary and yet difficult to grasp. A detail of his miniature of the Creation illuminating a tiny Earth in all its latitudes and roundness makes a similar impression: it is at once recognizably radical and cryptic (fig. 6). In both instances, Holanda spotlights the world as a whole, a world in which the most distant and opposite points reveal equal intelligibility. But the implications of these wide-ranging observations are not self-evident, especially when one wants to avoid approaching Holanda as expansionist from the start. Can a global perspective, particularly one focused on the unexpected dynamics of artistic exchange and experimentation that accompanied the early modern globalization, help elucidate Holanda's textual and pictorial vision of the world?[1] To some extent, yes. Traveler, collector, and artist, this Portuguese author seems to incarnate the perfect case study to look at the Renaissance from territories considered peripheral to art history (Portugal, the Americas, Asia, Africa) and to address the impact of the so-called extra-European objects on art theory. Holanda offers precious keys to move beyond the Eurocentrism of a discipline

that, in spite of some major efforts, still remains limited by nineteenth-century geopolitical and chronological parameters and by "hierarchies of genre."[2] To look at this author from a broader historical and art-historical perspective also helps exonerate him from a long tradition of accusations (of being an unreliable writer, a minor artist, a puppet of the Italian entourage that he idolized, and so on), especially among Germanophone and Anglophone authors.[3] Notwithstanding the untiring work of renowned scholars like Sylvie Deswarte-Rosa and the recent complete translation of *Da pintura antiga* into English by Alice Sedgwick Wohl, Holanda remains largely disregarded by Renaissance specialists and almost completely unknown to nonspecialists.

There is more at stake, however, than just contributing to Holanda's recognition or exploiting his work to prove the benefits of a global perspective. I approach Holanda here as a pioneer thinker who, looking at a variety of artworks created all over the world, made a groundbreaking observation: their singular perfection, far from being of "exotic" appeal, makes them equal to any other great piece of art.

This observation allowed Holanda to articulate a threefold concept of *universal*. First, he claimed that artistic excellence, named "ancient painting" according to his lexicon, was endowed on humanity since its inception—hence, its universality. Here, the author was informed by Christian theology and Neoplatonic philosophy. Second, he conceived humanity tout court as universally artistic—several centuries before world art history defined art as "a panhuman phenomenon" *and* with crucially different nuances.[4] In fact, Holanda considered humanity immanently, not phenomenologically, artistic. Art is the common potential that constitutes humanity (a premise that is closer to Meyer Schapiro's vision of art as "the strongest evidence of the basic unity of mankind"[5])—hence, its equal intelligibility around the world. The theological and legal transatlantic debates on how creativity proves human rationality—debates that crystallized in the papal bull *Sublimis Deus* (1537)—undoubtedly influenced his view.[6] Third, he implied that the artworks made whenever and wherever, even in the "antipodes," can transcend their initial context of production and be compelling to anyone—even to someone considered the greatest living artist. Their excellence itself therefore becomes *universalizable*.

Holanda's threefold concept of *universal* is particularly relevant to art history today as it overcomes the polarization between the presentist drive of the discipline (and of all the humanities) toward the modern and contemporary and the dwindling interest in (or for) the premodern. Holanda's written and painted art theory matters to anyone who studies and practices the arts, redesigning its possibilities, questions, and methodologies. His

FIGURE 6 | Francisco de Holanda, *The Creation of Lights*, in *De aetatibus mundi imagines*, 1547–51. Painted manuscript, 41.5 × 28.5 cm. Madrid, Biblioteca Nacional de España, DIB/14/26. Photo: Biblioteca Nacional de España.

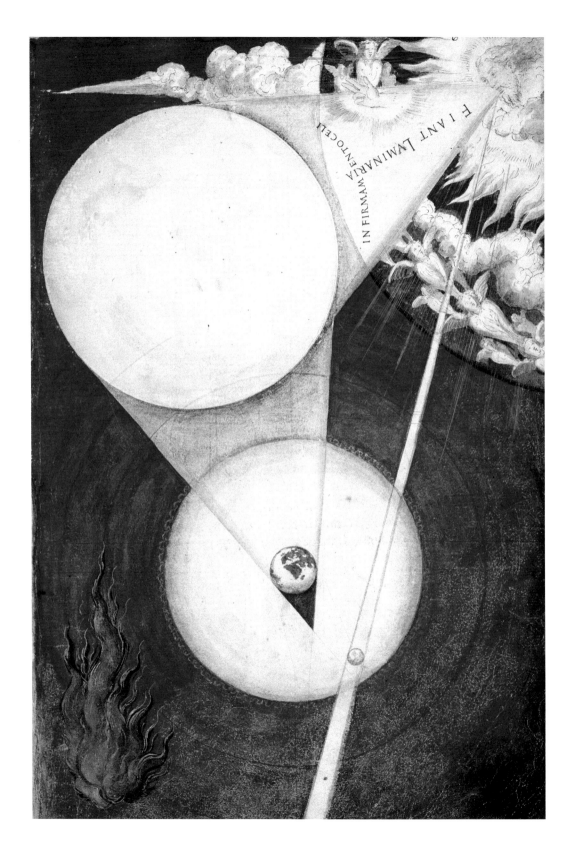

vision, however, is aligned neither with a world art history—including the anthropological approach to visual agency proposed by *Bildtheorie*—nor with a universal art history, if one intends them as disciplines trying to "understand all visual cultures," under a supposedly moral obligation.[7] No presumption of completeness or inclusiveness is offered in Holanda's work, much less a eulogy of otherness.[8] Nor does he provide definitive criteria to define artistic excellence. This is perhaps why his threefold concept of "universal" also complicates any generalization of early modernity from the standpoint of global studies. Reducing his vision to a by-product of European hegemonic universalism would obscure the fine elaboration of and departure from the Christian underpinnings of his thought.[9] Tracking in his pictorial and textual work the transformation of the idea of the world from a creation of God to an arena of profit for early capitalism and the project of modernity would overlook his pioneering effort to think of the Earth in artistic terms.[10]

Therefore, how can one approach Holanda's unique theory of the arts and articulate his relevance today? At once (art-)historically and theoretically. Such an approach begins with an itinerary of the places Holanda visited and the people he met in his youth. This retrospect look allows a glimpse into the variety of artifacts that gave shape to his sensibility: Roman antiquities; Ceylonese, Ethiopian, and Indian objects seen in Portugal; medieval art visited in France or Catalonia; and contemporary art observed in Rome. Next I propose a reading of his miniature *The Creation of Lights* informed by the previous discussion of Holanda's itineraries. The painting is not so much an accurate cosmographic image of a biblical episode as it is an invitation to look at a world inhabited by creativity. I then move to careful readings of several passages of Holanda's *Da pintura antiga*, claiming that we cannot separate, as has been the tendency in scholarship so far, the initial theoretical part of the treatise from the famous "Dialogues in Rome." Michelangelo's ideas and specific vocabulary, as reported by Holanda in those conversations, are, in fact, closely related to what the author has written in the first part of the treatise on the universality of ancient painting throughout the entire world, even in the antipodes. Finally, I address another one of Holanda's contemporary sources on universal human artistry: the outstanding Miller Atlas, painted in 1519 for King Manuel I of Portugal by a team of artists, probably including Holanda's father. Rather than the world map, as previously proposed, I assert that two New World maps in the atlas, in which the inhabitants are represented as thoughtful "inventors," resonate with Holanda's perspective.

## Holanda's Spaces

Santarém, Portugal, 1547. Working under the patronage of Queen Catherine and King John III and with the support of the infante Dom Luís, Holanda was just thirty years old,

but he already had far-reaching experience in the realm of the arts—in the practice and in the theory of the arts.

Son of António de Holanda, a prominent miniaturist and illuminator of the Portuguese court, Francisco began his visual training at home and in the streets of Lisbon. His father's commissions, in particular, the illuminated cityscapes and atlases, must have shown him the possibility of distilling the world into a tiny space. *View of the Rua Nova dos Mercadores*, attributed to António, condenses in a few inches the narrow width and pulsating activity of the city's merchant street.[11] The vanishing point of the image, however, lies on the intriguing strokes sketched in the distance. They evoke the ghostly skyscraping masts of the vessels that sailed in and out of the Atlantic port—like those featured in the foreground of another of António's miniatures.[12] A later oil painting depicting the *View of the Rua Nova dos Mercadores* also focuses on the swarming activity of the merchants' street, though it conceals any pictorial reference to oceanic voyages.[13] The miniatures attributed to Francisco's father instead signal how the ships' horizon constituted an integral part of the urban economy and reality.[14]

Lisbon was, in a way, a miniature of the world, with a vanishing point outside itself. Precious cargo and people in the flesh were continuously arriving on and departing from its shores. If Seville was turned toward the Americas, the city on the Tagus was the privileged port of entry for Africa and Asia.[15] Since the late fifteenth century, vessels coming from West Africa carried those "velvety" raffia textiles celebrated as surpassing even the fancy cloths made in Italy.[16] These smooth fabrics promptly acquired the status of singular artifacts and entered the space of religious painting, becoming the preferred tapestries on which Portuguese artists staged the Annunciation (fig. 7).[17]

During the Holandas' lifetimes, two overseas arrivals—one from Africa and the other from Asia—could have directly impressed the royal miniaturist and his son. In 1527, an Ethiopian embassy passed through Portugal on its way to Rome. For the Orthodox monk Saga Zaab, however, the stopover lasted several years. He was retained at court and faced a thorough interrogation on the faith of the Ethiopians. Several key persons, including the humanist Damião de Góis, met him.[18] António and Francisco were probably also introduced to Saga Zaab, in which case they may have had the chance to admire the precious crown and the two letters he had brought to the king.[19] It is tempting to imagine that other artifacts, perhaps intricate metal crosses, painted panels, and books, also arrived from East Africa and left an impact on their observers. In 1542, another embassy docked in Lisbon, that of the king of Kotte (Ceylon, present-day Sri Lanka)—the first Asian embassy ever sent to Europe, meant to strengthen a delicate political alliance. The Tamil chamberlain Sri Ramaraska Pandita offered the Portuguese court a variety of royal gifts created in Sinhalese workshops: ivory caskets (fig. 8), fans, combs, and rock-crystal jewelry. These astonishing objects combined Hindu, Buddhist, and European iconographies that must

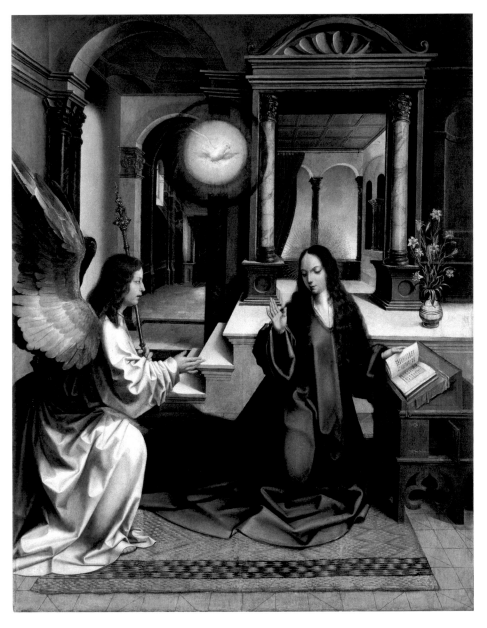

FIGURE 7 | Attributed to Jorge Afonso, *Annunciation*, ca. 1515. Oil on panel, 160.5 × 129.5 cm. Lisbon, Museu Nacional de Arte Antiga, 1279. Photo: Museu Nacional de Arte Antiga / Directorate-General for Cultural Heritage / Photographic Documentation Archive (DGPC/ADF).

FIGURE 8 | opposite | Coronation casket, Kotte, Ceylon (Sri Lanka), ca. 1545. Ivory, 18 × 30 × 16 cm. Munich, Residenz München, Schatzkammer, inv. ResMüSch. 1241. © Bayerische Schlösserverwaltung, Rainer Herrmann / Ulrich Pfeuffer, München.

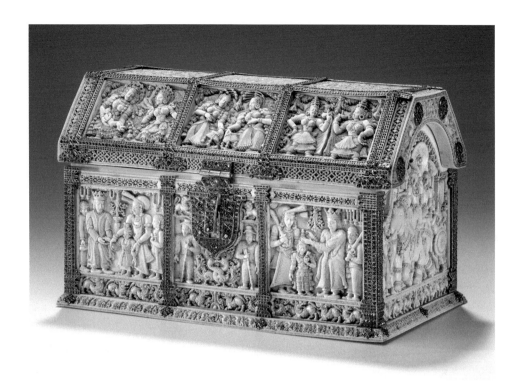

have puzzled their Portuguese viewers. The ivory coronation casket was publicly carried through the royal palace and remained accessible to key members of the court.[20] As a royal artist, António de Holanda, together with his son Francisco, may have been among the elite who met the Kotte ambassador. By the time he left in 1543, Sri Ramaraska had mastered the Portuguese language and had probably provided his hosts with some explanation of the coronation casket, a hypersophisticated piece.

In Lisbon, Francisco must have also witnessed the arrival of the slave-trade vessels. The infamous commerce was so conspicuous that, at about the middle of the century, approximately 1,600 enslaved Africans were sold every year.[21] They became a frequent presence in Portuguese streets and households. Another miniature attributed to António portrays an enslaved African man serving a family—if not Holanda's own, then one of his social status.[22]

For the young Francisco, the "emporium city" of Lisbon had also been a door into the past. As he would remember later in life, "sendo mouço" (when he was young), he wandered through the streets of former Olisipo in search of the relics of Roman presence. A statue of Asclepius, the god of medicine, still worshiped by his contemporaries, had particularly impressed him.[23] This close familiarity with ancient, hidden treasures eventually led him to the role of cicerone for the antiquarian André de Resende, considered

the father of archaeology in Portugal. His unique sensibility toward antiquities and their afterlives permeates the impressive collection of drawings that Holanda started compiling when the court sent him to Rome. Between August 1538 and March 1540, he traveled to Italy with Dom Pedro de Mascarenhas, the Portuguese ambassador to the Holy See. Former captain in North Africa and future viceroy of Goa, the powerful Mascarenhas was in charge of obtaining from Paul III the authorization for a Portuguese Jesuit mission to Asia.

Introduced to the Roman entourage by Mascarenhas and the pope, Francisco promptly met the humanist Lattanzio Tolomei, the artist Michelangelo, the poet Vittoria Colonna, and the miniaturist Giulio Clovio. They all feature in the famous "Dialogues in Rome" that he completed once back in Portugal, recreating the theoretical nature of the conversations on the arts that he had (or wished he had had) with them. In the Eternal City, Francisco also studied the city's antiquities with the perfect "guide" under his arm—Giacomo Mazocchi's *Epigrammata antiquae urbis* (1521)—annotating in the printed book every single inscription that he saw.[24] From Rome, he traveled to Venice, Mantua, Padua, Treviso, and Spanish Naples, among numerous other sites, sketching ancient and new monuments, as well as landscapes.[25] But his proximity to Mascarenhas granted Francisco a privileged access not only to Italian circles, artifacts, and cities but also to a cutting-edge perspective on the wider world. The correspondence of the Portuguese ambassador with King John III shows that, while in Italy, Mascarenhas was continuously bringing to the attention of Paul III pressing questions relating to the colonization and Christianization of Africa and Asia.[26] It is therefore possible to imagine a day in Rome for the young Portuguese: sketching the Roman past, hearing Michelangelo's and Colonna's ideas on painting, and craving *as novas* (the news) on the Kingdom of Kongo, Ethiopia, India, or Constantinople, which his protector was discussing at the Holy See.

In 1540, after finally obtaining Paul III's authorization for the Jesuit mission, Mascarenhas and Holanda traveled home in the company of Francisco Xavier, spending time together in Loreto and Bologna. Back in Portugal, the experienced artist quickly reintegrated into the Portuguese court and began contributing to its needs. He sketched what was probably his only architectural project: a plan of restoration for the fortress of Mazagão, in Portuguese Morocco. In the early 1540s, he cultivated relationships with the soldier and administrator João de Castro, recently returned from India with vivid impressions of its artistic richness. In his logbook (*Roteiro*, 1539), Castro describes, among other things, the "sumptuous temples and magnificent buildings" of the islands of Elephanta and Salsette.[27] Holanda even visited Castro in his residence in Sintra, the Quinta da Penha Verde, which featured a forest inspired by Indian gardens. A few years later, several Sanskrit stelae looted in Diu would be displayed there.[28] Holanda may have also received personal correspondence from Portuguese India by three of his family members

who were appointed to strategic posts: his brother Miguel was a high official in Goa; his brother Jerónimo was superintendent of the fortress of Chaúl; and one of his brothers-in-law was treasurer of Cochin.[29]

Endowed with a variety of experiences that included direct observation of novel artifacts and classical antiquities, engagement with Michelangelo's ideas, and involvement in debates about the Portuguese expansion toward Asia and Africa, this traveled man in August 1545 set to work on a series of astonishing images on the creation of the world.

## Return to Earth

*De aetatibus mundi imagines* (Images of the ages of the world) is a painted chronicle of the Christian history of the world from the Creation to the Apocalypse.[30] It comprises 156 drawings that Holanda made over almost three decades. He completed the first three in Évora in 1545. After a pause of two years, he drew the fourth and fifth images in Santarém in 1547 and colored them in Almeirim in 1551. It is the fourth of the paintings, *The Creation of Lights*, that deserves our special attention (see fig. 6).

According to the Book of Genesis, on day four, the luminaries were created: "The greater light to rule the day, and the lesser light to rule the night" (Gen. 1:14–19).[31] Holanda transcribed the Latin text of the Vulgate (fol. 5v) and illustrated it on the opposite page (fol. 6r). On the upper right corner of the image, God's mandate emanates from his mouth in the form of an inverted bow: "Fiant Luminaria in firmamento coeli" (Let there be lights in the firmament of the sky). Two interlocked triangles kinetically project clarity on the sun and, from there, on the terrestrial globe. Like a powerful magnet, this Lilliputian Earth immediately attracts the eye as it casts a bold shadow cone in space. It is encircled by a larger white sphere, which itself is encapsulated by a third and a fourth concentric circle (probably Mercury and Venus), both colored with the same ultramarine blue of the sky. Another discrete cone originates from God's mouth and reaches a distant and tiny moon. Its shine, like an invisible arrow, reaches the bottom of the page in our direction.

Deswarte-Rosa demonstrates that the making of *De aetatibus mundi imagenes* is based on an impressive array of sources—including Plato's *Timaeus*, Giovanni Pico della Mirandola, Johannes de Sacrobosco, Nicolaus Cusanus, Hartmann Schedel's *Liber chronicarum*, Juan Maldonado's *Somnium*, and the most recent work of Renaissance cosmographers.[32] It is worth inquiring further how, precisely, Holanda in *The Creation of Lights* transformed all that he knew into an unparalleled think piece.

In Évora, one major inspiration had certainly been the royal cosmographer Pedro Nunes (1502–1578) and, in particular, his *Tratado da sphera* (Treatise on the sphere), published in Lisbon in 1537. Dedicated to one of the supporters of the *De aetatibus*, Infante

FIGURE 9 | Lunar eclipse, in Pedro Nunes, *Tratado da sphera: Con a theorica do Sol & da Lua* (Lisbon: Per Germão Galharde, 1537), n.p. Providence, Brown University, John Carter Brown Library. Photo: John Carter Brown Library.

FIGURE 10 | Concentric spheres, in Pedro Nunes, *Tratado da sphera: Con a theorica do Sol & da Lua* (Lisbon: Per Germão Galharde, 1537), n.p. Providence, Brown University, John Carter Brown Library. Photo: John Carter Brown Library.

Dom Luís, this cosmographic treatise was a translation of the works of Ptolemy, Sacrobosco, and Georg von Peurbach, updated through the recent experiences of navigation.[33] Nunes demonstrates that the sphericity of the Earth, hypothesized by the ancients, was confirmed by the physical experience of sailors. Three of the Ptolemaic arguments had acquired a global proving ground: it was now clear that, from different points of the navigable world, the observations of day and night, of the starred sky, and of the eclipses were different. "That the earth is round is proved by the fact that the signs and the stars don't rise and set equally everywhere for all the human beings," Nunes concludes.[34] An engraving illustrates that when half of the Earth shines in the sunlight, the other half is immersed in the dark (fig. 9). The terrestrial globe casts a projected shadow in the sky and reaches half of the moon (as, according to geocentrism, it was the Earth's shadow that produced lunar eclipses). Other illustrations of Nunes's book clearly show the mix between ancient and new cosmography: the terrestrial globe includes subequatorial regions of Africa and Asia and a glimpse of the New World, even though the Earth is still surrounded by a clear sequence of encircling spheres, all sealed by a solid firmament (fig. 10).

The *Tratado da sphera* could have prompted Holanda to represent the biblical theme of the Creation of lights cosmographically—that is, conveying how the sunlight rules the day and the moonlight rules the night simultaneously in different parts of the world.[35] However, looking carefully at the painting, one realizes that Holanda did not do that. Rather, the artist made in Santarém five decisions that set his image apart from both the

biblical and the cosmographic narratives. These decisions are crucial to understanding how Holanda's extraordinary painting newly conceives the world.

35

1.  First of all, in Holanda's painting, the *firmamentum*, the firm vault or dome of heavens, does not encircle and protect the interior spheres, as in Nunes's engraving, nor does it lock the entire upper part of the image, as in earlier representations of the Creation (see fig. 6).[36] The image still owes much to Aristotelian and Ptolemaic astronomy, which posited that the terrestrial globe, made of the heavy element of Earth, pulls itself at the center of the universe while remaining always in a low point in relation to the higher, perfect heavens. Yet, here, the firmament only partially shelters the universe. The planets occupy a rather vast, unprotected space. Holanda may have done here what Nunes would have liked to do. The royal cosmographer was familiar with Nicolaus Copernicus's heliocentric revolution, which was made public in 1543 with the publication of *De revolutionibus*.[37] By moving the firmament to the side and rejecting a rigid application of the concentric spheres model, Holanda opened up a space that has no perfectly central pivot point.[38] However, it is the terrestrial globe that attracts the viewers' eyes. This results in a thought-provoking paradox: the Earth is slightly off-center in the cosmographic space—as it is slightly off-center in Genesis's fourth day, which is about the creation of the luminaries—and yet, it is precisely the Earth that *becomes* central to the painting.

2.  The centrality of the Earth explains the second decision made by Holanda, who strove to represent an extremely precise—and extensive—portion of the terrestrial sphere (fig. 11). The African continent is shown in its entirety, up to the Cape of Good Hope, rounded by Bartolomé Días in 1488. On its right, the large island visited by Diogo Dias in 1500 and named San Lourenço (present-day Madagascar) is represented. India, reached by Vasco da Gama by ocean in 1498, is also outlined. On the right side of the sphere, possibly the Spice Islands (the Indonesian archipelago of the Moluccas) are shown. On the left side, another large landmass emerges from the waters: undoubtedly, the Americas. Holanda places both the Americas and the Moluccas in the roundish parts of the globe, highlighting the circular movement that is necessary to completely visualize them—and the circular movement that is necessary to circumnavigate the world. That possibility had become a reality in 1520, when Ferdinand Magellan passed from one ocean to another through the strait that would bear his name. The Magellan-Elcano expedition then continued to round the globe precisely through the archipelago of the Moluccas and the African Cape of Good Hope, both clearly represented in the painting. For this particular representation of the Earth, Holanda might have had in mind not only the Miller Atlas's world map, as has been previously proposed, but also Battista Agnese's oval maps (figs. 12 and 13).[39] In the former, made in 1519 (before the Magellan-Elcano expedition), the

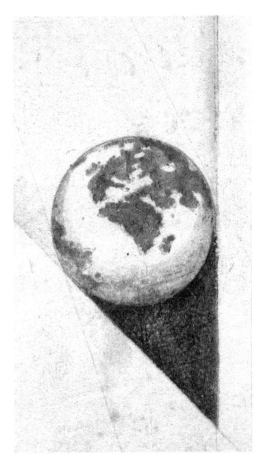

FIGURE 11 | Francisco de Holanda, detail of the Earth in *The Creation of Lights* (fig. 6).

FIGURE 12 | Lopo Homem, world map, in the Miller Atlas, 1519. Illuminated vellum, 42 × 59 cm. Paris, Bibliothèque nationale de France, GE D 26179 RES. Photo: Bibliothèque nationale de France.

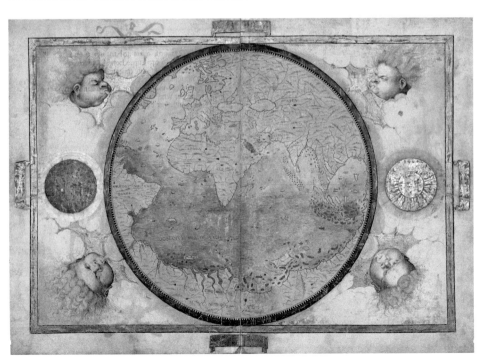

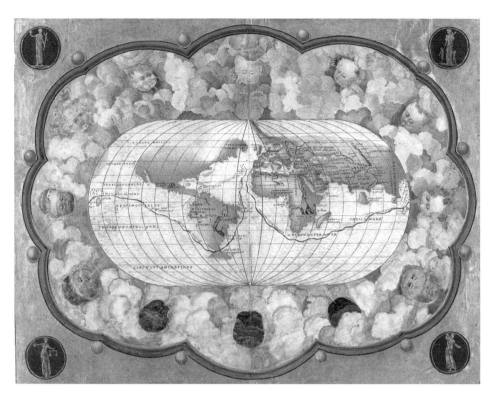

FIGURE 13 | Battista Agnese, world map with oval projection, Venice, ca. 1543–45. Vellum, 27 × 34 cm. Providence, Brown University, John Carter Brown Library. Photo: John Carter Brown Library.

FIGURE 14 | Francisco de Holanda, detail of *The Creation of Lights* (fig. 6), seen from the observer's viewpoint.

terrestrial globe's sphericity is still abstractly geometric; in the latter, made in the 1540s, the Earth's roundness is demonstrated through a precise line that follows the ship *Victoria*'s trajectory from Sanlúcar back to Sanlúcar via the Americas, Asia, and Africa. While in the Miller Atlas land seems to seal the circle from within, impeding any fluid passage, in Agnese's map, the sea is open to circumnavigation. The focus of Holanda's *The Creation of Lights* is this circumnavigable world.

3.  To be in focus, one needs the best possible light. This is why Holanda kept the entire visible part of the world in daylight. While in Nunes's illustration half of the globe is plunged into darkness, in *The Creation of Lights*, the sun is at its zenith from the Americas to the Moluccas (cf. figs. 6 and 9). This is undoubtedly another decision made by the painter, who theorizes about the power of light in his artistic treatise *Da pintura antiga*: "It would be of little value to portray a face from life in semidarkness, because we would see no more of it than the place it occupied, but with bright light it will be seen at once and will become intelligible."[40] The recourse to bright light proved to be particularly appropriate for the portrait of the world—an "intellectual portrait," since Holanda could not paint it "from life." Leaving all the visible and extensive "face" of the world in the sunshine, Holanda captured with his "invisible eyes" the Earth's intelligibility.[41]

4.  Holanda painted the terrestrial globe according to a rule of colors distinct from the rest of the painting. The precious ultramarine blue used for the sky permeates the dry land while the seas are colored in white. These chromatic inversions between air, water, and land make the Earth recognizable through a purposeful unrealism. This specific pictorial choice shifts the apparent geographic modality of the Earth's portrait into a different conceptual terrain.

5.  Finally, the shadow cone cast by the Earth does not eclipse the moon, as in Nunes's engraving (see fig. 10) or in earlier representations in Sacrobosco's treatise. In Holanda's painting, the moon remains fully visible and projects a powerful light that, bearing in our direction, emphasizes our position as observers of the entire scene (fig. 14). We (the painter included) are looking at the terrestrial globe that we inhabit.

Holanda's five decisions—to move the firmament to the side, to outline an extremely large extension of the visible world (from the Americas to the Moluccas), to leave the world entirely in the bright light of the day, to color the Earth distinctively and unrealistically, and to direct the moon's light toward the painter and the viewer—make the Earth, or rather, the "return to Earth," the focus of the painting.

In a remarkable reflection on the early modern roots of globalization, German philosopher Peter Sloterdijk used the expression "return to Earth" to name the "new and inevitable encounter-from-outside with the earth" that happened when the existence of

the firmament lost its currency and the physical exploration of the globe transformed both the idea and the image of the terrestrial orb. As opposed to the *vil semblante*, the "humble appearance" of a distant Earth described from the heavens by Dante Alighieri after ascending through the seven spheres (*Paradiso* 22), it was a beautiful "earth teeming with life" that caught the interest of early modern cartographers, naturalists, scientists, and astronomers. According to Sloterdijk, the terrestrial globe became "the central icon of the modern world picture"; however, the craze for describing, mapping, and quantifying the physical nature of "shell-less humanity's own planet" resulted also in an increasing "lack of interest in humanity" itself.[42]

Holanda's gemlike terrestrial sphere participates, at first sight, in the same amazement for the Earth's geographic beauty. If so, it would appear a celebratory image of the unbounded, wild world available to the Iberian expansion and to the new global transactions—the "world interior of the capital," as Sloterdijk's book reads in English translation.[43] But this extraordinary painting may also deserve a less skeptical interpretation. Although cartographically accurate in the depiction of the globe and astronomically visionary, Holanda's *The Creation of Lights* is not a cosmographic image—it represents neither the globe's different exposures to day and night nor a lunar eclipse. The unrealism of the Earth's palette pushes further against any protoscientific or imperial interpretation of Holanda's painting. Instead, it encourages viewers to understand differently Holanda's own return to Earth.

## Ancient Painting Throughout the World

Crucial for understanding Holanda's return to Earth is his decision to direct the moonlight toward the beholders. Placing us in the direction of the moon's piercing shine and diametrically opposite to God, Holanda signals that the observation of the Earth concerns us humans (painter included). Our position is therefore ubiquitous, as we are both outsiders—observers of the "object" world—and insiders—inhabitants and "subjects" of that world. The indisputable beauty of the circumnavigable, terrestrial globe becomes a device for introspective exploration by its inhabitants. The act of painting stands in a similar, ubiquitous position: it paints the world as an object while it is an active subject of that world, one that is even capable of materializing it. The outstanding artistic quality of the painting incites a reflection on what painting is.

"What Painting Is," word for word, is the title of the second chapter of the treatise *Da pintura antiga* that Holanda was writing precisely while he was painting *The Creation of Lights*. The book, dated between 1540 and 1548, is composed of two parts.[44] In the first one, Holanda defines what painting—more precisely, "ancient painting"—is, outlining its history and general precepts. In the second part, he stages four dialogues in which

Michelangelo shares his ideas on creation with an audience composed of, among others, the poet Colonna and Holanda himself. From the beginning of the treatise, it becomes immediately clear that "painting" is not just painting and that "ancient" does not mean "old." Here is an excerpt of Holanda's definition in chapter 3:

> [Painting] is exaltation of the arts and an expression of the inner man, resembling the intricacy of the soul and not that of the body. It is . . . the mirror in which the work of the world is reflected and seen. . . . It is true and reasoned simulation . . . it is a new world of man and his own kingdom and handiwork . . . it is a lamp, a light that in a dark place unexpectedly reveals works that were previously unknown. . . . And finally painting is making and creating from nothing, [so] that it seems that what is so near is far away.[45]

"Expression of the inner man." This power of unearthing our most intrinsic nature makes of "painting" both a human potential and the medium through which it manifests itself. It is not a skill that can be learned.[46] Humans everywhere are born with such potential, as Holanda clarifies in chapter 10: "Engenhos em toda parte podem nascer" (Talents can be born anywhere), referencing Juvenal ("[Artists] may be born in a dullard air and in the land of thick-heads," *Satires* 10.49–50). When this human potential expresses itself in its highest possible quality, it is recognizably "ancient painting," an expression that alludes neither to painting nor to the past. In fact, the term *painting* embraces also sculpture and architecture. It broadly refers to *desenho* as both design and drawing, idea and making: that is, the capacity to mentally conceive and materially realize.[47] As for "ancient," Holanda repeatedly explains in chapter 11 that this adjective has nothing to do with something "made in the older times." On the contrary, ancient "is the one that is excellent and elegant."[48] By not being just painting anymore and not old at all, "ancient painting" becomes the name of a nonprescriptive artistic excellence, one that can be found in any artifact, made by any artist, anywhere, and at any time.

I have synthesized in a few lines Holanda's groundbreaking universalization of the arts in time and in space. Where did he find the impulse to take such a step? And what were its consequences for the treatise and for his own artistic practice? For instance, to what extent does the Earth in *The Creation of Lights* express in painting this universalization of the artistic human potential? Keeping these questions in mind, let us now follow more closely Holanda's intellectual process. The possibilities opened by this universalization may have been giddying to Holanda himself, which may explain the frequent backslides in the treatise. It is as if the author was testing his visionary perspective in the text itself. He gives to Michelangelo the assessing task.[49] On the one hand, the Italian artist plays the role of ultimate prescriptive touchstone against which the quality of any other artist must

be measured. He is the symbol of perfection. On the other hand, especially in the first of the dialogues, Michelangelo is an active character who pronounces bold judgments, on a global scale, using a resolutely geographic and geopolitical language: "Of all the climes and lands on which the sun and moon shine, there is no other in which it is possible to paint well except the realm of Italy."[50] It is a perfectly tailored, Italo-centered discourse on artistic excellence that Holanda puts in Michelangelo's mouth—even though pronounced not in Tuscan but in Portuguese.[51] However, if Michelangelo plays the testing role to Holanda's universalization, Holanda plays the countertesting role to Michelangelo's fictive Italo-centrism. Recalling a beautiful female portrait seen in the Franciscan monastery of Avignon, he says, "There is a work of painting that I saw which should not be passed over in silence, even though it is outside Italy."[52] From this moment, a progressive deprovincialization unfolds in the treatise to the point that in the second dialogue, it is Michelangelo himself who surprises the reader with an unexpected definition of the true painter: "[The true] painter . . . will not only be instructed in the liberal arts and other sciences such as architecture and sculpture, which are properly his occupations, but if he has a mind to, he will undertake all the other manual trades that are practiced throughout the entire world [*officios manuaes que se fazem por todo o mundo*], with far greater skill than the proper masters of them."[53] At first sight, what Michelangelo affirms is the usual opposition between the liberal and mechanical arts, with (Italian) painting pertaining to the former and ("world") manual skills to the latter. But the fact that the true painter needs to be instructed and even be able to excel in *all* the manual trades that are practiced throughout the entire world complicates things. "Painting" becomes intrinsic to *any* of those manual trades. This universalization of human creativity is further theorized by Holanda's Michelangelo a few lines later: "Thus he who carefully considers and understands the works of humankind [*obras humanas*] will find without doubt that they are either painting itself or some part of painting."[54] An unprecedented conflation between manual/mechanical arts, painting, and humanity is pronounced here. If Leon Battista Alberti in *De pictura* (1435) had defended the dignity of painting based on its superiority to manual occupations, here the reasoning is the opposite.[55] If all artifacts are "painting" and if "painting" (as *desenho*) results from and is in itself a thinking process, all human artifacts are also generated through a thinking process. And since any "work of humankind" is "painting," including the artifacts resulting from manual trades, the separation and opposition between liberal and mechanical arts is undone.

According to William J. Bouwsma, between the mid-fourteenth century and the end of the fifteenth century, a particular realization took place: that of human creativity and the belief in its possibilities. Distancing itself from a mere imitative activity, human creativity had the power to express human dignity precisely through artistic achievements. A passage that Bouwsma quotes from Cusanus's *De ludo globi* (ca. 1463) is particularly

telling of this profound change: "The mind, having the free faculty of conceiving, finds within itself the art of unfolding its conceptions. . . . The potters, sculptors, painters, turners, metal-workers, and similar artists all possess this art."[56] Holanda's treatise both confirms Cusanus's perspective and complicates Bouwsma's proposal. On the one hand, Michelangelo's words acquire context with Cusanus's statement. Painters and artifices are equal in that they all unfold concepts through manual work—art is precisely this physical, thoughtful, and subtle unfolding of a concept. On the other hand, Michelangelo's words bring Cusanus's vision to its logical extreme through the different historical context in which *Da pintura antiga* was written. What did Holanda's Michelangelo mean by "manual trades that are practiced throughout the entire world" and "the works of humankind"? If we read only the second part of the treatise, with its frequent references to classical Rome, the world remains reduced to the Roman Empire's territory. In this limited purview, the phrases apparently refer to the arts produced in the Ptolemaic world.[57] But if we read Michelangelo's words while looking at Holanda's *The Creation of Lights* (fig. 6)— with its wide world running from the Americas to the Moluccas—and if we recall that the painting and the treatise are contemporaneous, we can follow a completely different theoretical avenue. The expression "throughout the entire world" (*por todo o mundo*) is comparable to the extensive portrait of the Earth in the painting, where the world's visible portion coincides with recent expeditions that proved the globe circumnavigable. It is the "works of humankind" from this circumnavigable globe that redefined the territory of "painting" in the treatise. Artifacts coming from "throughout the entire world," like the African raffia textiles, the Ethiopian objects, and the Asian ivory chests, became powerful proofs of the unbounded possibilities of human creativity.

Holanda's materialization, in image and words, of a world defined by the innate potential of a creative humanity becomes even more noticeable if one pays attention to how he uses the term *mundo* (world).[58] In *Da pintura antiga*, *mundo* generally alludes to the physical world as it is known in discrete historical periods (such as the "Roman" world in chapter 5) or, more broadly, to the world conceived by God (such as the "mayor mundo" in chapter 2). Holanda employs *mundo* in this latter sense when discussing how history ("historia do mundo") and geography ("gran máquina do mundo") need to be known by the painter in order to portray "the solemn and new image of the world" (chapters 7 and 33). The particular use of the expression "throughout the entire world" ("por todo o mundo"), however, unmistakably refers to the world revealed by the fifteenth- and sixteenth-century navigations: this meaning is fixed in chapter 13, when Holanda discusses the presence of "ancient painting" even in the antipodes, "throughout the entire world." This is the particular expression that is picked up by Michelangelo's interventions in the first and second dialogues discussed earlier, alluding unmistakably to the artifacts coming from that circumnavigable world.

As Far as to the Antipodes

Chapter 13 is precisely titled "How the Precepts of Ancient Painting Spread Throughout the Entire World."[59] At this point in the treatise, readers are aware that "ancient painting" refers to a specific but not fully determinable artistic excellence, with criteria (invention, proportion, and decorum) that leave room to maneuver. Being an innate potential for thought, artistic excellence or "ancient painting" cannot be *learned* through established sets of rules.[60] At the beginning of the chapter, Holanda affirms that the artistic precepts of the ancient masters "were disseminated and spread among mortals so that they filled the entire world." He offers examples of places that he personally visited while returning to Portugal from his sojourn in Rome. The sequence retraces a specific itinerary from Italy to Portugal through France, Catalonia, and Spain. During this trip, Holanda observed the presence of sculptures carved according to the same principles that had been taught in Rome and in Athens. He writes:

> The thing in past times that I consider deserves very much to be remembered and which I would not credit if I had not experienced it, is that those same precepts in the art of painting or sculpture which ancient masters considered good and to which they subscribed, those same ones were disseminated and spread among mortals so that they filled the whole world. And you cannot point to any foreign or barbarian nation where there is a practice of painting or carving that does not retain that same art and teaching that was customary in ancient times in the center of Rome or Athens, because the ancient stones that I saw that were produced in France were like those that I saw in Italy; and so were the ones I saw in Catalonia and those that I saw around Spain. And here in our native land of Portugal, if there is any sculpture, you will not see an ancient stone that does not have the same characteristics as those of the city of Rome.[61]

After this first part, in which Holanda suggests the physical and didactic spread of a Greco-Roman artistic perfection, he moves to the arts of the Iberian Peninsula and deplores the loss of and lack of interest in that perfection. He holds up the possibility of returning to such splendor through a direct experience of the Roman past, self-promoting the role that he is playing in this revival:

> And what sometimes rouses my ire is how these regions that I mention (now that they are more presumptuous) have lost their original elegance; however, I am consoled by knowing with great certainty that they must yet return to it, and we already see some signs of this in the good fortune of the blessed times

in which God gave us such an excellent prince and king. But at this point may I be permitted to say that I was the first person in this kingdom to praise antiquity and to proclaim that it is perfect and that there is no other excellence in works of art, and this during a time when everyone was inclined to scoff at it, when I was a youth in the service of the infante Don Fernando and the most serene Cardinal Dom Alfonso, my master. And knowing this gave me a desire to go to Rome, and when I returned I did not recognize this country, seeing that I did not find a stonemason or a painter who did not say that the ancient (which they call the mode of Italy) was the source of everything; and I found them all such masters of this that no one had any recollection of me. And, nevertheless I was glad of this because of the love I have for my native land and for this art of mine.[62]

As if he were sailing through the Strait of Gibraltar, Holanda then moves out from the Mediterranean and looks beyond the columns of Hercules: "But to return to the subject, I was told that even in Africa, in the interior of Morocco, there was a sculpture of imperial eagles and carvings by the Romans. In India, even if their pagodas are poorly proportioned, they claim to follow the ancient *discipline*, and the same is true of things in China. Now, what shall I say of the Levant and Asia? That everything emanates antiquity."[63] In the itinerary drawn here, Holanda affirms that the artworks found in the interior of Africa, in India, and even in China and toward the East ("Levant and Asia") may still be related to the physical extension of the Roman Empire. But he looks at these sites while mentally circumnavigating the African continent, India, and heading toward China—thereby following the recent maritime routes opened by the Portuguese. The argument for the presence of "ancient painting" is still related to the physical and historical movement of people.

It is in the last paragraph of the chapter that Holanda performs a theoretical tour de force by turning toward the New World: "But what is more amazing is that even in the New World of the barbarous people of Brazil and Peru, who had been hitherto unknown to us, even they maintained the same principle and discipline of the ancients in many golden vases that I saw, and in their figures; which is no mean argument for the notion that those people *encountered and became conversant* [with ancient painting] in another time and that the precepts of ancient painting had been already disseminated throughout the entire world, even to the antipodes."[64] Through an apparently logical connector ("even in the New World"), a conceptual rupture takes place. Up until that moment in the text, the physical expansion of the Greco-Roman concept and the materiality of antiquity had flashed through the following list of toponyms: Rome, Athens, France, Catalonia, Spain, Portugal, Africa, Morocco, India, China, the Levant, and Asia. From this sequence, one could infer that the precepts of ancient painting, proceeding from Rome and Athens, traveled the world. The rationale seems, until this point, geopolitical: it was through the

expansion of the Kingdom of Macedon, or of the Roman Empire, or through the merchant's routes to Asia that "ancient painting" can be recognized in a North African, Chinese, or Indian monument.[65] Read in these terms, the treatise *Da pintura antiga* becomes the perfect textbook of imperialism. The introduction of the arts of the New World, however, renders the spread of the principles of "ancient painting" through transmission no longer plausible. The evidence that golden vases (*vasos de ouro*) and figures (*feguras*) were made by people who were "hitherto unknown to us" disrupts any discourse on the physical spreading of ancient painting as *Greco-Roman* ancient painting. People in the New World cannot be identified as historical subjects of the Roman or Hellenistic Empire. While still "barbarous" (that is, not understandable for the Greeks, outside Greek domination, or, by extension, outside Roman domination), they must have encountered the principles of "ancient painting" in remote times. Let us look at the precise artworks that disrupt the imperialist discourse.

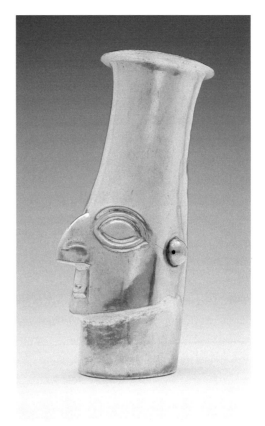

FIGURE 15 | Beaker, Inca, Ica Valley, south coast, Peru, late fifteenth to early sixteenth century. Gold, 16.5 × 6.4 cm. Art Institute of Chicago, Kate S. Buckingham Endowment, 1955.2587. Photo: Art Institute of Chicago.

The New World golden vases that Holanda references as having personally seen ("que eu vi") may include the Peruvian ceremonial drinking cups called *aquillas* in Quechua (fig. 15). The chronicles of the conquest of Peru are filled with episodes in which these artifacts play a crucial role: Spaniards stared at their beauty in temples; Incas offered corn beverage (*chicha*) in golden and silver vases; Spaniards considered how the Incas emptied their richest mines to make these vessels, learning that metalworkers were exempted from Inca tribute in exchange for sending the precious vases; and Spaniards looted innumerable beakers during the war of conquest, most infamously in Cajamarca.[66] In the 1570 chronicle of the penultimate ruler of the Inca dynasty, Diego de Castro Titu Cusi Yupanqui, the *aquillas* are even presented as the casus belli of the war of conquest: "When [Atahualpa] offered our customary drink in a golden cup to one of them, the Spaniard

poured it out with his own hands, which offended my uncle very much. After that, those two Spaniards showed my uncle a letter or book. . . . My uncle, still offended by the wasting of the *chicha* . . . took the letter (or whatever it was) and threw it down."[67] The rest of the story is known.

After being looted, "golden vases" or "cups" arrived in Europe. They circulated in enormous quantities and are documented in inventories and letters with different terms in Portuguese and Spanish (*vasos, vasijas, vasillas, tinajas*).[68] The ship *Santa Maria del Campo* docked in Seville in 1534 with hundreds of them, of all sizes and shapes. It is generally thought that they were immediately melted down, but these precious objects, especially the most portable ones, like the *aquillas*, must have also traveled through and outside the Iberian Peninsula. Holanda could have admired them in Portugal (like those probably sent by Charles V to his sister Catherine, the queen of Portugal), in Spain (for instance, in Valladolid, where he stopped while heading to Italy), or in the papal collections in Rome. It is extremely difficult, however, to know precisely which ones he saw. The "almost complete absence of [surviving] early collections from the Andean highlands" impedes matching any particular artifact to one of the hundreds of golden vases mentioned in the sources.[69] But the variety in shapes and dimensions—and the outstanding artistic quality—of existing beakers gives us an idea of what Holanda must have felt when seeing them in different stops of his journey to and from Italy (see fig. 15).

Searching for clues of these material encounters in Holanda's own drawing practice, though, is both deceiving and illuminating. Why, for instance, do none of the biblical vases in his *De aetatibus mundi imagines* resemble the Peruvian ones? Could not Holanda have introduced in his visual interpretation of the Bible one of those New World "golden vases" that he said he saw? His Portuguese peers had staged the Annunciation on African raffia rugs (see fig. 7); a Chinese porcelain appears in an *Adoration of the Magi* by Andrea Mantegna, thoroughly studied by Alexander Nagel, and Holanda himself made creative associations in his work between different spaces and times (as when he locates, with an annotation, a biblical episode on Lisbon's Tagus River).[70] But nowhere does he seem to have sketched an artifact from the New World. How could one theorize this absence—at least until such a drawing is discovered? Perhaps the impact of the Peruvian vases would have lost force if subliminally placed in lieu of something else.[71] It is in the treatise that they find their own place and with no possible misunderstanding about what they are. A similar explanation may be given as to why Dürer, who celebrates the variety and quality of the Mexican objects he saw in Brussels, seemingly does not provide drawings of them. It seems that, for both artists, situating—"installing"—these artifacts in writing most unmistakably proved their impact.

As for the "figures" from the New World that Holanda could have seen, he is most likely referring to the Mesoamerican pictographic manuscripts painted on deerskin, maguey, or

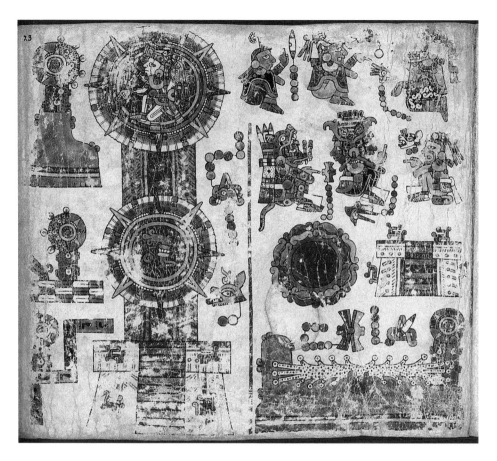

FIGURE 16 | *The Rising of the Sun*, detail in plate 23 of the Codex Vindobonensis Mexicanus I, Mixtec, fourteenth century. Painting on deerskin, screenfold: 26.5 × 22 cm. Vienna, Austrian National Library. Photo: Saeko Yanagisawa and published with the authorization of the Austrian National Library.

bark paper that arrived in Europe as early as 1520, which were often referred to as *figuras* or *feguras*. Holanda might be concretely referring to the so-called Codex Vindobonensis I, a Mixtec pictographic screenfold painted on deerskin, today housed in the Austrian National Library in Vienna (fig. 16).[72] The codex arrived in Lisbon before 1521 and was probably owned by Manuel of Portugal. António de Holanda might have had access to it, and it is likely that his son Francisco heard of this manuscript from his father. In spite of the difficulties of properly understanding the meaning of these "figures," the innumerable details of the folded book could have captured the imagination of António de Holanda. The pictorial manuscript is composed of fifteen parts, painted on deerskin, glued together and folded into fifty-two pages painted on the obverse side. Unfolded, it measures 13.5 meters (44 feet). We know today that it represents the origins of the world and the founding of the city-states of the region of Tilantongo, in the modern-day state of Oaxaca, Mexico.

Some of the most striking scenes are: the birth of the "cultural hero" Lord 9 Wind from a huge flint, his arrival on Earth with the water of the heavens, the great tree of origin from which the local lords were born, the rising of the sun for the first time on Earth (fig. 16), and the foundation of the city-states. The thirteen pages of the reverse, although today considered painted with less care, are also interesting, as they represent the genealogy of the rulers of Tilantongo. It is difficult to measure the impact of these images on the artistic practices of their observers. But comparing the magnificent genealogy attributed to António de Holanda with the "figures" of the Mixtec creators shows how radical difference and uncanny familiarity can simultaneously unfold. In the two genealogic manuscripts, the characters are painted according to different gestural and chromatic codes, but they both employ a similar vegetal metaphor for representing generational "growth": lineage sprouts from and is visualized on the ramifications of a tree.[73]

The Codex Vindobonensis I was eventually offered by Manuel of Portugal to Giulio de' Medici, who in 1523 became Pope Clement VII, along with "a cover of parrots' feathers and bells."[74] If it is true that the manuscript left Rome for Capua in 1537, Francisco de Holanda may have arrived too late in Rome to see it in person.[75] That said, the memory of that unique pictographic masterpiece coming from the antipodes must have remained alive in the circles Holanda frequented. As in the case of the "golden vases," the impact that Mesoamerican pictography could have had on his artistic practice is difficult to measure. Just as there is no evidence so far that any Peruvian vase made it into the imagery in *De aetatibus mundi imagines,* no Mesoamerican pictography (not even those striking Mixtec representations of the creation of the world) can be associated with Holanda's own images of the creation of the world. The impact was instead theoretical, and to fully measure it, one needs to return to the treatise.

## A Conceptual Turn

Evidence that in the New World there are artifacts complying with the (nonprescriptive) principles of "ancient painting" and that these were made by people who were "hitherto unknown to humans" (*que ategora forão inotos aos homens*) disrupts in Holanda's treatise any diffusionist assumption regarding the physical spread of ancient painting as a set of stable (Greek or Roman) canonical principles. While "barbarous" (that is, not Hellenized or Romanized), the people of the New World must have encountered the "principles of ancient painting" before having encountered (other) humans—hence, the fact that they were "hitherto unknown." Holanda indeed specifies that the encounter with the principles of ancient painting must have happened in the New World "in another time" (*n'outro*

*tempo*). This chronological precision propels the event of the physical dissemination of those principles to a different temporal logic. It is not the linear, imperial time of the Hellenic or Roman progressive territorial conquests but rather a prehistoric and primordial time in the sense of *priscum*—"pristine," understood as original, uncorrupted, perfect, and perennial.[76] Interestingly, Deswarte-Rosa has precisely named those artistic principles with the expression *prisca pictura*: divinely inspired, they spread all over the world in an immemorial time (*priscum*) and became common to all humanity with no exception.[77]

To explain the presence of ancient painting—that is, the artistic excellence of those previously unknown people—Holanda uses another intriguing term. He states that the subtlety of their artifacts demonstrates that "these people were, in another time, *conversadas*" (*ja aquellas gentes serem n'outro tempo conversadas*). "Conversadas" has been translated into *conversadas* in Spanish, *versé* (versed) in French, and *civilized* in English.[78] But the expression may indicate something more specific regarding, precisely, the rational qualities of the people of the New World as artificers and their pristine exposure to the "principles of ancient painting."

A first avenue of analysis is provided by the fact that, in his 1563 translation to Spanish, Manuel Denis takes *conversado* not as an adjective but as a past participle of the verb *conversar* (*Aquellas gentes han sido conversadas en otros tiempos*). The verb originates from the Latin deponent *convertor*, meaning "to converse, to keep company with, to associate, to live, to practice."[79] Interestingly, the expression was used in biblical texts to explain how God's wisdom spread on Earth. The Latin translation of the deuterocanonical Book of Baruch indicates: "Post hæc in terris visus est et cum hominibus conversatus est" (and then [God's wisdom] appeared on the Earth and associated with humans) (Bar. 3:38).[80] A Catalan painting from the late fifteenth century represents the scribe Baruch holding a flamboyant scroll on which this exact verse is written (fig. 17). Holanda probably never saw this painting (although he passed through the region), but he may have accessed other sources related to Baruch's text.[81] The idea of divine wisdom spreading throughout the world and its integral association with humanity echoes his own realization that "ancient painting" (as *prisca pictura*) was constitutive to humanity anywhere in the world, since a pristine time. This "philosophical faith," as Fernando Pereira convincingly names Holanda's belief in the transcendental origin of the innate gifts of creativity, helps explain why the opposition barbarous/civilized did not matter to Holanda when reflecting on artistic excellence.[82] Even in parts of the world where people have not been "Hellenized" or "Romanized," there was clear evidence of artificers, hence humans. Accordingly, *conversadas* could even be translated as "converted" but in the sense that the people of the New World had a direct contact with the Universal Revelation.[83] This "conversion," which I translate as a real "encounter" (hence my translation of the term), happened prior to

50

FIGURE 17 | Follower of Lluis Borrassa, *The Prophet Baruch*, 1450–60. Painting on poplar panel, 52 × 37.5 cm. Private collection. Photo: Binoche et Giquello Drouot, Paris.

any contact with other people that would diffuse artistic excellence as a set of stable knowledges. Artistic creativity is, therefore, a constitutive potential in any human being.

By using the term *conversadas*, however, Holanda also may be making here another important statement on the New World people, precisely as rational artificers. After being used in chapter 13 of the treatise, the term *conversado* appears as an adjective in the second part of *Da pintura antiga*, the "Dialogues in Rome." Here Holanda, in conversation with Clovio, refers to Michelangelo as "homem . . . conversado, não de tão má condição," an "affable man . . . not of such a bad temperament."[84] The meaning of this sentence becomes clear if one goes back to the first dialogue, where Michelangelo himself defends the painters (namely, artificers in the broader sense) from the accusation of being unable to undertake a conversation.[85] Actually, the entire project of the "Dialogues" is to demonstrate that Michelangelo (as well as Clovio and Francisco himself) are not *desconversais* and can, in fact, sustain subtle conversations about the arts, demonstrating the liberality of their undertakings.

Now, there seems to be a relationship between the first reading of the term *conversado* and the second one—hence my translation of chapter 13's passage as "those people *encountered and became conversant* [with ancient painting] in another time": the fact that the artificers can indeed sustain a conversation is precisely due to their exposure to the "educative force" of the *prisca pictura*.[86] It is precisely because they have encountered the (nonprescriptive) principles of the art of "painting," in a pristine time, that they are then able to both transmit in painting (and discuss in words) elaborate ideas. This is true for the artificers of the antipodes as much as for Michelangelo, Clovio, and Holanda himself. In this sense, chapter 13—although certainly only a small portion of the treatise—constitutes a highly condensed key moment in the entire *Da pintura antiga*. Through the

antipodes, the strongest case for the rationality, humanity—and hence, liberality—of the artistic gesture is made on a universal scale.

## Antipodean Artificers

"The precepts of ancient painting were already disseminated throughout the entire world, even to the antipodes." In the last sentence of chapter 13, Holanda mobilizes the reference to the antipodes to move from an imperial theory of artistic diffusion to a theory of a primordial endowment of artistic excellence as a universal human potential.

The antipodes in antiquity corresponded to unknown lands. They were zones situated at the opposite ends of the known and inhabited world, the *oikoumene*—located "at the opposite of its feet." Antipodeans were imagined as having inverted feet, an effect of having to walk on the Earth upside down. The antipodes were considered not only unknown but impossible to know since they were situated beyond the so-called *zona torrida* (or *perusta*: "burned"). The *zona torrida* corresponded to the strip between the Tropics of Cancer and Capricorn. Due to its extreme heat, this zone was thought to impede any attempt of human passage further south. The antipodes were therefore impossible to know because it was impossible to reach them. The size of the encircling ocean was believed to represent another physical limit.[87]

The antipodes rarely appear on medieval world maps since these were maps of the known, inhabited world. A world map type that included the depiction of the antipodean, unknown world was the so-called quadripartite map, based on the eighth-century Spanish monk Beatus of Liébana's description of the world in his *Commentary on the Apocalypse*. The numerous maps based on this model, called Beatus quadripartite maps, include not only the three known parts of the world (Europe, Africa, and Asia) but also a fourth one. The Beatus map kept in the Spanish cathedral of Burgo de Osma includes on the right side a zone inhabited by a *sciapode*, or "shadow-footed" man, with a single foot so large that it provided him protection from the intense heat of a burning sun (fig. 18).[88] The body of the inhabitants potentially living in the unknown parts of the globe was represented by an oddity in their feet, the very part of the body that touches the Earth.

What did the antipodes become in chapter 13 of *Da pintura antiga*? Holanda continues to refer to the antipodes as a previously unknown yet inhabited land, but their inhabitants do not present any exceptional physical feature. The absence of any commentary on their bodies represents a double shift: first, there is no conflation between being "antipodean" and having imaginary monstrous physical traits, and second, the inhabitants of the New World are not even characterized by their own real physical features or

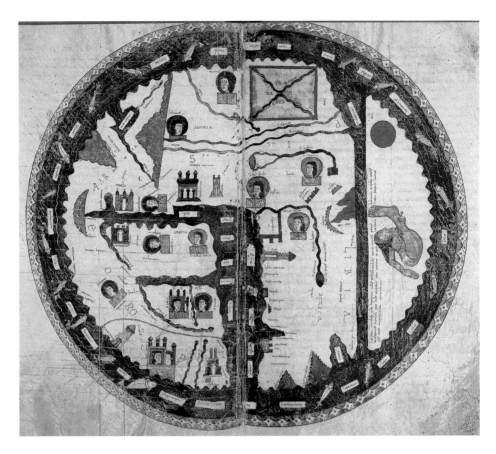

FIGURE 18 | World map, in Beatus de Liébana, *The Commentary on the Apocalypse*, eleventh century. Painting on vellum, 36.1 × 25.3 cm. Cathedral of Burgo de Osma, MS 1, fols. 34v–35r.

the supposed activities involving the body (such as anthropophagy or human sacrifice), an obsession for many authors before and after Holanda.[89] The antipodeans—those of the New World but potentially any antipodean from any part of the world—are transformed from inhabitants identifiable by bodily characteristics into great artists tout court. In this way, through the antipodean referent, the argument of a primordial endowment of artistic excellence as an innate human potential becomes conclusive. The notion of the antipodes is completely reconceptualized: because the inhabitants of the antipodal lands are artists, they are humans, regardless of their somatic appearance. Because they are endowed with a potential for artistic excellence, they are comparable and in a position of equality to any great artists and to any other human beings. In the antipodes, "ancient painting" becomes the name of an exceptionality that any real artist can achieve: Apelles or Zeuxis in Greece; Michelangelo in Italy; the people of the New World, Africa, or Asia, in their figures, vases, pagodas.

Ancient painting is therefore both an original endowment and a horizon: an artistic quality that anyone, anywhere, at any time, can achieve. There are no definitive criteria to say what this artistic exceptionality should look like. The golden vases, in particular, challenge any stable definition of "ancient painting" as they are not painting and, most probably, not so ancient. In fact, they were likely almost contemporary to Holanda: the language of inventories listing the hundreds of golden vases arriving in Europe suggests that they had been very recently collected by the Sapa Inca, in Cajamarca, probably from the coastal city of Chan Chan—just before the Spaniards arrived.[90]

## What Is Human Creativity?

Holanda's theoretical statement on the antipodean arts and artificers was nourished by the artifacts that he personally saw. The already-mentioned Miller Atlas may have provided another visual "source" for his groundbreaking universalization (see fig. 12). He could have known this atlas, not only because it was made by the Portuguese cartographer Lopo Homem but also because his father probably took part in its making. As commented earlier, the Miller Atlas represents the known world in 1519—the year just before Magellan's circumnavigation. It is composed of a world map and several regional maps. In the world map, the New World is represented as a large mass extending to the north and to the south and embracing the entire sphere, yet with no known passage through it. Besides the obvious "error" corrected by the circumnavigation one year later, the world does extend toward the southern parts of Africa, thereby reaching all five of the climate zones from north to south.

In the Miller Atlas, two detailed maps of the New World, representing people actively at work, demand our attention. In the northern part of the continent, under the word "Antilles," four individuals are portrayed. One is hunting, and the other three are apparently preparing the soil for sowing (fig. 19). However, a cartouche indicates that "in this part of the Antilles of the Crown of Castile golden minerals are found" (*In ista Antiliarum Castelle Regis parte / auri Mineralia inveniuntur*). One of the men points out where to dig. He and his peers are the subjects behind that passive "inveniuntur." Specific people, probably enslaved individuals of African descent, are represented both as the physical extractors of the gold and as the minds who found it—the cartouche should be more conceptually translated as: "*They* found gold minerals." Interestingly, the author that we are about to study in the next chapter, Pietro Martire d'Anghiera, had precisely written that, in the Antilles, people are capable of recognizing precise signs, including the color of the soil, that indicate where gold is ("quibus signis noscant aurum inesse").[91] Human agency is also portrayed in the map representing the southern part of the continent. Here,

FIGURE 19 | Lopo Homem, world map in the Miller Atlas, detail of Antillians, 1519. Paris, Bibliothèque nationale de France, Paris, GE D 26179 RES. Photo: Bibliothèque nationale de France.

FIGURE 20 | Lopo Homem, world map in the Miller Atlas, detail of Brazilians, 1519. Paris, Bibliothèque nationale de France, GE D 26179 RES. Photo: Bibliothèque nationale de France.

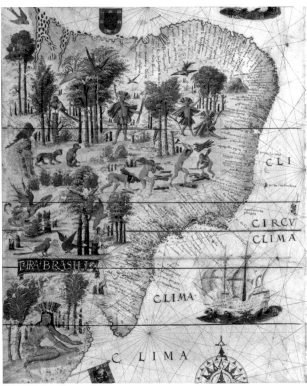

above the cartouche "Terra Brasilis," numerous people gather and transport redwood (brazilwood; fig. 20).[92] Three other people are portrayed in different positions, standing or seated, all wearing beautiful feather garments. Birds sporting feathers of the same colors as their headdresses and skirts fly around.

55

These two outstanding folios of the Miller Atlas show that these lands are inhabited and that their inhabitants are people capable of thinking: working, hunting, and gathering wood with their hands, guessing the presence of a gold vein, and, most importantly, creating. These human beings are depicted as capable of transforming nature: extracting gold from minerals and employing birds' feathers as an artistic material for garments. Because of their artistry, these inventors from the antipodes are human—regardless of their particular bodily characteristics or their particular customs. Their humanity is demonstrated less by their physical features than by their manual capacities, which, in turn, depend on intellectual, rational ones. How can one transform a bird into a feather headdress? The complexity involved in accomplishing this manual work calls for rational capacities that intertwine the technical and symbolic levels. These meaningful details of the Miller Atlas resonate with Holanda's perspective on a universal artistic humanity. His chapter 13 of *Da pintura antiga* also designs, in some sense, a new atlas, with the antipodes at the center of a reflection on the artistic world. Through their centrality in the argument, the antipodes "embody a mobile potential," redesigning the Earth from the vantage point of its multiple evidences of creativity and thought.[93]

Let us now return one last time to Holanda's Michelangelo and his claim that a true painter needs to measure himself against the excellence of the works of humankind—the "obras humanas." Assuming that this passage of *Da pintura antiga* is not completely fictive, may it even refer to some specific artifacts personally seen by Michelangelo? Holanda probably brought him precious gifts received from the Americas, Asia, or Africa when he arrived from Lisbon in Rome in 1538. There is evidence that Michelangelo could have seen a variety of artifacts "made throughout the entire world." His friend Tommaso de' Cavalieri owned feather works and sculptures from the Americas.[94] Earlier in his life, Michelangelo could have had access to objects from distant places that arrived in Florence, at the Medici court, and in Rome. As mentioned above, one of his patrons, Pope Clement VII, had received the Mesoamerican Codex Vindobonensis I in the early 1520s. Had Michelangelo seen this fantastic pictorial sequence (especially the images devoted to the origins of the world), he would have perhaps been reminded of his own unfolding of the Creation on the vault of the Sistine Chapel. Furthermore, both were major efforts of narrative organization in a pictorial space. The Sistine Chapel vault is reminiscent of an unfolded—and magnified—Mesoamerican codex. Clement VII might have offered Michelangelo at least two other occasions to cross paths with specific objects arriving from the antipodes. The pope had met Pigafetta, who, after his circumnavigation with the

Magellan-Elcano expedition "to the antipodes," as Paolo Giovio writes, brought back gifts "from the other hemisphere."⁹⁵ Pigafetta distributed these material proofs of distant lands and their peoples all around Europe, traveling to Valladolid, Lisbon, France, and Rome. In 1533, the pope received in Bologna a collection of American objects from Domingo de Betanzos, a Dominican friar recently returned from the New World. The Dominican Leandro Alberti described them in detail in his *Historie di Bologna* written in 1548:

> [The pope Clement VII received] two coverlets made and weaved out of blue, green, black, yellow parrot-feathers, which looked like velvet. Hence it seems to recognize what is said in the Scriptures about the God's shrine [the tabernacle] which is recommended to be embellished with feather materials. Afterwards [the Dominican Domingo de Betanzos] gave the Pope stoles, maniples, and granite textiles for chemises made in a similar way and gracefully worked with the said feathers, as well as other ornaments for priests. He also presented him with some nicely painted books that looked like hieroglyphs by which they understand each other as we do by letters. Afterwards he gave him some very thick masks furnished with turquoises, through which he said the demons were speaking to those peoples. Then a two fingers-wide and two ounces-long knife made of yellow stone with the handle entirely covered by turquoises. Then some stone knives that cut like razors, which they used for shaving. By these knives we knew the kind of those knives of which the Bible speaks when the Lord says: "Make me the stone knives to circumcise."⁹⁶

Four categories of objects are listed: feather objects, painted books, turquoise-studded masks, and stone knives. In spite of some traces of aesthetic appreciation ("looked like velvet," "gracefully worked"), Alberti seems more interested in conjecturing about the origins of the objects and their possible relationships with other populations. Here and elsewhere, Jewish and Egyptian associations are invoked in order to make sense of such unexpected evidence of human abilities: to Alberti, painted books coming from Mexico uncannily look like Egyptian hieroglyphs, feather objects recall Exodus's passage on the appearance of the tabernacle (made "opere plumario"—according to some translators, "with a work of feathers"), and ceremonial stone knives evoke God's commission to make knives for circumcision.⁹⁷ These conjectures imply that there could have been physical transmission of these abilities.

Holanda's and Michelangelo's statements in *Da pintura antiga* are radically different. The variety and quality of the artifacts coming from the antipodes prompt Holanda to declare that they were the fruit of a "pristine" endowment, when the potential for artistic excellence was infused and spread *throughout the entire world*—the world that would

become circumnavigable in the sixteenth century. For Michelangelo, in the second dialogue, the question of a "localizable" origin matters even less, as the *obras humanas* that are made throughout the entire world become themselves indispensable horizons of his own endeavor (and that of any veritable "painter"). What is prescriptive about the antipodean artifacts is that one can no longer ignore them.

# Acuity Through Art
## Artifact-Based, Oceanic Humanism

*There are most insightful creators everywhere.*
*Opifices sunt ubique argutissimi.*
—Pietro Martire d'Anghiera, *De nuper* (1521)

A half century after Columbus returned from a previously unknown hemisphere with captives wearing intricate beaded collars and belts, the Portuguese artist and theorist Francisco de Holanda, in his *Da pintura antiga*, put the arts "of the antipodes" at the center of a major revolution in thought. As seen in the first chapter, the artworks made outside the Ptolemaic world, especially those arriving in Europe largely looted from the New World, were not add-on exceptions that proved the rule. They transformed the coordinates of aesthetic judgment. In particular, they prompted a redefinition of the totem of humanism. Disentangled from a relationship to the past, antiquity could mean any evidence of artistic excellence that may be found anywhere and at any moment in time. Presence and absence were theorized with equal force by Holanda, who also addressed the discontinuities in history and the blank spots in the atlas where antiquity was not detectable. Neither inheritable nor reproducible, antiquity—that is, artistic excellence—was not a given. It had to be invented always anew.

As antiquity was freed from temporal and spatial boundaries, becoming potentially universal in time and space, it could no longer respond to specific formal, material, and stylistic characteristics. This became evident when Holanda referred to Indian pagodas: "Ainda que são mal proporcionadas, la querem tirar á desciplina antiga."[1] No doubt derogatory at first sight, that sentence actually marked a watershed moment in the *Da pintura antiga*. If a literal translation reads, "In India, even if their pagodas are poorly proportioned, they claim to follow the ancient system,"[2] then, in the light of the previous chapter, one can also read it in context as, "In India, even if their architectural principles differ from the Vitruvian ones, their pagodas follow the concept of antiquity." Indian pagodas come to demonstrate that the staple principles Holanda had listed as imperative in the previous pages of his treatise, proportion included, fall inevitably short as global criteria. It is a breaking point in the theorist's argument: "ancient painting," understood as artistic excellence, could not be subservient to any particular principle.

Liberating antiquity from a stable concept of time and artistic excellence from a preconceived body of rules, Holanda pioneered a turn in art history. Indian pagodas, golden vases from Peru, pictographic books from Mexico, and art objects from Brazil were also recognizably ancient—in the sense of outstanding—in spite of having been made according to their own distinct principles. But instead of opposing two artistic worlds, "the West" (with its Greco-Roman, Vitruvian, classical manifestation of antiquity) from all "the rest" (unproportionate pagodas and so forth), Holanda demonstrated the relevance of the arts of the antipodes to defining what we can call, echoing Walter Benjamin's famous essay, the task of the artist.[3] After interrupting a discourse ultimately devoted to praising the canon, Holanda made Michelangelo—its living personification— declare that the aspiration of a true painter should be to look at and surpass all of the "manual masteries made throughout the world."[4] One infers that these manual masteries did challenge the set grandeur of any great creator and that they gave the artist a new task. As we saw in the first chapter, Michelangelo's passage in the *Da pintura antiga* also undid the opposition between the liberal and mechanical arts, claiming that the proper training of a painter should embrace them all.

Yet Holanda did not flesh out the singular principles of those masteries; he did not describe in the treatise nor seemingly represent in his drawings and paintings any of those artifacts in detail. In spite of having personally seen and probably packed, transported, and offered some of them during his voyages, Holanda's theorization bypassed ekphrastic demonstration, either visual or textual, of their phenomenological intricacy—probably because he considered himself authoritative enough to judge their quality or because he preferred forceful concision over lengthy demonstration. In any case, he somewhat missed the opportunity to describe them more carefully.

60

While Holanda's texts and images are unparalleled in terms of theoretical exploit, other authors painstakingly describe the physical aspect of myriad novel artifacts, the artistic processes that originated them, and, most important, reflect on the evidentiary role they played to prove the humanity of their makers. Somewhat contrary to Holanda, for these authors, it is precisely the material subtlety of those pieces that provide the key to understanding their significance. The promptest of these authors is undoubtedly Anghiera.

## Looking West

On May 14, 1493, the Italian humanist Pietro Martire d'Anghiera (1457–1526) wrote from the court of the Catholic Kings in Barcelona to Count Giovanni Borromeo, a former protector in Milan. With telegraphic brevity he announces: "A man from Liguria, a certain Columbus, has returned from the western antipodes . . . he has brought proofs of many precious things."[5] In this well-known inaugural sentence celebrating Columbus's return, Anghiera gives the antipodes a fresh look. They no longer correspond to an unreachable southern portion of the Earth but instead to a western, inhabited land, whose natural and human characteristics could be evinced in their material manifestations.[6] He calls them *argumenta*, a key term in rhetoric to denote the most persuasive elements of an orator's speech. Not only precious metals but also puzzling handmade artifacts become tangible, three-dimensional evidence that those far lands are prosperous.

But the other nascent argument in Anghiera's brief is precisely the one that we saw, in the first chapter, developed in Holanda's treatise and in the images of the Miller Atlas: those proofs coming from the western antipodes demonstrated the intelligence of their creators, capable of transforming gold into golden vases and plumes into lavish garments, after having themselves found the golden veins, gathered the birds' colorful feathers, and artistically reworked these raw materials. Look again at the map of Brazil from the first chapter: the three beautiful sets of capes and headdresses mix, each one different, the colors of all the birds flying around (see fig. 20). No natural species had them all. It is the "intelligence of art," as Thomas Crow calls it, that collected and selected them and composed distinct artifacts.[7] We will see in chapter 5 how Guevara located the invention and relevance of a novel form of painting in a precise series of intentional actions.

In his letter introducing the western antipodes, Anghiera also alerts his Milanese correspondent of the danger looming over Italy. The Italian Wars (1494–1559) were about to start, and they would last for decades. If Italy allowed the French army to enter the peninsula, he writes, the "genitrix of the fine arts" would rapidly become their booty. Without imagining the horrors of the colonization of the Americas that Columbus's voyage

initiated nor the sacking that, three decades later, the troops of Charles V would enact in Rome, Anghiera's words sound both farsighted and ominous: anywhere in the inhabited world, "fine arts"—*bonae artes*, a locution that we want to keep in mind and that can be translated, on purpose, as "fine arts," avant la lettre—can demonstrate human finesse or fall prey to invaders.

This second chapter studies how, in the context of the oceanic travels and the invasion of the Americas—as well as of Africa and Asia—Anghiera developed an artifact-based reflection on the ethical qualities of the human makers of these objects. It was a philosophical realization: defining what humans are through the observation and description of the artistic object. In order to follow how this idea unfolded, I will first sketch a brief intellectual biography of Anghiera, pointing to two aspects of his life that have been overlooked until now: his background in Rome—in particular, as secretary of the highest magistrate of the city and as participant in the foremost Roman humanist circle—and his labor as a teacher at the Spanish court. These experiences, I contend, founded his conviction that fine arts help shape and define the ethical qualities of the human. However, looking west, he precisely transformed both concepts—what "fine arts" are and how they construct the human. In order to identify the specific stages in this transformation, I will proceed backward. Starting from a letter dated 1523, in which he most firmly presents the artifacts arriving from Tenochtitlan as evidence of their people's refinement, I will then read a cluster of texts penned by Anghiera in the five previous years. These describe the Mexican monuments and the art pieces encountered by the conquistadors. The looted ones were sent to Europe. Anghiera saw and made them the fulcrum of his demonstration on the civilization of their makers. I identify how he textually displays the artifacts and first builds his demonstration through a rhetorical contrast between artistic refinement and sacrificial practices and, next, presents the aesthetic subtlety of the artifacts in ekphrastic isolation. But this conclusive argument—art as civilization—actually emerged in his texts written more than a decade earlier on the arts of the "Antilles." It is there that he set in motion, on a gradually more universal scale, a meditation on the human based on the intricacy of handmade works. Here, too, the specific Latin language he uses bears witness to this conceptual innovation.

At the end of the chapter, I discuss the methodological novelty of what I call Anghiera's "artifact-based, oceanic humanism" in relation to both humanism and scholarship on humanism at large. Anghiera's thought and his sources—encompassing material artifacts and written and oral accounts by a variety of people crossing the ocean—complicate, in fact, both what humanism has been and how it has been studied. I also explain how Anghiera's artifact-based, oceanic humanism relates to and yet diverges from antiquarianism. While antiquarians "studied the past through things" and reflected on humanity in a past-tense modality, Anghiera finds in the artifacts made in the western antipodes a

demonstration of the human on a *metatemporal* scale.[8] This points to another distinction with antiquarianism. While antiquarians often came to serve a localist agenda, especially in the Rome that Anghiera left for Spain, his own artifact-based humanism looks at a *metaterritorial*, universal scale.

## From Rome to Spain

Anghiera arrived in Spain from Rome in summer 1487, following Iñigo López de Mendoza, second count of Tendilla. The Spanish ambassador had been sent to the Holy See by the Catholic Kings with the task of obtaining from the pope an extension of the Bull of Crusade and to help mitigate the tensions between the papacy and the king of Naples.[9] With both missions accomplished, López de Mendoza convinced Anghiera to leave Rome, where he had lived for a decade as secretary for high-ranking curial functionaries and for the most powerful magistrate of the city, Monsignor the Governor of Rome Giovanni Alimento Nigro (in office 1484–87).[10] This background shaped Anghiera's own writing style. When he uses the term *argumenta* in his 1493 letter, he may have been referring not only to rhetorical argumentation but, more specifically, to legal argumentation, a genre he must have mastered working for Nigro and his tribunal.

Anghiera's fond letters from Spain to the antiquarian Giulio Pomponio Leto (1428–1498), the prominent humanist leading the so-called Accademia Romana and one of the major collectors at that time, attest that in Rome Anghiera had also been part of Leto's "cultural network."[11] The activities of the group revolved around unearthing, interpreting, and *reliving* Roman antiquities. Especially under the papacy of Sixtus IV (in office 1471–84), Leto's circle was part of the *renovatio urbis* promoted by the pope, who wished to "found Rome anew."[12] They studied ancient Latin authors and inscriptions; copied, corrected, and commented on the texts; undertook archaeological trips; and staged plays and even pagan rituals. This active approach to classical antiquity surely impacted the way Anghiera eventually looked at the artifacts coming from the western antipodes. Leto, in fact, became a privileged recipient of numerous letters on the living people and "fine arts" of the Antilles, something that probably thrilled him more than stumbling upon an umpteenth Roman fragment.

However, beyond some basic understanding of what the proximity to Leto signified, we do not know much else about Anghiera's experience of that milieu. It is not even clear why he decided to leave Rome. Once in Spain, he stated that he broke free from the agonizing political climate of the Italian peninsula. But a bitter letter to his former patron Nigro, the governor of Rome, sounds personally resentful, citing the papal high prelate's juridical power to decide on "people's life and death" in the city (OE, Ep. 42). It

is perhaps a coincidence, but a few weeks before Anghiera departed for Spain in August 1487, the humanist Pico della Mirandola fled the capital for France. He had been accused of heresy for several of the nine hundred theses on philosophical peace that he had published in Rome the previous year. In January 1487, the wealthy Pico had arrived in Rome for a grandiose, self-funded public debate of his theses, attended by international leaders.[13] The speech that he had written to open the conference was eventually published as the famous *Oration on the Dignity of Men*. But the debate did not take place, as Pico faced an Inquisitorial investigation initiated by Innocent VIII and his scholastic advisors. He hastily left the city.

Anghiera must have met Pico. As a secretary of the governor of Rome—the pope's "own man," who was the chief and president of the court—Anghiera may have even been involved in preparing the paperwork of his case in 1487.[14] That acrimonious letter to Nigro sent from Spain could refer to what he believed to be Pico's unfair prosecution. What we know for sure is that Anghiera highly respected Pico since he later called him and Marsilio Ficino "clear luminaries of philosophy of our times" (OE, Ep. 132). Pico's ideas echo more than one of Anghiera's convictions: rejection "of any dogmatic crystallization of humanistic ideals and claims"—blind subordination to classical antiquity included—and a conception of the human as the only divine creature "constrained by no limits" and endowed with an "almost unlimited power of *self-transformation*."[15] Anghiera brought these ideas along with him to Spain.

Departing with López de Mendoza was life changing. Like Holanda, who fifty years later traveled in the opposite direction, from Lisbon to Rome, with the Portuguese ambassador Mascarenhas, Anghiera's social world widened in one trip. While, thanks to the powerful Mascarenhas, the young Holanda met Michelangelo, Colonna, Giovio, and Xavier in Italy, Anghiera was introduced by the Spanish ambassador to the Catholic Kings and to an impressive network of people in the highest ranks. He rapidly joined the royal court for the rest of his life, participating in military campaigns (between 1488 and 1492 in the sieges of Granada) and diplomatic expeditions (Egypt in 1501).[16] He was progressively named *contino*, *maestro*, counselor, senator, *cronista*, ordained canon, chaplain, priest, and even abbot of Jamaica (to which he never traveled). Following the itinerant court, Anghiera witnessed both the smallness of a close-knit peninsular world and major epochal changes. In 1492, he was in Granada when Columbus secured the crown's support for his eccentric plan to reach the East by heading southwest, and the following year, he saw the sailor return to Barcelona. He annotated everything he saw and heard in hundreds of letters that offer a unique window into day-to-day news, on a global, a local, and often a hyperlocal level. First reporting scattered episodes of the overseas navigations and then authoring a multivolume history of what he had baptized, already in 1493, a "new orb," he eventually became chronicler of the Indies.[17]

However, this almost protojournalistic ability—to write quickly about fast-breaking news—has obscured a facet that inevitably unfolded at a slower pace: Anghiera's labor as a teacher.[18] This other dimension, on the contrary, is fundamental to understanding how his sensibility toward the "fine arts" of the western antipodes progressively unfolded.

## Seeing and Cultivating Human Life

Upon his arrival in Spain in August 1487, Anghiera's pedagogical influence was immediately widespread. He became the tutor of Iñigo López de Mendoza's children, including Antonio, future viceroy of Mexico and Peru, and Luis, future president of the Council of Indies (notably, during the Valladolid Debate). All these connections will prove important to understanding the outreach of Anghiera's thought. He was then appointed by the Catholic Kings as *maestro* of their son Juan (the heir) and of the royal household. In 1492, Queen Isabel invited him to open a school.[19] In honor of the woman whom he calls the promoter of the fine arts (*bonarum artium cultrix*), Anghiera conceived of an academy on a par with that of Socrates or Plato in Athens (OE, Ep. 113). Two years later, Columbus's sons became his pupils. Ferdinand Columbus's passion for books and prints and the innovative cataloguing practices he developed for his library are considered today to have developed in his school years with the *maestro*.[20]

The letters to his pupils highlight the mentorship role that Anghiera played through four decades, with fellows of all ranks and ages, both inside and around the court. They also give us a glimpse of what today we would call his teaching philosophy. A 1488 missive to the young prince Juan underlies the importance of the "fine arts" (*bonae artes*), celebrating the ten-year-old's precocious wit ("acuity of ingenuity" [*ingenii acumen*]) and the *humanitas* Anghiera cultivated as his teacher.[21] A few years later, he addressed the then fourteen-year-old heir of the crown as "Prince of Spain and the Islands" and called him "a tree rising toward the vastness." But curbing the protoimperial tone of the metaphor, he advises the youth to always water that tree with study (OE, Ep. 98). Another letter is addressed to Diego Fernández de Córdoba, a former pupil, who by then was in his twenties and fighting in the war of Granada (OE, Ep. 50). Anghiera advises the soldier to bring books on the battlefield and read, especially Sallust, available at the time in Leto's edition.[22] Writing to Jaime of Portugal, Duke of Bragança, who had become his student at age eight, he lays out his major pedagogic stance: stimulating even the nobler pupils to cultivate their own virtues without taking their moral qualities for granted or compromised on the basis of their family history (OE, Ep. 148). This advice may have resonated deeply in that young correspondent, who had seen his father, Fernando II "the African," publicly beheaded by King John II. Anghiera encouraged Jaime to find his own path.

I contend that this sensibility to identify, nurture, and cultivate his pupils' talents and wit provided Anghiera with a specific point of entry to see and reflect on the human qualities of the antipodean people living in "the new orb." The same humanistic vocabulary, in fact, addresses both his students' potential, the qualities of his humanist peers, and the qualities of the inhabitants of *de orbe novo*. Particularly telling are the letters sent over three decades to Pedro Fajardo, Marquis of the Vélez (1478–1548), a former student at the court. If, in his early missives, the mentor urged the teenager to continue cultivating his personal *ingenium* (OE, Ep. 150) or to exceed his predecessors in wisdom (OE, Ep. 204), later in life, the same Fajardo will receive Anghiera's enthusiastic remarks on the *ingenium* of the Mexicans as it was revealed in their artifacts.[23] In order to understand the contents of these letters and the precision of their lexicon, however, we must first closely read Anghiera's most incisive statement on the *ingenium* in the *orbe novo*.

## The Civilization of Art

Readers may remember that when Anghiera celebrated Columbus's return in 1493, he characterized the material arrivals from the western antipodes as *argumenta*: they were clear evidence that those lands existed and were inhabited. Exactly thirty years later, in 1523, Anghiera recurred to the same term. This time, he used it to distill the meaning of the magnificent artworks contained in one of the twelve boxes sent to Charles V from Mexico by Cortés—the only one that was not seized in the Atlantic by the French pirate Jean Florin. The single box that reached Spain in 1523 contained a variety of "images made with great art and the figures embroidered with flowers, herbs, animals, birds; a great argument to demonstrate that those people are civilized, keen with ingenuity, and industrious" (*Admirati sunt decorum & pretium, & arte mira laboratas imagines, & contextas omnium florum, herbarum, animalium, laqueorum, ac volucrum figuras; quod populi sint illi politici & ingenio acuti ac industrii, magno sunt argumento haec* [OE, Ep. 779]). Writing to Giovanni Ruffo Theodoli da Forlí, archbishop of Cosenza and papal legate to the Spanish court, Anghiera was actually recalling a visit that Ruffo had made to Valladolid.[24] This letter most sharply theorizes Anghiera's philosophical realization—art is the demonstration (*argumentum*) that these people are *politici*, in the sense of civilized. Before reconstructing the genesis of this idea, it is worth fleshing out the force of the lexicon and syntax he employed:

1.  The locution *arte mira* or *mira arte*, "with great art," was common in classical and medieval Latin to refer to the most refined artistic achievements. It was still in use in the fifteenth and sixteenth centuries. From Ovid's praise of Pygmalion's ivory statue in the *Metamorphoses* ("mira feliciter arte sculpsit" [10.248]) to the English Magister

Gregorius's twelfth-century Latin description of a Roman equestrian statue in *De mirabilis urbis Romae*, to Lorenzo Ghiberti's 1452 signature on the *Gates of Paradise* in Florence's baptistry—made "mira arte"—the two words were a seal of unmistakable perfection. Even printers used the locution to present their new technology as a human-made art and not a machine-made reproduction.[25] In his writings, Anghiera uses *mira arte* to refer to the most accomplished art pieces: the gorgeous Flemish tapestries hanging in the streets of Burgos in 1497 for the entry of Prince Juan and his bride, Margaret; the beauty of the pyramids and obelisks that he personally admired in Egypt in 1501; or the splendors of the "African city" of Tripoli, narrated to him in 1510 by those who had been there.[26] The architecture and art pieces seen in and coming from the New World are also blessed with the expression *mira arte*. But if novelty is revealed through a familiar language, novelty also impacts that language.[27] Being employed to write about Pygmalion's chef d'oeuvre, Roman statuary, Ghiberti's bronze work, impeccable printing results, Flemish tapestries, Egyptian architecture, North African urbanism, and New World imagery, the very term *ars* does not refer to a preconceived body of works, of known techniques, and of famous names. It comes to praise, in Anghiera's writing, a variety of admirable artworks that could be found at any place and at any time. This semantic transformation is comparable to that of the term *antiguidade* in Holanda's treatise. Naming the quality of an entirely new series of artworks, the terms *art* and *antiquity* now mean a nonprescriptive artistic excellence potentially detectable whenever and wherever—and in any medium.

2.  In order to state the ethical qualities revealed by the artifacts, Anghiera employs the locution *ingenio acuti ac industrii* (keen with ingenuity and industriousness). *Acuti* is the adjective of the noun *acumen*, which was used in rhetoric to denote the foremost condition of the novelty of a discourse. Cicero defined it as the capacity of a good orator to find the perfect word and to create compound words or piquant associations.[28] As for *ingenium*, often translated as "talent," "wit," "vivacity," "ingenuity," or "ingeniousness," its lexical richness is anchored in the verb *gignere* (to produce), indicating "a generation from within"—an inborn openness to explore any creative path. Pomponio Leto had precisely advised readers to recognize this quality in youth, when their "wit is ready for anything" (*ingenium ad omnia*).[29] Anghiera often celebrated these prime qualities in his interlocutors, from children to adults. In 1493, he had precisely saluted Ruffo's *ingenium* and *acumen* as virtues proving how full of *humanitas* the archbishop was ("vir humanissimus" [OE, Ep. 132]). Let us also recall that he praised his pupil Prince Juan's precocity precisely using the term *ingenium* (OE, Ep. 47). But now, it is the inhabitants of the New World who are recognized to be *ingenio acuti* (sharp in ingenuity), hence comparable in *humanitas* to an archbishop or a prince. These qualities, however, were not inferred from reading abilities

or speech originality. The intellectual sharpness of the inhabitants of the New World were inscribed in their artifacts, hence the use of *industrius*.[30] Meaning "industrious," "hardworking," "purposeful," this term denotes the subtle and intentional effort that is indispensable for achieving such artistic results.[31]

3. But the most conclusive term in Anghiera's demonstration on the evidential power of artifacts is certainly *politicus*. A detour in European political thought is in order here. According to Nicolai Rubinstein, until the end of the fifteenth century, the connotation of *politicus* and "the derivatives from *polis* continued to be used in the sense of relating to the State in general."[32] Becker has recently underscored, however, an important relational dimension, strongly informed by gender, that is inscribed in the terms *politikos/politicus/civilis*: being employed to describe not only perfect citizenship but also perfect marriage, they pointed to the ideal (and fiction) of equality inscribed in these human relationships.[33] The "civic humanism" defined by Eugenio Garin can also be thought as this ideal of egalitarian and active participation in the government of a city.[34] For several humanists, art was actually a form of civic engagement, which in turn demonstrated the liberality of the arts.[35] Now, Anghiera states that the evidence that the New World people are *politici* is manifest in their art pieces. It is not that the artist contributed in participative politics but that this foremost quality of a people—being *politici* in the sense of capable of living in relationship with other living beings—was demonstrated by the refinement of their artifacts.[36] This point will prove crucial to understanding the genesis of Anghiera's thought.

4. Finally, Anghiera describes these outstanding qualities of the people—sharpness of wit, purposefulness, and what one might call "relational civility"—in the present tense: the artifacts are an argument for what these people are (*sunt*). In other words, he does not state that the artifacts demonstrate the refinement of a bygone society but of a live one. The subtlety of the objects "made with great art" stand as evidence of what these people remain in spite of becoming booty to all sorts of intruders, conquistadors, and pirates—the artifacts demonstrate, to employ Judith N. Shklar's vision, "the extraordinary capacity of intellectual and moral dispositions to survive intact under the assault of social change."[37] We will see, in the third chapter, how this point will become crucial also for Las Casas.

Now that we have elucidated the lexicon and syntax used in the powerful statement of the 1523 letter to Ruffo, which most explicitly theorizes art as evidence of civilization, we will go back to what I consider its two generative periods.[38] One comprises the years that were marked by the arrivals of news and artifacts most directly related to that passage—those observed in or arriving from Mexico, between 1518 to 1523. The other period dates back to the early commentaries on the news and artifacts of the Antilles between

1493 to 1501. By starting from 1523 and proceeding backward (from the texts written in the period between 1518 and 1523 to those from the period between 1493 and1501), I aim to better isolate the stages of Anghiera's theoretical elaboration and identify its specific construction.

## Human Art vs. Human Sacrifice

In a letter dated July 1518 to Pedro Fajardo and Luis Hurtado de Mendoza (Iñigo's son), two of the former pupils already mentioned, Anghiera reports breaking news: sailing southwest from Cuba the Spaniards have found cities with streets, stone palaces, and temples. It is the first notice on Maya architecture. They have also seen "books, with images of kings and idols" (OE, Ep. 623). Anghiera compares them to colored engravings that attract buyers with their beauty. He probably had in mind his pupil Ferdinand Columbus, who by then was traveling through Europe to purchase the best books and prints for his nascent library.[39] The humanist shares with the alumni his enthusiasm and particularly celebrates the architectural splendor of "magnificent atriums" (*atria magnifica*) and "egregious temples" (*templa egregia*). Then, all of a sudden, he abruptly reports to Fajardo and Hurtado de Mendoza that within those astonishing architectural spaces, the inhabitants annually perform massive human sacrifices, especially of young boys and girls.

The contrast between extreme refinement and brutal violence creates a profoundly uncanny effect. What can be the reason for such a disturbing juxtaposition? Human sacrifice has certainly been the most powerful alibi supporting the brutal conquest of the Americas. But can we simply interpret those passages as Anghiera's support to the impending conquest—a conquest that not even the argument of artistic sophistication would be able to halt?

Juxtaposition seems to have mattered to the writer as he returned to a comparable textual structure in a number of his writings on the New World. He probably thought of a particular rhetorical device, *antithesis*, in order to express, by contrast, the opposition between what he progressively understood as two incompatible domains: namely, human-made art and the sacrifice of human beings. The first was the demonstration of a capacity to relate with the living, the second its antithesis, suppressing the living human. The realization of this opposition, I contend, cannot simply be related to the project and process of colonization.

The next year, 1519, the same recipients, Fajardo and Hurtado de Mendoza, received another letter praising the books, the grandiosity of the cities, and the artifacts "made with great art in gold, silver, and different birds' plumes" in the New World (OE, Ep. 650). The expression *mira arte* points again to the highest level of refinement. Yet, here

too, the following sentence juxtaposes to this finesse the distressing details of human sacrifice. In 1521, again, the former pupils read about the splendors of Tenochtitlan. The immolation of human flesh stands in close narrative proximity to the refinement of the statues (OE, Ep. 717). A source that clarifies why Anghiera repeatedly juxtaposed artistic refinement to sacrificial horrors and why he separated aesthetic creativity from ritual disembodiment is the forty-three-page booklet he published in 1521.

Shortly after Cortés's first delivery of objects and news from Veracruz arrived in Spain in October 1519 (to then travel through Seville, Tordesillas, Valladolid, and Brussels in August 1520), Anghiera completed the *De nuper sub domino Carolo repertis insulis*.[40] It was published in Basel in 1521 with a cover engraved by Hans Holbein the Younger, who at the time was actively working for the prominent printer Adam Petri. The text, largely excerpting other sources, both oral and written, narrates several expeditions undertaken by the Spaniards from Cuba: those of Fernández de Córdoba (1517), Juan de Grijalba (1518), and Cortés in the Yucatán, through Veracruz, and until the foundation of Villa Rica (1519). It also includes glimpses of the expedition on the string of islands that are known today as the Florida Keys, to which we will return later in the chapter. The *De nuper* will eventually become Anghiera's "Fourth Decade" in the *De orbe novo*.

Anghiera originally dedicated the *De nuper* to Margaret of Austria (1480–1530), governor of the Netherlands. He knew her from her youngest age. The daughter of Maximilian and Mary of Burgundy had married his pupil, Prince Juan. In his letters, Anghiera described how the entire court had awaited and then welcomed "the so much desired Margaret" and called her "Venus herself" (OE, Ep. 176). For the princely couple's entry in Burgos, in 1497, as we have already seen, the city was decorated with those splendid Flemish tapestries made *mira arte*. After Juan's premature death and his wife's grief over the stillbirth of a child, Margaret married the Duc of Savoy, only to be widowed again in 1504. She moved to Mechelen and was summoned regent of the Netherlands. Her court became one of the most important and refined cultural centers of the Renaissance. While she did not become queen nor mother a king, she was godmother to a future emperor. Her young nephew Charles and his sisters moved with her to Mechelen and received an impeccable education in the entourage of their aunt, whom they adored as a "new mother."[41] The boy was instructed by Adriaan Florensz Boeyens van Utrecht, future pope Adrian VI. In 1519, after the demise of Margaret's father, Maximilian, Charles succeeded him as Emperor of the Roman Empire, crowned Charles V. That same year, Cortés sent from Veracruz the magnificent artifacts that eventually traveled to Brussels and were seen by Dürer. Anghiera's opuscule can actually be read as a presentation on the artifacts' history, narrating where they came from, how they were obtained, how they were used, and—most important—how to look at and understand their astonishing level of artistic refinement.

p tot si facena quello. Disse ch parena ere un modo de sacre-
fitio et ch lischanauano iquelle pile de pietra et li trageuono
il Core del pecto et lo abrusauano et lo offeriuano aquello idolo
et li cauauono le polpe de li brazi et de le gabe et quelle ma-
zauono ch quello faceuono alli suoi inimizi co chi haueuono
guerra et ad ardo cosi p quel luogo fu trouato sotto terra
2. uasi de alabastro ch se poteua p serrare a ogni grade
re
S. pieni de pietre di molte sorte et qui si trouovono molti
fructi tutti buoni da mazare / A laltro di da mattina uedes-
semo molte badiore et gete assai uterra El Capitanio mado
a frar° de moteglio Capitano de una barze co uno indo
de quella prouincia p vedere quel ch uoleuono et rivato aquelli
li detono molti mazi piu amolti modi belli et demadando
de loro dissono el portoriano altardi Et cosi se tornassemo
alli nauilj. Et altardi uene una a Canoa co tre indj et
portauono alcuni mazi al Capitano elquale lui li dette
da uestire et dissono ch laltro di p portoriano molto oro
et cosi sene adorono. Et laltro di da mattina apparsono nella
spiaza co alcune badiore biacse et comedorono abia-
mare il Capitanio ch uscisse uterra co alquata gete et
li portorono molti rami uordi de serba flos se asetassono

FIGURE 21 | opposite | Alessandro Zorzi, marginalia drawings of architecture, sculpture, pottery, and anthropophagy, in *Paesi novamente ritrovati* (Milan, 1519). Florence, Biblioteca Nazionale central, Banco Rari, MS 234, fol. 80v. © Ministero dei Beni e delle Attività Culturali e del Turismo / Biblioteca Nazionale Centrale, Florence.

FIGURE 22 | Human-shaped vessel, Isla de Sacrificios, Mexico, postclassic, 900–1521. Alabaster (*tecali* or onyx), 23 cm. London, British Museum, Am1851,0809.1. Photo: Trustees of the British Museum.

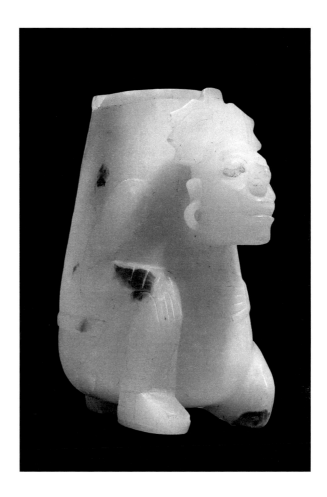

The subtlety of art making and the horrors of sacrificial practices are placed side by side in the first part of the *De nuper* / "Fourth Decade."[42] Anghiera prepares the reader to "close the stomach to not be disturbed" before narrating what the Spaniards say they saw on the island that they eventually called "de los sacrificios": truncated heads and mutilated corpses. Immediately following, in a narrative continuity that seems unbothered by the jarring juxtaposition, the text portrays one of the explorers meandering through the island and finding two alabaster vases "nicely made, with many stones of different colors" (*pulchre laboratos, lapillis diversorum colorum plenos*). The Venetian editor Alessandro Zorzi copied this text, probably relying on the Italian translation of Bernal Díaz del Castillo that Anghiera had also excerpted.[43] One page's marginalia read "human sacrifice" and, immediately below, in striking contrast, "alabaster." Zorzi added also a drawing: two vases, different in shape, aiming to illustrate that they were of "molte sorte" (of many kinds of shapes) (fig. 21). We know today exactly the type of vases seen by the explorers in

1518, as a variety of travertine recipients from the Isla de Sacrificios is kept today in several museums (fig. 22). They were actually funerary urns, some still containing ashes when they were excavated. The panoply of forms carved into the translucent stone, known as *tecali*, is astonishing.

In his drawing, Zorzi seems to have had in mind something other than the ornamented urns referred to in Díaz's text: he was probably more familiar with the Cypriot vases that he could have seen in Venice, which, at the time, occupied the Mediterranean island. In spite of the obvious error, we must see his effort as an attempt to signify, after that disturbing passage about human sacrifice, the human artistry of the creations. We will see a similar visual logic at play in an image of the Florentine Codex analyzed in chapter 4. There, the artistry of a sculpture representing a pre-Hispanic "idol" was visually translated as reflecting contrapposto—an obvious anachronism but, at the same time, a way, I contend, to signal its position of equality to Greco-Roman sculpture (see fig. 52). As in Zorzi's marginal drawing of a Cypriot-like *tecali* vase, an apparent misunderstanding may signal a way to conceptually visualize "artistry."

Anghiera's uncanny proximity and stark contrast between artistic, civic (*politicus*) refinement, and sacrificial horror returns in another page of his *De nuper*. Here juxtaposition is achieved in yet a different way. A passage fondly narrates how astonished Cortés and his soldiers were at the beauty of houses' ornamentations in Cozumel (*domorum ornatus variorum colorum*), at the intricacy of the hammocks, and at the innumerous quantity of books. These lines are strikingly placed between two lengthy accounts of sacrificial practices. When the text was reprinted in Nuremberg in 1524, the string of annotations at the margin magnified the odd narrative logic of these passages.[44] One first reads "island of sacrifices," then, "Those people have books," and, finally, "They sacrifice children."

So, let us now return to the question: why such recurrent juxtaposing? Geoffrey Eatough also underlines the textual proximity between artistic subtlety and sacrificial horror in Anghiera's *De nuper*.[45] But his explanation is that artistic sophistication plays a role against the harsh colonization model that, on the contrary, is based on the supposed barbarity inferred from human sacrifice. My reasoning is different. I propose that Anghiera's detailed remarks, rather, located human civilization precisely in the artistic object and in contrast to human sacrifice. That is to say, art did not "mitigate the horrors of sacrifice" nor make a case for "tolerance and accommodation," as proposed by Eatough.[46] Instead, the intended contrast—the antithesis—between art's refinement and sacrificial practices illustrated the juxtaposition of two domains that were irreducible for Anghiera: art intended as human refinement should be separated from the ritual practices often described as *ferine* (animal and inhuman). It is this separation that the *De nuper* / "Fourth Decade" achieves when presenting the artistic subtlety of the first objects sent by Cortés to Charles V.

## Uninterrupted Ekphrasis

Cortés shipped the artifacts with an inventory in 1519 from Veracruz. They arrived in Spain to Charles and his mother, Juana, in 1520.[47] Shortly after, Anghiera wrote another letter to his pupils Fajardo and Hurtado de Mendoza. Praising those astonishing pieces "completely unknown to us," he did not refer to any uncanny contrast with the brutality of sacrifice practices (OE, Ep. 665). This is probably due to the fictive category of *dona* (gifts) that severed them from the need of that juxtaposition. Supposedly offered by Moctezuma to Cortés and gifted by Cortés to Charles and Juana, the objects undoubtedly served the fiction of an amicable first contact. But one cannot understand Anghiera's celebration of their artistic potency plainly in those terms.

As is well known, after traveling through Spain, the objects arrived in Brussels. In August 1520, they were admired, among others, by Dürer and, most plausibly, Margaret of Austria.[48] On that occasion, she may have shown particular interest in specific pieces, as several years later her nephew eventually offered her a selection.[49] The *De nuper* / "Fourth Decade," dedicated to Margaret, presents these splendid artifacts in their most exquisite aesthetic qualities. The text displays them through an uninterrupted ekphrasis that makes them visible in their minute details, undisturbed from any information that would cast a shadow on their ingenious artistry. It is like seeing them under a glass dome, in a museum. Let us have a closer look at the passage of *De nuper* that will become the ninth chapter of the "Fourth Decade."

The text opens with a lengthy description of the artifacts' material richness. Describing two golden necklaces *egregie laborati* (egregiously made), Anghiera writes that the first is composed of 8 thin chains, with 232 red and 183 green stones inserted, from which hang 27 golden bells, separated by 4 figures of a precious stone set in gold and with golden pendants hanging from each bell (for comparison, see fig. 23). The second necklace is composed of 4 thin chains, with 102 red and 162 green stones, from which hang 26 golden bells, separated by 10 large gems set in gold with 150 golden pendants hanging from the bells. Anghiera philologically observes and describes each millimeter of the two discrete necklaces. But the stakes are higher than this microscopic demonstration of technical prowess. The following long passage—eventually titled "The author celebrates the purposefulness of the artists of the indies" (*Laudat industriam artificum indorum*)—has been compared to Dürer's famous words of praise on the "subtle ingenuity of people in foreign lands."[50] Anghiera, however, is even more explicit in praising the actual artistic labor involved and its profound signification: "I do not marvel at the gold and jewels, but I stand amazed at the skills and flair/training demonstrated in the way the object masters the material. I have seen a thousand shapes and figures that I am unable to describe. In my judgment I have never seen anything whose beauty had the same power to attract human gaze."[51] What follows

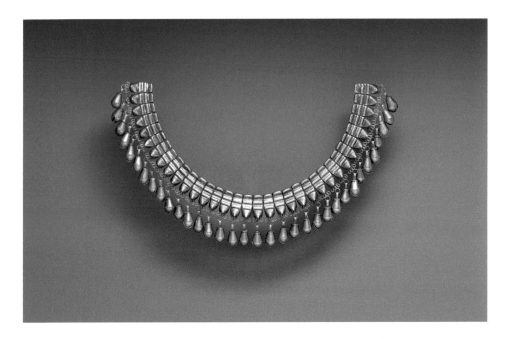

FIGURE 23 | Necklace with beads in the shape of jaguar teeth, Central Mexico, Mixtec (Ñudzavui), thirteenth to sixteenth century. Gold, 11.4 × 3.5 × 12.7 × 38.7 cm. New York, The Metropolitan Museum of Art, 2017.675.

is an impressively detailed description of all sort of artifacts: helmets (*galeas*), a scepter (*sceptrum*), a sculpted stone resembling a sphinx (*sphingem*), several animal-shaped figures (a lizard, a duck, several birds, and fish), all composed of precious metals and stones, along with several oval shields and gold sheets also decorated with animals.

A comparable textual display of the artifacts, in ekphrastic isolation from the brutality of human sacrifice, appears in the passages devoted to Mexican objects in the "Fifth Decade," composed between 1521 and 1523 and dedicated to Pope Adrian VI. The former teacher of young Charles at his aunt Margaret's court in Mechelen, then called Adriaan Florensz Boeyens van Utrecht, had eventually resided in Spain between 1520 and 1522, when his pupil appointed him "'administrator and governor" of Castile, the Canary Islands, and the Americas.[52] Anghiera can therefore refer to Adrian's personal observations since, during his tenure in Spain, he had seen the artifacts arriving from Mexico. In a passage titled "Ingenious artists among the Indians" (*Arguti opifices apud Indios*), Anghiera recalls their common admiration for those handmade (*per manu factam*) jewels and their conclusions: "They have the most insightful artists in all the arts."[53] Here again, he praises how "art surpasses the material" (*in quibus ars materiam vincebat*).

The "Fifth Decade" also incisively describes the objects brought to Spain by Cortés's lieutenant Juan de Ribera in 1523.[54] The account is vivid: Anghiera portrays Ribera bringing

the artifacts to his house, where three of the highest Italian functionaries have come to see them. Gaping at the pieces, the Neapolitan prothonotary Marino Caracciolo, the Venetian ambassador Gasparo Contarini, and Tommaso del Maino, nephew of the Duke of Milan Francesco II Sforza, "were not amazed by the abundance of gold . . . but by the number and shapes of the vases full of gold." The account continues, describing the "variety of jewels and rings" and the artists' special wit for their capability of representing wild life. He writes that there is no animal—neither quadruped nor bird, nor fish—that they cannot "diducere ad vivum" (make alive), even if they have seen them only once (figs. 24 and 25).[55]

Here Anghiera's words may echo an astonishing passage of Cortés's "Second Letter." Dated 1520, just before he waged war against the Triple Alliance, the letter was published in Seville in 1522. The conquistador expressed his amazement at the variety of artifacts that he saw in Moctezuma's palace. In a striking eulogy of the Mexica *tlatoani*, whom he calls a "barbarous leader," the letter praised him for having golden, silver, stone, and feather artworks "made after all the things that under the sky are in his dominion." Celebrating Moctezuma's imperial microcosm, Cortés's words also complicated the antinomy between barbarity and civilization, precisely via the artistic sophistication evident in the pieces. These were made so "al natural," with such truthfulness to nature, that no goldsmith or silversmith in the world could rival them. It was impossible, according to Cortés, to understand with what tools the stonework had been made so perfectly. Neither wax nor embroidery could achieve what featherwork had.[56] Where the "Second Letter" writes "al natural," Anghiera uses "ad vivum." Before the sixteenth century, this Latin expression seems to have been rarely used to refer to the liveliness and trustfulness of visual representation.[57] One of the first instances may be in a letter written by Erasmus in 1525, celebrating the double portrait of Martin Luther and his wife, Katharina von Bora, as made "ad vivum." If still in 1540 the locution pointed to "a non-classical expression that was either colloquial or even new," then, in the second half of the sixteenth century, it rapidly became the key term to express visual likeness in naturalistic illustration. The Swiss naturalist Conrad Gessner considered painting *ad vivum* "the highest degree to which the artist's talent (*ingenium*) can advance."[58]

But when in 1523 Anghiera used the expression *ad vivum* to praise the astonishing representation of animal life in the artworks coming from Mexico, he may have been one of the first to employ it.[59] In other words, he was not projecting a traditional language of Renaissance artistic theory onto the New World. That specific language may rather have generated precisely from the observation of the New World artifacts. Moreover, the sophistication praised by Anghiera was not only a representational one. The expression *ad vivum* embraces materiality. The ekphrasis of a mosaic mask "marvelously made" (*perpulchre laborata*), with bands of obsidian and turquoise tesserae running through

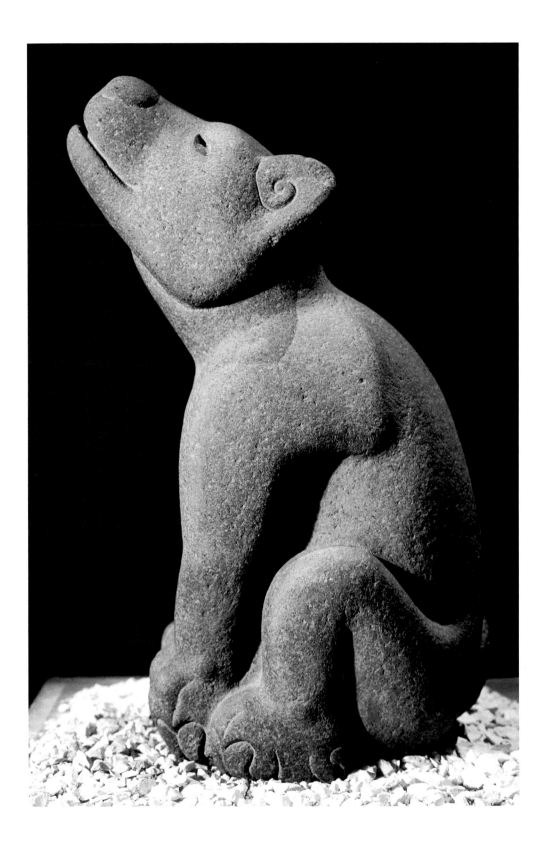

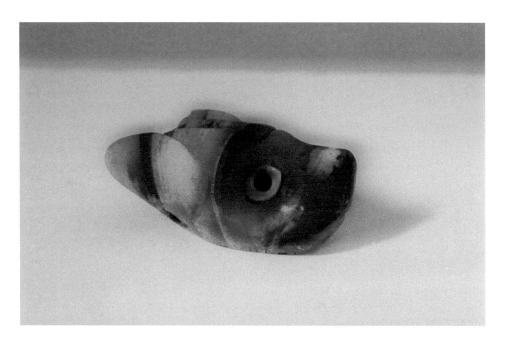

FIGURE 24 | opposite | Hauling Dog, Mexica, late postclassic. 48 × 20 cm. Museo Regional de Puebla, inv. 10-203439. Photo: Instituto de Investigaciones Estéticas, Archivo Fotográfico Manuel Toussaint.

FIGURE 25 | Heads of dogs, Mexica, ca. 1430–1500. (top) G13364 (quartz variant onyx) and (bottom) G13221 (quartz variant amethyst), each, 2 × 1 × 1 cm. Florence, Collezione Medicea, Museo di Storia Naturale, Museum Hub of the University of Florence.

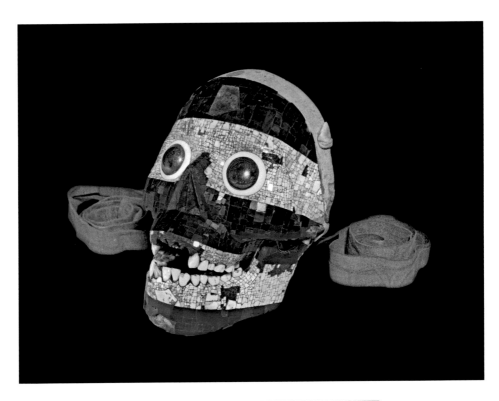

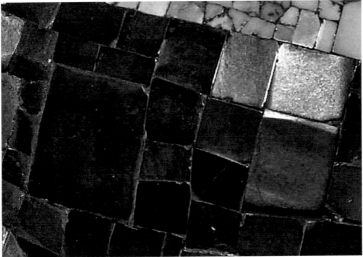

FIGURE 26 | Decorated human skull, Mexica, 1400–1521. Deerskin and maguey fiber; turquoise, obsidian, and lignite mosaic held in place with pine-resin adhesive; nasal cavity filled with red thorny oyster shell; eye sockets filled with polished pyrite surrounded by white shell, 19 × 12.20 × 13.90 cm. London, British Museum, Am, St. 401. Photo: Trustees of the British Museum.

FIGURE 27 | Detail of human skull (fig. 26) with mosaic of the obsidian tesserae. Photo: Trustees of the British Museum.

the face "from one temple to the other," is particularly telling in this sense. The description matches several features of the Mexica mosaic skull mask kept today at the British Museum (fig. 26). We can look at it closely since we have microscopic pictures of its tesserae (fig. 27).[60] Recalling the collective visual and tactile observation of the artifact brought by Ribera, Anghiera writes that the tesserae of the mosaic were set in such an impeccable way that they would fool not only one's fingertips, but one's fingernails (*ut fallere ungues possint*). The sound of the gesture would still make one believe that it was the polished, even surface of a single stone.[61] It is quite spirited to imagine Anghiera and Ribera with the three Italian guests brushing the tips of their fingers on the tesserae of the mask, probably with their eyes closed, amazed at the smoothness and silence.

## Architectural, Oceanic Intricacies

We have seen how, between 1518 and 1523, Anghiera explored two textual displays of the New World artifacts: he juxtaposed art to human sacrifice in order to show their irreducible contrast, and he described artistic refinement uninterruptedly, isolating its perfection from any reference to the violence of sacrificial disembodiment. Actually, even when he described the skull mosaic that modern scholars have associated with sacrificial practices, he said only that it was placed on the face of the sick king and would have been left there for his burial had he not recovered.[62]

Through this specific construct, Anghiera arrived at that stunningly lucid statement, writing to Ruffo in 1523, when he declares that artistic refinement—achieved, as we saw, with purposefulness, wit, and technical mastery, and producing visual and even sonic illusion in the observers—is evidence of these people being "politici," in the sense of civilized. Barbarism and civilization were no longer oppositions between different peoples but opposite sides that could exist within a single society. Before being spelled out with such clarity, that groundbreaking idea had been distilled through more than four decades.

It would be an error, in fact, to see the Mexican artifacts commented on above as the sole agents of this conceptual innovation. As I have proposed from the beginning of this chapter, Anghiera's humanistic training and his labor as teacher provided him a special sensibility to identify *ingenium*, in particular the cultivation of the *bonae artes*. I posit that his early reflections on the arts and architecture of the Antilles were generative. It is there that we can see how terms, locutions, and topics start peeking out of his monumental work: a veritable philosophical lexicon made of conceptual and linguistic resonances that were brought to their extreme consequences in the passages on Mexico.

Anghiera's so-called "First Decade" is composed of ten books or chapters: the first three were completed by 1494 and dedicated to Cardinal Ascanio Sforza, chapters four through nine seem to have been written in 1501 and were dedicated to Cardinal Ludovico de Aragona, and a tenth chapter was addressed to Iñigo López de Mendoza. Stelio Cro reconstructs the complicated editorial history of the text. When, in 1501, Anghiera passed through Venice on his embassy to Egypt, he brought the manuscript along. Angelo Trevisan translated and published it as *Libretto* (Venice, 1504). Three years later, the same translation was published as *Paesi* (Vicenza, 1507), but this time as a narration of the expedition of Amerigo Vespucci (!)—it is the same year as Martin Waldseemüller's map baptizing a continent as America. In 1511, Antonio de Nebrija prepared the first edition of Anghiera's text in Latin in collaboration with the author. It was published in Seville by Jakob Cromberger as *Oceani decas*, along with other writings by Anghiera, and accompanied by a fascinating glossary authored by Nebrija. A new edition was published in 1516, also by Nebrija, eventually becoming part of the *De orbe novo*, the posthumous edition comprising the first three decades published in Alcalá in 1530.[63]

The first three books of the *Oceani decas* / "First Decade," dedicated to Ascanio Sforza, interest us here. Brother of Ludovico Maria Sforza, Duke of Milan and patron of the arts (including of Leonardo da Vinci's *Last Supper*), Cardinal Ascanio was also a major artistic patron—in particular, of several architectural projects undertaken by Donato Bramante: the cathedral of Pavia, Sant'Ambrogio in Milan, and the abbey of Chiaravalle, where the artist also painted the famous *Christ at the Column*.[64] Interestingly, Bramante also built several major architectural projects sponsored by the Catholic Kings in Italy, most illustriously the Tempietto in Rome for the tenth anniversary of Columbus's voyage.[65] It is tempting to imagine Ascanio receiving Anghiera's handwritten account already in 1494 and reading it in one of Bramante's cloisters. This text was radically different from the letter that he had received in 1493, where Anghiera portrayed islands populated by naked kings and belligerent people (OE, Ep. 134). In the *Oceani decas* / "First Decade," Anghiera counted on a variety of oral accounts of the participants in Columbus's first and second voyages. It is likely that these were further filtered and embellished by intermediaries, including Italian merchants, who had easier access to these sailors' circles at the port and brought the information to the court. We will return later to this important aspect as it can shed further light on Anghiera's language.

The humanist reports to Ascanio several episodes where the explorers express veritable admiration (*admiratio*) for the fine construction techniques and architectural design seen in the islands. First, in Hispaniola, where the houses are "made with great art" (*mira arte laboratas*), an expression that we now recognize.[66] A longer passage describes that, on the island known today as Marie-Galante, "wandering through the island they found innumerable villages, though each consisted of merely twenty or thirty houses. They

observe the shape of a square, with huts built in a ring round the square." Anghiera senses that he needs to give a full account (*enarrare*) of that episode and continues:

> They say that they are all made of wood and fashioned into a round shape. First they build the outer circle of the house by driving very tall trees, which they use as piles, into the ground, and afterwards set other shortened beams on the inside, which support the tall exterior timber and prevent them from slipping; they join the tops of the tall timbers into the shape of a camp tent with the result that all those houses have pointed roofs. They cover the roofs with leaves from palms and some other similar trees, woven together in a way which gives complete protection against the rain. Afterwards on the inside they string from the shortened beams to the main timbers ropes which they twist together from cotton and from some roots, which are like esparto grass, and they place on these blankets of cotton. For the island grows wild cotton—which the Spaniards in their common tongue call *algodón*, the Italians *bombasio*—or with straw thrown on top. They have a court, which the other ordinary houses surround, into which they all come together to play. They call the houses *bohios*, the middle vowel being acute. They noticed two wooden statues, albeit rather crude ones, each with snakes rising on end clinging to them; they thought that they were images which they worshipped; but afterwards they learned that they had placed them there for decoration.[67]

Ekphrasis turns here into a lexical tour de force as Anghiera is reporting in Latin on a construction technique that has probably been orally narrated to him in vernacular—a new construction technique that moreover had never before been described in any writing. Particularly fascinating are the verbs he employs in order to describe material intricacy—*construo* (build), *appono* (set), *sustineo* (support), *coniungo* (join), *tego* (cover), *contengo* (weave together), *deduco* (string), *contorgo* (twist together), and *superimpono* (place on). These precise actions allow the materials to become a building, acquiring strength, height, spaciousness, and impermeability.[68] This architectural compound, Anghiera continues, is decorated with two statues emerging from snakes. In spite of looking suspiciously idolatrous, they were, in fact, placed there only "ad decorem" (to beautify). The translation of this passage in *Paesi* (1507) adds that the Spaniards thought the statues were idols, but they were placed there "solum per bellezza."[69] Zorzi's marginal drawing on this page in his manuscript is particularly meaningful (fig. 28). We see the houses placed around a plaza, the tentlike architectural structure, the strong, intricate texture of the roots and cotton woven together, and two statues emerging from serpents—obviously only imagined by Zorzi. The word "Fede" (faith) relates to the worship of the stars and the moon.

uo molti caseli de.xx.in.xxx.case luno.Lequale erano tute
edificate per ordine.in circo atorno una piaza ritonda:che
li staua de mezo:tuti erano de ligno fabricate intondo. Pri
ma furno in terra tanti arbori altissmi che fanno la circon
stantia de la casa:Da poi limettano dentro alcuni traui cur
ti:acostati a questi legni longhi che non caschino.El coper
to lo sanne in forma de pauioni. Et cosi tute queste case hã
no el tecto acuto. Da poi tessono questi legni de foglie de
Palme:& de certe altre simile foglie che sonno securissime
per lacqua. Ma dentro dali traui curti tessono cum corde de
bambaso:& altre radice che simigliano al Sparto. Hãno al
cune sue lettere che stãno in aere. Sopra a lequale mettano
bambaxo:& stramo per lecto. Et hanno portichi:doue se re
duccano in zuccare. In uno certo loco netteno doe statue
de ligno:che stãno sopra a.ii.bisse:pésorono fossero soi ido
li. Ma erano poste solum p belleza che elli solamente adora
no:el cielo cú soi pianeti. Acostandosi li nri a ქsto loco:doe
hoi:& dóne se mesino asugir:& abádonádo le sue case.xxx.
femine & garzoni che erano psoni:liქli garzoni ქsti C ani
bali haueuano psi de alcúe insule p mãzarli:& le femine p te
gnir p schiaue:fuggero ali nri.itrati i le sue case:trouoró che
haueano uasi de pietra a nra usanza de ogni sorte:& ne le
cusine carne de homini lesate insieme cú Papagalli:& oche
& anare erano in spiedo per rostir:per causa trouarono ossi
de brazi & cose humane:che saluauano per fare serri a sue tri
ze:perche nõ hãno ferro:& trouoró etiam el capo de un gar
zone morto pocho auanti che era attachato a un trauo:& 
giozaua anchora sangue. Ha questa isola.viii. grandissir i

The following marginalia, all of a sudden, abruptly introduces the word "Anthropophagy": a drawing represents a vase but actually refers to the containers where human flesh was, according to the text, slowly cooked. The decapitated head of a man spilling blood ends an odd string of marginalia where the highest creative refinement of the construction techniques is juxtaposed to the most destructive impulses.

A third passage of the "First Decade" read by the connoisseur Ascanio reports the architectural finesse observed in Hispaniola. "While they were exploring the land between these two rivers, they saw in the distance a tall house. . . . Those who measured the house report that when they marked out the diameter, from circumference to circumference (for it was round) it was thirty-two large strides; it was enclosed by another thirty ordinary houses with ceilings laid above of different colored reeds, most artfully woven together [*mira arte intertextis*]."[70] The perfectly spherical architecture and the artistic effect of the thirty houses, with their colorful reeds, will make a reader of a later Italian edition not hesitate to gloss: "Architettura de Indiani" (see fig. 30).[71] Architecture it was indeed.

## A Conjunct Humanity

Praising to Ascanio the architectural refinement of the first buildings observed in the islands, Anghiera claimed an aesthetic dimension for several statues wrongly treated at first as *simulacra*: false images to be worshiped. Unveiling the error of judging too quickly, Anghiera realized that only by setting aside hasty preconceptions could one see the artistic dimension of those statues. In his descriptions to Ascanio, Anghiera also staged that uncanny opposition between human sophistication and cruel anthropophagy. This particular "textual display" was eventually retaken two decades later. In his texts on Mexico, human subtlety is juxtaposed to human sacrifice and then ekphrastically isolated to allow a close look at the art pieces.

But in all these passages, Anghiera goes beyond demonstrating that, in the New World, artistry was independent or severable from rituality. From very early on, he seems to have intuited that the capacity to create *mira arte* (with great art) revealed, from the tiniest islands of the Antilles, a common thread of humanity worldwide.

The vivid accounts addressed to Leto between 1495 and 1499 record this change in perspective. Detailing to his fellow humanist the myriad techniques observed in Hispaniola—methods involving stone, wood, cotton, gold, shell, and more (OE, Ep.

FIGURE 28 | Alessandro Zorzi, marginalia drawings of architecture, sculpture, pottery, and anthropophagy, in *Paesi novamente ritrovati* (Milan, 1519). Florence, Biblioteca Nazionale centrale, Banco Rari, MS 234, fol. 5r. © Ministero dei Beni e delle Attività Culturali e del Turismo / Biblioteca Nazionale Centrale, Florence.

156)[72]—Anghiera also discusses Calicut constructions to make a powerful statement: their artistic customs are not only comparable between themselves or reminiscent of an original golden age of humanity, but they are the same as "ours" (*nostro more*) (OE, Ep. 181 and 185).[73] Looking East and West, Anghiera demonstrates, on an increasingly global scale, a shared metatemporal humanity that his prior generation of fellows humanists had only intuited. This is also probably due to the limited number of contemporary societies to which they had been exposed. Take Leto. His only travel experience had been accompanying Cardinal Osia di Podio to Germany and Poland in 1480 to obtain books on behalf of Sixtus IV. During that journey, Leto had also visited Russia. He eventually inserted some memories on the practices of living Scythians and Russians that he observed in person in his commentaries to Virgil's *Georgics*,[74] but he does not seem to have pushed his observations beyond a comparison between rural societies.

Certainly, like Leto, Anghiera also read the New World with classical references in mind. But he often exceeds a rigid, comparative paradigm to state the total novelty of what he has seen and read about and to consider the possibility of interweaving the new evidence through time on an increasingly global scale. For instance, he describes at length all sort of myths, including those associated with the artifacts, such as the story of the beautiful gold-alloy collars offered by a woman of the sea to the first prince of an island to thank him for descending in the abyss to see her (OE, Ep. 177). Meditating on the narrative complexity of these plots, he says to his friend that they demonstrate that the islanders, too, like the Romans, are great "inventors" (*inventores*) (OE, Ep. 189).

Read from the perspective of a progressive universalization of the human through a variety of inventions—mythological, architectural, sculptural—the letters to Leto have thus a resonance other than as a protoanthropological corpus of exotic particularities and differences. It is precisely the opposite philosophical conclusion that Anghiera develops in a letter dated 1499. After having described to his fellow how the inhabitants of the islands practice the art of medicine, he states: "Nature can bring even the naked ones to develop their ingenuity toward the fine arts, since nobody has been created wearing clothes by Nature" (OE, Ep. 206).[75] By the rhetorical use of the pronoun *nemo* (nobody) to show a truism—nobody is born clothed—Anghiera can claim evidence that, in fact, anyone's *ingenium*, anywhere, can be driven toward the "fine arts." It is a statement that resonates with Holanda's passage, discussed in the previous chapter, where the Portuguese theorist and painter stated "engenhos em toda parte podem nascer" (talents can be born anywhere). In the *Da pintura antiga* that bold sentence was an overt quotation from Juvenal (poets "may be born in a dullard air and in the land of thick-heads," he wrote in his *Satires* [10.49–50]); Anghiera, however, may have been the first author who brought the Latin author—whom he knew by heart[76]—to a New World dimension. No climate, no geographical position, and no somatic characteristic or custom could prevent anyone

from developing that "generation from within," namely *ingenium*, in the direction of the *bonae artes*.

Anghiera's realization that humanity can potentially have the same natural dispositions anywhere actually contradicts several of his earlier statements. In his letters prior to Columbus's return, in fact, he seemed rather eager to highlight the differences and unevenness between humans: in 1488, he stated how Nature offers her favors to humans in various degrees (*Variam esse erga homines naturae beneficentiam* [OE, Ep. 46]), and in 1490, he laconically asked, "What happens in Nature so that humans have such different tastes and desire such different things?" (*Quid hoc siti in natura, ut tam diverso gustu homines appetent diversa?* [OE, Ep. 86]). The people of the New World—myth tellers, artificers, doctors—not only provided new answers to such questions. They also radically transformed the questions and catalyzed a major shift: the universalization of the human contingent upon a shared talent and sensibility toward all sorts of inventions.

Take another passage of the *Oceani decas* / "First Decade." Describing again to Ascanio the astonishment of an elder from Hispaniola when he saw how the Spaniards reacted to the pieces of raw gold he had brought to them—one as large as a nut, another like an orange—Anghiera's commentary merits to be quoted in full:

> One aged inhabitant brought two gold nuggets, almost one ounce in weight. When he saw our men were amazed at the size of the nuggets, he was so amazed at their amazement and indicated that these were small nuggets and of no importance, and grasping four stones in his hand of which the smallest equaled a nut in size, the biggest however a large orange, he said that round pieces of gold of that size could be found everywhere in his country's soil, which was about half a day's journey from there, but that among his neighbors there was not much interest in gathering gold. For it has been discovered that they do not make much of gold, in so far as it is gold, but they value it for the pleasure a person gets from the shape into which the hand of the artificer has learned to draw it out or mold it. For who pays much for rough marble or uncarved ivory? No one indeed, but if it is fashioned by the hand of Phidias or Praxiteles and emerges as a Nereid with glowing hair or a beautifully shaped Hamadryad, there will be no lack of buyers anywhere.[77]

Recurring again, as in the passage to Leto, to the power of rhetoric—there the negative pronoun *nemo*, here the negative pronominal adjective *nullus* and the negative adverb *nusquam*—Anghiera states here that *no one* would pay much for raw marble or ivory, while *nowhere* will there be a lack of buyers if the hand of an excellent sculptor has transformed the material into a masterpiece. Anghiera thus explains the otherwise

86

unexplainable reaction of the man of Hispaniola.[78] The classical reference, however, does not serve to move the New World closer to a distant antiquity but to conflate time and space around artistic excellence—what this book calls a new antiquity. We can spell out Anghiera's theorization in the form of a mathematical proportion:

Disinterest in Raw Gold : Enthusiasm for Classical Sculpture = Disinterest in Raw
Marble or Ivory : Enthusiasm for Golden Necklace

or

DRG : ECS = DRMI : EGN

In other words: the disinterest of the man of Hispaniola in raw gold (DRG) is to the enthusiasm of the modern buyers and collectors of refined classical sculpture (ECS) as the disinterest of a modern collector in a piece of raw marble or ivory (DRMI) is to the pleasure that the man of Hispaniola would get from the subtlety of a golden necklace (EGN) fashioned by the hand of an artificer.

Two other passages of the *Oceani decas* / "First Decade" provide further evidence of the progressive universalization of humanity based on artistic sensibility (both as actual art making and as art appreciation). These are found in the books of the "First Decade," which were dedicated to the Neapolitan Cardinal Ludovico de Aragona (1474–1519). Another of Anghiera's former pupils, Ludovico was an art connoisseur (OE, Ep. 320). Later in life, he embarked on a pan-European journey that led him not only to meet Leonardo da Vinci in person in Amboise but also to celebrate Gothic architecture and Flemish painting.[79]

Anghiera relates that Ludovico visited the court of the Catholic Kings in 1495 and introduced him to artifacts that had arrived from the Antilles—including objects that, at first, he did not immediately consider the most refined (OE, Ep. 210).[80] These were the so-called çemis, which he latinizes as *zemes* (which I discuss in chapter 4). Anghiera severely judged them as fruits of the devil's deceptions. Probably shortly after that trip, Ludovico received in Naples four of these *zemes* made in cotton (*ex gosampio imagines*) to show them to King Federico of Aragon.[81] But other artifacts from the islands did not reveal the overseas diabolical outreach at the Spanish court of Naples. In a passage of the third book of the "First Decade," Anghiera refers to a fascinating episode involving the Neapolitan doctor Giovanni Battista Elisio. Describing the variety of subtle wooden pieces arriving in Spain from the province of Xaragua, which was governed by the cacica Anacaona, he writes to Ludovico: "Her treasures were not gold, not silver, not gems, but only implements and things of use to people, for example, chairs, side plates, dishes, bowls, plates made from a very black, slippery, glistening wood, which your Giovanni Baptista Elisio, a doctor eminent in arts and medicine, maintains is ebony; and they are

fashioned with marvelous art [*arte mira laborata*]. For the inhabitants exercise on these all the talent Nature has granted them [*in his enim, quidquid est incolis ingenii a natura tributuum, excercent*]."[82]

A Neapolitan doctor at the court of Federico of Aragon, Elisio turns out to be the author of an important treatise of natural philosophy published in 1490, *De philosophia naturali*. The book was largely read and collected throughout Europe, and several decades after its publication, Ferdinand Columbus purchased in Cologne Elisio's bestseller for his Sevillian library.[83] In 1500, Elisio seems to have also visited the court of the Catholic Kings; we can suppose that it is during his stay that he observed the wood artifacts.[84] Knowing more about Elisio may shed light on Anghiera's language, which borrows from the lexicon of natural philosophy. But, here too, we might imagine Elisio revising his ideas about dispositions and human limits when encountering the "treasure" paid by, or rather extorted from, Anacaona and brought by Columbus to Spain. It included fourteen ornamented "seats" (called *duhos*) and sixty table utensils and cooking pots.[85] But these were not trivial dining-table pieces. Their subtlety can be evinced by the magnificent *duho* kept today at the British Museum (fig. 29). It is tempting to imagine Anghiera and Elisio inspecting together the wood marvels that arrived from overseas, debating not only about what tree they were made of (Elisio took *Guaiacum* for ebony) but also about the evidence they presented, that of the artificers' *ingenium*. The doctor's visit at the Spanish court in 1500 coincides with the time Anghiera wrote these passages. It must have been a conversation, in Italian, with the natural philosopher and doctor that impacted his commentaries in the "First Decade."

This philosophical meditation on the human on a universal scale reaches its clearest enunciation in the eighth chapter, also dedicated to Ludovico de Aragona. Commenting on the variety of traded artifacts seen in Hispaniola and coming from the nearby islands, Anghiera states: "There is no one who does not take pleasure in obtaining some strange thing which his own country does not have, since Nature has bestowed this trait on all human beings with no exception [*cum hominibus cunctis*], to be eager for novelties and enticed by them."[86] Anghiera's expression "cum hominibus cunctis" is remarkable for the choice of the adjective *cunctus*. An etymological excursus is indispensable here.

Considered since antiquity a contraction of *con-junctus* = *conjunct*, the adjective differs from the pronoun *omnes*.[87] The distinction is clearly highlighted in the so-called *Lexicon of Festus*, dated to the ninth century: "*Cuncti* means *omnes*, but conjuncted and congregated" (*cuncti significat quidem omnes, sed conjuncti et congregate*).[88] While the term is largely present in classical literature in Latin, Jerome used this adjective for the Vulgata's translation of the Genesis passage introducing Eve.[89] Where the Hebrew reads "im kol chai (of all life)," the Vulgata has "mater cunctorum viventium" (the mother of all living people with no exception) (Gen. 3:20).[90]

88

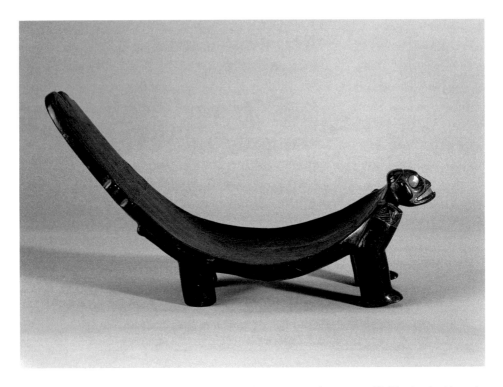

FIGURE 29 | High-backed *duho*, Taino culture, Hispaniola (Santo Domingo), 1292–1399 (?). Wood and gold/guanin (?), 44 × 16.5 × 22 cm. London, British Museum, Am1949, 22.118. Photo: Trustees of the British Museum.

Lexicographers have devoted important scholarship to the adjective *cunctus*, pointing out how it denotes a "collective numerical totality," "a characteristic totality that expresses a unitary vision, one which is the result of all its parts ... not an indistinct totality, but the plurality of its constitutive parts."[91] It seems that Anghiera used *cuncti homines* in this particular sense. While *omnes homines* would have been translated as "every human being," *cuncti homines* translates as "all the human beings with altogether no exception."

This universal outreach of the term seems to have been already explored by the earlier generation of humanists. If some, such as Francesco Patrizi (1413–1492), still used *omnes homines*, others including Ficino recurred to *cuncti* as a way to envision the "reunification of the humanity as a whole."[92] Anghiera takes this definition as evidence of humanity as *cuncta* (conjunct), based on a philosophical meditation on the contemporary artistic gesture evinced from the New World artifacts and sensibility. If Pico had already declared that *humanitas* could only be defined philosophically and not philologically, Anghiera saw precisely how the contemporary artifacts coming from and even appreciated by the inhabitants of the new worlds pointed to a universal, conjunct humanity.[93] We are at a place that is opposite to an exotic vision of the other.

## Acuity Everywhere: An Artifact-Based, Oceanic Humanism

Historiography has often been content to highlight two aspects of the relationship between Pietro Martire, humanism, and the New World: the continuous presence in his texts on the New World of "a vast range of classical authors" and the reading of the New World through the "paganizing humanism" he learned from Leto's circle.[94] The literary elaboration that Anghiera made of the *novus orbis*'s reality via the myth of the Golden Age has been considered paradigmatic of a mechanism supposedly shared by entire generations: that of "antiquing" the New World and projecting authors, themes, and verses onto a new space.[95] The oxymoron that gives the title to this book, *A New Antiquity*, points toward a different conceptual and methodological direction. As seen in the first chapter with Holanda, the concept of antiquity was not projected onto the New World. Instead it was deeply renovated by the antipodes, becoming synonymous with a timeless and universal potential for artistic excellence—something probably closer to our concept of the classic. With Anghiera, we followed another specific metamorphosis of antiquity. The encounter between humanism (its methods, authors, themes, language, and so on) and the novelty of the antipodean artifacts produced, through ekphrastic engagement, the unprecedented universalization of humanity that former generations of humanists, especially Pico and Ficino, sought but lacked the material proof to sustain. Pico died in 1494; Ficino in 1499. These were exactly the years when Anghiera's reflections on the artistic humanity of the antipodes gradually developed a philosophical dimension that continued to evolve until he passed away in 1526.

The connection between humanism and the new worlds through the artifacts did not end, therefore, in the antiquing or paganization of the New World in a Golden Age key nor in a celebration of the supposed humanistic ideal of unbounded human potential during the exploration and subordination of a sphere unknown by the ancients—the thesis of José Maravall.[96] Instead of going after a specific quotation of a classical author in a text on the New World, what we have explored in this chapter is the completely new vision of humanity that Anghiera distilled through a dialogue between his solid formation in the *studia humanitatis*, his labor as *maestro*, and his inspection and description of the art objects coming from a previously unknown part of the world. This encounter gave shape to Anghiera's very specific form of humanism. Its originality has not yet found a place in the history of humanism since this history has been mostly written from the supposed antithesis between two vantage points: from one side, Garin's grandiose philosophical and heavily criticized concept of "the humanistic discovery of man" (based on authors such as Pico and Ficino) and, from the other, Paul Kristeller's philological and historical focus on the disciplinary structure of the *studia humanitatis*.[97] Considered irreconcilable, these two approaches have marked the field, especially in the United States.

Although Garin already highlighted the importance of humanism's pedagogy, Anthony Grafton and Lisa Jardine have further argued that fifteenth- and sixteenth-century humanism was an "educational movement" that deserves particular attention to what they call "taught humanism."[98] Based principally on command of the lexicon—the etymological, syntactical, and rhetorical analysis of classical texts—this "dense accumulation of technical material," they contend, would have been hard to convert "into quintessential humanity," even for a charismatic teacher of the fifteenth century.[99] The binomial model—Kristeller's focus on the practice of learning or the philosophical humanism identified by Garin—still largely prevails today.[100]

Anghiera's observation and ekphrasis of the artifacts made by a previously unknown humanity complicate the opposition between "taught humanism" and "philosophical humanism" precisely because he combined them. It is probably in this combination, achieved through a specific—yet also theoretical— ekphrasis of the artifacts, that the universalization of the human-as-artist took place. On one side, his arsenal of classical authors with their vocabulary and the themes that recur in his letters find an echo in the description of the objects coming "from the antipodes." On the other, precisely when he sits down to describe those objects, those terms and themes gain a true universal projection, achieving what perhaps no humanist had done before. If universality had been a more conceptual condition of humanity in authors such as Patrizi, Ficino, and Pico della Mirandola, and if Anghiera himself had strived to define what makes us human in several of his "pre-Columbian" letters (in particular, one written in 1490), then the arts of the antipodes provided a completely new basis for his reflection.[101] After a somewhat abstract "intentional reinvention of the human" by the previous generation of humanists, Anghiera based his affirmation less on an intellectual intention than on a close observation and description of the excellence of concrete human-made art works.[102] It is what I have called "artifact-based humanism."

# An Indestructible "Indian" Universe of Artists

## Thinking with Hands

*They cannot be made and not even imagined without
foremost and admirable wit and judgment.*
—Bartolomé de las Casas, *Apologética historia sumaria*
(ca. 1555)

After almost three decades of observing and describing the astonishing artifacts arriving, mostly looted, from a variety of places across the ocean, Anghiera condensed in a short sentence a philosophical realization that transcended his personal experience: "There are most insightful creators everywhere."[1] As seen in the second chapter, the variety of jewelry, textiles, masks, temples, houses, books, sculptures, and furniture that had been set, interwoven, embroidered, constructed, painted, and carved, with admirable artistry (*mira arte*), demonstrated the excellence of what Anghiera called "creators" (*opifices*) and even "Indian artificers" (*artifici indi*). Instilling classical and medieval Latin vocabulary with contemporaneity—as in *Indi*, a term that starts denoting novelty, not mistaken geography—he presented the inhabitants *de orbe novo*, of the new orb, as most refined inventors.[2]

Readers understood. Recall the marginal note an Italian reader had laconically handwritten next to Anghiera's description of the traditional houses in Hispaniola: "Architectura de Indiani" (Architecture of the Indians) (fig. 30). Built with tree trunks, wood, reeds, leaves, ropes, canvas, and roots, the constructions created beautiful compounds of twenty to thirty houses with perfectly waterproof roofs set at acute angles. Was the reader thinking of the so-called Vitruvian triad—strength, utility, and beauty—when synthesizing Anghiera's text?[3] One can only guess. In any case, the marginalia fully identified those buildings as Architecture—with a capital *A*.[4] As for "Indian," when the gloss was written, those architectural principles had already been learned by colonizers, who circulated them. In 1514, arriving in Santo Domingo, Gonzalo Fernández de Oviedo y Valdés saw how the *casas pajizas* (straw houses) were built with pre-Hispanic know-how for the rapidly growing colony of Spaniards. He brought that knowledge to Santa Maria de la Antigua (present-day Colombia), where he had been appointed ward of the gold mines. In the autograph manuscript of his *Natural y general historia de las Indias*, he relates how, upon his arrival in the Darién, he built with his hands a *casa pajiza*, putting into practice what he had learned in Hispaniola.[5] Oviedo made two fine drawings showing how well he could interweave wood, straw, and reeds (although he confesses that he secured the structure with some iron nails) (fig. 31). It was a costly project, worth more than 1,500 pesos of gold. But the building was so spacious that he could have hosted a prince (*pudiera apossentar a un principe*).

Oviedo's pages were written and illustrated by one of the most ruthless actors of the colonization of the Americas, and the Darién colony stands among the darkest moments of the Spanish conquest. In Anghiera's own words, Spaniards' thirst for gold caused there "all terrible things, nothing pleasant" (*horrida omnia, suavia nulla*).[6] Oviedo's pages, nonetheless, are also a testimony of the dynamics of creation—encompassing observation, description, practice, and transformation—that run parallel to the upheaval and destruction brought with colonial expansion. Oviedo himself embodies these contradictory dimensions. The same man waging war and trading slaves in the New World had extensively traveled to Italy at the service of the Sforza, the Este, the Borja, and Federico de Aragón. He had personally met Leonardo da Vinci and Mantegna, admired *The Last Supper* in Milan, the Camera degli Sposi in Mantova, the paintings of Fra Angelico and Pinturicchio in Rome, and much more in Pavia, Ferrara, Bologna, and Naples. He seems to have also stayed the entire year of 1502 at Palermo.[7] This traditional visual training—comparable to what is expected today from an art history student—explains, in part, why his celebratory pages on the arts of the New World are often accompanied with classical references, Vitruvius included.[8] But Oviedo is also intrigued by totally new artistries. He describes everything, from sculpture to goldsmithing, body painting to architecture, and even performing arts.[9] For instance, he devotes a long passage to the *voladores* of Teçoteaga (Nicaragua), the acrobatic men "flying" around a tree trunk,

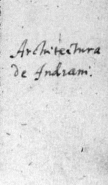

dell'Ifola Spagnuola che haueuano feco. Cercando la Ifola tro
uorono molte ville & borghi di xx et xxx cafe l'uno, lequali
erano tutte edificate per ordine attorno à vna piazza tonda, le
cafe come dicono tutte erano di legno fabricate in tondo in
quefto modo. Prima ficcano in terra tanti arbori altiffimi che
fanno la circunferentia della çafa, dapoi mettono datorno alcuni
traui corti accoftati à quefti lunghi per puntello accioche nõ cafchi
no,& il coperto fanno in forma di padigliõe da cãpo, in modo che
tutte quefte hanno il tetto acuto, dapoi cuopron quefti legni di
foglie di pa'me ,& di certe altre fimili foglie, che fono ficuriffi
me per l'acqua. ma dentro fra traue & traue tirate corde di co
tone, o di alcune radici, che fimigliano fparto vi pongon fu tele
fatte di cotone. Hanno alcune fue lettiere che ftanno in aere.

B ii

FIGURE 30 | Marginalia "Architectura de Indiani," in Anghiera, *De orbe novo*, "Libro primo della historia" (Venice: [Stefano Nicolini da Sabbio], 1534), fol. 6r. © Ghent University.

attached from the waist. Their dance and the beautiful bird masks and feather costumes they wear, he adds, would impress anyone in Spain, France, Italy, Germany, and in "any parts of the world."[10]

A pressing question seems unavoidable: how do we deal today, as readers, scholars, and people, with these decidedly opposite realities—bloody conquest and aesthetic awakening? Certainly not by trying to "reconcile" them, much less by silencing the horrors of the colonization in favor of a hedonistic vision of encounter. Those pages were indeed written and illustrated by a ruthless conquistador *during* the very process of conquest.

Let us return to Anghiera's statement: "There are most insightful creators everywhere." By adding "everywhere" (*ubique*), the short sentence made another important point. The ubiquity and wide provenance of the artifacts observed in Spain by Anghiera—from dozens of islands in the greater Caribbean archipelago and distant regions of continental America—revealed the vastness of a new artistic territory and the common thread of all humanity (*cuncti homines*). The extensive artistic territory became visible to the Europeans while the unforgivable process of conquest and colonization advanced. In view of Oviedo's example, Anghiera's sentence could, in fact, be read as, "There are most insightful creators *anywhere* the Spanish crown is advancing and conquering." The paradox is striking: at the same time that deterritorialization, war, forced labor, enslavement, Christianization—and, soon, Inquisitorial activity—destroyed the majority of the political and social relationships established prior to the arrival of the Europeans and upended the lives of millions, artistic refinement inexorably surfaced as inherent to the people gradually colonized. In that disturbing simultaneity, however, there is also a theoretically generative line of inquiry.

esta fixa la casa toda. o caney. y por que
mejor se entienda esto, pongo aqui la
manera o figura del caney. como baste
a ser entendido. y otras casas o buhios
haze assi mismo, los indios y con los
mesmos materiales, pero son de otra
facion y mejores en la vista, y de mas
aposento para ombres mas prin
cipales y caçiques hecha sados agua e,
y luengas como las de los xpianos. y de posses y paredes
de cañas y madera como esta dho. estas cañas son maciças y
mas gruessas q las de castilla, y mas altas, pero cortanlas a la
medida del altura de las paredes q quiere hazer. y derechos
en la mitad van sus gorcones q de ca tamaños hay tin a lep
q llegan a la cumbrera y canaletes alto. y en las principales ha
zen unos por tales q sirve de caguan o rresçibimiento. y cu
biertas de paja: de la manera q yo he visto en flandes cubier
tas las casas de los villajes o aldeas: y solo uno es mejor q lo
otro y mejor puesto, creo q la ventaja tiene el sobrir otras
indias a mi ver, por q la paja o yerva de dca pa esto es mu
cho mejor q la paja de flandes. y los xpianos hazen ya estas
casas en la tierra firme con sobrados y quartos altos y venta
nas, por q como tiene clavazon y haze muy buenas tablas
y lo saben mejor edificar q los indios, hazen algunas casas de
a q tan buenas q qual quier señor se podria aposentar en
algunas dellas. y yo hize una casa en la cibdad de sa maria
el antigua del darien, q no thenia sino madera y cañas y pa
ja, y alguna clavazon: y me costo mas de mill y quinientos pe
sos de buen oro: en la qual se pudiera aposentar un principe, con
buenos aposentos, altos y baxos, y con un hermoso huerto de
muchos naranjos y otros arboles, sobre la rribera de un gentil
rio q passa por aq lla cibdad: la qual se ha en desdicha dello de
3 nos della y en desserviçio de dios, y de sus magestades y en
daño de muchos particulares, de hecho se despoblo, por la maliçia
de quien fue causa dello. Así de una destas dos maneras q he dho

FIGURE 31 | Gonzalo Fernández de Oviedo y Valdés, *Natural y general historia de las Indias*, 1535. San Marino, Huntington Library, MS HEM-HM 177, fols. 3v and 4r. © Huntington Library.

son las Casas o buhios o Eracras desta ysla ¬ de otras yslas q las
indios hazen en pueblos y Communidades ¬ y tanbie en caserias de
partadas enel Campo: y tanbie de otras diferencias de maneras
Como se dira En la segunda p<sup>te</sup> desta natural y g<sup>n</sup>al hystoria/quando
se tracte delas Cosas dela t<sup>rr</sup>a firme. Por q alla en algunas pro
uincias son de otra forma: y aun algunas dellas nunca oydas ni vis
tas ni en ngl<sup>a</sup> t<sup>rr</sup>a. Pero pues se deuuxo la for<sup>ma</sup> dell Caney, o
Casa Redonda quiero assi mismo poner aqui la segunda manera de
Casas que he dho: la qual es Como aq<sup>i</sup> esta q esta aqui patente pa que

right margin: ¶ otra man<sup>a</sup> de Casa

mejor se entienda lo que
en la vna y en la otra
tengo dho. y puedesse
thener por cierto que
los dos otros buhios p<sup>ri</sup>
meros, la cubierta
de paja, si es buena
y bien puesta q son
de menos goteras q
las Casas de teja en es
paña: pero passado
El tpo que dyxo ya

la paja va pudriendose ¬ es necessario ¬ Renouar la cu
bierta ¬ avn tanbie los estantes o postes ecepto si son de
algunas maderas delas q ay en estas partes q no se pu
dren debaxo de trra assi como la cor baña en esta ysla. y el
guayacan medise q en la prouincia de ven<sup>a</sup>cula haze estantes. Mas casas
con ello ¬ q no se pudre. por mucho tpo. y en la trra firme ay otra ma
dera q la llaman los xpianos/madera prieta/y tampoco no se pudre de
baxo dela trra. pero por q En otras partes se ha de tractar delas ma
deras/y se specificara mas las calidades dellas/no ay necessidad de
dezir aqui mas delo q toca destos edeficios o maneras de casas:.

¶ Cap. y. dl Juego del Batey/dlos indios/q es el mismo q el dla
pelota. avn q se Juega de otra manera Como aqui se dira. y
la pelota es de otra especie/o Materia: q las pelotas que
entre los xpianos se vsan:.

¶ Pues en el Cap. dsuso se dixo dla forma delos pueblos ¬ delos Casas
delos yndios. y q en Cada pueblo auia lugar diputado en las plaças

right margin: 60 / ¶ maderas q no se pudren debaxo de trra

We have seen in the previous chapter how Anghiera's philosophical realizations were difficult to grasp from within the gears of the early modern hegemonic process because the sophistication of the artistic pieces he praised and the perceptivity of his reflections complicate both colonialist and decolonial discourses. Recall how, throughout the *Decades*, he juxtaposed and separated human sacrifice and artistic refinement as two different, antithetical domains. The latter could not be used as an alibi to conquer without mercy—as the former was. But think also of how Anghiera brought together news from the West with that from the East. He commented on the buildings of Hispaniola in tandem with those of Calicut, not to imply an exotic, non-Western similarity between them nor a historical connection but to explicitly declare that their artistic customs are "like ours" (*nostro more*). That declaration, in turn, did not point to a de facto resemblance. Far from isolating particular alterities or highlighting shared particularities, Anghiera stated the potential that "all human beings with no exception" (*cuncti homines*) are equipped with: *ingenium, argutia,* and *industria*—wit, insightfulness, and laboriousness—as well as eagerness and enticement for artistic novelty.

On a spherical scale, humanity became recognizable by that common denominator: a potential for artistic refinement and creative exploration. This claimed universality was certainly inspired by classical and Judeo-Christian referents—from Plato to the Bible—and by their humanist, in particular Neoplatonic, elaborations. But Anghiera's claim of universal artistry and sensibility is not assimilable to a hegemonic universalizing strategy—what Wallerstein calls "European Universalism" and its impulse to turn the world into a Europeanized one—nor to a one-way projection of static humanistic ideals.[11] Inscribed in the singular materiality of the pieces, of the architecture, in their astonishing and sophisticated technes, art came to reveal the ubiquity of human wit. As for Oviedo, in spite of his numerous aesthetic observations and in spite of embracing and propagating some artistic know-hows along the emerging, bloodstained territory of Spanish colonialism, his reflections did not go in Anghiera's direction. Oviedo did not infer any constructive argument related to New World creators.

Las Casas is the author who developed Anghiera's radical, philosophical realizations—connecting material expressions to people's intellectual virtues and advancing the ubiquity of artistic refinement. Las Casas went further and envisioned a systematic, artifact-based demonstration of the humanity of the populations of the New World.

## Las Casas's Artistic Humanity

Bartolomé de las Casas (1484–1566) was nine years old when he saw the captives brought by Columbus from the Antilles to Seville. It was March 31, 1493. He later recalled, with

extreme precision, that they were posing "near the arch that is called 'of the images,' in Saint Nicolás."[12] The child knew well those streets, as his father's bakery (where he was probably lending a hand at the time) was an eight-minute walk away.[13]

Named after the Christian images that decorated it, the Arco de las Imágenes was the memento of a territorial boundary; in fact, it covered a passage through the wall of the former Judería, where the Jewish community had lived.[14] During the massacre of Jews in 1391, its door, which opened to the main religious and economic axis of the Judería, had been burned.[15] The neighborhood had then undergone a rapid transformation, being repopulated not only by conversos but also by functionaries of the Crown, including Inquisition officials. The images painted on the arch probably signaled that "conversion." It is therefore not surprising that the Hispaniola captives were walked there, in a part of the city that embodied a history of conflict—recently reinforced by the 1492 edict of expulsion of the Jews.

The "Indians" paraded with the high-rank ornaments that, in the islands, were distinctive of their caciques. If Anghiera, who eventually saw them at the royal court in Barcelona, did not describe those first artifacts in detail, Las Casas meticulously records the vivid impression they made on him, especially the "*guayças*, which were some masks made with beads of fish bones, like pearls [*aljófar*], and some belts made in the same way, with admirable artistry."[16] It is perhaps just a coincidence, but Las Casas affirms in a completely unrelated passage of the *Apologética historia sumaria* that from the age of nine a child is able to transform the sensible modality predominant in infancy and early childhood into rational judgment.[17] Was this what happened when, as a boy, he understood, at that precise moment in Seville, the significance of the admirable artistry that those people displayed on their captive bodies? Was that early aesthetic experience of a nine-year-old Bartolomé what gradually matured into something completely unpredictable? As a grown-up, Las Casas kept looking back to that day. The ekphrasis of what impressed him—those masks and belts—shares with Anghiera the use of precise rhetorical locutions that he seems to translate almost to the letter from Latin to Spanish. "Por artificio admirable" (with admirable artistry), for instance, comes directly from the locution *mira arte*, discussed in depth in the previous chapter. But beyond lexical commonalities, Las Casas shares with, and, in part, inherits from, Anghiera the realization of what is at stake in the observation of these art pieces. In his seventies, Las Casas made that realization fundamental to one of his major works.

Most probably in the aftermath of the famous Valladolid Debate of 1551, Las Casas completed, in Spanish, his monumental *Apologética historia*, an "apologetic history" of the inhabitants of what he calls the "Indian orb" (*orbe indiano*) or "Indian universe" (*universo indiano*).[18] During the debate, Las Casas had presented a text known today as *Apologia*, a thorough response to Ginés de Sepúlveda's infamous *Democrates alter*. After having

argued for the Spanish Crown's right to wage war in his *Democrates primus*, Sepúlveda's second installment made the case for the violent colonization of the New World, claiming the supposed bestiality of its people.[19] Opposing Sepúlveda's exotic vision of a barbarous other, Las Casas's *Apologia* proposed the reverse argument, that "Indians" are, actually, "like us." The Dominican used the persuasive rhetoric proper of the juridical context but with a highly emotional style—interrogative modality and dubitative phrasing—recalling a preacher's sermon.[20]

Based on materials collected through the previous decades, the *Apologética histo-ria* developed these convictions into a systematic series of historical arguments on the rationality of the "Indians."[21] The astonishing variety and quality of their artifacts and monuments created over time—both pre- and postconquest—was presented as one of the most striking pieces of evidence of the inhabitants' intelligence. This argument may remind readers of Anghiera's assertions, analyzed in chapter 2. Interestingly, one of the recipients of the boldest letters written, in the early 1520s, by the Italian humanist in praise of the artistic civilization found in Mexico—Luis Hurtado de Mendoza, at the time in his early twenties—was now the president of the Consejo de Indias. It was he who, in his seventies, oversaw the debates of the junta of Valladolid where Las Casas made a case for the intellectual capacities of the "Indians," based also on their manual artistries.

Las Casas described a rich variety of art pieces, comparing them to objects and buildings from other eras and other parts of the world: from the Phoenicians to Germans, encompassing the Jews, Romans, Chaldeans, Greeks, Egyptians, Castilians, and more. By doing so, he found a unique balance between universal comparativism and singular incomparability. In particular, he showed how the "Indian universe" autonomously (namely neither via diffusion nor contact) obtained artistic results that may look similar to those achieved in different parts of the world, Europe included, but using such distinct technical processes that make the works and their authors *exceder* (excel) over any other in the world.[22] Particularly relevant are the chapters devoted to the *artífices*, the art makers working in a creative atlas extending from the Caribbean to the continental South, Central, and North Americas, from the Atlantic to the Pacific. These pages of the *Apologética* were briefly studied by Jorge Alberto Manrique (in particular the three chapters on Mexico) as exemplary of what he calls Las Casas's "basic, radical, optimism toward the nature of the Indian."[23] The chapters were labeled by Kubler as a "rudimentary history of art" and more recently interpreted by David Colmenares as ancillary to the Dominican's conversion project.[24]

Returning to the holograph manuscript kept at the Real Academia de la Historia of Madrid,[25] with Las Casas's additions, erasures, and corrections (fig. 32), I look at this pioneer piece of thought as a subjective writing process, and I analyze it in three new directions:

FIGURE 32 | Bartolomé de las Casas, *Apologética historia sumaria*, holograph manuscript, mid-sixteenth century. Madrid, Biblioteca de la Real Academia de Historia, MS 9/4809, fol. 197r. © Real Academia de la Historia, Spain.

99

1. I propose that Las Casas made of the most technical dimensions of artworks a demonstration of the intellectual, rational capacities of *all* the inhabitants of the New World. Anchoring creative subtlety to a specific, Aristotelian-based form of reason-in-action named "prudence," he multiplied his ekphrastic proofs of an "Indian universe" of artists.

2. I therefore address Las Casas's text as an extremely precise textual cartography combining micro- and macroregional observations of artistic subtlety. Charting through the "Indian universe," place by place, and taking us across distant regions with frequent changes in scale, the *Apologética* draws a map of artistic vitality spanning thousands of miles—in which each one counts.

3. Demonstrating the humanity of the inhabitants of the New World through the artistic and the artistic as an indestructible dimension of the people of the "Indian

universe," Las Casas deemed artistic potential an indestructible dimension of the human at large.

Las Casas's vision has been groundbreaking for the history of the people of the New World. But his argument for their artistic-inferred humanity must be acknowledged today as revolutionary for the history of art history as well. Mobilizing material refinement as intellectual evidence and demonstrating the plural artistic refinements mastered by the artists of the New World, the Dominican contributed to a contemporary debate in the sixteenth century: the location of the difference between the specialist knowledge inscribed in each one of the mechanical arts and the supposed superiority of the liberal arts—what Robert Williams names *metatechné*.[26] Let us recall Michelangelo's statement in Holanda's *Da pintura antiga*, discussed in chapter 1. The Italian artist declared that any great painter (that is, any artist)—Michelangelo included—had to practice and excel in the plurality of the "manual trades that are practiced throughout the entire world" (*officios manuaes que se fazem por todo o mundo*) and all "the works of humankind" (*obras humanas*). I proposed that these words were a response to the high-quality artifacts arriving in Europe from all over the world, especially from the New World. As if he was dialoguing with Michelangelo, Las Casas states in the *Apologética* that in the New World (especially in New Spain), artists practice many different arts and excel in each one of them: "The multitude and diversity of artistic trades and artmakers that exist," he writes, are impossible to describe since "not only does one artmaker know one art, but many of them know many arts as if they knew just one and each one perfectly."[27] How to explain this powerful resonance between Michelangelo's words in the *Da pintura antiga* and Las Casas's statement? Could Michelangelo and Las Casas have encountered each other, albeit indirectly?

Before delving into the handwritten folios of chapters 61 to 64 of the *Apologética*, it is necessary to account for some key moments in the life of a "traveler through two worlds," as Isacio Pérez Fernández calls him, or a restless vagabond, in the words of Toribio de Motolinía.[28] This biographical excursus will prove indispensable to fully understand the *Apologética*'s argument on an artistic humanity. It will also allow us to cross paths with both Anghiera (1457–1526) and Holanda (1517–1584). Las Casas met Anghiera in Spain in 1518 and likely Holanda in Portugal in 1547. This chapter studies the specific philosophical ideas that interlace the three of them.

## Traveling Through the Worlds

Shortly after his life-changing impressions of 1493, the young Las Casas saw his father, the bread merchant Pedro de las Casas de Peñalosa, depart for Hispaniola on Columbus's

second voyage. Bartolomé probably remained in charge of the Sevillian bakery with his mother and sisters. Some of the *bizcochos* and other dry treats traveling by quintals on the oceanic fleets may have been twice-cooked in their ovens. Pedro returned home from Hispaniola six years later, on a ship carrying three hundred Spaniards, each with one enslaved captive. He brought one to his own home.[29] Juanico, as he was apparently baptized, probably served as page to Bartolomé, who, at the time, was fifteen years old and studied canon law at the university of Salamanca.[30] We do not know much about Juanico's treatment by Las Casas or what the teenager thought about owning an enslaved individual. It took Las Casas several decades to articulate what perhaps he had already intuited in Seville, where hundreds of enslaved people from the islands were arriving in those years, and it took him even longer to understand that African slavery was inhumane. Juanico returned to Hispaniola in 1499, and Las Casas writes that he met him again there, in 1502, when he arrived with Nicolás de Ovando's expedition.[31] On the island, Las Casas started the factotum life of a Spaniard in search of wealth. He first worked in the mines of the Río Haina and the Cibao, participated in the wars of Xaraguá and Higüey, received an encomienda and then some land to cultivate, and finally funded a hacienda in Janique.[32] The portrait he gives of Hispaniola in these early years is one of desolation. Enslaved Indians were dying in the mines, along with Spaniards. He offers precise numbers: in 1502, of the 2,500 passengers that arrived with him to the island, lured by the attraction of gold, 1,000 died and many others fell ill.[33]

Las Casas affirms that in 1507, he went to Rome.[34] He was probably ordained priest by the pope, on March 31, and accompanied Bartolomé Columbus (Christopher Columbus's brother) to meet with Julius II. Las Casas witnessed the Lupercalia, a pre-Christian festival at that time still celebrated in the Eternal City, with pagan notes that recall Leto's approach discussed in chapter 2. But what else did he see in the city of Michelangelo? In another passage of the *Apologética*, Las Casas celebrates Italy's artistic richness in a testimonial tone. Did the two Spanish travelers visit Bramante's Tempietto, a project funded by the Catholic Kings on the tenth anniversary of Columbus's departure? Whom did they meet in person? Anghiera's "First Decade" was largely available at the time.[35] Did the two Bartolomés offer the Roman entourage firsthand accounts of the *novus orbis*? When Michelangelo eventually painted *The Creation of Adam*, did he think of the new humanity narrated in Anghiera's texts and perhaps by Las Casas and his fellow traveler, viva voce? We do not have any evidence to pursue these questions further, but asking them is useful. It reminds us what it could have meant to be contemporary in 1507.

The Roman journey must have made Las Casas aware of the polarization of his world—where sumptuous Rome and distressed Hispaniola joined. When he returned to Santo Domingo, he started celebrating Mass, while still working in the mines and managing the encomienda and land he owned. The event that catalyzed his own "conversion"

seems to have been Antonio de Montesino's famous sermon of December 21, 1511. Las Casas did not hear it in person. But based on a written version that he probably consulted later in life, he eventually staged the sermon as a two-hundred-word lightning talk in his other major work, the *Historia de las Indias*, including the passages: "I who am the voice of Christ in the desert of this island . . . you must hear it with your heart and all your senses . . . you are all in mortal sin for the cruelty and tyranny you use with these innocent people . . . aren't they human beings? . . . in the state you are, you cannot be saved."[36] After Montesino's sermon, the Spaniards, writes Las Casas, were left "astonished, many even left unconscious, others unrepentant, and others somewhat contrite, but none, to what I later understood, converted."[37] Perhaps the only one converted to Montesino's *doctrina nueva* was he. In 1512, the Burgos Laws started curbing the institution of encomienda, and in August 1514, Las Casas publicly renounced his. The following year, he traveled with Montesino to Spain to denounce the grievances in the islands and negotiate precise remedies (*memorial de los agravios, de los remedios y de las denuncias*). As is well known, among the "remedies," Las Casas proposed to bring enslaved Africans from Castile, a statement that he later profoundly regretted.[38]

In 1517, he sailed back to Hispaniola with the new title of "procurator and universal protector of all the Indians of the Indies," but after a few months, he returned to Spain, where he stayed until 1520.[39] His goal was to regulate the colonization process and, in particular, to persuade the Crown to send to the Indies Spanish *labradores*: experienced farmers who were assigned by the Crown land to cultivate and who were required to instruct the local population without exploiting them. Las Casas presented his program to the Consejo de Castilla in Zaragoza, in summer 1518. In that same session, Anghiera appeared in person to negotiate becoming a member of the nascent Consejo de Indias. We do not know if the two men had previously been acquainted, but the meeting in 1518 had an impact.[40] Las Casas recalls the episode three times in the *Historia de las Indias*, saying repeatedly, "I was present and I saw him."[41] In that year, Las Casas also personally met in Valladolid with Magellan, who was carrying "a globe that showed the whole world."[42] It was also in Valladolid that, in spring 1520, he saw the artifacts sent by Cortés from Mexico. He later described them in detail in the *Historia de las Indias*. Echoing Anghiera's text that was discussed in the previous chapter, Las Casas writes that their real value was not the gold but the artistry: "Solo la hechura y hermosura suya se pudiera vender muy cara" (Just their making and beauty could be sold very high).[43]

In 1520, Las Casas returned to the Indies, where he stayed for twenty years, moving across the islands and the continent, with different titles. In 1522, he took the Dominican order in Santo Domingo, and in 1526, he founded the convent of Puerto Plata, personally overseeing its construction. He decided to incorporate ruins from the first villa constructed in 1493, in particular leaving a stone, which he calls "an antiquity," apparent in an

external corner of the church. Meditating on history while at that convent, he started to write the *Historia de las Indias* there. In Santo Domingo, in 1533, he saw Hernando Pizarro passing through Hispaniola on his trip from Peru to Spain, with the ransom extorted from Atahualpa—thousands of astonishing art pieces.[44] That same year, Las Casas left for Peru with friar Tomás de Berlanga, bishop of Panama, who had been appointed to recount the treasures of the Incas looted by Francisco Pizarro. But the boat on which Las Casas traveled remained stuck in the ocean. After two months on the sea, he landed in Nicaragua, where he stayed until 1535. He then traveled to Guatemala and Mexico, where he met Bishop Juan de Zumárraga and participated in active debates about conversion. These debates resulted, as we will see shortly, in the papal bull *Sublimis Deus* in 1537. They may have also impacted a series of lectures delivered in Spain by the Dominican Francisco de Vitoria in Salamanca, which, in turn, informed Las Casas's later thought.[45] In 1539, Las Casas traveled again to Mexico City, Tlaxcala, and Oaxaca. In 1540, he sailed to Spain and obtained a meeting with the emperor to discuss "the universality of that New World."[46] In 1542, he penned his most famous text, *Brevísima relación de la destrucción de las Indias*, which was published a decade later. The New Laws, restricting the encomienda system and prohibiting the enslavement of the "Indians," were promulgated in 1542. The following year, Las Casas was nominated bishop of Chiapas by Charles V. After a stop in Seville, where he intended to "free all the slaves that were there" and where he witnessed the move of Ferdinand Columbus's library, he sailed once again to the New World.[47] He arrived in Chiapas in 1545, where he stayed two years while traveling to Honduras and Guatemala. At every stop, he received art objects as presents. Las Casas also visited Mexico City, where he attended the bishop's junta called by Viceroy Antonio de Mendoza (who had been Anghiera's pupil) and gathered a parallel group to discuss Indigenous enslavement.[48] After a stay in Oaxaca, he went to Veracruz, from where he embarked in 1547 to return to Spain.

That was the eighth and last time Las Casas crossed the Atlantic. He made that final trip with Pedro de Carmona, an enslaved man of African descent whom he had met in Nombre de Dios, Panama, and three other friars.[49] After a stopover in the Azores to change ships, they arrived in Lisbon. From there, they continued by land toward Spain. The passage through Portugal was critical for his thought.

## Path Crossing in Santarém?

The Portuguese trip is recognized today as a watershed in Las Casas's life—the moment when he finally realized the horrors of the African slave trade.[50] The Dominican who, three decades before, had advised the king to send enslaved people from Spain to the

Caribbean in order to spare the lives of the Indigenous population dying in the mines now acknowledged his fatal error. It is usually thought that this subjective awakening happened in Lisbon, where Las Casas could have gathered sources and met authoritative people. The long chapters devoted to Africa in his *Historia de las Indias* extensively quote Gomes Eanes de Zurara, João de Barros, Garcia de Resende, and Fernão Lopes de Castaneda, among others. Las Casas critically used their works, however, to denounce the leading Portuguese role in the human disaster of slavery.[51]

But his Portuguese travels were not limited to Lisbon. He continued by land toward Valladolid and then Aranda de Duero. The itinerary that Las Casas must have followed passed through Portuguese towns that may have also proved relevant to his historiographic and legal inquiry. Based on Villuga's *Repertorio de todos los caminos* (1546), Pérez Fernández states, for instance, that at the end of Las Casas's first day of travel, he stopped and slept in Santarém (which constituted a "jornada").[52] If so, he was probably hosted there in the monastery of the Dominican order, also known as the Convento de Nossa Senhora da Oliveira. In Santarém, which was, until recently, the residence of the court, Las Casas should have seen several important monuments closely related to the Portuguese expansion toward Africa, Asia, and the Americas.[53] John I of Portugal had planned the conquest of Ceuta (1415) in the Royal Palace, and the sepulcher of his first governor, Pedro de Meneses—whom Las Casas refers to in the *Historia de las Indias*—was in the Augustinian Convento da Graça, along with the tomb of Pero Álvares Cabral and his wife.[54] After leading the expeditions to India and Brazil, the explorer had retired in Santarém. The sepulcher of another servant in the African campaigns, Pero Rodrigues de Portocarreiro—about whom Las Casas had previously learned in Eanes de Zurara—was in the convent of Santa Maria Marvila, along with that of Gonçalo Gil Barbosa, who had traveled to Calicut with Álvares Cabral.

A stopover in Santarém in the spring of 1547, however, could have offered more than these spectral encounters with Portuguese expansionist history. Las Casas could have met and talked with people in the flesh. The renowned Dominican's passage through town was probably awaited and welcomed by people of high rank. One of the town officers was João Homem de Holanda, who had studied canon law in Coimbra, as Bartolomé had done in Salamanca.[55] João Homem may have been particularly interested in exchanging views with his transatlantic peer. He had overseas connections, with brothers and brothers-law serving in Goa and Chaúl.[56] But João Homem had also a brother in town, a thirty-year-old named Francisco, who probably jumped on the occasion to meet Las Casas.

Our Francisco de Holanda was in Santarém in 1547, staying at the home of João Homem, in the neighborhood of Marvila, not far from the Dominican convent.[57] He was resuming, after a pause of two years, his work on the *De aetatibus mundi imagines*. In

particular, Holanda was drawing, or about to draw, the astonishing image we analyzed in the first chapter (see fig. 6). *The Creation of Lights* is precisely glossed: "He made the drawing in Santarém, in 1547"; Holanda will color it in Almeirim, in 1551. Readers recall that Holanda depicted there the New World—the one from which Las Casas was returning. It was also in this period that Holanda was writing—or about to write—his *Da pintura antiga*. The treatise comprises that bold statement on the theoretical relevance of the art pieces coming from Peru and Brazil (*vasos de ouro* and *feguras*, which he saw) for his groundbreaking definition of "ancient painting."[58] Interestingly, in the *Apologética*, Las Casas devotes celebratory passages to Peruvian *vasos de oro*, which he also saw in Santo Domingo, and he frequently employs the term *figuras* to describe figurative ornamentation in different media. Are these just coincidences, in language and ideas, between the two? Or did Las Casas and Holanda meet in Santarém, in spring 1547? Until further archival evidence is found—and being aware of the difficulty of finding such evidence—we can only speculate that they did.

A personal exchange in Santarém could have fueled their respective written and visual reflections on the universality of artistic potential. If Las Casas and Holanda had met, they could have examined some artifacts together, a common practice at the time, as we saw in chapter 2. Returning from New Spain, it is plausible that Las Casas was carrying portable art pieces in order to provide new evidence of the civility of the New World population. These could have been the presents he had received in the last year, while visiting the most recondite zones of his bishopric of Chiapas, a Maya region. If he passed through Santarém, did he show any of them to his hosts? We would like to have archival evidence comparable to the documented conversations and scrutiny of objects reported by Anghiera in Seville, with his Italian guests silently brushing their nails on the polished surface of a mosaic mask made in Mexico. We would like to be able to similarly portray Las Casas discussing with the Holanda brothers a Maya jade figurine, with Francisco commenting how it was recognizably a form of *pintura antiga*, of excellent artistry. Francisco and João Homem could have also shown some treasures to the visitor. Santarém's collections of art objects from Africa, Asia, and the Americas are yet to be researched, but it is plausible that the explorers gifted some memorabilia to their convents, in part, in order to be buried there.[59] Could Las Casas have had the chance to see and even try on a Tupi feather garment brought from Brazil by Álvarez Cabral (like those represented in the Miller Atlas; see fig. 20) and taken out of the cabinets of the Convento da Graça by the Holandas? Or could the Holandas have shown to Las Casas art pieces they had received from their brothers in Goa and Chaúl? If they had met, the Holandas could have told Las Casas of the descriptions made by João de Castro in his *Roteiro* (which Francisco knew at the time), describing the "muitos sumptuosos templos e maravilhosos edificios" of the Island of Salsete, in India.[60] These could have eventually

inspired Las Casas's descriptions of the New World temples, in the *Apologética*, which are written in the same celebratory language.[61]

But we must refrain our imagination. Let us just suggest a more likely connection in Santarém—one that may have been generative for the revolution in thought we are studying in this book. After his Portuguese stopovers, Las Casas continued his journey toward Valladolid and then Aranda de Duero. He was now better informed about the dark side of Luso-African history. His Portuguese journey, however, probably equipped him with something else, too. Had he conversed with Francisco de Holanda, Las Casas may have understood how to develop his observations of the New World's artistic humanity in a universal direction. And, reciprocally, Holanda may have understood with Las Casas what was at stake when directing light on the antipodes in his painting. The surprising echoes between Michelangelo's statements on the artistic relevance of the "works of humankind" in the *Da pintura antiga* and Las Casas's convictions about how human intelligence is revealed in artistry are worthy of further study.

## Las Casas's Universalism

On the road again, Las Casas passed through Salamanca, in spring 1547. This is when he probably became aware that Sepúlveda was trying to obtain a license to print his *Democrates alter*. Las Casas responded with a series of actions that resulted in royal *cédulas* against slavery, against *repartimiento* and forced labor in the Indies, and even, symbolically, against the term *conquest*. Yet, in 1550, Sepúlveda managed to publish in Rome his *Apologia pro libro de iustis causis*. Las Casas wrote his *Apologia*, in Spanish, today lost. Another text, in Latin, also known as the *Apologia*, is preserved. We can take the contents of these works as the arguments presented in the so-called Debate of Valladolid. As is well known, a proper live debate between the two never took place. Instead, a special junta of the Consejo de Indias, presided over by Anghiera's alumnus Luis Hurtado de Mendoza, gathered to discuss Sepúlveda's and Las Casas's ideas on the conquest. The outcome was inconclusive, as several members did not vote. But Las Casas's *Brevísima relación de la destrucción de las Indias* was published in 1552. In the aftermath of Valladolid, probably at a distance of several years, the author completed the very long text of the *Apologética Historia*.[62]

Las Casas demonstrates in the *Apologética* that the populations of the "Indian universe" were not only fully rational—hence they could not be legitimately conquered and enslaved—but also that they had been and were still capable of extraordinary achievements.[63] This demonstration runs through the 267 chapters and the epilogue of his monumental autograph manuscript. The work remained unpublished until the

twentieth century, although it circulated as manuscript copies.[64] In 1967, the Mexican historian Edmundo de O'Gorman directed a magisterial, critical edition of the Madrid holograph. Based on two previous modern editions, the Mexican historian and his group of paleographers published two volumes totaling 1,500 pages. According to O'Gorman's interpretation of the *Apologética*, the work was divided in three books: 1. Physical environment (chapters 1–22), 2. Demonstration of the rational capacity of the Indians based on the physical aspects (chapters 23–39), and 3. Demonstration of the rational capacity of the Indians based on historical developments (chapters 40–263).

Still unsurpassed today, O'Gorman's edition presents two main problems. First, it added titles to numerous chapters that had none. Although put in brackets, these titles can be misleading for readers who ignore that they are editorial additions. It is a matter of concern in particular for the section that interests us, which O'Gorman presents as a discrete text on what he calls "artisans." Las Casas, however, never employed the term *artesanos*. He did address the *artifices*, which, at the time, meant "the master of an art" (*el maestro de algún arte*), including painting and sculpture.[65] Second, also based on previous editions of the *Apologética*, O'Gorman's paleographers transcribed in the footnotes the corrections (*testaduras*) in the manuscript but in a way that makes it difficult to understand them as part of Las Casas's subjective writing process. This modern critical edition, in sum, presents an impeccable yet static textual product that, although highly readable, complicates our ability to grasp developments in its author's thoughts while writing. This is what I have tried to do by going back to the holograph manuscript. But before closely reading some pages, let us have a better look at the general structure of the work.

In spite of its mesmerizing length, the *Apologética* is an extremely well-organized text. As O'Gorman demonstrates, Las Casas constructs his purpose page by page, making systematically transparent its logic and theoretical progression. The term *prudencia* is the fundamental concept of the work.[66] Based on Aristotelian and Aquinian terminology, Las Casas defines prudence as "the good use and exercise of reason, and the virtue and intellectual habit subjected [infused in] the practical reason."[67] Around the concept of prudence, Las Casas draws three triptychs.

First, he presents the three kinds of prudence:

1. "monastic prudence," meaning self-governance;
2. "domestic prudence," which is directed to the family or household; and
3. "political prudence," concerning living in groups, villages, cities.

Second, he underlies the three acts of prudence:

1. asking advice, "which means to inquire, search, and reason or think";

2. judging "the things that one finds by inquiring and searching"; and
3. governing as "the application of the things inquired about and searched, and then judged."

Third, he addresses the three aims of prudence:

1. good of the individual (*bien del hombre*);
2. good of the family (*bien de la familia*); and
3. good of the city or kingdom (*bien de la ciudad o del reino*).

The *Apologética* is organized to demonstrate the existence in the "Indian universe" of the three kinds, three acts, and three effects of prudence. Las Casas sustains his demonstration through the "natural causes" (*causas naturales*), spanning from the climate to the fertility of the land, and through the "accidental causes" (*causas accidentales*), which always imply a human choice. The existence of the kinds, acts, and aims of prudence demonstrate, especially in chapter 28, that the people of the Indian world are "bien intelectivos"—fully rational. The infinity of people (*naciones infinitas*) of the New World are presented in comparison with people of the Old World to demonstrate that "Indians" surpass them all. We have therefore a double movement. From one side, Las Casas aims to claim that the inhabitants of the "Indian universe" possess all the levels of prudence and hence they are fully rational and cannot be enslaved; from the other, "these Indians" can on their own become an *exemplum*.

His claims on the rationality and humanity of the New World's original inhabitants were undoubtedly based on the "universalist vision of a Christian community" and a Christianization drive.[68] But where Sepúlveda argues that conquest was right because of the irrationality of the "Indians," the Dominican demonstrates the opposite: their rationality made the project of conversion possible—but only if without conquest. This staple of Las Casas's thought goes back to his first work, *De unico modo vocationis* (On the only way to call all the people to the true Faith), written in the 1530s. Helen Parish proposes that Las Casas brought the manuscript to Mexico City in 1536 and that the treatise had an enormous impact on the debates on the nature of the Indians. First, on the Mexican juntas promoted by Zumárraga about issues of conversion, slavery, and conquest; then, on a manuscript sent by the bishop of Tlaxcala Julián Garcés to Rome and immediately published as *De habilitate et capacitate gentium*; and also on the famous 1537 papal bull *Sublimis Deus*, in which Pope Paul III declares that "Indians are truly men."[69] The *Apologética historia sumaria* adds to these important precedents a universalist component that can be ascribed to the impact of Francisco de Vitoria. His theoretical demonstration of the juridical principles of equality between individuals and between people was probably

known by Las Casas since the late thirties.[70] But it is believed today that he got to fully appreciate them in 1547, when he returned to Spain. Yet, Sepúlveda's infamous writings proved that the debate on the nature of the "Indians" as animal or human was not over. After the debate, in the 1550s, Las Casas develops in the *Apologética* his previous reflections in unexpected directions.

## A Cartography of Artistic Reason

As we have seen, the *Apologética* presents prudence as the exercise of reason and reason as the foremost faculty defining the human. Relying on Cicero's *De legibus*, Las Casas declares: "All the people of the world are humans; there is only one definition for all the humans and for each one of them, and this is that they are rational."[71] Reason turns into the common denominator of all humanity with no exception: of *todos los hombres— cuncti homines*, as Anghiera wrote in his *Decades*. At stake is providing the evidence for the distinct forms and exercises of reason, which Las Casas previously identified as "voluntary acts."[72]

After discussing monastic and domestic prudence, Las Casas moves to political prudence. He states, in chapter 46, that for "a city or council of people to socially live," according to Aristotle, six classes of workers are needed: farmers (*labradores*), art makers (*artífices*), soldiers (*hombres de guerra*), wealthy people (*ricos hombres*), priests (*sacerdoces*), and judges (*jueces*). Before demonstrating the presence of these six classes in the "Indian universe," Las Casas devotes a long chapter to the wild men of Italy: "There where there is so much civility [*policía*] . . . where there are so many populated, famous, and illustrious cities, and many things that are not only necessary to living, but very curious, pleasant for the senses [*deleitables a la sensualidad*], and where the arts flourished," people had also been living as savages in the past.[73]

This prepares the reader for the four long chapters devoted to art makers. Artistic refinement had already been presented in the 1530s as juridical proof of the abilities of people in the New World to receive Christianity, notably by the Tlaxcala bishop Garcés.[74] But Sepúlveda had taken that same argument as a proof of their animality—spiders and birds also make beautiful structures that are furthermore inimitable by humans, he argued.[75] Las Casas therefore picks up the argument on *ingenium*, first sketched by Anghiera as we analyzed in chapter 2, and fully develops it to reinforce the case for an art-inferred humanity. He demonstrates how art makers' *ingenium* reveals them as human in three ways: by arguing that artistic endeavor is beyond necessity and originates in an "operative act," by proving the refinement of each human artifact, and by recounting the variety of artistic processes embedded in every artifact and mastered by every artist.[76] While spiders

cannot build nests and birds cannot weave spiderwebs, for Las Casas, as already seen, "not only one art maker knows one art, but many of them know many arts as if they knew just one and each one perfectly." The development of this specific argument makes him the first and only author to produce a self-standing treatise in which the demonstration of an artistic humanity goes beyond his own Christianization agenda. In fact, there are numerous sections of the *Apologética* where artifacts and monuments are discussed as proofs of a rationality beyond necessity: constructions, jewelry, and architectural finesse are discussed by Las Casas throughout the manuscript when he describes American cities, temples, gods, and more. But chapters 61 through 65 present the argument of an artistic humanity in a distinct way, through the combination of three cartographic modes of description: geographic (large territories), chorographic (smaller regions), and odeporic (travel narration). Las Casas begins in chapter 61 with the *artífices*, the art makers of Hispaniola. From this microcosmic view on the arts of one single island, he then moves to the *tierra firme*, to the continental New World: first to the coast of Cumaná, then to the Kingdom of Venezuela and the province of Santa Marta and Cenú, next to Veragua and Honduras, and finally Yucatan. At the end of the chapter, he brings us to the Mar del Sur, the Pacific Coast of the Nuevo Reino of Granada, including Popayan and the numerous provinces inland. Chapters 62, 63, and 64 bring us north. All three chapters are devoted to New Spain, a large territory that Las Casas conceives as teeming with artistic life. Focusing on Mexico City and Tlaxcala, he again produces the impression of a chorographic narration. Chapter 65 takes us back south: we first return to Yucatan, next move to Guatemala and Nicaragua, and then visit the Kingdom of Granada, Venezuela, and Popayan via the Darién. Lastly, we travel to Peru, stopping in Cuzco. The chapter ends on the silver of Potosí.

Commenting on some key passages in Las Casas's manuscript, my transcription reflects the text in the following ways: words are stricken through when they are in the original, curly brackets indicate additions between the lines, and dashes indicate additions at the margins, introduced by a double-sided arrow (↔). I have not transcribed minor typographical errors. After each quotation, I provide the folio reference.

## Artistic Labor in Hispaniola

In the manuscript of the *Apologética*, chapter 61 lacks a title.[77] Las Casas seems to have conceived it in close relationship with the previous section, devoted to the *labradores*: the workers occupied with the "cuidado y obras de la agricultura"—the care of produce obtained through the cultivation of land and raising cattle (according to Aristotle, shepherds perform a sort of "live agriculture").[78] Readers may remember from the biographic

excursus that, several decades before, Las Casas had advised the Crown to send Spanish *labradores* to the islands in order to make the colony run full steam. In the *Apologética*, the term *labrador* is employed to refer to one of the qualities of the "Indians." In compliance with Aristotle's first principle, this proves that the Native inhabitants were self-sufficient before the arrival of the Spaniards. As further proof of their rational land working, Las Casas adds that all the species introduced from Castile are thriving thanks to the intelligence of the local *labradores*. For instance, the impeccable grafting of fruit trees yields apricots that look like cantaloupes. Las Casas had not seen this when he had proposed to bring Spanish *labradores*.

The *artífices*, the art makers, are introduced as a peculiar kind of *labradores*: they transform what is available in nature into instruments of high precision to manufacture the most refined artifacts. Las Casas stages the encounter with this sophisticated state of high-precision technology as transformative (see fig. 32):

> The people of this island of Española and also those of the neighboring islands were, in the opinion of our Spaniards, judged as very simple and less able to use good judgment and this was wrong, a grievous blindness as we will say below: it is true that when we came to this island, we saw things made with their hands, without having any other tool or instrument than a stone or a bone {or the tooth} of a rabbit that we have said is called *hutia*; in Spain this would be considered a subtle artifice. These works were some necklaces of fish bones, whose making was comparable to those of gold the golden necklaces that were worn by the ancient lords of Castile. These were made of white bone studs, each one two inches long and as large as the pin of a pendula or of a quill with which we write. (fol. 197)

With the juxtaposition between two discrete artifacts—marine and golden necklaces—Las Casas immediately short circuits any evolutionary explanation and avoids any predictable conclusion. Made with the simplest tools and the most common materials, New World jewelry was recognizably a *sotil artificio* (a subtle artifice), not only for him but for those who used to stare at the finesse of the goldwork worn by the Castilian nobility in Spain. The glimpses of New World art demonstrate that what becomes comparable in pieces that are set apart—not only by form, material, or technique but also by time and space—is the perfection of their radically different making. Juxtaposition, contrast, and singularity, in fact, reveal equality. Probably after rereading the passage, Las Casas added an important remark. Right after noting the precise length and width of each bone stud, he wrote in the margins: ↔ estaban labrados como con un sinzel (they were carved as with a chisel).

What did Las Casas compare to the fine, pointed, and sharp metal tool used with a hammer by European goldsmiths?[79] The tooth of a *hutia*, as he specified, namely the *Plagiodoantia aedium*—probably the lower incisor of a native rodent, whose oblique shape may have provided good angles for carving and chasing.[80] These completely different instruments enabled the art makers of Hispaniola to create exquisite objects on a variety of media, including shell and fish vertebrae (fig. 33). Such artifacts, says Las Casas, become fully appreciable only when letting go of preconceptions. It is not because the art makers used basic instruments found in nature that they and their objects stood in an inferior position compared to the Iron Age of Spanish jewelry. On the contrary, it is precisely the intelligent use of the simplest tools—stones, bones, animals' teeth—that demonstrate their makers' wit, judgment, and highest artistic refinement.[81] A unique connection between hand and thought is theorized, which opens up the possibility to see art making in itself not as a mechanical repetition of gesture and knowledge, but as a purposeful, rational process of creating forms, symbolism, and beauty—a real "will to art," as theorized by art historians several centuries later.[82]

Las Casas then continues (see fig. 32):

> First the collar had sixty or seventy of these next set one on to the other and interwoven with cotton thread, and at the ends there were laces to tie the collars behind the neck when they wore them, they were very fine; in the middle of the part that was worn on the chest there was—↔ like a jewel—a human face as little as that of a little small cat; this was a real marvel, as it was entirely made of stones, set in the same way that pearls are set in the miter of bishops. To look at this was a marvel: as all it was all made of {very fine} stonework as the *aljofar* {set} in the miters of the bishops. All this stonework was made of nothing else than fish bones—↔ made as tiny beads—that from afar looked like pearls; they interposed some small colorful beads {in order to look like textiles [*porque pareciesen labores*]}. They dyed them or they found them like this in the fish. (fol. 197)

Here Las Casas further places Hispaniola marine jewelry in a position of comparability and equality with the arts of the goldsmith: the central piece of a necklace lays on the chest as a jewel and the multicolored minute beads, supposedly made of fish bone, are alternated in such a way that they look like textile work.[83] Let us clarify that the comparison reported by Las Casas is not his own (as when he compared tooth/bone carving to chisel work). The illusionistic textile effect was sought after by the Native art makers (*porque pareciesen labores*).

No evidence of multicolored fish-bone beads has been found in artifacts made in the Caribbean prior to the arrival of the Spaniards.[84] How to explain this incongruence?

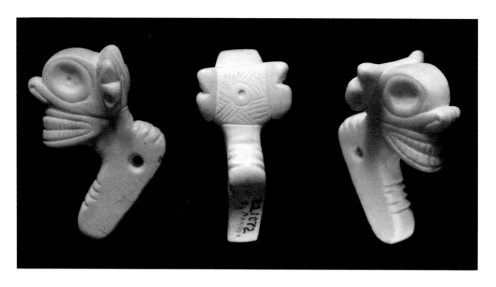

FIGURE 33 | Pendant, Taino culture, Hispaniola, eleventh to sixteenth century. Conch shell (*Aliger Gigas*), 4.7 × 3.9 × 2.3 cm. Washington, DC, Smithsonian Institution, Department of Anthropology, A221071. Photo: Joanna Ostapkowicz.

Can we simply tag the information as erroneous? There might be a more complex explanation. Writing decades après coup, Las Casas probably combined several impressions. On the one hand, there is his early encounter as a boy walking in the streets of Seville in 1493, with the parures worn by the captives. These were probably made with shell beads whose labored shine may have looked like pearls (*como aljofar*).[85] On the other hand, we have his later observations, in Hispaniola, of intricate artifacts that were indeed made with the bones of a "fish," the manatee (fig. 34). Although the Caribbean *Trichechus* is, in fact, a mammal, Las Casas calls it a *pez*, a fish, in his writings. This combinative memory reminds us that we are not reading a conservator's report. The richness of the passage encompasses different personal experiences and sheds light on the subjective dimensions at play in any ekphrasis, conveying Las Casas's multilayered aesthetic sensibility.

Later in the chapter, he describes the belts made in Hispaniola with beads and cotton. Once again, he compares them with another artistic technique, writing that the textile work has been so finely interwoven that it looks "como si estuviera pintado" (as if it were painted). Reporting that the texture of the belts was so strong that a crossbow could not pierce them, he turns to his own aesthetic experience. Referring to the presents offered by Guacanagarí to Ferdinand Columbus on December 22, 1492, which included a belt (*cinto*), the *Historia de las Indias* clearly states, "I got to see some of those" (*yo alcancé a ver alguno de ellos*).[86] Moreover, the art of belt making continued after the arrival of the Spaniards.[87] Two belts that are preserved today—one in the Museo delle Civiltà in Rome

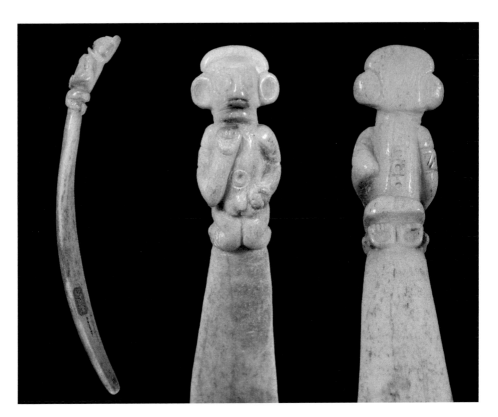

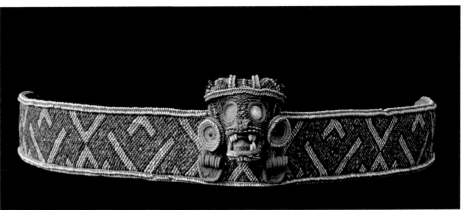

FIGURE 34 | Vomiting spatula, Taino culture, Hispaniola, eleventh to sixteenth century. Manatee (*Trichechus manatus*) bone, 24 × 2.9 × 1.8 cm. Washington, DC, Smithsonian Institution, Department of Anthropology, A221072. Photo: Joanna Ostapkowicz.

FIGURE 35 | Cotton belt, Taino culture, Hispaniola, fifteenth to sixteenth century. Indigenous shell beads, European jet, brass, glass, rhinoceros' horn, and other mirror additions, 117 × 7 cm. Vienna, Weltmuseum Wien, inv. no. 10.443. Photo: Joanna Ostapkowicz.

and the other in the Weltmuseum of Vienna—are made with shell beads and include materials brought from other continents: glass, brass, and rhinoceros horn (fig. 35). Las Casas says that Columbus brought to the Catholic Kings several belts and that they celebrated their artistry. He then abruptly juxtaposes the situation of artifacts made with gold: "Of the golden pieces that [Columbus] brought, such as crowns, I cannot say how they were made as I have not seen them, neither back then nor have I later seen other fine things that the Indians make or had made; only some golden leaves {of less artifice} for the ears of the women that they made" (fol. 197v.) Las Casas stages three temporalities of art making in gold. The first is marked by dynamic vitality: when Columbus arrived, local artists could produce elaborate shapes, including crowns that were obviously made for him—comparable to the objects created for Cortés (and even patronized by him) on the Mexican coast.[88] The second stage is marked by technical simplification and reduction in scale: when Las Casas arrived in Hispaniola in 1502, ten years after Columbus, he only saw small earrings of basic shapes. The third stage is the absence of local goldwork when he writes the *Apologética*. Need we remind ourselves of the reason why, by the 1550s, gold artifacts were no longer made? It was not because of the decline of artistic verve but because of the amount of gold that had been extracted, with deadly impact on the population, and shipped away. We know today that the exhaustion of gold deposits dates, precisely, to the 1520s.[89] In this sense, two apparently minor changes in the original manuscript are telling. Las Casas specifies "of less artifice" (*de poco artificio*) to highlight the gradual simplification of goldwork in the second stage, when the primary material had already become increasingly unavailable for art making. He also corrects the present tense with the past, to emphasize that not even small low-weight earrings were made when he was writing.

Las Casas surprisingly concludes, however, by saying "si en las cosas de arte se ejercitaran, que las hicieran muy primas" (if they [the "Indians" of Hispaniola] would practice art making, they would make excellent things). In spite of physical death, brutal extraction of natural resources, and artistic inactivity, not everything has been destroyed and dried out. The potential for artistic reason is still latent. The indestructibility of an "Indian universe" of artists provides the evidence for the profound human nature of the New World's past and present inhabitants.

## Micro to Macro

The same chapter where Las Casas looked at the past, present, and potential artistries of the island of Hispaniola—with a silent note on how ferocious extractivism had not only upended the lives of people but also impacted local creativity—rapidly zooms out to a vast

continental territory (*tierra firme*), flanked by two oceans and extending approximately two thousand miles. The inhabitants of this vast macroregion also made, and still make, admirable things beyond necessity, particularly textile and goldwork. Las Casas undertakes the demonstration of their artistic-inferred rationality (hence, humanity), moving us through a large territory that he outlines while writing. This territory comprises "from the coast of Cumaná, in which or close to where, like in the island of Cubagua, one fished pearls, where starts in which is contained the kingdom of Venezuela, and the province of Santa Marta and Cenú, until Veragua and Honduras and Yucatan, a region that is what we call of the North {inland of Veragua and Honduras until the Sea of the South, moving around through} moving around through many provinces toward the new kingdom of Granada and toward Popayan and many other provinces that exist inland." If Las Casas had had the chance to illustrate his manuscript, as we can do in this book, he could have provided pictures of golden artifacts such those made precisely in Santa Marta (Colombia) and Veragua (Panama) (figs. 36 and 37).

Las Casas progressively stretches the artistic territory and even makes the addition of the Sea of the South, that is, the Pacific Coast. This vast, continental America projects the artistic humanity demonstrated in Hispaniola onto a macroregion that Las Casas personally knew: "I have seen many pieces of gold very precious and made with excellence {and subtlety}, pieces that they had and exchanged among neighbor Indians, from the Coast of Cumaná and Venezuela and inland." Yet, even this large portion of the New World is not enough for his argument: "But in other parts of these Indies there have been and there are workers of many and almost any specialties, so many that and so excellent in their perfection, that they not equalled with their pieces and with the result of their works those that today we—↔ see—throughout the world, but they over outrun them" (fol. 198). The passage not only expands the territory and temporality of a universe of artists who have been and still were active throughout "these Indies" when Las Casas was writing. The passage also makes these art makers active players in a world-scale artistic contest. Their pieces are finer than any made elsewhere in the world, according to personal observation (*que oy vemos*). Does this not remind readers of Michelangelo's words in the *Da pintura antiga*, studied in the first chapter: "[The true] painter . . . will not only be instructed in the liberal arts and other sciences such as architecture and sculpture, which are properly his occupations, but if he has a mind to, he will undertake all the other manual trades that are practiced throughout the entire world [*officios manuaes que se fazem por todo o mundo*], with far greater art than the proper masters of them"?[90]

Surprisingly, this is exactly the idea that Las Casas developed in the following section devoted to New Spain, where local artists furtively observed, often while physically concealed (*disimuladamente como que no pretendía mirar nada*), how the Spanish art makers worked in order to surpass them. Moved by a vital subjective desire, New World

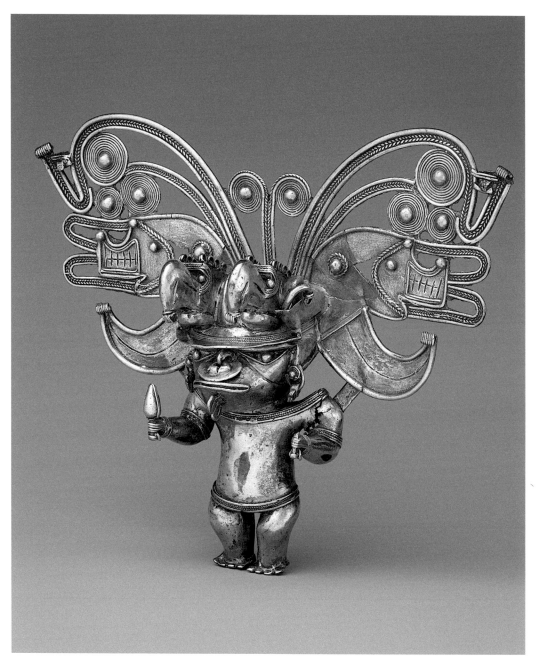

FIGURE 36 | Figure pendant, Colombia, Tairona culture (Santa Marta), tenth to sixteenth century. 13.7 × 16.8 × 5.1 cm. New York, The Metropolitan Museum of Art, 69.7.10.

FIGURE 37 | Masked figure pendant, Panama, Veraguas culture, eleventh to sixteenth century. Gold, 10.8 × 12.1 × 2.5 cm. New York, The Metropolitan Museum of Art, 1979.206.777.

self-taught art makers achieved perfection in whatever they did, bypassing the master-pupil hierarchy that art academies in Europe were inheriting from the guilds at the time. As evidence that it was not a compulsive reproduction, Las Casas notes that New World silversmiths in New Spain could only see the half of the Spanish process. When they went home, they made artifacts as and even more perfect (*tanto y más perfecto*). They could design the rest of the puzzle without a complete image of what it was supposed to become. This is certainly not copying: it is undertaking any art making "with far greater art than the proper masters of them," as Michelangelo would say.

## Artistic Effervescence in New Spain

Having guided the reader through the vast territory of Indian creativity spanning from the Caribbean to South and Central America up to Yucatan, Las Casas devotes three chapters to New Spain (fols. 198 ss.). He addresses a myriad of artistries still visible through a huge territorial extension—200 by 150 by 50 *leguas*, he specifies. This vast area echoes the impressive creative purview encompassed by every artmaker: "Not only one single maker knows with excellence and subtlety one's trade, but many of them know and perform different artistic trades as if they knew a single one, and each one perfectly." It is a nonspecialized world of artistic creativity, very far, once again, from the world of the guilds. It is a world where *metatechné*, in Williams's words, is the real artist's endeavor.

Las Casas reviews all the expressions of "Indian" creativity, connecting it with the contemporaneous world: his discussion of architecture includes the houses built for the Spaniards and the convents constructed for the friars; the tableware made with gourds is painted so nicely that it could be used by the emperor; the palm mats are so fresh that they could be hung as wall tapestries in Castile; the bed covers are so fine that they could be "put on the king's royal bed as another very fine thing." Often, these qualifications are added in the margin (↔ *como en nuestra Castilla*; ↔ *y aún el rey*, etc.) in order to provide a further argument—currency—to the main text.

After commenting on obsidian blades and mirrors and highlighting the rapidity and desire to create and learn new techniques, Las Casas then moves to painting. Here, too, he expresses a profound appreciation for the painters' willingness to include new repertoires (*las cosas pintadas que quieren hacer*). He offers precise examples of their eagerness and sensibility, as when they render episodes of the Redemption, in particular the Descent from the Cross, with "special grace" (*gracia especial*) (figs. 38 and 39). He adds that they can scale up and scale down, in perfect proportion, any image. Both these arguments—the sensitive elegance with which they paint and the geometric intelligence used to alter proportions (*como las proporcionan*)—demonstrate their "potency

of imagination" (*potencia de la imaginación*): their powerful, sensible rationality made of both emotion and calculus. Readers are then introduced to a completely novel terrain of creativity, "which without any doubt seems to exceed any human ingenuity," something that will appear to any nation of the world "newer than rare" (*más nuevo que raro*). This means that it is not just unusual but completely novel. It is feather painting. I have analyzed elsewhere the importance of this long passage.[91] Here, I want to return to its final section, which helps us to better define Las Casas's universalism—that is, when he takes a position regarding an ongoing debate, in those years, over the relationship between a biblical passage and New Spain feather art. The Vulgate translation of Exodus refers to the curtains of the tabernacle as having been made "opere plumario" (Ex. 38:18). According to some of Las Casas's contemporaries, that passage should be translated as "made with feathers." This would demonstrate that the "Indians of New Spain," making feather art, were in fact of Jewish origin. Las Casas philologically refutes this interpretation of the Bible, whose original text, he states, referred to embroidered art *representing* feathered beings —not art *made with* feathers.[92] But, most important, Las Casas refuses the imaginary connection that this wrong interpretation supported, emphasizing the absolute novelty of feather art. This total originality further proves the innate potential of its authors as universal human beings: because of their rationality, they invented themselves a unique artistic process and could do whatever they wanted with it (*otra mil maneras de cosas que se les antojaban*), including the exploration of Christian repertoires (see figs. 38 and 39). The optical results obtained by the precise positioning of the plumes and the illusionistic effect produced in spectators from all over the world are the ultimate argument for the fine intelligence of their creators.

According to Las Casas, therefore, the universality of feather painting, like the formidable Baptism of Christ today kept at the Musée du Quai Branly (fig. 40), is absolutely not that it has been diffused to the Americas from somewhere else. Rather, it is that it originates from a human potential that is universal and active in the New World—its singular development can be now admired by anyone in the world (*que a todos los del mundo puede poner en admiración*). Las Casas concludes his discussion of New Spain's artistic prowess with myriad other examples, one of which deserves special attention. He reports that, in the square of Mexico, he saw an enslaved Indigenous man with cuffs and whips that were so perfectly made that he himself praised them to the person who was at his side—"{who was his master [*que era su amo*]}," he adds between the lines (fol. 203v). He responded that the art maker was the enslaved man himself. The passage is highly disturbing and yet crucial. Las Casas put himself in the paradoxical position of praising the cuffs and whips used in the slavery system to ultimately praise the artistic finesse of the one who had been reduced to slavery. The paradox allows him to also put the master in an even more contradictory position, praising his enslaved man's finesse,

FIGURE 38 | Detail of the Crucifixion on the north wall of the Sala de Profundis, ex-convent San Juan Bautista, Tlayacapan, Morelos, Mexico, sixteenth century. Photo: Eumelia Hernández, Instituto de Investigaciones Estéticas, UNAM.

which Las Casas is advancing in the treatise as a demonstration of humanity. Therefore, the slave-as-fine-human cannot be enslaved. Once we resist the highly uncomfortable feeling produced by a hasty reading of the passage and try to grasp what Las Casas wants the reader—and the master—to deduce, we can glean a unique theoretical insight.

A comparable yet distinct theoretical complexity is embedded in the Christian festivities minutely described in chapters 63 and 64. If at first sight they demonstrate the positive outcome *of* Christianization, they also point to the unlimited creativity of an indestructible Indian world of artists that has remained alive through Christianization, conquest, and enslavement. From chanting to writing, performing to flower decorating, ephemeral theater to flute playing, anything is possible in New Spain, because the artistic potential is still active in any living and newborn human. This potential reveals itself in the artwork, and the artwork praises the nature of its maker at any level of experience and any age: "la obra alaba al maestro official o maestro"—Las Casas strikes through

FIGURE 39 | Pietá, mural painting, Augustinian convent of Epazoyucan, Hidalgo, Mexico, sixteenth century. Photo: Eumelia Hernández, Instituto de Investigaciones Estéticas, UNAM.

FIGURE 40 | Baptism of Christ and the Good Shepherd, Mexico, sixteenth century. Feather mosaic, 20.4 × 30.2 cm. Paris, Musée du Quai Branly.

"master," placing "worker" in front of "master"). The very young age of the artists (*officiales*) is often highlighted as particularly meaningful, as in the following chapter devoted to Peru.

## Striking Techne in Peru

The artistic territory reported by Las Casas—encompassing Hispaniola, circling down through the northern part of South and Central America up to the Pacific Coast, and then extending up to Yucatan and New Spain—was the one that Anghiera might have meant when writing that "there are most insightful creators everywhere." But when the Italian humanist passed away in 1526, he had not known about Peru. In the final chapter of the section devoted to art makers in the *Apologética*, Las Casas takes us there. As mentioned earlier, he never actually reached Peru, but he had prepared for the trip in Santo Domingo in 1534, with Friar Tomás de Berlanga, after meeting Hernando Pizarro

the year before. Brother of Francisco, the sanguinary conquistador of Peru, Hernando had stopped by the island in 1533 with the famous ransom of Atahualpa. The Sapa Inca had been abruptly betrayed and murdered by the Spaniards after he had given them what they had asked—"which he fulfilled and he even offered much more," as Las Casas notes (*lo cual cumplió y mucho más*). Las Casas narrates this episode in a long passage of the *Apologética* devoted to Inca temples. He clearly recalls the monumental quantity of golden vases (*más de cuatrocientos cargas*), whose "number, quantity, variety, making, grandiosity, and refinement" (*número, cantidad, diversidad, hechura y grandeza y riqueza*) he had personally seen in Santo Domingo.[93] But Las Casas goes beyond counting the contents or size of those pieces, as the inventory of the ship *Santa Maria del Campo*, which docked in Seville in 1534, does. He tries to poetically translate the unprecedented artistic effects of those vases. For instance, he describes the golden and silver artifacts that combined the two metals with astonishingly smooth effects: "How silver getting close to gold starts losing its color while taking that of gold and how gold getting close to silver starts losing its color while taking that of silver" (*Como va llegándose la plata hacia el oro, va pediendo su color y tomando la del oro y como el oro se va llegando a la plata va perdiendo su color y tomando la de la plata*). This particular artistry impressed the Iberian artists, puzzled by how their transatlantic peers, the metal art workers, could put together "silver with gold, and gold and silver with ceramic, without soldering [the materials]." Today, the technique is called the "mechanical combination" of materials.[94] Las Casas adds that "there is none of our workers who can compete, and who does not get scared [*espantados*] to see how such different materials can be joined." The Iberian artists were intimidated by the novelty of a technique that they had never imagined and whose secrets they could not guess. Here too, as in the chapter about Hispaniola, Las Casas frequently points out the artists' almost total lack of tools (*falta de instrumentos*). He writes that the objects are made "without anything to help them" (*sin otra cosa ninguna de que se ayuden*), further emphasizing the pure intelligence embedded in the act of art making. The Dominican insists on the contemporary vitality of the silversmith's art: "In the past there was an infinity of them, and still today there are many whose inventiveness, industry, and subtlety can hardly be sufficiently praised. In fact, it may be impossible to overstate it." This vitality is also represented by the extremely young age of the silver- and goldsmiths, a fact that Las Casas decides to add: "Of these artmakers [*oficiales*] there are many who are so young that have just learned to speak well" (*destos hay muchos tan muchachos que apenas saben bien hablar*).[95] Young children of three or four years of age develop their *ingenium* in the very practice of art making.

The chapter also praises Peruvian architecture. The Dominican relies on textual sources, since he had not seen those monuments in person, but this did not prevent him from advancing a much broader argument: "They are great intellectual experts in geometry,

which we call architects {who draw up the plan, organize the work accordingly} and then order what has to be done; and there are manual workers, who are the ones who get down to work" (fol. 212).[96] Las Casas draws a clear line between the "intellectual experts in geometry," responsible for the design of Andean architecture, and those who partake in the manual labor. Nonetheless, the splendid final results, according to the Dominican, require the combined effort of both groups. His use of the present tense suggests that he is also referring to the great quality of the architecture built after the arrival of the Spaniards, as in another passage devoted to textile production, where he assures readers that the weavers continue their prolific work "every day" (*muchas obras déstas hacen cada día*).

## Indigenous Ingenuity in a Colonial Mine

Chapter 65 ends with a long passage on the mine of Potosí, discovered in 1545 and immediately exploited by the conquistadors—with high costs for the local population.[97] Here Las Casas relies on the information gathered by Pedro Cieza de León, who visited the region between 1549 and 1551. The latter describes Potosí in chapter 109 of his *Primera parte de la crónica del Perú*, published in 1553. Las Casas borrowed the same information, images, and language used by the Spanish soldier.[98] What both Cieza de León and Las Casas celebrate is the exploitation of the mines through an Indigenous system of extraction. We know today that shortly after silver Potosí was found, the laborers of the Inca mines of Porco brought there the portable ovens known as *huayra* (from *huairachina*, meaning "wind" in Quechua). *Huayras* used the speed and force of the wind, as well as available natural combustibles, to melt silver. They also allowed them to start refining the precious metal, as fire volatilized both sulfur and lead.[99] The Spaniards tried to introduce large bellows to activate the *huayra* without wind, but they could not make them work, as Las Casas reports. A later watercolor, today kept at the Hispanic Society, translates the perfect mastering of the power of wind by mine workers (fig. 41).

Via Cieza de León, Las Casas celebrated this ingenious Indigenous system for extracting silver. He did not know yet that an Italian merchant, Nicolao del Benino, would soon bring a system of excavation of deep galleries in the 1550s, nor that Spaniards would introduce in the 1570s the mercury amalgamation that made it possible to refine six times more silver.[100] Both innovations eventually caused incalculable losses among miners, forced to work in brutal conditions. But Las Casas knew for certain the report he received in 1550 by the *visitador general* of Peru, Domingo de Santo Tomás. His fellow Dominican had written to Las Casas a letter denouncing the labor situation in the mine of Potosí, which he called the "boca del infierno" (mouth of hell).[101] Las Casas seems therefore to have made a choice here: to emphasize the intelligence of the Indigenous population beyond

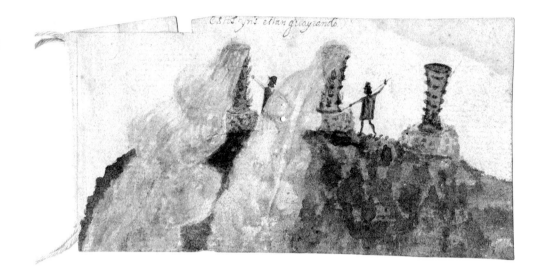

FIGURE 41 | "Éstos yndios están guayrando" (These Indians are using *huayras*), Potosí, ca. 1585. Watercolor on paper, 12.3 × 6.5 cm. New York, Hispanic Society, Atlas of the Sea Charts. Courtesy of The Hispanic Museum & Library, New York.

the exploitation of the mine. This is not historically incorrect. We know today that during the first decades following the discovery of Potosí, the Indigenous population was decidedly in technical control of the refinement of the mines.[102]

The omission, given what we would expect from Las Casas, is still troubling. Since the Indigenous and African populations (enslaved Africans were brought to the mines as early as the 1550s) were indeed still working with Indigenous techniques, why did he not say that their conditions were so rapidly deteriorating? My answer to this question summarizes the thesis of the chapter. The same author who denounces in all details the horrors of the colonization of the Americas in the *Brevísima* and who had read desperate reports on Potosí, the same author who later, in the *De thesauris* (1563), testifies how Spaniards had "despoiled the proper owners ... of mines or veins of gold and silver,"[103] the same Las Casas decided in these specific passages of the *Apologética* to tell us the story of Potosí from another viewpoint: that of the force of Indigenous rational *ingenium* as indestructible.

## Indestructible Humans

Las Casas is known worldwide for the publication, during his life, of his bestseller, *A Short Account on the Destruction of the Indies* (written in 1542 and printed in 1552), a forthright

denunciation of the atrocities that the Spaniards committed during half a century in the New World, destroying places, people, and societies with brutal cruelty. The *Brevísima*, as it is referred to in Spanish, was translated and illustrated in many editions, including the famous one printed by Theodor de Bry. Still today, the name of Bartolomé de las Casas is associated with the term *destruction*—with the unquestionable brutality of the Spanish conquest and with the project of a "defense" of the inhabitants of the New World based on the evidence of that infamous destruction. Looking at the *Apologética* complicates things. Unpublished for centuries, the very long history of the "past and present" Indies—whose focus is the "apology," so to speak, of the Indians who are still alive—set forth from an antithetical philosophical premise: that something of the Indian world had not been destroyed by the conquest.

It has often been affirmed that Las Casas's logic for introducing postconquest artworks was to demonstrate that Christianization and Christian imagery allowed local artists to improve their repertories and techniques. However, there is something that exceeds this program of conversion and is related to Las Casas's theorization of humanity as inherently artistic—even when facing life-threatening challenges.

Through a subtle interplay between the trajectory of the gradual and destructive Iberian conquest of the territory and the geography of art that emerged through the military and missionary campaigns—and between the undeniable devastation brought by colonization and the possibility of a new blossoming of the human through the artistic—Las Casas states that the "Indians" had been and *still were* able to create subtle artifacts. Thoroughly describing and theorizing around their material expressions, including postconquest ones, and insisting on the fact that they were mostly achieved with very simple tools, he continuously intertwines the observation of the specificities inherent to the making of the artifacts with a broader reflection on the powerful creativity of their authors. This groundbreaking reflection of the humanity of the "Indians" as artists in the *Apologética* allows us to understand in novel terms Las Casas's intellectual project and contribution. Art is ultimately presented as an innate potential that not even the atrocities of a half-century of brutal conquest and colonization were able to annihilate.

# The Sublime Art of the Idol
## From Forensic to Aesthetic Judgment

*Idols so portentous and giant, and so richly adorned, that it is
no less argument and sign of the subtle wit of these people.*
—Bartolomé de las Casas, *Apologética historia sumaria*
(ca. 1555)

As seen in the third chapter, to prove by any means the humanity of the New World's
inhabitants based on their artistic rationality, Las Casas went very far in the *Apologética
historia sumaria*. In a work aimed at denouncing the maltreatment and enslavement of
the Native population, he surrealistically depicted himself in the square of Mexico, prais-
ing aloud how well made the chains and whips of an enslaved Indigenous man were. But,
in fact, he was praising the qualities of their artificer—the enslaved man himself, as the
slaveholder specified—hence claiming an artistic-inferred humanity. His readers could
themselves conclude that the artificer should not have been enslaved. Las Casas also
celebrated the wind-fueled *guayras* invented by Indigenous miners to extract and refine
silver in Potosí—knowing well at that time, and therefore silencing, the degrading labor
conditions of the mines that were already called "the mouth of hell"—to highlight the
intelligence of the workers, therefore focusing on their forceful agency. As for the pas-
sage depicting an Indigenous silversmith hidden beyond his cape, stealing with his eyes

the techniques brought to New Spain by the Spaniards, it plainly staged a typical colonialist stereotype: Native people depicted as tricksters. "Spanish call them monkeys," Las Casas recorded verbatim.[1] But then he added a detail that demonstrated the exact opposite: undercover "Indian" art makers could see the process of the work just halfway and complete it at home, more perfectly than the Spaniards. Readers could deduce that it was not aping at all; the finesse required to put in practice and improve on an original the makers saw only once denoted exceptional intellectual capacities.

Yet, the vignettes of the enslaved man, the miners, and the silversmith test our analytical poise as, at first, they seem to just reveal Las Casas's embarrassing self-contradictions, not to say a willful colonialist mentality. Were they intentional rhetorical coups? If so, why did he leave *us* to decrypt them, if elsewhere he could be so blunt and unmistakable? It is a question that none of his writings can answer. But here is my attempt. The effort required to understand those highly ambiguous passages, without drawing hurried conclusions, is worthy of the real project of the *Apologética*: that of thinking differently of the "Indians"—certainly not as barbarians, as Sepúlveda argued, but also not as annihilated victims. Portraying them as capable of artistic perfection even in the middle of the worst is Las Casas's ultimate demonstration of their humanity, which, logically, could not be determined by the dehumanizing conditions imposed on them: by slavery, labor exploitation, war, colonization, forced conversion, imprisonment, colonial prejudice, and, ultimately, by the finitude of death. This recalls Abdulrazak Gurnah's reflections on how colonialism has shaped but not defined the people who experienced it.[2] Remember how Anghiera repeatedly used the present tense when he admired the ongoing artistic vitality of the New World, after the conquest. As seen in the second chapter, the subtlety of pieces being always "made with great art" demonstrated that their authors' humanity remained intact even when under assault.[3] It is a radical change of perspective. Instead of characterizing people by their relationship to subjugation—either as victims of, resistant to, or collaborative with domination—locating their humanity in their lively artistry signals what persists through the most real effects of domination itself, somewhat autonomously.

## Artistic Idols

The passages from the *Apologética* not only unveil several paradoxes of the history of colonialism, but they also expose their unexpected imbrications with the history of art history. Consider the following: in a section devoted to the temples, Las Casas salutes "the infinity of idols, big and small" found in the Great Temple of Mexico, "[idols] so richly adorned, that it is no less argument and sign of the subtle wit of these people" (fig. 42). Amid the height of the "idolophobic" era of Christianization, with the apostolic

Inquisition zealously smashing idols, destroying ceremonial books, and chasing, con-
demning, and even burning supposed idolaters in New Spain, the Dominican makes
the reverse case: the artistry embedded in the idols is, in fact, evidence of the people's
rationality. Las Casas does not simply emphasize appearance: "All these figures were not
absurdities; they could explain them all."[4] Both their form and their content illustrated
their authors' mental faculties.

One could argue that this is not so different from how an Inquisitorial process worked:
searching for material evidence and hidden meaning and then organizing the findings
in a sort of "idolography"—a grammar of idol making and worshiping that could then
serve to tag idolaters and punish them. As we will see, Inquisitors did investigate human
manufacture in detail, including the repair of objects, precisely to claim the origins, con-
tinuity, and liability of the veneration's error. But the purposefulness embodied in those
"idols"—in their quantity, diversity, scale; in the astute labor required to create them; and
in the process of symbolization—pointed for Las Casas to the same artistic humanity
he demonstrated in the section of the *Apologética* devoted to the artificers. The endless
formal variety of idol making manifested the myriad possibilities humans found to intel-
ligently deal with all sorts of matter: "I have seen myself almost an infinity of them: some
were made of gold, other of silver, other of copper, other of ceramic, other of wood, other
of dough, other of different seeds. They made them big, others bigger, others medium
size, others small, others smaller, and others even tinier."[5]

Las Casas's poietic (and poetic) perspective on idols is in many ways unique. It is
also paradigmatic, however, of another constitutive paradox of early modernity—prob-
ably the most relevant for the history of art history. The discourse of idolatry—namely,
the search, scrutiny, and condemnation of idols' production and worship—served the
Christianization of the world: it is not a coincidence that idols were identified, in the
greatest range of formal possibilities, everywhere the Roman Church and the Catholic
Monarchy headed.[6] We must recall the context of the Protestant Reformation here. After
being accused of venerating Christian idols (the saints) and even of worshiping Christ as
an idol—requesting favors, pardons, promises—the Roman Church forged itself a new
identity by tackling and fighting the supposed pervasiveness, throughout the world, of
pagan idol veneration.[7] In doing so, the Roman Church redirected the meditated icono-
clastic fury of which it was the object, becoming iconoclast, in its turn, or rather idoloclast
in the new territories that it was gradually Christianizing.[8] But since the human artistry of
the "idols" was contended as proof of their false sacrality, the discourse of idolatry ended
up generating a gigantic documentation on human artistry, at a global scale. To prove
how ubiquitous idols' production was and how their beautiful and attractive appearance
caused their wrong worship all around the world, the discourse of idolatry extensively
documented how idols were made, everywhere, *arte mira* (with admirable art).

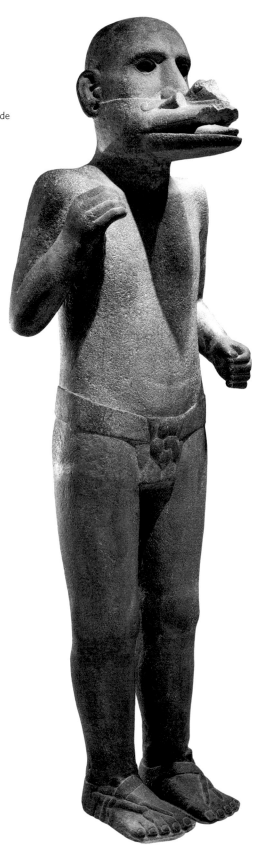

FIGURE 42 | Quetzalcoatl-Ehecatl, Mexica, late postclassic, ca. 1500. Stone, 189 × 33 cm. Toluca, Museo de Antropología e Historia del Estado de México.

This documentation includes not only letters and chronicles written by conquistadors and missionaries, Inquisitorial proceedings, inventories for shipments and collections, and travelers' diaries but also texts and images produced by Indigenous and mestizo authors. The present chapter addresses a modest yet revealing selection from this gigantic archive—running from Jamaica to Japan, from Peru to China, from West Africa to New Spain—to inquire into the tensions and the intersections between the concept of idol both with the discourse of idolatry and with that of art.

We know today that in the early modern period, the category of idol became contemporary with the nascent modern concept of art, eventually playing a crucial role in "what counted as art" and serving as a formative concept in art history.[9] This role, however, would have been merely negative, as it eventually resulted in a divide between idol and art, even separating "humanness between art and non-art." Certainly, art history and even museums still reflect that divide, which continues to influence college curricula and collections' displays. If you visit the pre-Columbian galleries of a museum, say the American Museum of Natural History in New York, at some point you will come across a wall text pointing to the relationship between a certain object and the religious sphere: the word *idol* will probably appear in that text; the word *art*, nowhere.

Considering a large corpus of sources produced in the context of the Iberian expansion, however, allows me to reconsider the early modern contemporaneity between the category of idol and the concept of art, envisioning the positive, albeit unforeseen, role that the category of idol played in what counts as art today. I contend that due to their most artistic manufacturing and the mesmerizing effects induced on their viewers, the pieces identified and described (textually and visually) as idols, in fact, contributed to generating the modern concept of art.

Bernal Díaz del Castillo, a soldier-chronicler who participated in the expeditions to Mexico and in the brutal war of conquest, is probably the early author who most clearly tied the concept and material reality of what he calls idols to their extraordinary artistry. Celebrating the finesse and instantaneous, transatlantic success of some precious Mexican statuettes looted in 1518, he describes them as "many idols made with gold, that even if it was of low value, was elevated by the art [*sublimábanlo de arte*]; and this became renowned in the islands of Santo Domingo and Jamaica, and even in Castile."[10] Díaz del Castillo makes here an argument comparable to that analyzed in the previous two chapters. Readers may recall how both Anghiera and Las Casas write that the veritable value of the artifacts made in the New World was not to be found in their natural matter, such as gold, but in their human making. Here they echo Renaissance art theorists like Leon Battista Alberti who had praised the artificers for their work and not for the material they used. Laudable was the painter who could imitate the rays of gold with colors, not the one who was lured by gold to ennoble paintings.[11]

According to Anghiera, as seen in the second chapter, what captured the attention of a Sevillan audience observing a large quantity of looted vases made of the purest gold was precisely their different shapes, not their precious material. Anghiera also inserted in his *Decades* the telling episode of a Native man from Hispaniola surprised with the greed of the Spaniards receiving unrefined gold, since for him and his people, that material would acquire value only when the hand of an artificer gave it the desired form (*quanti artificis manus in formam cuique gratam diducere aut conflare didicerit*). Those Hispaniola artificers were then compared by Anghiera to the renowned Greek sculptors Phidias and Praxiteles, who transformed with their hands heavy, raw marble into the most pleasant and detailed mythological figures, with airy long hair and delicate beauty. As for Las Casas, with his customary literary finesse, he marveled at the pieces "made and created with such great artistry, that it looked like a dream and not things made by the human hand," adding "just their making and beauty could be sold very high."[12] The value of those artifacts was foremost in their outstanding immanent manufacture. Let us keep in mind this insistence on the hands of the artificers. Even in Holanda's *Da pintura antiga*, as seen in the first chapter, Michelangelo celebrated the "manual trades that are made throughout the entire world" (*officios manuaes que se fazem por todo o mundo*), having most probably in mind the variety of fine handmaking observable in the objects reaching Europe from the antipodes—manual artistries that, he believed, any excellent artist should now be able to master.[13]

But Díaz del Castillo goes one step further here. To express that pure artistic worth, which was diametrically opposite to economic value (low gold versus high art), and to record the immediate sensation "idols" gained abroad, he employed a verb—*sublimar*—that deeply resonates with one of the pillar concepts of aesthetics: the sublime. In Spanish, the term was in use at the time with the meaning of "to elevate," "to dignify," especially by mystics.[14] Yet, Díaz del Castillo uses the verb *sublimar* to name both a specific artistic agency—elevating matter by making—and a specific response—valuing art making over the weight of precious material. By the mid-sixteenth century, the sublime had entered humanist debates about rhetoric and visual arts thanks to the Italian translation of the Greek treatise on eloquence titled *Peri Hypsous* (Περί ὕψους).[15] In the seventeenth century, its French translator, Nicolas Boileau, will define the sublime as "something extraordinary and marvelous that strikes us in a Discourse and makes a work elevate ravish and transport us."[16] In the eighteenth century, Edmund Burke will famously equal it to "a greatness beyond all possibility of calculation, measurement or imitation."[17] For these later authors, the sublime transcended rules and discourse, pointing rather to the relationship between the singularity of an artwork ("something extraordinary and marvelous") and the singularity of experiencing it ("makes a work elevate ravish and transport us"). These formulations of the sublime as escaping calculation or demonstration

help to articulate the central thesis of this chapter: in the context of the early modern global Christianization, the attentive observation and experience of the purposeful and always unique workmanship of the idol—what I call "the art of the idol"—while being generated from *within* the colonial discourse of idolatry and from *within* its deep ties with colonial extractivism (many golden parts of the "idols" were melted down, as we will see shortly, so the liquid gold could then be reshaped into salable gold bars), exceeded that discourse, entering the realm of what we can call, even if anachronistically, early modern aesthetics.

Another passage by Díaz del Castillo helps us excavate further the intersections between the concept of idol and the modern concept of art. Later in his book, the author addresses the artistic panorama of postconquest Mexico in the mid-sixteenth century:

> Let us consider now the great artificers who work and set up feathers, and the painters and the sculptors who are all the most excellent [*muy sublimados*]. From what we see today in the works they make, we will have much to consider in what they used to make. There are today three Indians in the City of Mexico who are so outstanding in their trade of sculptors and painters, they are called Marcos de Aquino and Juan de la Cruz, and Crespillo. If they had lived in the time of Apelles, or of Michelangelo and Berruguete, who are of our days, they would deserve to be counted among them.[18]

Tracing a clear line of continuity between the exploits of contemporary painters and sculptors and what their past fellows had made, Díaz del Castillo recurs, again, to the same verb: *sublimar*, here in the adjective form preceded by the adverb "very" to denote how outstanding (*muy sublimados*) these artists were. The artistic excellence of Aquino, Cruz, and Crespillo being comparable to Apelles, Michelangelo, and Berruguete (and vice versa) prompts Diaz to retrospectively consider the finesse of those sublime idols their predecessors "used to make," which were on a par with the art made by the six of them. The common denominator among idol making and the paintings of Aquino, Cruz, and Crespillo and the work of Apelles, Michelangelo, and Berruguete is, precisely, the elevation of matter through indisputable artistry. It is interesting to note here that by the mid-sixteenth century, the activity of Native painters and gilders was regulated in New Spain by the Church and by precise ordinances aimed at tracking any residue of idolatry or heretic content.[19] But for Díaz del Castillo, the artistic excellence of contemporary painters prompts the reconsideration of what their predecessors made (and vice versa, the artistry of the idols explains the contemporary artistic panorama), bypassing what the Church could deem heretic or idolatrous.[20]

## Describing Art Making

So, how did the art of the idol break away from the discourse of idolatry while being documented from within it? Ekphrasis played a fundamental role in this process. If, since the ninth century, the accurate formal description of idols had substantially diminished, in the new context of the early modern Christianization of the world, the demonstration of idols' existence hinged again on the accurate textual (and sometimes visual) recollection of their most detailed appearance.[21] Each idol that was identified as such, in fact, presented different formal features, recalling what Bernard of Clairvaux had written of the attractive idol-like varied figures inhabiting the Benedictine monasteries in the twelfth century: "There appears everywhere such a great variety of heterogeneous forms" (*mira diversarum formarum apparet ubique varietas*).[22] Bernard famously called it a "deformed beauty and beautiful deformity" (*deformis formositas ac formosa deformitas*): a beauty morally deformed for being beautiful only in form but not in content, the opposite of the concept of *pulchritudo*.[23] Let us recall that the term *idol*, according to Tertullian, had precisely to do with form, appearance, look, sight (*eidos*, Gr. εἶδος).[24] Therefore, form was central to the discourse of idolatry, and it had to be accurately described. Only through a thorough description—an ekphrasis of their human artifice, of their worldly origins, and of the aesthetic effects produced on the viewers—would all sort of readers (spanning from local Inquisitorial judges to distant armchair travelers) be able to visualize the perilous omnipresence of idol making. Something radically unexpected, and not yet addressed by art historians, happened during this process.

In the history of art history, the *Lives* of Vasari (published in 1550 and 1568) is considered the first text where ekphrasis became a practice to celebrate artistic activity itself: it was no longer a tool to describe what was represented but how.[25] I contend that this practice started in the texts written in the context of the early modern globalization. Ekphrasis of the idols' art making constituted the space where both the discourse of idolatry was performed and where the art of the idol overflowed that same discourse, revealing human artistic activity tout court. Remember, from the introduction, Chiericati bringing in 1521 to the court of the Sforza-Bentivoglio near Milan "idols masterfully made with mosaic technique" that he had received during his visits to Portugal and Spain.[26] We can almost see him unwrapping the pieces under the uncertain expectations of his audience and then proudly introducing the *idoli maestrevolmente lavorati di musaico*. Did his Italian hosts feel that the papal nuncio's enthusiasm for the artistic labor of the statuettes was out of place from a man who was supposed to denounce them as idols? Or was it rather that the art of the idol could displace, albeit momentarily, the discourse of idolatry?

In what follows, I analyze this momentary displacement. After a start in medias res, with Cortés simultaneously admiring the beauty of some idols while destroying others in the name of Christianity and shipping still others overseas, I return to the opposition that had foregrounded the Christian theory of the image: that between acheiropoieton *icon*—supposedly made without human hands—and *idol*—manifestly handmade. In the context of the Iberian colonization, this opposition certainly served and was reinforced by the global discourse of idolatry. But it also made possible novel insights on human artistry in a surprising simultaneity with the pictorial and textual statements of artists and theorists such as Dürer. I address these tensions between the discourse of idolatry and the insights on human artistry in a selection of early modern sources:

1. The description of the wood and stone sculptures labeled as idols and named *çemi* by Catalan friar Ramón Pané (the latter based, he says, on a Taino term), which he observed in Hispaniola between 1495 and 1497. Pané clearly stages a contrast between these handmade artifacts and a vegetal Christian cross that suddenly appeared rooted in the island. But the resonances between the genesis of *çemi* making on which he himself reports and that of sculpture making in the Renaissance, as much as the references to *çemis* embedded in the appearance of the miraculous cross, transcend Pané's agenda and provide a reflection on the human transformation of matter in form.

2. The drawing of twelve lively miniature sculptures in the round illustrating what the Native Peruvian author Felipe Guaman Poma de Ayala calls "idols and *uacas*" (based, he says, on a Quechua and Aymara term), in his chronicle of 1615/16. The anthropomorphic *uacas* surprisingly sport Spanish hats, pointing to how novelty was captured by art making. In 1602, the Dutch trader Pieter de Marees, visiting Portuguese trading posts in Africa, made a comparable observation regarding African *fetissos* (a pidgin term referring to the manufactured quality of all sort of charms): they incorporated a myriad of novel things brought to West Africa by colonization and trade.

3. The search for idols and their description in the Inquisitorial process of Don Carlos Ometochtli, the cacique of Texcoco, New Spain, in 1539. The depositions of the Nahua witnesses interrogated about the statues were translated into Spanish by a group of renowned Franciscans. The specific language of their testimonies, as well as the attention devoted by the apostolic Inquisition to scrutinize the repairs made on a statue they considered an idol, offer important insights on the theological debates about objects' matter, human authorship, and effects on the viewers.

4. The transcription and translation into Nahuatl and the illustrations of the passages on idol making and worshiping from the Book of Wisdom in the Florentine Codex (1570s, New Spain). The changes between the biblical text, the Nahuatl translation, and the visual depiction of the episode turn crucial for our inquiry. In the painting,

the manufactured idol, in fact, presents clear Mexica attributes and yet stands in an anachronistic contrapposto position (see fig. 52). This detail provides a glimpse at how the *tlacuilo*, the Native painter, considered Greco-Roman and pre-Hispanic sculpture in a position of artistic equality.

5. The description of the Buddhist temple of Sanjūsangen-dō in Miyako (today Kyoto), written in Portuguese around 1585 by Luis Frois. The Jesuit missionary addresses the statues as "idols" and calls them *fotoque* (based on the Japanese *hotoke*, 仏). He recalls his movement through space to record the idols' shapes in terms of an astonishing experience. Other contemporary sources on Asia underscore the pleasant experience of the idols' formal variety as transformative. The sensuality ascribed to the statues certainly has an orientalist taste. Reading these texts against Cusanus's famous description of the frontal experience of a Christian icon, however, can help appreciate how they finely observe the tridimensional, solid form.

The vast temporal, geographical, and linguistic range of these sources—written or including terms in Spanish, Italian, Nahuatl, Latin, German, Quechua, Aymara, Portuguese, African pidgin, Dutch, Japanese, and Chinese; composed between the late fifteenth and early seventeenth centuries; and stemming from what is today the Dominican Republic, Ghana, Peru, Japan, Mexico, and China—helps me tackle, on a vast global scale, two specific early modern intersections between the concept of idol and that of art: the relevance of observable manufacture as evidence of artistic human action and the aesthetic experience of the viewers. At the end of the chapter, I discuss how scholarship has previously stated the relevance of early modern descriptions of idolatry for the disciplines of ethnography and history, proposing that the studied intersections between the category of idol and that of art demonstrate their relevance for the field of art history.

## The Human Hand: From Threat to Promise

"The most important of these idols, and the ones in whom they have most faith, I had taken from their places and thrown down the steps."[27] One of the best-known passages of Cortés's "Second Letter" (1520–22) synthesizes an entire colonization program. At the heart of the Mexica territory in Tenochtitlan, the conquistador performs an act of correction, where conquest and Christianization become undividable. Recurring to a well-established topos, Cortés uses throughout his letters a perfectly crafted discourse on idolatry to cement his enterprise: we can follow, almost day by day, how the supposed evidence of idol making and worship peppers the writing in crucial moments; his advance in the territory seems to depend on it.[28] Local idols also secure the conquistador a place

in a genealogy going back to early Christianity, proudly set up against, but also complementary to, paganism.[29] Cortés writes, "Everything has an idol dedicated to it, in the same manner as the pagans who in antiquity honored their gods."[30] His words in Tenochtitlan evoke Paul the Apostle's experience in his missionary travels to Athens, observing "the city full of idols" (Acts 17:16), and both recall the famous Old Testament passage: "Their land is full of idols; they bow down to the work of their hands, to what their fingers have made" (Isa. 2: 8).[31] Paganism is reenacted and, once again, corrected in Mexico. And the biblical interdiction ("You shall not make idols for yourselves or erect an image or pillar, and you shall not set up a figured stone in your land to bow down to it" [Lev. 26:1]) becomes a powerful prompt for colonization. Accusations of idolatry are as weapons wielded to conquer. Nothing seems new.

Yet, this linear narrative of conquest and Christianization falls short of explaining the global projection and transformation of the category of the idol. From one side, it certainly was a key, for priests and conquistadors, to rapidly control, conquer, and Christianize new lands. But from the other, once the category of the idol was confronted with new realities, it generated a major shift in the observation, definition, and description of the objects. Cortés is the best example of this productive contradiction. His hegemonic discourse (Mesoamerican sculptures denounced as idols, to be destroyed and replaced by Christian images; people accused of being idolatrous so that they can be colonized) is often suspended to appreciate those same "idols, of remarkable size and height, sculpted with many intricate figures in stonework and woodwork."[32] It is actually this precise sentence that Las Casas used to infer their authors' artistic rationality, in the passage of the *Apologética* commented on at the beginning of this chapter. Not only did Cortés overtly celebrate in his letters from Mexico the art of the idol, but between 1519 and 1526, he shipped and even personally brought to Spain myriad objects, whose artistic intricacy is detailed in the shipments' inventories.[33] As seen in the previous chapters, Anghiera and his guests, as well as Las Casas, saw some of these art pieces in Spain, as did Margaret of Austria and Dürer, in Brussels. "Idols" became "treasures" worthy of display in Europe. They became treasures, however, not *in spite* of having being labeled idols but precisely *thanks to* their fine handmaking, which was constitutive of the discourse of the idol. Dürer famously calls those artifacts "künstliche Ding" (things made with art) and marvels at "the subtle ingenuity of people in foreign lands" (*subtilen jngenia der menschen jn frembden landen*). We will see shortly how Dürer solved the apparent contradiction between artistry and idolatry.

So, from one side, there is the biblical prohibition against making and worshiping any form of handmade creation, which was actually stated in the second commandment: "You shall not make for yourself a sculpture in the form of anything in heaven, above or on the earth beneath or in the waters below" (Exod. 20:4). From another angle, there is a novel astonishment for that art making, which interestingly borrows the same biblical

language. Readers might remember, from the second chapter, Cortés celebrating how the Mexica *tlatoani* had his artists so perfectly imitate (*contrahacer*) in gold, silver, stones, and feathers "all the things that under the heavens are in his dominion." Cortés had added that they were all made "tan al natural," so lifelike that no other artist, anywhere, could do any better, in any known medium.[34] Conversely, that undisputable artistry did not halt the conquistador's idoloclastic fury against "those idols which they had made with their hands."[35]

Recurring to the expression "made with their hands" to highlight the human authorship of the idols was not just a biblical reference at the time. Since the mid-fifteenth century, the expression "by the hand of" (*di mano di*) was increasingly related to artistic activity and to autograph rights and duties: contracts for paintings of Piero della Francesca, Benozzo Gozzoli, and Domenico Ghirlandaio use different Italian versions of this terminology (*di mia mano*; *di sua propria mano*), even when the final piece would obviously be the result of many hands in workshops.[36] Leonardo da Vinci advised apprentices to always learn "by the hand of a good master" (*di mano di buon maestro*).[37] The expression also started to appear frequently in wills and inventories, even when the name of the master was unknown.[38] In 1500, a Latin poem to Dürer admires the painter's "sovereign hand" (*docta manu*), comparing it to that of Apelles and of Phidias.[39] At the end of the sixteenth century, the hand of the artist became the staple of excellence embedded in an artwork.[40] In the seventeenth century, the word will carry the promise of the final touch of the master: Guido Reni boasted to intervene in the apprentices' works and turn them into ones entirely made "by my hand" (*di mia mano*), and Gustave Colbert instructed Gianlorenzo Bernini to "put the last hand" (*mettre la dernière main*) to the equestrian statue of Louis XIV.[41] Treatises also increasingly considered art a "hand operation" (*hoperatione di mano*), and by the end of the seventeenth century, hands were definitely considered to be connected to the intellect.[42]

I contend that the subtlety of the artworks observed and described in the context of the early modern globalization participated in this major shift: manufactured "idols" proved artistic refinement, and myriad handworks were considered related to and even sources of thought. Once more, it is Las Casas who openly addressed the "Indian hands" as conveyers of their mental capacities. He reports, for instance, how perfectly they could paint pages of polyphonic organ songs with all their letters and notes (*de letra y punto*). When the Dominican brought the scores to the Council of Indies, some of the attendants did not believe that they could be "made by the hand of an Indian of New Spain" (*hecha de mano de indio de la Nueva España*).[43] Artistic work had to be highly considered, he said: even what carpenters carve and paint with their hands (*obras de sus manos*), like crucifixes, deserves the best possible praises as they provoke Christian devotion.

In order to understand the relevance of this major change—ascribing to handmaking authoritative, rational artistry in lieu of condemning it as the source of idolatrous, irrational

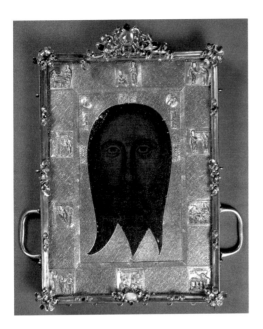

FIGURE 43 | Holy Face (*Mandylion*), San Bartolomeo degli Armeni, Genoa, Byzantine with additions of the fourteenth to fifteenth century. Photo: Courtesy of the Kunsthistorisches Institut in Florenz—Max-Planck-Institut (Campaign 2003/2004).

worship—and to appreciate its simultaneity with the observation of myriad artworks made outside Europe, a detour in Western art theory is necessary.

The opposition between idol and icon impacted centuries of Christian theology. The *manufacture* (lit., hand-making) of the idol was antithetical to the acheiropoieton icon, which is by definition "not made by human hands." This characterization was the only way for an image to overcome the biblical interdiction and to be venerated as independent from human action and as generated by Christ's action (even if it was made by way of an Evangelist, such as Saint Luke). All the images considered *acheiropoieta* share a highly auratic, almost immaterial, presence (fig. 43).[44] But the characteristic of *acheiropoieton* inevitably also constituted "an agent of authenticity independent of the talents of the painter."[45] To be an acheiropoieton icon, in fact, meant to be unpainted: produced by direct contact with the sacred (which impregnated a fabric, a piece of paper, or even a brick), by the mediation of a vision or a dream, or by some miraculous revelation (such as fallen from heaven, but always without purposeful human artistic intervention).[46] Sculpture complicated a plausible antithetical position of a Christian object in regard to the idol. Its "making-ness" being undeniable, it was the approach to miracle and legend that guaranteed its holiness—Christian statues crying, bleeding, sweating, and more importantly healing.[47]

The possibility to combine artistry and religious subjects arose in the late medieval period and became crucial in the sixteenth century, primarily because, in case of copies of an original icon, human intervention was considered increasingly admissible.[48] If in medieval times an authentic icon could already be copied, the preservation of the auratic powers in the replica was now precisely ascribed to the painter's capacities. This constituted what Nagel and Wood call the "paradoxical moment" in the Renaissance where, in fact, an "*acheiropoieton* [image] serves as a model for authorial claims."[49] Copies of non-handmade icons could, at the same time, be as miraculous as the original and yet regarded

as artistically exceptional, precisely in their capacity to carry the initial power of the prototype. Eventually, a more overt statement on artistic authorship further problematized the definition of an artifact's manufacture as materially corrupt and corrupting. Here is where the contemporaneity between the observation of overseas objects and the earliest articulations of the modern concept of art deserves particular scrutiny.

Readers certainly recall that when, in August 1520, Dürer saw in Brussels the display of myriad things made in Mexico, he described them as "künstliche Ding" (artistic things). Sent by Cortés to Spain and parading through Europe, these things included art pieces often described as idols (remember Chiericati's "idoli maestrevolmente lavorati di musaico," which most probably included objects shipped from Mexico). The German artist did not use the term *idol* and focused instead on the "subtle ingenuity of people in foreign lands."[50] But he was obviously aware of the issue related to their human making. A few years after, in the dedication of *The Painter's Manual* (1525), Dürer states: "It must be an ignorant man who would worship a painting, a piece of wood, or a block of stone. Therefore, a well-made artistic and straightforward painting provides betterment rather than vexation" (*gemel mehr besserung dann ergernuß bringt, so das erberlich, künstlich und woll gemacht ist*).[51] Instead of being offensive or threatening, therefore, veritable human artistry participates in a complex and pleasant sensorial experience. Worthy of note is Dürer's use, in both cases, of the adjective *künstlich* to name that positive side of artistry and to celebrate the Mexican art pieces. If previous scholarship has interpreted that adjective as denoting the artificiality (not art) of the objects made in Mexico, this textual evidence proves, on the contrary, that Dürer considered their artistry on a par with that of a respectable painting.[52] Also remarkable is that, in both instances, Dürer expresses in comparable ways the profound aesthetic experience triggered by artistic pieces: the Mexican objects pleased (*erfreuen*) and astonished him (*verwunder*), and any good artist should provoke *besserung* (a betterment, an improvement)—actually, he may have meant the uplift needed for a physical and moral recovery.[53]

The relationship between Dürer's textual passages can be excavated further. As is well known, in 1500, the German painter signed a self-portrait that was a powerful statement on the authority of the artist as creator (fig. 44). According to Margaret A. Sullivan, it was precisely the magistral rendering of his creative hand that paid homage to Apelles, the ancient painter celebrated by Pliny the Elder for the rendering of the figures' fingers.[54] Here is another piece of the puzzle: opposed to this bold celebration of his art, in 1514, Dürer composed the famous *Melancolia I*, which Mitchell Merback interprets as a poignant visual meditation on creative paralysis and how to undo it.[55]

We have in Dürer, therefore, the author who assumed in painting his artistic authorship (1500), the artist who in his *Melancolia I* (1514) portrayed the stalling and desired restoration of creativity, the traveler who acknowledged in his *Diary* (1520) the human

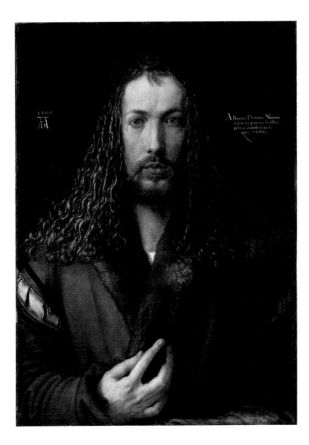

FIGURE 44 | Albrecht Dürer, *Self-Portrait*, 1500. Oil paint on wood panel, 67 × 49 cm. Munich, Alte Pinakothek.

FIGURE 45 | opposite | Albrecht Dürer, man wearing feather attire, in the Prayer Book of Emperor Maximilian, 1515. Munich, Bayerische Staatsbibliothek, 2 L.impr.membr. 64, fol. 41r.

artistry handmade by his Mexican fellows and its aesthetic effects, and the writer who in his treatise on painting (1525) solved the conundrum between artistry and idolatry, exonerating any excellent artwork from being the source of idolatrous deviation (which was, instead, ignorance) and locating its duty precisely in providing a therapeutic aesthetic experience. Could these four groundbreaking events in art history be related? Seen in sequence, the chain of these major interventions is impressive, to say the least. Until we find more historical proofs, one thing seems clear: the artistic objects handmade in "foreign lands" provided an exceptional vantage point to reflect on the vitality and variety of the human hand on a universal scale—what Las Casas will eventually identify as the indestructible and endlessly restorable creativity with which humanity is everywhere ontologically equipped. Interestingly, when, in 1515, Dürer illustrated in the Book of Hours of Emperor Maximilian, representing the divine universal dominion on all the people inhabiting the Earth, he depicted a man wearing intricate feather artistry, whose manufacture he depicted in full detail, evoking again the "subtle ingenuity" of foreign people (fig. 45). A Portuguese artist, probably in the very same years of Dürer's illumination, had associated the same intricacy to diabolic making: in the painting known today

minati:tunc immaculatus ero:
et emundabor a delicto maxi=
mo·Et erunt vt complaceant
eloquia oris mei:et meditatio
cordis mei in cõspectu tuo sem
per·Domine adiutor meus τ
redemptor meus·Gloria·An
tiphona · Sicut mirra electa
odorem dedisti suauitat͛ san
cta dei genitrix· Antiphona·
Ante thorum· ☙ Psalmus·
Omini est terra:et ple
nitudo eius orbis terra=
rum:et vniuersi qui habitant

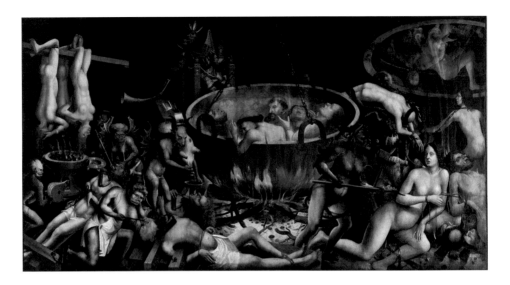

FIGURE 46 | *Hell* (four details of two devils and one sinner with feather garments), 1510–20. Oil on panel. Lisbon, Museu Nacional de Arte Antiga, inv. 432 Pint. Photo: Museu Nacional de Arte Antiga / Directorate-General for Cultural Heritage / Photographic Documentation Archive (DGPC/ADF).

as *Hell*, kept in the Museu de Arte Antiga of Lisbon, Evil and his assistants wear feather garments, as do their guests (fig. 46). The attention given to the very making of these artifacts—for instance, the impressive painterly rendering of their knots—demonstrates that the sublimity of human technical intricacy, its *deformis formositas* or *formosa deformitas*, could be condemned without mercy as idolatrous or elevated as sign of a universal artistic humanity.[56]

## Matter to Form in Hispaniola and Rome

By the 1520s, the indisputable human artistry of things (Dürer's *künstliche Ding*) made an ocean away was convincingly stated, both from within the discourse of idolatry and from outside it. Let us now step back and return to the opposition between *acheiropoieta* images and handmade idols. The text written in Hispaniola around 1497 by the Catalan Hieronymite friar Ramón Pané offers a good starting point for this inquiry as it both globalized the opposition overseas while also, unpredictably, turning idols into artistry.

Friar Pané arrived at Hispaniola on Columbus's second trip. Probably around 1497, he penned a brief narrative, most likely in Catalan, on his experience as a missionary. His original text is lost today, but it must have circulated in a manuscript version. As we have seen in chapter 2, Anghiera relied on Pané when describing the mythology of

Hispaniola to Pomponio Leto. He also explicitly referred to his writings in the *Decades*, when he recalled to Ludovico de Aragona his observation of the fine artifacts arriving from the island and circulating from Spain to Naples. Las Casas also relied on Pané's work to describe Hispaniola's customs. An Italian translation of Pané's text was published in Venice several decades later, based on a transcription contained in the memoir by Columbus's son, whose original is also lost.[57] The text includes large portions devoted to the statues handmade on the island and worshiped as gods. Pané judges these statues as unanimated ("cosa morta, composta di sasso o fatta di legno" [fol. 135v]), calling them, from the start, *idols* and highlighting how they were sculpted out of wood or stone in a large variety of forms. Yet, he also reports that the believers on the island named them *cimini* (according to the Italian version). Anghiera's transliteration in Latin spelled the same statues as *Zemes*, and Las Casas philologically intuited that the word should be spelled "*çemi*, with the last syllable long and acute."[58] I retain Las Casas's spelling.

Pané provided the most thorough description of these statues and their conceptualization according to the Native inhabitants of Hispaniola (fig. 47). It is by traveling through the landscape, they say, that *çemi* idols are found embedded in nature. For instance, a tree could signal that it wanted to be sculpted by moving its roots. A medicine man would then acknowledge it as a *çemi* and give it a recognizable form, following instructions given by the tree itself ("Dicendogli la forma nella qual vuole che lo faccia. Egli lo taglia e lo fa nel modo che gli ha ordinato" [fol. 137v]). This act of releasing form from matter immediately recalls Italian Renaissance ideas on the origins of sculpture. Alberti had affirmed in his *De statua* of 1464: "I believe that the arts of those who attempt to create images and likenesses from bodies produced by Nature originated in the following way. They probably occasionally observed in a tree-trunk or clod of earth and other similar inanimate objects certain outlines . . . some proceeded merely by taking away, like those who by removing the superfluous reveal the figure of the man they want which was hidden within a block of marble. We call these sculptors."[59] Michelangelo, who started carving precisely when the Hispaniola sculptures were being observed and described, will eventually reiterate Alberti's definition when asked to define what sculpture is: "By sculpture I mean that which is fashioned by effort of taking away [*per forza di levare*]." Probably influenced by the Neoplatonic concept of a priori forms existent within matter, especially marble blocks, Michelangelo's work, at least from his *Saint Matthew* (1503–6), reveals a deep conceptualization of artistic form as a gradual revelation—the *non finito* that we often associate to his signature.[60] But for our purposes, it is actually one of his first sculptures, the *Bacchus*, completed in 1497, that can trigger some comparative and connected remarks (fig. 48). Let us look at it, side by side with the *çemi* that is today kept at the Metropolitan Museum of Art.

Both figures are related to ecstatic states: the *çemi* holds on his head a plate for the inhalation of the hallucinogenic cohoba, while Bacchus holds a wine cup in his hand.

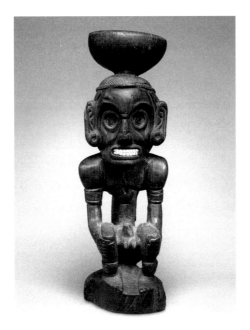

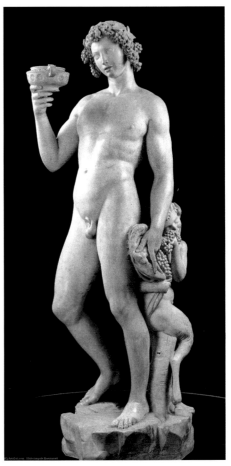

FIGURE 47 | Çemi, Taino culture, Hispaniola
(Dominican Republic), eleventh to fifteenth century.
Guaiacum wood and shell, height: 68.5 cm. New York,
The Metropolitan Museum of Art, 1979.206.380.

FIGURE 48 | Michelangelo, Bacchus, 1496–97. Marble,
203 cm. Florence, Museo Nazionale del Bargello.
© Su Concessione del Ministero della Cultura-Museo
Nazionale del Bargello.

Where the Hispaniola artist has carved the statue out of *Guaiacum* wood, Michelangelo
has chosen marble, but the challenge of transforming the stiffness of both materials into
portraits of rhapsodic states is comparable. In the case of *Bacchus*, we have the extraordi-
nary testimony of Michelangelo telling how he chose *that* specific piece of marble with
Cardinal Raffaele Riario, who had commissioned him to do "something beautiful."[61]
Michelangelo adds that the marble was "lifesize" (*d'una figura del naturale*), implying
that they could see the figure to be carved in the raw material. And indeed, today schol-
ars still refer to "Bacchus, the divine bearer of the drink, emerging from Michelangelo's
stone."[62] Although the çemi is seated while Bacchus stands in an unmistakable contrap-
posto, both figures are naked, their mouth open and showing their teeth, with their eyes
fixed. Also worthy of note is that, in both cases, the sculptures were collected and curated
through generations.[63]

We cannot demonstrate a factual connection between the theory of *çemi* making, as reported by Pané, and Michelangelo's *Bacchus*. We should note, however, that Pané's news was circulating in Rome precisely in the same year and precisely in Michelangelo's circle. Surprisingly, Cardinal Riario, who commissioned the *Bacchus*, was very close to Pomponio Leto, who, in that precise year of 1497, received excerpts of Pané's descriptions in Anghiera's letters (Eps. 177, 180, 181, 189). The simultaneity is telling and could help explain why the *Bacchus* was rejected by Riario. Did the cardinal decide not to install the pagan deity in his palace in part because of fear of being accused of promoting the idol viewing that was condemned overseas?[64] Beyond a historical connection worth pursuing in the future, the parallel viewing of the *çemi* today at the Met and the *Bacchus* at the Bargello de-exoticizes the genesis of the former and reveals similar material and social challenges that their artists were negotiating.

Let us now return to Pané's text. The Hieronymite continues his account of the beliefs associated with the *çemi* by talking about the three-pointed idols used in agricultural settings: "They [Indigenous people] believe that they [the *çemis*] make the yuca grow" (*hanno tre punte: e tengono che facciano produr la Giuca* [fol. 138v]). Downplayed as human-made artifacts by Pané, the *çemi* idols are yet referred to as highly portentous by the islanders. It is actually a *çemi* idol that prognosticated the arrival of the clothed people who would dominate and cause famine in the island. With this abrupt incursion of Spanish conquest, the text moves from the register of the idolatrous to that of the miraculous. In a testimonial tone, Pané retells how he and his missionary brothers brought to the island Christian images and how, before leaving for Castile, they left some of them in a land he had received to farm ("alcune possessioni che io aveva lavorate & fatto lavorare"), building an adoratory to allow local people to kneel in front of them. But a group of six local people stormed in, violently putting the Christian images on the floor, breaking them, covering them with soil, and urinating on them. They buried the images in a farmed land and sarcastically said, "Now you will bear good fruits from what has been planted." Had they in mind the three-pointed *çemis* that helped the yuca grow or were their comments sarcastic? We will never know, but Pané's following chapter, titled "Of what happened to the images, and of the miracle that God made, to show its potency" (fol. 144), unveils what grew from those broken Christian images.

After the conflict between the conquistadors and the inhabitants escalated and resulted in the murder of several people on both sides, a miracle occurred. Those broken pieces of Christian images grew under the field in the form of root vegetables that took the shape of a cross. The mother of the local cacique, who had resisted conversion until then, found them and immediately recognized the improbable discovery as a miracle, saying, "This miracle has been signaled by God, where the images have been found"

("Questo miracolo è stato mostrato da Dio, ove le imagini furono trovate" [fol. 144v]). An *acheiropoieta* cross had grown in the island. But its shape and function recall the three-pointed, artistically handmade *çemi*, making any blunt distinction between human art and divine miracle difficult to sustain.

## Artistic Incorporation of What Is New (Peru and West Africa)

The globalization of the idea of idols as human-made and its unpredictable effects are differentially perceptible in Felipe Guaman Poma de Ayala's monumental work, *El primer nueva corónica y buen gobierno*, written and illustrated around 1615/16 in Peru and addressed to Philip III. A trilingual speaker of Quechua, Aymara, and Spanish, Guaman Poma had been, back in the 1560s, translator and assistant to the Spanish friar Cristóbal de Albornoz, who had undertaken a thorough investigation on and extirpation of local beliefs considered idolatrous. Guaman Poma's position is therefore complicated: while he contributed to the discourse of idolatry, he also kept a critical stance toward this weapon of colonization, explicitly denouncing the excessive violence used to punish idolaters. In this and some of his other open condemnations of Spanish rule, Guaman Poma was clearly influenced by Las Casas and Santo Tomás.[65]

Guaman Poma dedicated a section of his manuscript to what he refers to as "idols and *uacas*," producing an assemblage between the Quechua/Aymara concept of *huaca*, a sacred entity that could be imbued in a variety of material phenomena and things—a mountain, rainfall, an animal, a particularly beautiful flower, or an object—and the term *idol*. Through this assemblage, Guaman Poma short-circuits the difficulty of translating the pre-Hispanic term, something comparable to what the Spanish Francisco de Ávila was doing in the same years in his treatises on local idolatries.[66] The accompanying images sustain his translation, depicting *huacas* with clear characteristics attributed to idols, as Lisa Trever convincingly demonstrates.[67] This precise materialization can be also regarded as the lure of being able to extirpate them.[68] But in the framework of our discussion, it is interesting how the materialization transforms the *huacas* into sites of indisputable human artistry. One drawing is particularly relevant here (fig. 49). It depicts the Sapa Inca being able to talk with the *huacas*, which are presented as twelve animated sculptures in a circle. Both their positions and their spirited character enable viewers to appreciate their tridimensional carving in the round. But if we look carefully, the anthropomorphic statues sport hats clearly associated with the Spaniards, as is evidenced in other drawings of the *Nueva corónica*.[69] Therefore, in spite of being located in a pre-Columbian time, where the Inca could speak with the *huacas*, their visual rendering as idols turns into a commentary on how Native artistic activity refracted the irruption of the Spaniards.

FIGURE 49 | Guaman Poma de Ayala, Sapa Inca talking with the *huacas*, in *El primer nueva corónica y buen gobierno*, ca. 1615. Copenhagen, Royal Library, GKS 2232 4°. Photo: Royal Library of Denmark, Copenhagen.

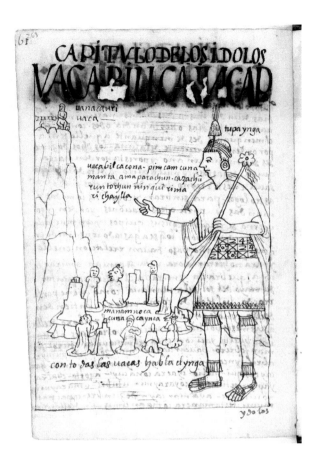

The Dutch trader Pieter de Marees, in his *Description and Historical Declaration of the Golden Kingdom of Guinea*, published in Amsterdam in 1602, makes a comparable remark regarding the so-called *fetissos* observed in West Africa:

> Around their necks they hang a string of beads or pearls [*madrigetten*] of diverse colors, which are brought by us Dutch, but a member of the Nobility or someone who wishes to be a great Nobleman has golden Rings around his neck. Around their feet they have straw-wisps made of reeds. They call these *Fetisso* (referring to their idolatry) . . . ; generally, they also wear a string of polished Venetian Beads mixed with golden beads and other gold ornaments around their knees, in nearly the same way as young ladies in our Lands wear their rosaries [*paternosters*] around their hands. Furthermore, they wear caps . . . they make hats out of green reeds, with broad rims after our fashion [*op onse fatsoen*].[70]

Derived from Iberian medieval law to name all sort of fictitious charms, the term *fetisso* rapidly became a staple of African religiosity.[71] But, in fact, De Marees did not hesitate to

FIGURE 50 | "Fetish," in Christen Smith and James Hingston Tuckey, *Narrative of an Expedition to Explore the River Zaire, Usually Called the Congo* (New York: W. B. Gilley, 1818), 376. Courtesy of the New York Public Library.

equal *fetishes* with both *idols* and *saints*, blurring the distinction between Africa and Catholic Europe. This is also evident when he documents the high vitality of *fetisso* making at the time: instead of presenting them as exotic products of local beliefs and materials, De Marees records their artistic capture of what is new, in a way comparable to Guaman Poma's *huacas*. A later illustration and description of African fetishes clearly retain this characteristic (fig. 50). In their *Narrative of an Expedition to Explore the River Zaire, Usually Called the Congo*, published in 1818, the English travelers Christen Smith and James H. Tuckey describe the composite and novel manufacture of these multimedia artifacts, pointing to how they can be composed by "the horn, the hoof, the hair, the teeth, and the bones of all manner of quadrupeds; the feathers, beaks, claws, skulls, and bones of birds; the heads and skin of snakes, the shells and fins of fishes, pieces of old iron, copper, wood, seeds of plants, and sometimes a mixture of all or most of them, strung together."[72]

## Overmade and Remade Idols in Mexico

With the texts of Pané, Guaman Poma, and De Marees, we have seen how the category of the idol served the discourse of idolatry, Christianization, and colonization while also intersecting in different ways with the nascent modern concept of art: the idol was itself a materialization, a memento of the vitality of the artistic process *tout court*. In all three cases, *çemi* idols, *huacas* idols, and *fetisso* idols captured the novelty of the contemporary world: the agricultural power associated to three-pointed *çemi* metamorphized in an *acheiropoieta* cross made of yuca, the polymorphous nature of the *huaca* anthropomorphized in characters wearing Spanish hats, and the *fetisso* (a term in itself already mixed) combined local materials and referents with materials and forms brought by colonial trade. Minute Murano and gold beads were strung together to create rosaries, and Dutch wide-brimmed hats were made with West African reeds.[73]

Our excavation of the unexpected outcomes of the discourse of idolatry, however, has not yet confronted the most paradigmatic document where idols are the indisputable protagonists: the Inquisitorial proceedings in a trial for idolatry. Actually, what did an accusation of idolatry entail? From a strictly juridical point of view, the accusation of idolatry, as Rosalba Piazza remarks, is incoherent. An idolater should simply be converted, not punished. This is why, very soon, during the decades of the so-called apostolic Inquisition, the accusation in New Spain was coupled with that of heresy. Once the Indigneous population was subtracted from the authority of the Inquisition in 1569, however, the sin of idolatry became the most characteristic one attributed to them.[74]

The trial of the Indigenous leader of Texcoco (Valley of Mexico), Don Carlos Ometochtin Chichimecatecuhtli, dated 1539, is well known in colonial historiography.[75] On June 22, 1539, after being denounced by an Indigenous nobleman of the region, Don Carlos was accused by the Mexican apostolic Inquisition of bigamy, idolatry, and heretical dogmatism. He was sentenced on November 30 of the same year and executed the next day in the Plaza Mayor of Mexico City. The process involved renowned witnesses and translators, including the Franciscans Alonso de Molina and Bernardino de Sahagún. During the five months of the trial, and particularly during the first three weeks, Bishop Zumárraga tried to gather all the information about Don Carlos's behavior, tailoring a questionnaire in which "idols"—their making, their display, and their worship—played a crucial role. Nearly thirty local witnesses responded. The transcription of the trial reveals the deep political tension internal to the local nobility, who, as Lopes Don remarks, "abandoned him [Don Carlos] to the Spanish stake."[76] Barely twenty years after the Spanish arrival, idolatry was offered by the apostolic Inquisition to the Indigenous population as a powerful weapon against their own Don Carlos. Yet, the witnesses' oral depositions about the leader's idolatrous practices were halfhearted, ambiguous, and unsatisfactory. After having found material proofs of Don Carlos's supposed idolatry, Inquisitors therefore launched thorough fieldwork through the region.

The investigation started in Don Carlos's main house, on July 4, 1539, where the Inquisitors went to seize the accused's personal belongings.[77] This first catch was poor: four wood bows, ten or twenty arrows, one painted book, and several scarfs (*mantillas*), all of which were considered so inconclusive (*de poca importancia*) that they were left with Doña María, Don Carlos's wife. The Inquisitors were then told that the leader had another house and were brought there by the nobles of Texcoco. There, they found two sets of stone sculptures (*figuras de ídolos de piedra*)—the first one openly on display, the second hidden inside the wall and visible only once the first row of statues was knocked down. The local witnesses told the Inquisitors that these were the "figures" of Quetzalcoatl, Xipe, Coatle, Teocatl, Tecoacuilli, Cuzcacaotlitli, Tlaloc, Chicomecuautli, and Cuanacatl, several temples' models, and thirty other "figures of different kinds" (*figuras*

*de otras maneras*). All the human-made statues were gathered and brought to Mexico as evidence in the trial. The expression "para hacer sobre ellos justicia" may suggest that they were also somewhat "sentenced," as if they were actual people.

Another series of interviews followed in order to inquire whether the statues were venerated and which particular ceremonies were associated with them. But the answers were, again, unsatisfactory. A certain Pedro, who was present during the discovery of the idols, seems to have deposed in Spanish. He said that he had previously noticed that these figures were on display on the wall but that he had always looked at them "as stones" (*como a piedras*). In his succinct yet powerful statement, Pedro highlighted the material dimension of the sculptures and nuanced the religious one. Another witness, Gabriel, was deposed in Nahuatl, which was translated by the Spanish clerk Juan González. Gabriel said that he was also present when they demolished the wall ("e vido deshacer la pared y pilares de donde se sacaron los dichos ídolos"). But he then declared that even Don Carlos had not offered anything to those statues: "He always just entered where the said idols were, he looked around and came out."[78] Gabriel said that he, too, had noticed the "idols"—here the Spanish translation of his deposition uses the very term—that were visible on the wall but that he looked at them just "as broken stones, displayed on the wall" (*como piedras quebradas puestas en la pared*). It is difficult to know what Gabriel precisely meant here. Did he insinuate that those "idols" had been broken on purpose, that there had been local "idoloclasty," so that Don Carlos could not be considered idolatrous? Or should one rather imagine that the translation failed? What became "broken" could have been in fact the verb *tzayana* (cut), denoting the pointed angular shape obtained by taking away the material ("per forza di levare," as Michelangelo would say). An astonishing stone sculpture of Xiuhcoatl kept today at the British Museum and whose provenance is precisely Texcoco makes us wonder if the term could not have referred to this very style (fig. 51).

As for the translation "idols" chosen by the clerk, we will never know which precise Nahuatl term Gabriel used, but it was probably one of those provided by the Franciscan Molina (who participated in the trial) in his dictionary of 1550. The most plausible seems the composed word *tlachichihualtin*, translated as "ídolos labrados y compuestos y adereça-dos."[79] *Chihua* means "to make," and its repetition (*chichiua*) in the agglutinated noun denotes its *overmakingness*, which is rendered in Spanish in the series of human actions associated with idol making: to labor, to compose, to decorate. The same verb *tlachihua* reappears in other sixteenth-century sources. In his *Descripción de la ciudad y provincia de Tlaxcala*, the mestizo Diego Muñoz Camargo calls the pyramid of Cholula *tlachiualtepetl*, adding, "It means in the Mexican language 'handmade mountain' and it seems that it is a work made by human hands, because it was made with brick and adobe, thick and in great quantity."[80] To point to the instability of meanings, we note that while Molina translated

*tlachihua* as "hechizar," Sahagún eventually recurred to the same Nahuatl verb to refer to Christian divine making. In his *Psalmodia Christiana* of 1584, in a verse of a choral where God made himself into the body of Christ (*corpus induit*), he precisely used *tlachihua* to translate the Latin *inducere*.[81]

In the following days of the trial, other depositions followed: the witnesses continued to downplay the presence of the idols (several witnesses affirmed that Don Carlos had placed them as a joke—"jugando," "de burla") and used the statues to distance themselves from the sin of idolatry, bringing as proof idols that they did not idolize. Inquisitors inspected them. One of them was an old statue of Tlaloc, which the proceeding textually dissected to identify how it was made (with a greenstone,

FIGURE 51 | Xiuhcoatl, Texcoco culture, Mexico, 1300–1521. Stone, 77 × 60 cm. London, British Museum, Am1825,1210.1. Photo: Trustees of the British Museum.

different seeds and substances, "ole, chia, maiz y cyetl e cuauhtle"), mentioning also how it was repaired with gold and copper wires.[82] After the statue of Tlaloc, idols kept appearing. Attention was turned to several figures sculpted on a hill. The Inquisitors ordered the locals to "undo them and break them . . . to take their shape off and the features of the face, so no memory of them would remain" (*quitarles las formas e figuras de las caras . . . de manera que no quedase memoria de ellas*).[83]

So, from one side, idols kept appearing but with no confirmed idolater. Even Don Carlos's wife candidly affirmed that "no le conoció ni sintió ídolos ningunos": she did not know of him having any idol nor had she had any impression about that. It was then the turn of Don Carlos himself, whose deposition was translated by none other than Bernardino de Sahagún. Don Carlos's truth was plain: yes, there were "idols" in his home (he said that his uncle had put them there on display), but he did not consider them idols nor did he know they were (*no tenia por ídolos aquéllos ni los conocía como tales*).[84]

Had Dürer been the Inquisitor of this process and had Don Carlos succeeded in proving that he did not worship those sculptures as idols (even though those statues were idols in the sense of handmade objects), he would have probably absolved him. But the Inquisition did not, as a separation between the manufactured origin of those statues and

the sin of idolatry was not institutionally possible. Don Carlos was publicly sentenced in the Plaza of Mexico, and his last public words to his people, according to the *Proceso*, were that "they take him as an example and free themselves from their idolatries."[85] The discourse of idolatry had turned in on itself, with Don Carlos trapped inside. He probably did not really pronounce those words that day, but as a character of this infamous Inquisitorial sentence, he did.

Bishop Zumárraga's decision to burn the cacique of Tezcoco was immediately denounced, and a royal junta was assigned the role of judging the Indians, under Viceroy Méndoza. Las Casas seems to have had an impact on this decision, as in 1539 he wrote extensive works on the pacific conversion of the Native inhabitants, denouncing how guilty are "even those who have the authority of bishops" to correct the Indians for supposed sins they had done before or after being converted.[86] This is probably why he decided to do the exact opposite: to praise the art of the idol as a proof of their authors' rationality. Where Zumárraga and his officers scrutinized the idols with obsessive focus on their making and remaking to prove their human authorship, Las Casas scrutinized the human authorship of the idols to prove their artistry. Through their physical and textual dissection, the trial found the materials of which idols were composed and with which they were repaired. In contradistinction, Las Casas looked at the idols' final appearance, intuitively praising the process used to compose them. But, actually, how was an idol made?

## An Idol in Contrapposto

Even though, from a Christian perspective, idol manufacture was the main argument against them, the representation of their creation is almost completely absent in medieval and early modern visual sources. The wrongness of their human fabrication was rather suggested by the exaggerated forms of an idol (its *formosa deformitas* and *deformis formositas*) or by the total insignificance and antirepresentability of its making—astutely depicted in a French *Bible Moralisée* that portrays the idol as a ghost, bare of paint.[87]

The very act of "idol" making was surprisingly painted by an artist in New Spain around 1570, within the Florentine Codex, the monumental work composed by the Franciscan friar Sahagún and Nahua scholars, in Spanish and Nahuatl, and illustrated by painters creatively transforming Mesoamerican and European repertoires (fig. 52). At the end of the first book, devoted to "Gods," Sahagún added an appendix titled "Confutación de la idolatría"—a disproof of idolatry—based on selected parts of the Book of Wisdom, which were transcribed in Latin from the *Vulgata*, translated into Nahuatl with important additions and illustrated.[88] Let us quickly review the relevant excerpt from the Book of Wisdom:

FIGURE 52 | "Idol" making, in the Florentine Codex, ca. 1570. Painted manuscript on paper. Florence, Biblioteca Mediceo-Laurenziana, MS Med. Palat. 218, fol. 38r. Su concessione del Ministero della Cultura. Any other reproduction is prohibited with any medium.

156

If an artist, a carpenter, hath cut down a tree proper for his use in the wood, and skillfully taken off all the bark thereof, and with his art, diligently formeth a vessel profitable for the common uses of life. . . . And taking what was left thereof, which is good for nothing, being a crooked piece of wood, and full of knots, carveth it diligently when he hath nothing else to do, and by the skill of his art fashioneth it, and maketh it like the image of a man: And maketh a convenient dwelling place for it, and setting it in a wall, and fastening it with iron, providing for it, lest it should fall, knowing that it is unable to help itself: for it is an image, and hath need of help.[89]

The Nahuatl translation of this text is quite literal, but it adds important precisions about making that are not found in the *Vulgata*. Most important, the Nahuatl text says that, in order to sculpt a man, the artist had to shape every body part, "a head for it, and eyes, and a face, and a body, and hands and feet" (*qujtzontecontia, qujxtelolotia, qujxaiacatia, qujtlactia, qujmatia, qujxitia*). In the image that accompanies this passage on idol making, a trunk of wood is transformed into a humanlike statue. Three moments coincide: a man cutting down a fresh, green tree; the knotty trunk lying on the ground; the sculptor rapidly carving the wood into a well-shaped form. On the bottom, the finished sculpture now features sacred attributes. It stands in front of two kneeling young men who offer round items, while a taller man, referred to in the Book of Wisdom as the father, is admiring the statue in a composed attitude.

There are several elements where the image departs both from the *Vulgata* text of the Book of Wisdom and from the Nahuatl text. First, the sculptor and the devotees are depicted with iconographic elements associated postconquest with the Mexica: the *tilmatli* (cloak), the *maxtlatl* (loincloth), and the distinctive hairstyle. They also offer to the statue what seem to be tortillas. Furthermore, the statue is wearing recognizable attire associated with several "deities" of the Mesoamerican pantheon (e.g., the scepter, the conic hat with cotton finishing).[90] The idol-making scene is therefore relocalized in Mexico or in New Spain, which makes the story current and relevant. But there are two less-apparent elements that depart from the original text. First, the seemingly broken arms of the statue-in-progress make it resemble damaged ancient sculptures, such as the famous Apollo Belvedere, or statues that had been damaged on purpose, as the Mexican "idols" were.[91] There could also be another explanation, as we will see shortly. The second element that meaningfully diverges from the text is the fact that the finished and now-intact statue in the lower panel is standing on its feet. There is no need to put it against a wall and fasten it with iron, as the Book of Wisdom states—"with pegs, or iron nails," as the Nahuatl text specifies. The sculpted god stands freely, and even more important, it almost moves. How? Because it is sculpted (or, rather, it is painted to appear sculpted)

in a subtle yet unmistakable contrap-
posto position: the left knee is slightly
bent, while the right leg is extended. This
very particular stance had been invented
by Greek sculptors and was frequently
re-created by Renaissance artists, often
via the intermediary of Roman copies
unearthed in the fifteenth and sixteenth
centuries. The contrapposto position
could infuse liveliness to any sculpted
or painted body.

The painter of the Florentine
Codex was well acquainted with this
Renaissance visual idiom that had been
"globalized" by the Iberian expansion
via engravings (fig. 53). But I believe
that in this representation of idol mak-
ing, there is more at play than stylistic
borrowing. In this image of the Floren-
tine Codex, the idol in contrapposto is
an artistic device that equates Mexica
sculpture with Renaissance and classi-
cal sculpture. Representing a Mexica
statue in this distinctive classical posi-
tion was undoubtedly anachronistic: in
pre-Hispanic Mesoamerica, full-body

FIGURE 53 | Marcantonio Raimondi, *The Apollo Belvedere*,
ca. 1510–27. Engraving, 29.1 × 16.2 cm. New York, The
Metropolitan Museum of Art, 49.97.114.

sculptures were carved in varied positions but never in contrapposto; for standing fig-
ures, sculptors seem to have privileged hieratic postures (see fig. 42).

Therefore, that equation is based on an element that is not factual. It is rather a way
to say that Mexica sculpture is comparable to—in the sense of equal to—contrapposto
Renaissance or classical sculpture. Now, what is comparable is that, although the object of
all those sculptures can be "wrong" (representing false gods), their human manufacture is
highly artistic—in contrapposto or not, in marble, bronze, wood, and so on. Furthermore,
the painter of the Florentine Codex image has perhaps added an important commentary:
the missing arms of the statue-in-progress could also point to the technical fact that in
order to make a wood idol with extended arms, the sculptor would have needed to sculpt
the pieces of the arms in at least two wood blocks and then combine them. The Floren-
tine Codex painter probably had in mind the wood crucifixes or representations of saints

that were then being made in New Spain.[92] In this aspect, the image therefore could refer also to the new artistic form of Christian religious imagery that was explored at the time by local artists.

While it is included in a "confutation of idolatry," the Florentine Codex image subtracts itself from the Christianization project and from the discourse of idolatry in one paradoxical point: participating in the contemporary debate about the independence of artistry from a worship's function—good or otherwise. If it is true that the Renaissance debate of what art is shifted from the object of representation to the principles of representation (proportion, *disegno*, and so forth) and to a reflection on the process of art making in itself (such as how to give liveliness to a figure),[93] we can better understand the proactive role of "idols" in this debate. There can be beautiful idols because now the object of representation and its formal characteristics can be evaluated separately. There can be false gods but beautifully represented. The human manufacture of those sculptures points precisely to the intention of the artists who created them: "la figura que el artifice quiso dalles" (the figure that the artificer wished to give), as the Jesuit José de Acosta wrote in his discussion of handmade idols.[94]

## Pleasurable Artistry Beyond Orientalism

The philosopher Jean-Luc Marion has analyzed what is revealed by the etymological differences between the terms *idol* and *icon* and how the original meanings of the two words remain active throughout the centuries in the practices associated with these terms.[95] In the Greco-Roman and biblical tradition, the idol (from Gr. εἴδωλον / Lat. *eidolon*, deriving from εἶδος [that which is seen]) pertains to the realm of the gaze. According to Marion, it would even be "a function of the gaze."[96] To the contrary, the icon (from Gr. εἰκών / Lat. *eiko, eoika*, deriving from εἰκώ, "to be like, seem likely") is a "semblance"—in Saint Paul's own words, "of the invisible God," who remains always invisible even if depicted by the icon.[97] In the Christian tradition, therefore, the relations of the idol and the icon with the realm of vision are antithetical: the idol results from a vision, and the icon provokes one (of the invisible).

The fact that "the idol places its center of gravity in a human gaze" can help us explain why, in the context of the Iberian expansion, authors so laboriously recorded this visibility in terms of subjective observation.[98] In order to demonstrate that they have seen idols with their own eyes, they invented myriad ways to describe this visibility, often in terms of a true aesthetic experience. In their texts, therefore, the category of the idol vividly mobilizes gaze, observation, and ultimately writing itself. Both aesthetic experience and ekphrasis produce understanding, which frequently recurs to comparison and connection with other artistic expressions. A text that suggestively addresses the experience

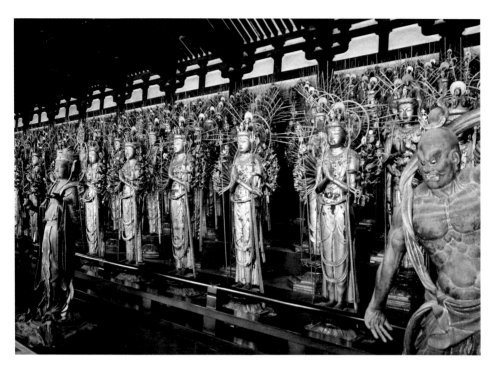

FIGURE 54 | Interior of the Temple of Sanjūsangen-dō, Kyoto, twelfth to thirteenth century.

of the "idol" in aesthetic terms is a passage from the *History of Japan* written around 1585 by the Portuguese Jesuit Luis Frois and based on several decades of missionary work in Japan, where he had arrived in 1563. Frois kinetically describes the Buddhist temple of Sanjūsangen-dō, "the temple of the Thirty-three Bays," in Miyako, today Kyoto (fig. 54).[99] The passage on the idols is introduced by Frois as one of the proofs of the "limpeza e concerto" (order and harmony) of the Japanese people:

> One can appreciate the level of veneration and esteem that the Japanese anciently had for the cult of their idols. Outside the city of Miaco there is a temple called Sanjusanguen; it has a unique doorway in the middle, big, in front of which there is the figure of Amida, to whom the temple is dedicated; it is tridimensional [*de vulto*], seated in the position of a Brahmin, with his big ears pierced, the beard shaved, and the hair on the head frizzy; it is very tall, completely gilded, and in no way inferior to what can be done in Europe. All around this great machinery of the idol, on its sides, there is an enormous number of minute statues of *fotoques*, also gilded. All this, as mentioned, is displayed after one enters the door situated exactly in front of this big *fotoque*. Extending the eyes through that big and frightening number of figures is a very noble thing.[100]

FIGURE 55 | Tankei, *Senju Kannon*, twelfth to thirteenth century. Kyoto, Temple of Sanjūsangen-dō.

Following the movement of the Jesuit from the exterior to the interior of the build-
ing, readers approach the gilded statue of Amida and the one thousand statues that lead
to it along the 387 feet of the temple's length. The visibility of the whole and, in particular,
of what Frois recognizes as Amida—the statue of Senju Kannon, carved, lacquered, and
gilded by the sculptor Tankei (1173–1256)—begins upon entering from the former single
doorway of the building (fig. 55). This architectural element secures a frontal encounter
with the statue, and yet this focused vision is progressively fragmented into a thousand
other potential glances toward the statues disposed on either side, referred to by Frois as
*fotoque*, adapting the Japanese term *hotoke*, 仏. The paragraph ends with apparent non-
sense: "Extending the eyes through that big and frightening number of figures is a very
noble thing."

Describing the visibility and multiplicity of idols—even linguistically, since the term
*fotoque*, as elsewhere *cami* (or *kami*, Jap. 神), is used by the Jesuit to diversify the types
of idols—and recalling the subjective experience resulting from that view, Frois delivers
here a sort of Japanese counterpart to the theory of vision proposed by Nicholas of Cusa
in his *De visione Dei, sive De icona* (On the vision of God, or On the icon; 1453). In the
preface of his treatise, the German theologian had invited the recipients of his text, the
monks of the abbey of Tegernsee, in the Bavarian Alps, to perform a spiritual exercise in
order to understand the "gaze of the one who sees everything." He asked his addressees

to display a painted icon of God that he had sent along with the text on the north wall of the building and then, each one taking a different position but remaining at an equal distance from the icon, to look at it. From any of the diverse perspectives, the monks will see that the eyes of God look directly at each of them. The icon can follow their gazes— even if two of them moved in opposite directions while observing it—while remaining exactly in the same position. In Cusa's own words, "This immobile face moves at the same time towards the east and towards the west, towards the north and towards the south."[101] Michel De Certeau's acute reading of this text is worth quoting here: "This mathematical liturgy brings into play a space divided into places by a system of differences among single entities constituted by their reciprocal positions."[102]

In Frois's tale of the Buddhist temple of Sanjūsangen-dō, on the contrary, we witness the transformation of the gaze of the observer approaching the central figure. Nothing remains immobile. The Jesuit even calls Amida "the great machinery of the idol," stressing the dynamic effects achieved by the whole. The accent is put on the spectator's look, not on the fact that he is looked at by Amida and by the *fotoque*—something that would furthermore be impossible in a Christian definition of the idol, since this is always unanimated, so it cannot see. There is a further aspect, in Frois's tale, that calls our attention. What apparently seemed, at the beginning, as a frontal view achieved from the single doorway, in fact, splits into a continuous delocalization of the observation. Frois relates here his own all-seeing experience—a visual experience that he cannot address except in terms of the potentially infinite multiplication of *fotoque*: their "enormous number" gets symbolically closer to the infinite than to one.[103] His vision has changed, as has his own way of theorizing about images. We cannot therefore posit a Jesuit image theory in Frois without considering the deep transformation of his thought after his encounter with the arts seen in the the Buddhist temple of Sanjūsangen-dō.[104] Buddhist aesthetics became embedded in Jesuit art theory.

Comparable descriptions of idols are frequent in texts on Asia. In Beijing, the Portuguese traveler Fernão Mendes Pinto, for instance, marvels at "a large number of idols of different shapes . . . yet the total effect of the structure, when seen altogether, was much more striking and agreeable than one would expect because of the way in which it was laid out. . . . There was a silver idol in the shape of a woman who, with both hands, was strangling a serpent that was beautifully painted in green and black."[105] With his phrase, "more striking and agreeable that one would expect," Mendes Pinto anticipates the prejudices of his readers and transports them in the intensity of his all-embracing subjective experience ("when seen all together"), pointing not only to a distinct direction that creation has taken on the other side of the world but to the way vision, writing, and understanding are transformed by it. If analogy and comparison are recurrent narrative tools in other texts (Frois, for instance, affirmed that Japanese gilded statues were "in no way inferior

to what can be done in Europe"), here Mendes Pinto, rather, tries to translate what he had observed in accurately distinctive terms. Also, in an even more unexpected way than Frois, Mendes Pinto further separates the supposed error of the idol from its aesthetic dimensions. The frightening iconography of "a silver idol of a woman who, with both hands, was strangling a serpent" does not interfere at all with the appreciation of the serpent's artistic quality, "that was beautifully painted in green and black."

## Idols as Art

Conquistadors and missionaries condemned, sought, smashed, and burned idols while, simultaneously, seeing their art (*arte*) and even beauty (*bellezza*). The paradox is striking. Recall, from the second chapter, how Zorzi, in annotating the Italian translation of Anghiera's "First Decade," commented: "In a certain place they saw two statues made out of wood: they were placed on the top of two serpents. They thought that they were their idols. But they were displayed as such only because of their beauty [*bellezza*]."[106] If it is true that supposedly discovering idols made it possible to initiate the conquest of the local populations and to Christianize them under the pretext of their erroneous beliefs, there was also something in the projection and deep transformations of the category of idol that was worth excavating in a completely different direction. How did the "idols" observed all around the world also participate in a new definition of the artistic object?

The thesis proposed in this chapter can be summarized as follows. An "idol" is recognizable for its visible, human-made, creative aspects. If idols and icons were antonyms of a sort, idols and artworks were not. The observation of the infinite number of "idols," furthermore, participated in the advent of a new subject—one that is no longer *seen* but whose look needs to continuously delocalize itself in its desire to see as much as possible. At the opposite of Cusa's exercise, where the fixed gaze of the monks is observed by an all-seeing (and all-powerful) icon, in the texts written in the context of the Iberian expansion (often authored by missionaries), it is the authors' own all-seeing observation of a potential infinity of idols that mobilizes both the aesthetic experience and the writing process.[107] This theoretical perspective emerging from the archive both dialogues with, and diverges from, some of the considerable scholarship dedicated to the question of the idol and idolatry.

Inquiring about the relationship between the discourse of idolatry and the Iberian expansion in early modernity, Carmen Bernand and Serge Gruzinski propose that key categories, such as idol, priests, temples, rites, ceremonies, myths, sacrifice, and so on, have been used in the context of the conquest of America by conquistadors and missionaries not as any other European lens but precisely in order to convey that the Indigenous

population had religions—religion being paradoxically also one of these exported and imposed key categories.[108] They further point out how this vocabulary has remained practically unchanged four centuries later, both in the scholarship written on the pre-Hispanic world and on the colonial period. Objects presented in museums also depend on the supposedly self-evident meaning of the term *idol*. Through their "archeology of the religious sciences," Bernand and Gruzinski brilliantly demonstrate that the fabrication of a Native religion appears to have had a long-term impact on our perception of these societies, when, in fact, this fabrication is rather the result of the viewpoint of the conquest.[109]

As we have seen, however, from an art-historical perspective, this same discourse held some surprises. The same conquistadors and missionaries, when confronted with the reality of the objects that they had under their eyes, reoriented the category of the "idol" toward a direction that concerns essentially both the most creative aspects of the objects and the profound transformation of the subjective relationship to them. Going back to the primary texts, we realize that these two attitudes toward a panoply of objects found in Mexico and throughout all the territories touched by the Iberian expansion—seen under the lens of the idol and yet celebrated for their aesthetic qualities and their new effects on the looking subject—were, in fact, simultaneous. They were even two facets of the original concept of "idol": tied to the most pejorative of meanings (manufactured statues of false gods or the devil) and to the most intriguing artistic dimensions of object making (creation, matter, making, display). The complex coincidence of these two facets happened in situ, and it is difficult to separate a history of the conquest and Christianization from a history of its response in European collections. Even Diego de Landa, the unforgiving planner of the 1562 auto-da-fé of Maní, in Yucatan (in which twenty thousand statues and painted manuscripts were burned and destroyed), detached object making and belief. We read in his *Relación de las cosas de Yucatán* of 1566: "They knew perfectly that they had made them perishable and not divine; but they honored them because of what they represented and because they had made them with many ceremonies, especially the wooden ones."[110] Thus even for one of the most zealous of missionaries, a separation between making and worship is possible. What is revered is the artistic process itself. Cortés, Díaz del Castillo, de Landa, Frois, the Florentine Codex, the Inquisitorial process, Pané, Guaman Poma, and De Marees (and we could add a panoply of sources on India, Brazil, the Philippines, and so on) are all paradigmatic of the clichéd use of the category of idol as much as the unexpected transformation of this category.[111] Even though their material dimension was indeed symptomatic, under the Christian lens, of their treachery—made, fabricated by human hands, and hence false—the biblical interdiction of the Mosaic commandments ("You shall not make idols . . .") lost at least some of its ideological predictability and impermeability in the real face-to-face encounter with new forms.

164

In this aspect, my reflection rejoins Joan-Pau Rubiés's proposal on the innovative dimensions of the use of the category of idolatry from the vantage point of the history of religions. If, from one side, the concept of idolatry indeed helped conquistadors and missionaries to fabricate a Native religion, from the other, it also "needed interpretation in the light of an observed reality." According to Rubiés, in the context of the Spanish and Portuguese expansion, the concept of idolatry shifted progressively from theological and demonological terrain into the pre-ethnographic and historical. Rubiés considers that this progressive migration generated from the "intellectual atmosphere in the European Republic of Letters, a change which we might date around the 1650s."[112]

In this chapter, I examined how the concept of idol shifted to the art-historical terrain, both outside and inside Europe. Recording the manufacture of works considered as idols resulted in the most dynamic observation of the vitality and variety of the human hand's sublime creativity—what we can envision as a new definition of artistry tout court—in full contemporaneity and generative connection with the pictorial, sculptural, and textual statements of a Dürer or a Michelangelo.

# Novel Territories of Painting
## Coordinates for Another Renaissance

*Indians have brought something new and singular to the art
of painting.*
—Felipe de Guevara, *Comentarios de la pintura*

As seen in the previous chapter, "idols" brought something new to the history of art. While the discourse of idolatry was deeply anchored in the advance of Christianity, an unforeseen reversal happened within that same discourse and exceeded it: what I call "the art of the idol." Two methodological staples of the discourse of idolatry—the description of intricate and visibly nondivine human making and the demonstration of its dangerously pleasurable effects on viewers—made the idol paradoxically ambiguous: its status oscillated between theological judgment (specifically Inquisitorial verdict) and artistic scrutiny. The use of specific expressions, such as *mira arte, maestrevolmente lavorati, künstlich,* and even the recourse to the term *sublime* and its cognates, stands out as efforts to ekphrastically value the subtlety of the human artistry of idols as severable from the wrongness of their worship.

The present chapter continues excavating what "the subtle ingenuity of people in foreign lands," borrowing Dürer's felicitous aphorism, brought to the history of

art history by focusing on a particular awareness of the intersections of artistic pan-orama on a global scale. At the beginning of this book, we studied how Holanda turned to the concept of the antipodes to highlight how the artworks made in a previously unknown zone of the atlas decentered and then universalized the multiple origins of artistic excellence. In this chapter, I address the imbrications between the territories of nascent, national art histories and the ubiquity and high caliber of artworks circulat-ing—and having an impact—transnationally. Starting in Nuremberg, in 1500, with an epigram composed in honor of Dürer and clearly referring to the contemporary global extension of the artistic atlas, I move on to analyze the ways in which three treatises written in the mid-sixteenth century mapped artistic novelty: Vasari's *Vite*, once again Holanda's *Da pintura antiga*, and Guevara's *Comentarios de la pintura* (Commentaries on painting; 1567). I inquire into the ways in which the three authors located in space three distinctive "rebirths" of the arts after the supposed decadence brought about by the barbarian invasions of the Roman Empire.[1] In spite of being a term more tied to time than to space, the rebirth is addressed by all three authors in a bold geographical dimension, even more precisely in a geopolitical dimension—in close dialogue with the political projects of three rulers: Cosimo I de' Medici, John III of Portugal, and Philip II of Spain, three major collectors of artifacts coming from the Americas, Asia, and Africa. But for Guevara and Holanda, the artistic treatise is also the occasion to enter into a critical relationship with political expansion and to create yet another ter-ritory, an artistic territory, which the monarch or governor cannot completely conquer but needs to keep desiring. This artistic territory can limit the violence of the conquest and expansion effort, according to these two authors. Guevara also boldly states that the "Indians" brought something new to the art of painting—feather painting. It is a passage that echoes the clarity (and even the exact wording) with which Las Casas demonstrated the novelty of this unique art form for the entire world, as analyzed in the third chapter.

The final part of this chapter tackles the impact that the transnational circulation of this particular novel form of painting had in two specific microcosmic representations. One is the *Map of the Ten Thousand Countries on the Earth* made in China in 1602. Here, New Spain is identified, in Chinese characters, by its mastery of feather art. The other is the art collection, the *Kunstkammer*, of Rudoph II in Prague where, around 1605, nine feather paintings from New Spain were collected together with works of renowned mas-ters, including Parmigianino and Dürer. The chapter maps how, from Nuremberg to Madrid, from China to Prague, the physical evidence of the ingenuity arriving from "for-eign lands" fueled a myriad of theoretical and practical innovations: from historiographic to cartographic, from lexical to museographic.

## "In Hispaniae Agris"

In 1500, the German humanist Konrad Celtis (1459–1508) wrote an epigram in honor of Dürer's *docta manus*.[2] The poem is well known by Northern Renaissance scholars, who have remarked that it was written the same year as the famous *Self-Portrait* by the painter, today in Munich (see fig. 44).[3] Celtis praises Dürer's "learned hand" as "another Phidias . . . a second Apelles," assuring that "neither Italy has seen your like, nor fickle France."

The last verse of the epigram, however, has not previously elicited any commentary. After the reference to Italy and France, Celtis adds: "Neither will anyone ever [see Dürer's like] in the Iberian dominions [*in Hispanis agris*]."[4] What does it mean that the results of Dürer's handmade work excel any other artwork that *will* be seen "in the Iberian dominions"? This hasty trace—literally, a verse—of a historical comparison between the German painter and the arts visible in the territories being gradually colonized by the Iberian Crowns seems to appear out of the blue. Intuiting its importance means diving deeper into its context.

Celtis is one of the most important figures of Northern European humanism.[5] His many scholarly achievements range from discovering in 1494 the medieval *Tabula Peutingeriana* (twelve invaluable sheets of parchment representing the Roman road system) to being the first instructor to use globes in the classroom, setting a precedent that remains in place all over the world still today.[6] Celtis had a quite unusual mix of cosmographic, antiquarian, and philological interests. He studied astronomy and mathematics in Cracow and traveled to Rome. There, he seems to have participated in the entourage of Pomponio Leto in the summer of 1487 and probably met Anghiera just before he left the Eternal City.[7] In Italy, Celtis also became acquainted with the Neoplatonism of Ficino, whose ideas he helped spread north of the Alps. In 1488, he founded the Sodalitas Literaria Vistulana, modeled after Leto's Roman Academy. Nicolas Copernicus eventually studied at the Sodalitas, where he was introduced to Ficino's heliocentric intuitions in *De sole et lumine*.[8] The rest of the story is well known, but the mediator for such a revolution was the German humanist who brought Ficino's book to Cracow.

From 1497, Celtis was working at the service of Maximilian I, who had appointed him as professor of rhetoric and poetry in Vienna. He edited and published the *De mundo*, the Aristotelian cosmographic treatise ascribed to Apuleio, where one can find passages that echo several of the ideas discussed in this book, including the language eventually used in 1520 by Dürer to address the human ingenuities of the "new lands": "Indeed, everything required to sustain human life is due to its ingenuity [*ingenium*]: cultivating fields, harvesting fruits; artistic ability and what the arts can produce; the necessities of human life."[9] This brief biographical abstract gives a sense of the cosmographic horizons of the

Dürer epigram by Celtis. One supplementary piece of the puzzle is of interest here, to understand what the poet meant by "in Hispaniae agris." In February 1500, the year of the epigram, Maximilian's grandson Charles was born. Documents from that year clearly show that the newborn soon carried major promise.[10] The dominions that he would inherit from his mother, Joanna, and from his father, Philip, the heir prince, were pointing to a potentially imperial project. For Celtis, therefore, saying in 1500 that "neither will anyone ever [see Dürer's like] in the Iberian dominions" seems like a clear reference to the continental and overseas territories in the process of being inexorably (the use of the future tense is telling) conquered by the Iberian Crowns, in a crucial moment of merging with the house of Habsburg.

Now, in those very territories, human *ingenium* was becoming visible in a myriad of artifacts. This artistic geography seems to be precisely that pointed out by Celtis, who by 1500 had most probably seen some objects coming from the New World. He certainly had read a lot about them: by then, the letters of Anghiera, with whom Celtis may have coincided in the Roman years in Leto's entourage, were circulating widely. The first three books of the "First Decade" (eventually published as *Oceani decas*) were already completed, and interestingly, one of its passages makes the very same comparison that Celtis uses to praise Dürer. As thoroughly analyzed in the second chapter, when he addresses the subtlety of the artworks arriving from Hispaniola, Anghiera reports that the Spaniards had realized that the islanders valued "the hand of the artificer" for transforming matter into the shape they wanted (*quanti artificis manus in formam cuique gratam diducere aut conflare didicerit*), in the same way that one appreciated Phidias's or Praxiteles's hands for transforming heavy marble into the most exquisite forms. From that comparison, Anghiera infers a sort of egalitarian, universalist conclusion on humanity in its entirety (*cuncti homines*). Celtis employs the same vocabulary (with *manus* as the key word) and shares with Anghiera at least one reference (Phidias) in common, but, on the contrary, he uses the comparison with the arts made in the Iberian possession to sustain a particular pro-tonational discourse on Dürer's excellence.[11] Yet, we have in his epigram the demonstration that, by 1500, the arts made "in Hispanis agris" had become indisputably a horizon of human creativity—they *had* to be taken into account in a reflection on excellence in artistry. Artworks that the discipline of art history would mutually estrange in the following five centuries were considered by Celtis not only comparable but necessary *to be compared*.

Could this also explain why twenty years later Dürer himself, probably having in mind the language of the *De mundo* translated by Celtis, praised the artistic *ingenuity* of his fellow artists living one ocean away? After having seen, in 1520 in Brussels, the high caliber of what was made in the Americas—and being already aware, at the time, of the arts made in Africa, as he personally collected Sapi ivory saltcellars (for comparison, see fig. 5)—Dürer wrote that diary entry—as forceful and introspective as his self-portrait.[12]

## Artistic Topography

In his epigram, Celtis first opens up the artistic atlas but does so in order to close in on Dürer's (German) uniqueness. Other authors explored the geography of creativity to make geopolitical statements. It is perhaps not an exaggeration to say that a geopolitical underpinning characterizes several sixteenth-century art treatises. Certainly, the best-known of these treatises is that of the Italian painter and theorist Giorgio Vasari, who in 1550 published in Florence *The Lives of the Most Excellent Italian Architects, Sculptors and Painters*. Vasari wrote it in Tuscan—considered the most exquisite Italian language at the time—and dedicated it to the Duke of Florence Cosimo I de' Medici. Organized as a chronological series of more than 140 biographies, the *Lives* presented an Italian-based art history, spanning from the late thirteenth century to 1550 and culminating with the figure of Michelangelo, who was still alive at the time. It was he, according to Vasari, who had brought the culmination of the *rinascita*—the "rebirth" of the arts that had begun with an actual artist's birth (namely that of Giovanni Cimabue in 1240), after the decadence initiated by the fall of the Roman Empire and through eight centuries of "fervent zeal of the new Christian religion" (*fervente zelo della nuova religione Cristiana*).[13] One reason for Michelangelo's exceptionalism was his capacity to be "universally keen in every art and profession": equally superior as painter, sculptor, and architect, and even as poet.[14] However, we must also remember how Holanda put in Michelangelo's mouth the conviction that the true painter had to be aware and surpass "as obras humanas que se fazem por todo o mundo." Therefore, even in Vasari, the use of the adverb *universalmente* may subtly endow Michelangelo's excellence in every art with the broadest possible spatial association.

The *Lives* was immediately received as a bestseller, and in 1568, the author published a second edition with Giunti. He renewed his dedication to Cosimo I de' Medici, who in the meanwhile had become Grand Duke of Tuscany. This edition presented important changes. New artists were included in the chronological narrative, now largely expanded beyond the limits of the Florentine walls. As is made clear in the frontispiece of the last volume, the inquiry now included the very word *Europa*. Patricia Rubin proposes that in the second edition, the *Lives* are transformed into a "universal history" of the arts and that this transformation is topographical (it increasingly included artists from other parts and even outside Italy), temporal (it addressed antiquity and the Middle Ages), and technical (it included all media).[15] Even if always centered on Italy, a European dimension deeply renewed the contents of the 1568 edition. Using a Neoplatonist metaphor similarly employed in 1548 by Holanda, Vasari states that after "the ruin of Rome, having the masters *spread* in several places, the beauties of these arts have been communicated throughout Europe."[16] Where Holanda had used a diasporic metaphor to state that "ancient painting"

had been spread all over the world since the origins of time, Vasari asserts that a physical diaspora of the artists—their movement out of Italy to different parts of Europe—gave origin to an artistic rebirth across the continent.[17] This dimension is also present in the famous letter devoted to ancient sculpture, written by Giovan Battista Adriani to Vasari and included in the 1568 edition. Adriani states that after the "disfacimento di Europa" (dismantling of Europe) under the pressure of the barbarous nations, the *rinascita* now comes from Tuscany *back* to Europe: "After the dismantling of Europe and of the noble arts and sciences, the latter have begun to revive, to grow, and to blossom, and have finally reached the apex of their perfection . . . beyond the other gifts of Tuscany, which are infinite, we also have the ornament of such noble arts whereby not only Tuscany but all of Europe is embellished, since one can see the artworks of Tuscan artists and of their disciples shining everywhere."[18] Presenting art as historical progress (in space) was, for Vasari, an effective way to demonstrate that art improved over time.[19] It was not a set of repetitive mechanical skills but a liberal activity that was capable of perfecting itself in always novel directions. The concept of *disegno*, as both mental design and physical line—"the idea and the act of drawing"—was the most tangible intellectual faculty of a great artist, who had the power to delineate a subject in the mind and the practical skill of impeccably drawing and outlining it.[20] Grounding artistic excellence on *disegno* implied the theoretical possibility of finding that human faculty elsewhere and in other times. But Vasari did not take that route.[21]

This is a curious fact if we remember that Cosimo I de' Medici and his wife, the Spanish noblewoman Eleanor of Toledo, were passionate collectors of objects arriving from all over the world. The Medici inventories of the time list a variety of these artifacts, such as turquoise masks from Mexico and ivory artifacts from Portuguese Africa (which were also collected by Dürer, as we saw at the beginning of this chapter) (see figs. 1 and 5). Vasari was certainly aware of these objects; he mentioned them in his second edition in relation to the very space where they were going to be housed, the Guardaroba Mediceo.[22] Here, says Vasari, Cosimo would "put together once and for all these things both of heaven and earth."[23] These objects, considered private, were nonetheless made available to the court's entourage, and there is clear-cut evidence that painters and sculptors mentioned in the *Lives* looked at them. For instance, the goldsmith and sculptor Benvenuto Cellini knew well the precious stone animal heads coming from Mexico, today still housed in Florence (see fig. 24). He seems to have even intervened, making a hole in one of the heads to be used as a pendant.[24] The turquoise masks originally from Mexico inspired the design of a grotto's decoration in which Vasari's own workshop participated.[25] The author of the *Lives*, therefore, could have addressed in his treatise artifacts made from afar, precisely to sustain his theory; Mexican masks, African spoons, and the small but precious animal heads inspected by Cellini were also the fruit of human *disegno*. So, what prevented him

from doing so? Perhaps it was his biographical model, which was impossible to apply to those splendid artifacts.[26] The names of their artificers had been lost or never recorded, preventing the pieces from fitting within Vasari's narrative, even in his own identity as a biographer.[27] Also, the uncertain provenance and dating of the artifacts made it difficult to place them along a strict timeline or within a precise topography from which to follow art-historical progress.[28] Hence, the author's choice: "My intention has been only to write about the lives and the works of our artificers" (*La mia intenzione è stata di solamente voler scrivere le vite e l'opere degli artefici nostri*).

## Looking Afar

In the twenty years during which Vasari prepared and published his two editions of the *Lives*, two other artistic treatises found unexpected ways to deal with temporal uncertainty, spatial broadness, and unknown authorship. We already know from the first chapter that in 1548, the Portuguese Holanda completed *Da pintura antiga* and dedicated it to John III, King of Portugal, who at the time possessed large territories in the Americas, Africa, and Asia. Interestingly, *Da pintura antiga* also culminated with the celebration of the figure of Michelangelo as the perfect artist. But the argumentative path to that choice was different than Vasari's. Holanda did not choose a chronological, evolutionary frame (Vasari's is the late thirteenth to mid-sixteenth century) nor did he reduce the territory of his inquiry to a single part of the globe. He looked simultaneously at Roman and Greek ancient art; at Portuguese, Spanish, Flemish, and Catalan contemporary art; and even beyond the limits of Europe and the Old World: he openly commented on arts, sculpture, and architecture from Morocco, China, India, Peru, and Brazil. No historical evolution or territorial constraints limited Holanda. He moved around time and space seeking artistic perfection, which he called "ancient painting," a phrase that should be understood as "universal human *disegno*": the immanently human, intellectual, and practical faculty to design, draw, and produce artworks that transcend temporal and spatial limitations. Even though Holanda ended up identifying the lively example of artistic perfection in the figure of Michelangelo, readers may remember that he made the artist state that the universality of an artificer depended on looking at the artworks of an artistic humanity transcending the local.

A third treatise allows us to tackle the imbrications between a protonational art history and the contemporary artistic atlas: the *Comentarios de la pintura* written by Guevara between 1560 and 1563, dedicated to Philip II when the Spanish court moved from Toledo to Madrid. Settling the court was also an occasion to build a permanent collection of the highest possible value. For Guevara, the principle of artistic quality was not

so much related to the idea of progress but intimately tied to specific educational purposes—including the edification of the king, who could perfect himself through artistic observation. Good painting has a positive impact on future creations, hence, it needs to be properly displayed so other artists can find sources of inspiration. Here, Guevara introduces a new element to definine what should be collected: variety. He largely expands his scope beyond Vasari's tripartite model (architecture, sculpture, and painting), paradoxically by redefining and expanding one of its terms: painting. Artworks coming from afar, which would not necessarily have been associated with this term, enter the treatise and trigger new questions not only on the vocabulary of artistic activity but also on the unexpected criteria of producing a collection—and, ultimately, a canon.

In the next part of this chapter, I focus on how Guevara envisages the rebirth of the arts. In spite of echoing Vasari's conviction that Italy was a locus of artistic rebirth, the Spanish writer was able, much like Holanda, to expand this geography toward the new artistic territories revealed in the context of the Iberian expansion. However, these sites are not presented as the "colonies" of a classicist approach, that is, the sites toward which the principles of Italian Renaissance were being (or had to be) exported and imposed in the process of conquest. On the contrary, these Iberian regions ("In Hispaniae agris," as Celtis would say) are presented as the loci *from where* a rebirth, a new panorama for the arts, originates.

## The Expansion of Painting

To what extent can art any longer be conceived, practiced, and collected "nationally"? One decade after the publication of the first edition of Vasari's *Lives*, the Spanish art theorist, antiquarian, and collector Guevara discusses this question in his *Comentarios de la pintura*.[29] The pages of the *Comentarios* are mostly known for their numerous references to Flemish painters, such as Jan van Eyck, Joachim Patinir, Rogier van der Weyden, and especially Hieronymous Bosch—painters that he and his father had extensively promoted. Diego, Guevara's father, owned the famous *Arnolfini Portrait* by Van Eyck, and Felipe was one of the major collectors of Patinir's land- and seascapes, paintings that would later end up in Philip II's own collection.[30] This artistic treatise, nonetheless, is a milestone for reasons that go beyond the anecdotal presences of these painters.[31]

Dedicated to Philip II in the first years of his governance (Charles V had abdicated in 1556) and written just before the construction of the Escorial began in 1563, the *Comentarios* has often been overlooked as a mimicking impulse of a non-Italian author to defend Vasarian principles—such as the obligation to nature (*obbligo alla natura*)—in the desolate panorama of Spanish peninsular painting, a panorama that Guevara judged

mercilessly, in a way similar to how Holanda had treated Portugal. Guevara has also been mocked for offering unusable recipes for artists and chimerical proposals, such as the invention of oil painting by the Greeks.[32]

But the *Comentarios* are not only an artistic treatise. They are also a political program. Guevara writes as a kind of counselor to the king. He was *gentil-hombre de boca* (lit., gentleman of mouth) of the royal court, taking part in the royal meals, religious processions, and other solemnities. Hierarchically, he was close to the king. In a diplomatic way, he addresses to Philip II a series of principles on which the ruler should ground his governance. The beginning and the end of the treaty are revelatory of this program. The dedication to Philip II starts by recalling how Alexander the Great, during moments "in excess" of his military occupations, spent time "with Apelles"—referring both to the painter and to the art of painting—because "parecerle poco un mundo para conquistar" (to conquer a world was not enough for him). Passion for painting and artistic patronage are therefore presented as being in excess to war; they are nonmilitary conquests that truly characterize and fulfill the ruler. The dedication continues with other examples that confirm how even the most avid conquerors kept an autonomous space that Guevara called the "afición para la pintura" (fondness for painting) as the real inner "conquest" that distinguished their grandeur. After 247 pages, in the second-to-last paragraph of the final page of the *Comentarios*, Guevara returns to the same idea. He summons the figure of the barbarian, the Goth, and looks back to the damages done by invading and occupying the Roman provinces "como si de proposito ovieran contra las buenas artes, y no contra los hombres, tomado a fuego y sangre la conquista" (as if they had undertaken the conquest, with fire and blood, not against men, but against the fine arts).[33] The latter is one of numerous references to Vasari, who, in the preface to the first part of the *Lives*, had been even more precise about the aftermath of the Goths' arrival. Speaking of the "ira di Totila" (rage of Attila the Hun), he states that the destruction of artworks during the conquest of Rome meant also the destruction of the very shape and being of art at large.[34]

There is a crucial difference, nonetheless, between evoking the memory of the Goths' invasions from Florence and doing so in writing from Madrid: Guevara is writing to Philip II, not to Cosimo I de' Medici. To call into question the figure of the conqueror in a book dedicated to the Spanish emperor of the "four parts of the world" seems to be a *memento*, specular and complementary to the one sketched in the dedication: to limit the violence of the military conquest, to avoid destruction, to search for an inner conquest—namely, the conquest, in the sense of the exploration, of the art of painting.[35] Michelangelo's statement from the *Da pintura antiga* analyzed in the first chapter—claiming that the true painter had to surpass any mastery made in any part of the world—points to this inner conquest.

Another radical difference with the Italian art theorist is that if for Vasari, after the darkness of medieval times, the Italian Renaissance started with Cimabue, for Guevara, an analogous Spanish painter was yet to be born. The solution was, therefore, to be found outside the peninsula. Guevara celebrates the fact that Philip II has resuscitated the arts by "having brought and gathered together numerous people of good inventiveness and abilities, who obliges the people native from Spain to study and work."[36] To bring in artists from abroad and to collect their artworks, displaying them "en lugares donde algunas veces puedan ser vistas de muchos" (in places where sometimes they can be seen by many people) is therefore the ideal solution to resuscitate art in Spain.[37] But to celebrate Philip II's patronage seems, for Guevara, as important as defining the best artistic training for any painter (not only Spanish) and expanding the very theory of what the art of painting could be.

## Nations and Mixtures

Between the dedication and the end of the treatise, Guevara offers a panoramic view of the different genres and techniques of the art of painting, based on the principle that, for him, what distinguishes the art of painting is neither *disegno* nor color but the "mixture" (*mezcla*) of mediums so as to obtain a naturalistic or "painterly" effect. The Guevarian *mezcla*, similar but not identical to the Vasarian *unione nella pittura* (union/blend in painting), enables him to open the category of painting not only to oil painting or mural painting but also to glass or shell mosaics and other unexpected technes.[38]

Discussing the strong limits of "national" styles, Guevara combines a more practical discussion on the principles of the art of painting with a political statement on the effect of the art of painting on the ruler (and vice versa). There are, he states, "national" characteristics—and by nation, he certainly meant what Covarrubias defines as "kingdom or extended province."[39] Venice is for Guevara a nation as well. But these characteristics are due to the fact that too often painters have only been trained nationally and have not experienced the world at large. Venetian painters, therefore, continue to produce a narrow ideal of feminine beauty, the Venetian one; German painters continue to paint German horses that are very different compared to those found in Spain; and so on.[40] These remarks, sometimes trivial, on the limits of national styles are, however, crucial to the proposal of a solution to the Spanish artistic impasse.

While born in Brussels, once he settled in Spain, Guevara did not travel much outside the peninsula. But one trip gave him the occasion to visit different territories and to observe their artistic productions: in 1535, he took part in the Spanish expedition of Tunis, and we can see him on the battlefield in one of the famous cartoons painted

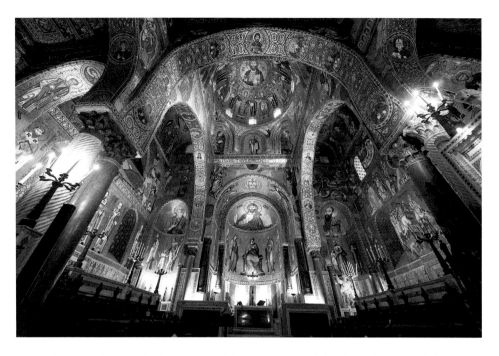

FIGURE 56 | Palatine Chapel in the Royal Palace of Palermo, ca. 1140. Fondo Edifici di Culto, amministrato dalla Direzione Centrale degli Affari dei Culti e per l'Amministrazione del Fondo Edifici di Culto del Ministero dell'Interno.

by Jan Cornelisz Vermeyen.[41] Guevara refers to this major episode of his life in the *Comentarios*, recalling the journey made from North Africa back to Spain, via Spanish Italy. During this long trip, he visited Sicily, Calabria, Naples, and Apulia, and his text includes interesting remarks on the Byzantine mosaics of Monreale and of the church of Saint Peter the Apostle (Palatine Chapel) in Palermo (fig. 56). While Vasari treats Byzantine art with a condescending air—made by those "remnants" of the Greeks whose style was for him old but not ancient—Guevara, on the contrary, attentively observes the Palatine Chapel walls shining with "little pebbles dyed with various colors" and invited his Spanish peers to view these monuments "as a wonderful thing" (*como cosa maravillosa*).[42]

It is therefore a "transnational" or "international" training that Guevara suggests for both painters and viewers. Far from the Vasarian project of constructing a "protonational" Italian art, he physically wanders the shores of the Mediterranean in search of both historical traces of painting and of a new, contemporary, and "transnational" definition of painting. Therefore, his theoretical search needed to expand not only temporally but spatially, well beyond the Mediterranean, actualizing the discussion on the art of painting according to completely unexpected territories and repertoires.

176

FIGURE 57 | The final battle between the Mexica and the Spaniards with their allies, nineteenth-century copy of the *Lienzo de Tlaxcala*, sixteenth century. Photo from facsimile published by Alfredo Chavero, Mexico, 1892. Collection: Alessandra Russo.

After the pages devoted to the mosaics found in Spanish Italy, Guevara takes the most definitive distance from Vasari in the section titled "On the Paintings of the Egyptians," in which he addresses the art of painting made by "Western Indians." While discussing the hieroglyphs of the Egyptians—via the *Hieroglyphica* of Horus Apollo—Guevara looks to the Mesoamerican pictography, called, in Nahuatl, *tlacuilolli*: "This sort of painting and the fact of expressing their concept through painting has been seemingly imitated by the Western Indians, and of the new world especially those of New Spain; having possibly received this practice from the Egyptians in ancient times, which could have happened, or on the contrary the people of these two nations [Egyptians and Western Indians] having shared the same imaginations."[43] Discussing pictographic arts of the New World within a "transnational" discussion of the art of painting tout court, Guevara does not simply refer to pre-Hispanic painted manuscripts but to those produced after the conquest and, more precisely, to the paintings that depict the Spanish conquest itself: "They figure in painting the Expeditions that the vassals of your Majesty and themselves made in the conquest of Mexico and other parts."[44] Guevara seems to speak of one of the numerous, postconquest Tlaxcalteca manuscripts—such as a copy of the *Lienzo de Tlaxcala*, a canvas painted around 1550 in New Spain within the tradition of the *tlacuilolli* but representing the conquest of Mexico from the vantage point of the Indigenous allies of the Spaniards, the Tlaxcalteca (fig. 57).[45] An embassy from Tlaxcala had traveled to Spain in 1552 with one of these copies, and it is very probable that Guevara, being close to the king, met them personally.[46] In his *Comentarios*, he therefore already speaks of a postconquest form of "Indian" painting, combining not only different styles and subjects but also

different technical mixtures: pigments, paper, or cotton canvases coming from Europe with local colors, and so on.[47]

To describe these "Western Indian" paintings in the 1560s, in a book dedicated to Philip II no less, had a specific relevance at the Spanish court when Guevara was completing the treatise. On July 12, 1562, the Spanish Franciscan Diego de Landa held the famous "unprecedented and unparalleled" auto-da-fé in Maní (Yucatan), ordering the burning of twenty thousand statues and forty Mayan pictographic manuscripts written on amate paper and deer hide.[48] The dates coincide with Guevara's *Comentarios*, and we can make the plausible hypothesis that while talking about the "barbarian" auto-da-fé of books at the end of the treatise, he was, in fact, recalling the Yucatecan one.[49] This reference would have been a spectral evocation to any reader at the time, especially to Philip II, who already in those years was dealing with accusations against de Landa made by the first bishop of the Yucatan himself, Fray Francisco Toral. Upon his arrival to the region in 1563, the bishop immediately denounced the Franciscan's unacceptable behavior to the king. In this light, the final reference to the destruction of libraries by the Goths, in the *Comentarios*, should be read as a veiled yet bold reference to the ongoing destructions within the Spanish empire itself, hence the need to limit the violence of conquest and offer a nonmilitary interest in the "expansion" of the category of painting.[50] Las Casas's ideas (the Dominican was in Madrid in those same years) may have impacted Guevara at the time.

Along with the criticism toward a pure national style, the appreciation of Byzantine aesthetics, and the inclusion of the art of Egyptian and Mesoamerican hieroglyphs (both pre- and postconquest), the other major "explosion" of the Vasarian canon in the *Comentarios* appears when Guevara addresses the striking novelty of the feather images that had arrived in Europe from New Spain (see fig. 40). At least one of them hung in his own collection: the inventory of the artworks that his widow sold to Philip II lists it as a "feather canvas" (*lienzo de pluma*).[51] Far from addressing this unexpected type of artifact in terms of exoticism and radical otherness, in his treatise, Guevara powerfully theorizes the groundbreaking place that feather painting had in the wider panorama of the history of painting: "It's fair to acknowledge that [Indians] have brought something new and singular to painting, as it is birds' feathers painting. With the chromatic diversity of the feathers that nature raises there, they diversify clothing, colors of the skin, and similar things. With their cleverness, they select the feathers, sort them out, set them aside and mix them."[52]

At first sight, the use of the terms *pintura* or *lienzo* can appear misleading; one could hastily assume that the *Comentarios* and the inventory applied to the feather images made in New Spain two dominant categories of the European Renaissance—painting and canvas—that have little to do with the singularities of the novel medium. But things

are more complicated. In fact, Guevara did not simply project a predetermined concept of painting onto feather images. Rather, he stated that their creators contributed to the history of painting with something completely new. Actually, in the first printed edition of the treatise in 1788, the word *painting* often appears capitalized as *Pintura*, signaling that the extraordinary artifacts made across the ocean participated in (and yet transformed) the very concept of painting itself.[53] Instead of reducing those images to a stable definition of painting, Guevara proposes that painting was reinvented by the "Indians"—meaning, here, the contemporary, postconquest artists of New Spain.[54] As creators of that new form of painting, they now stand on the same level as the numerous painters discussed throughout the treatise, spanning from Zeuxis to Michelangelo and Bosch, just as their new medium takes its place among the diverse array of painting techniques, encompassing encaustic, fresco, oil, and other media.

To understand Guevara's language in that specific passage, it is important to keep in sight the larger concepts of the treatise. His history of painting focuses on the arduous balance between two opposites: *diligencia* (diligence, carefulness, meticulousness, hard work) and *novedad* (novelty, invention, originality). A true painter cannot just be uniquely diligent or skillful; there must also be innovation. Addressing the art of a pupil of Pausias, for instance, he writes, "[su] diligencia era tal que solo los pintores la entendían," a spectral quotation of a passage from Pliny on Mecofanes, who possessed "a carefulness which only artists could appreciate."[55] Artists from New Spain, on the contrary, have been able to bring something so new and singular to the art of painting that even nonpainters (namely, viewers) can immediately appreciate it. The hard labor and the meticulousness required in their practice (swiftly described in the text through a series of active verbs) is therefore transcended when the final surface obtained by that specific material and those specific gestures can be called a painting. In this respect, "Indians" were capable of innovating the art of painting in a "metatechnical" way.[56]

## New Spain "Paintings" to China and Prague

It is possible to identify some exceptional cases in which the arrival and circulation of works from New Spain in renowned world collections inspired not only the quill pen of theorists but also novel linguistic meanings and artistic practices. Several decades after this testimony on feather painting in Guevara, the Italian Jesuit Matteo Ricci was in China. In Hangzhou, he collaborated with the engraver, astronomer, and geographer Li Zhizhao and the printer Zhang Wentao to produce the astonishing *Map of the Ten Thousand Countries on the Earth* (坤輿萬國全圖, *Kunyu Wanguo Quantu*). The map, published in 1602, is

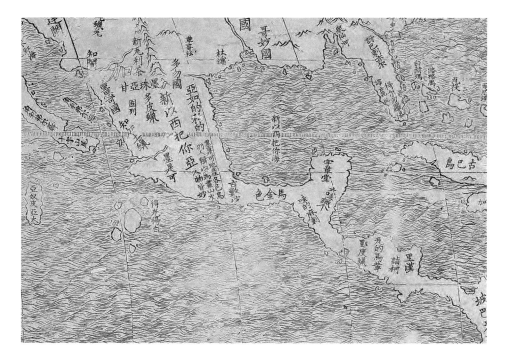

FIGURE 58 | Matteo Ricci, engraved by Li Zhizao, printed by Zhang Wentao of Hangzhou, detail of the map of New Spain, in *Kunyu Wanguo Quantu* (Map of the ten thousand countries of the Earth), 1602. Minneapolis, University of Minnesota, James Ford Bell Library. Courtesy of the James Ford Bell Library, University of Minnesota.

covered with Chinese characters that address the geographical and cultural specificities of every single part of the known world (fig. 58). On the territory of New Spain, one reads:[57]

墨是哥地産各色鳥羽。人輯以為畫。山水人物皆妙
*Moshike de chan ge se niaoyu. Ren ji yi wei hua. Shanshui renwu jie miao.*
The land of Mexico produces bird feathers of all colors. The people collect them and make them into paintings. The landscapes and human figures [they do] are all marvelous.

In the same years that feather paintings from New Spain reached the court of Wan Li, this exceptional text specifically takes recourse to the Chinese character 畫 *hua* (painting) to describe the intriguing artifacts made on the other side of the world. The Chinese character is composed of two parts. At the top are strokes from the character 書 *shu* (book), thus evoking calligraphy. At the bottom are strokes from the character 田 *tian* (field), suggesting the circumscribed quadrangular space of a painting. The Chinese character used to name the Mexican artifact is the exact term used at the time to refer to painting.

The conceptual dynamics of this passage are comparable to those detected above in Guevara's *Comentarios*. Here, the Chinese character *hua* measures itself against the new artifacts created in "the land of Mexico" and participates in the process of universalizing the feather artifacts that, when referred to in Chinese, transcend their specific local, historical, cultural, and even technical particularism to be named, described, and admired as a recognizably new form of painting—with no religious references.

Another astonishing case allows us to reconstruct the circulation and impact of feather paintings, from New Spain to the court of Rudolph II in Prague. In Pátzcuaro (Michoacán), in 1590, Juan Cuiris, a Native feather artist (*indio plumajero*) requested exemption from the *repartimiento* (forced labor) in which he was expected to contribute because he was "busy making works of his trade."[58] It would seem that his request was granted, if we observe the result of the commission on which he was probably working and which must have brought him considerable recognition at that time in the town. In the Schatzkammer (treasury) in Vienna, two magnificent feather mosaics, the first signed "Juanes Cuiris fecit Michuac" and the second "Iuan Bautista me fecit Michuac," iconographically and stylistically form a pair (figs. 59 and 60).[59] They represent two moments narrated in Luke 2:41–50, in which, during a visit to the temple in Jerusalem, Mary and Joseph lost Jesus. Only on the third day do they manage to find him seated in the Temple with wise men and teachers. The Virgin said to him: "'Child, why have you treated us like this? Look, your father and I have been searching for you in great anxiety.' He said to them, 'Why were you searching for me? Did you not know that I must be in my Father's house?'"

Two engravings printed in the workshop of Philippe Thomassin and his brother-in-law Jean Turpin (executed on the basis of a work by Clovio) were the main sources for these feather paintings (figs. 61 and 62).[60] The speed with which the source printed in Rome reached Michoacán—probably through the Jesuits (we know that Cuiris and several of his relatives were "benefactors" of the Jesuit convent in Pátzcuaro)—is surprising: we should recall that the engravings are dated around 1590, a period when Cuiris was already working as a feather artist.[61] Moreover, the place where, in the engraving, the name of the printers appears, has been skillfully occupied by the signature of the *plumajero* from Michoacán, erasing any trace of the source itself and of a possible "copyright."[62] Cuiris is now justly recognized as the *author* of the image, his mastery being actually not only comparable to but also eclipsing that of his European peers.

As in the case of all sixteenth- and seventeenth-century featherwork, Cuiris arranges the feathers in his images from bottom to top, so that they glow when illuminated by candlelight and when viewed from below by the kneeling beholder. At the same time, there is a characteristic in the technique of the featherwork that recalls engraving. The extremely subtle effects that are produced between the edges of each one of the feathers seem to imitate the lines of an engraver's burin, visible in the printed image. It is noteworthy that the work by Clovio—a painter of Croatian origin celebrated by Vasari in the

FIGURE 59 | Juan Cuiris, *Weeping Virgin*, New Spain, ca. 1590. Feather mosaic and paper, 25.4 × 18.2 cm. Vienna, Schatzkammer.

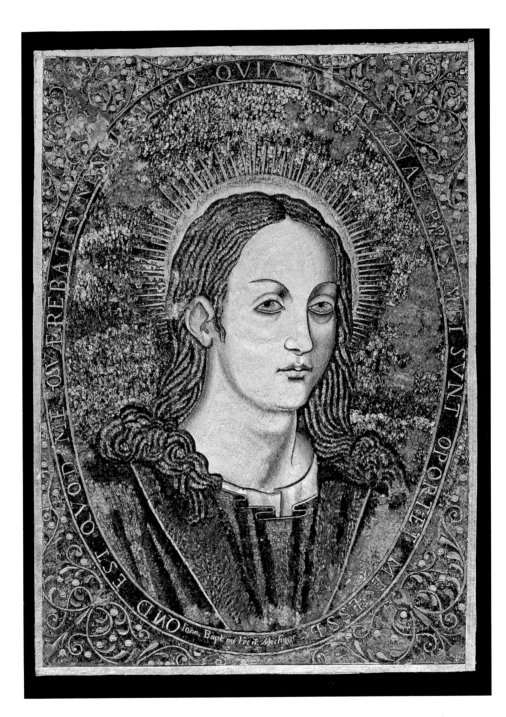

FIGURE 60 | Juan Bautista (Cuiris?), *Jesus at the Age of Twelve*, New Spain, ca. 1590. Feather mosaic and paper, 25.4 × 18.2 cm. Vienna, Schatzkammer.

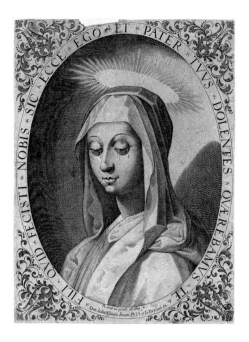

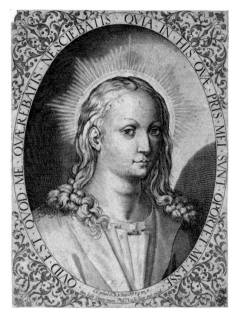

FIGURE 61 | Philippe Thomassin and Jean Turpin, after a drawing of Giulio Clovio, *Weeping Virgin*, ca. 1590. Engraving, 25.5 × 19.1 cm. Dresden, Kupferstich-Kabinett, Staatliche Kunstsammlungen. Photo: Herbert Boswank.

FIGURE 62 | Philippe Thomassin and Jean Turpin, after a drawing of Giulio Clovio, *Jesus*, ca. 1590. Engraving, 25.5 × 19.1 cm. Dresden, Kupferstich-Kabinett, Staatliche Kunstsammlungen. Photo: Herbert Boswank.

*Lives* as one of the most outstanding miniaturists of the Renaissance (calling him "piccolo e nuovo Michelangelo" and "dipintore di cose piccole")—once it was engraved in the atelier of Thomassin and Turpin and had traveled to New Spain, was newly metamorphosized in glorious color and light through an unexpected artistic technique.[63] We might say that after the transition from miniature to engraving (Clovio to Thomassin and Turpin), the object transitioned from engraving to feather painting when it passed into the hands of Cuiris, who again endowed the image with its chromatic power, through the radiant properties of feathers. In those same years, featherwork and miniatures were frequently associated: in 1604, Orazio della Rena wrote of New Spain that "they make images with feathers with such artistry that they seem to be illuminated with the brush, and gold painted on velvet" (*d'esse* [delle piume] *fanno in Nuova Spagna l'immagini con tale artificio che paiono miniate col pennello, et lumeggiate d'oro sopra il velluto*).[64]

The two feather paintings had reached Prague by 1607. An inventory of Rudolph II's collection from that year lists them along with seven others. In Rudolf II's *Kunstkammer*, the feather mosaics from New Spain joined the works of Antonio Allegri da Correggio,

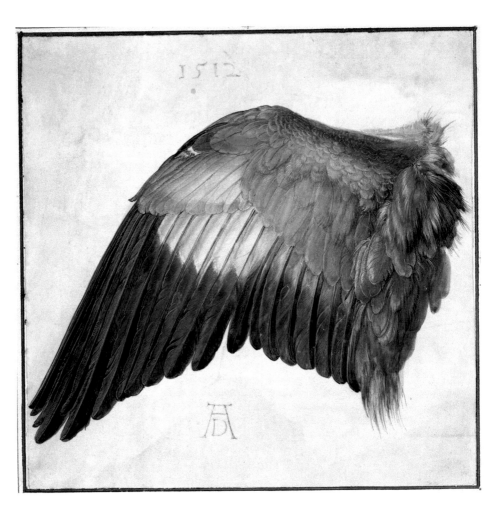

FIGURE 63 | Albrecht Dürer, *Wing of Coracias garrulus*, 1512. Watercolor and gouache on parchment, 19.7 × 20 cm. Vienna, Graphische Sammlung Albertina.

FIGURE 64 | opposite | Parmigianino (Francesco Mazzola), with restoration interventions by Joseph Heintz the Elder, *Cupid Sharpening His Bow*, 1535. Oil on panel, 135 × 65.3 cm. Vienna, Kunsthistorisches Museum.

Giuseppe Arcimboldo, and Pieter Bruegel, in addition to an incredible variety of *naturalia*. Rudolph II possessed, for example, the famous *Wing of Coracias garrulus* by Albrecht Dürer (fig. 63).[65] Painted in 1512, this watercolor was perhaps executed in dialogue with the novel artifacts brought from the Caribbean or Brazil, as well as from the East Indies. It is interesting to note that the date of the watercolor corresponds to the year when Dürer began to work for Maximilian I of Habsburg.[66] As we have already seen, in a drawing for the Book of Hours of Emperor Maximilian, Dürer represented the emperor's divine authority over the "plenitude" of the Earth (*Domini est terra et plenitudo eius Orbis terrarum et*

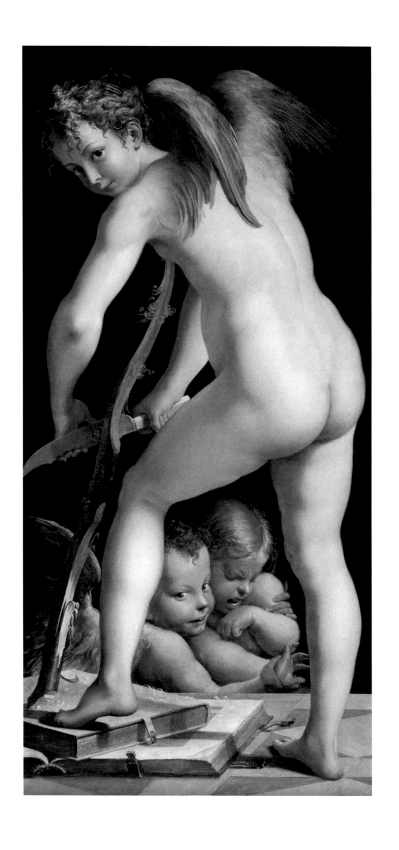

*universi qui habitant* [Ps. 24]) with a man clad in feathers (see fig. 45).[67] In the collection of Rudolph II, Dürer's *Wing of Coracias garrulus*, together with feather artifacts coming from afar, including New Spain, may have stimulated, in turn, a different way of looking at other pieces displayed in the *Kunstkammer*. We might think, for example, of Parmigianino's painting *Cupid Sharpening His Bow* (1535; fig. 64). It is known that once it reached the court of Rudolph in 1605, this work was restored by Joseph Heintz the Elder, who, probably inspired by the feather artifacts coming from afar, gave Cupid's wings a more natural appearance.[68]

From Celtis's epigram, dated 1500, to Rudolf II's *Kunstkammer* as a space where "the subtle ingenuity of the people in the foreign lands" may have impacted the way a Parmigianino masterpiece now looks to us, passing through the bold statements of Guevara and the inscription of feather painting on a Chinese world map, we have seen in this chapter how the artifacts made *in Hispaniae agris* did not enter artistic theory and practice as merely exotic souvenirs. On the contrary, they were capable of triggering new historiographic proposals, cartographic updates, and even pictorial interventions. These specific moments redesigned, in the long sixteenth century, the territories of painting. Vasari's silence is now less deafening.

# Conclusions
## A New Artistic World

This book developed as I was tackling the revolutionary impact made by the "antipodean objects" in early modern artistic theory. To flesh out their effect implied, first of all, criticizing the dead-end paradigm of exoticism. Michelangelo's assertion, in Holanda's words, that being a true "painter" in the mid-1550s meant measuring oneself against "the handmade artistries that are made throughout the world" (*officios manuais que se fazem por todo o mundo*) is also a memento for us today: these artistries were not—and still cannot be now—thought of as exotic alterities or as minor crafts. They drove new thinking about what it meant to be a contemporary artist, an artist responsive to his or her own existence in time.

The first three chapters demonstrated how Michelangelo's and Holanda's words had a history—a history generated not only through the encounter with specific artifacts but also with the ideas of previous authors. In the first part of this book, I retraced a possible "genealogy" of that realization—from Anghiera to Holanda/Michelangelo, via Las Casas. In the writings of Anghiera, I have followed the gradual philosophical revolution, over more than three decades (1493–1526), made by the artifacts coming from the "new orb," what I have called Anghiera's artifact-based humanism. With a vocabulary taken from natural philosophy and classical authors, Pietro Martire looked at the astonishing objects arriving, largely looted, from the Antilles and Mexico and stated that these *bonae artes*—these "fine arts"—demonstrated a common thread in humanity at large. Referring to objects and monuments personally seen or read about, from the Antilles to Egypt and

from India to Mexico, Anghiera posited that *cuncti homines*—all human beings without exception—have been endowed with a potential for artistry, meaning both art making and artistic sensibility. That artistic evidence allowed Anghiera to define what it is to be human and "civilized" (*politicus*) in contrast with what he considered the bestiality of anthropophagy and the sacrifice of other human beings. Particularly brave, in Anghiera's rhetoric, was the fact that he described both artistic finesse and brutal violence in antithetical proximity, precisely in order to separate the two. Las Casas, who knew not only Anghiera's writings but also had personally met the author, brought his predecessor's ideas to extreme and groundbreaking consequences. Equipped with the firsthand experience that Anghiera lacked, the Dominican gathered, during forty years in the New World, evidence that artistry was indeed found everywhere. Las Casas had a supplementary but key argument: artistry could also be found, anew, even in zones that had been devastated by Spanish conquest. That promise of an artistic rebirth demonstrated that artistic potential was indestructible in humanity, at large.

Las Casas's relentless demonstration of art as an intrinsically human, rational endeavor—hence art as a demonstration of the rationality of the "Indians"-as-humans and hence the rationale against their enslavement—also embraced a groundbreaking appreciation of the artistry embedded in idols. His affirmation on the inventiveness of idol making opened the path for chapter 4, which followed the gradual shift of the category of the idol from the religious and Inquisitorial terrain to the aesthetic one. The endless material refinement and variety of handmade idols prompted a number of authors—including missionaries involved in their Inquisitorial judgment—to recognize and appreciate their aesthetic dimensions. The term *sublime* and its cognates named the possibility of shifting forensic judgment (idols denounced in trials) to aesthetic judgment. This is what I have called the "art of the idol," proposing that the descriptions of idols, in the context of the Iberian globalization and of the attempted Christianization of the world, are, in fact, among the first and finest observations of the excellence of intentional and creative human handmaking.

As the category of "idol" was not simply projected onto colonized spaces but, rather, underwent a profound and paradoxical transformation—namely, becoming the space where artistic form was defined as severable from the supposed error of its contents—the same happened with the categories of "antiquity," "art," and "artifice," studied in the first three chapters. "Antiguidade," in Holanda, became the name of a nonprescriptive artistic excellence freed from a stable anchorage in time and space (chapter 1). "Ars," in Anghiera, became evidence of human thought and a measure of civilization (chapter 2). Las Casas claimed that the fact that the "Indians" were "artificers" (*artífices*) demonstrated their humanity, implying that artificers were not only mechanically reproducing a set of knowledge but thinking with their hands (chapter 3). A comparable metamorphosis

of a European concept happened to the category of "painting." Chapter 5 looked at its transformations through New Spain, Spain, China, and Prague, when the term was used to name a completely novel form of painting, namely feather painting. The last chapter made two other specific contributions: it demonstrated that the artistry observed "up to the antipodes" became relevant also to measure the artistry of renowned European masters, such as Dürer (Celtis *dixit*), and it started investigating the place of this artistry for the history of collecting. The arrival of astonishing feather pieces from Mexico had not only "brought something new" to the Western history of painting—and to the Escorial, in the words of Guevara—but also to the Chinese concept of painting (畫, *hua*)—and at Wan Li's palaces—as evident in the *Map of the Ten Thousand Countries on the Earth*. The novelty of feather painting may also have encouraged repainting. In Prague, at the court of Rudolf II, the presence of feather paintings made and signed in Mexico seems to have impacted Heintz's restoration of a Parmigianino.

Are there now further avenues of research to keep de-exoticizing the impact of the artifacts of the New Worlds in early modern history and art history? What happened with these objects when they entered the space of the museum? This is the guiding question that I ask myself while I embark on new research. The inscription located above the shelves of the museum of Ferdinando Cospi (1606–1686) in Bologna—or rather in the etching that represents the museum in the catalogue published in 1677—provides a good starting point (fig. 65).

## Art-Historical Machineries

"Erudita haec artis et naturae machinamenta ad excitandam antiquitatis memoriam" (This erudite machine of art and nature that can stimulate the memory of antiquity); we could wonder whether the Cospi Museum, which might be regarded as one of the earliest modern collections, did, in fact, include this intriguing inscription or whether it was added to the engraving by the artist Giuseppe Maria Mitelli. A prolific etcher, Mitelli was particularly inventive at adding moralizing title pages to his works.[1] Nevertheless, the inscription in the museum's gallery helps us understand how a panoply of artifacts functioned as parts of a great machine in which every element was considered indispensable: an "erudite" machinery, according to Mitelli's inscription—that is, following the etymology of the term *eruditio*, capable of eliminating the rough, the unpolished, the coarse. The term—or rather the concept—chosen for Mitelli's engraving, *machinamenta*, indicates the active role of the Cospi Museum's artifacts and their collective ability to set in motion something abstract or even tangible: to stimulate, sharpen, or awaken the memory of antiquity.[2]

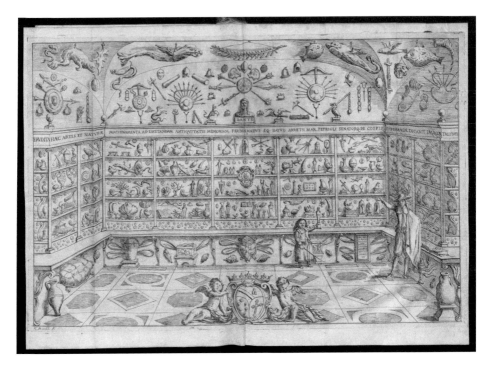

FIGURE 65 | Giuseppe Maria Mitelli, *Museo Cospiano*, in Lorenzo Legati, *Museo Cospiano annesso a quello del famoso Ulisse Aldrovandi* (Bologna: Giacomo Monti, 1677), foldout. Etching. Vienna, Austrian National Library.

*A New Antiquity* set foot with Holanda, who around 1547 liberated the concept of antiquity from its confinement in time, making it a synonym for artistic excellence rather than a historical period. More than a century later, stating that the Cospi Museum's artworks put "the memory of antiquity" in motion and help transport us not only to other spaces but to other times—the (somewhat atemporal) time of antiquity—the inscription situates objects and natural species from the four corners of the world and from the most diverse periods (including arrows, books, statuettes, fossils, fragments of rocks, turbans, corals, bones, vessels, coins, precious stones, and more) in opposition to the category that has often prevailed in studies of the early modern circulation of objects—precisely, that of exoticism.[3] In fact, the antiquity at stake in the Cospi Museum cannot be geographically or chronologically localized—it is neither Greco-Roman nor pre-Columbian, nor Indian, nor Egyptian. It is all these at the same time, and yet none of them exactly. Although the (supposed) provenance of each element seems to have been important in their spatial arrangement, the curatorial concept of the museum emerges through its ideological montage, to borrow Sergei Eisenstein's term, a new antiquity.[4] For this reason, concepts of the "proper," the "foreign," the "endogenous," and the "exogenous" are transcended by means of unexpected combinations, juxtapositions, collisions, and discontinuities that

set in motion a dialectical memory of antiquity. This "erudite machine of art and nature," I contend, not only produced encyclopedic knowledge but also original thinking about a world in transformation. The inventory of the Cospi Museum, compiled in 1680, offers us the opportunity to visualize this specific montage, one that recalls how German art historian Aby Warburg constructed his *Mnemosyne Atlas*.[5] Images and objects were associated by affinity, not by obvious iconographic relation.

On the eighth shelf of the Bolognese museum, we could have seen:

1 *Idolo dell'Indie con due faccie tutto lavorato di anelli minuti, d'osso torliti, e di varij colori* [One idol from the Indies with two faces, all worked with tiny rings, made of bones, in various colors]

2 *Idoli di terra bianca, e berrettina d'Egitto detti Iside* [Two idols made of white berrettine clay from Egypt; they call them "Isis"]

1 *Medaglia grande di Basso Rilievo rappresentante il giuramento di Muzio Scevola* [One large bas-relief medallion representing the oath of Gaius Mucius Scaevola]

1 *Patera, ò sia coperchio d'un'Urna antica, da molti stimata quella di Porsena, con Caratteri Etruschi, e figure Rappresentanti il Parto di Giove, di Bronzo.*[6] [One *patera* or probably lid of an ancient urn, which many say belonged to Porsena, with Etruscan characteristics and figures representing the Birth of Jupiter, and made of bronze]

On the tenth shelf, the objects displayed simultaneously were:

1 *Libro del Messico tutto Geroglifici* [One book from Mexico, all composed with hieroglyphs]

1 *Lettera amorosa antica con figure* [One ancient love letter with figures]

1 *Officio di Orationi Turche* [One book of Turkish prayers]

2 *Libri antichi di scorza d'Albero* [Ancient books made of tree bark].[7]

Shape, function, and medium seem to have played a role in the organization of the display. On one shelf, three-dimensional "idols" from "the Indies"—the biface one is now recognized as the *çemi* kept today at the Museo delle Civiltà in Rome (see fig. 2)[8]—Egyptian sculptures, a round fragment of Roman bas-relief, and Etruscan objects seemingly shared a common thread, at least for whomever had conceived their display. On another shelf, a Mexican book (the pictographic manuscript today known as the Codex Cospi), an "ancient" love letter, a Turkish liturgical book, and other "ancient" books made out of tree bark (American amate paper or Egyptian papyrus?) probably triggered discussions about writing systems. The archival evidence of their presentation in the Cospi Museum invalidates most of the historiography that has dissected this type of catalogue

to separate ethnographic objects (supposedly exotic) from archaeological objects (supposedly ancient, including Greek, Roman, Egyptian, and so on) and contributed to their physical estrangement today, in different museums and collections.[9]

On the contrary, these objects were part of a much more organic "machinery," one that not only triggered the memory, in the sense of construction of the past. Most important, their juxtaposition participated in a new understanding of the contemporaneous world, that *orbis universum* recently understood to be that world by whose roundness, according to the Jesuit Acosta, land and water embraced.[10] As the Inca De la Vega laconically wrote, it was a single world, where the concepts of "old" and "new" no longer held total validity.[11] The museum was thus a physical space where the world became one but only through the variety produced by its different astronomical and geographical positions.[12] The objects and fragments of this world—one but nevertheless heterogeneous—were the indispensable gears that operated the machinery of a universal antiquity, of a new artistic world. The collected artifacts were thus indispensable points of departure for a journey in time and space that was perhaps symbolized in Mitelli's engraving by the suggestive central figure of Dante, the traveler par excellence.[13]

The birth of early modern museums, such as the Cospi Museum, is intimately related, I contend, with the textual archive studied in this book: with the numerous pages written by a variety of authors who also explored the possibility of conceiving the new spatial and temporal coordinates of the world through the relentless reconceptualization of the category of antiquity. Whether observed in situ by Cortés just before the destruction of Tenochtitlan or by missionaries, travelers, traders, and soldiers in Japan, Congo, India, the Philippines, or Peru, the radical novelty of these objects challenged models of ekphrasis as previously practiced.[14] Once they were brought to European collections and observed along with artifacts from different times and spaces, they sustained an even more distinct type of ekphrasis, one that moved continuously between the here and there, erasing all previous distinctions and redesigning chronologies and territories in search of a new antiquity in fieri: an antiquity in motion. Let us a take an early, paradigmatic example of this combinatory process.

## Combinatory Art History

During the second half of the sixteenth century, a museum gradually took shape in the city of Bologna: the collection imagined and tirelessly expanded by Ulisse Aldrovandi (1522–1604). The visionary naturalist is well known today to scholars working on the history of collections: he not only combined *naturalia* and *artificialia* from all over the world but compiled catalogues and descriptions of these objects, with a rare sensibility to their making. One of the objects in Aldrovandi's collection was the magnificent turquoise mask

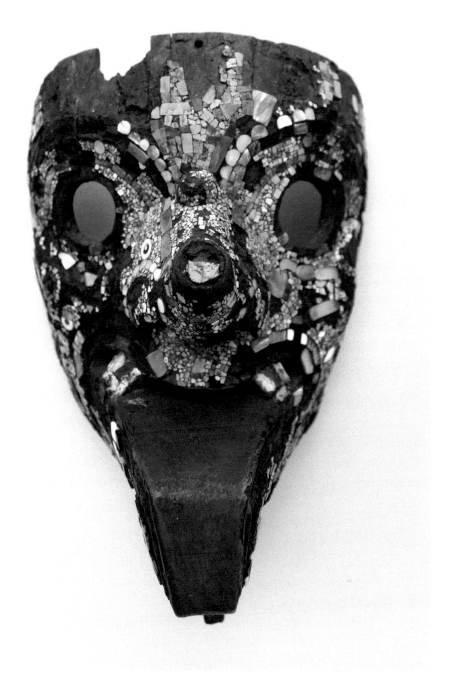

FIGURE 66 | Mask, Nahua, Mexico, fifteenth to sixteenth century. Turquoise, malachite, Spondylus, Strombus, mother-of-pearl, lignite, and metal mosaic on wood with pigments and resin, 24 × 15 cm. Rome, Museo delle Civiltà, inv. no. 4214. © Museo delle Civiltà. Photo: Davide Domenici.

of Mixtec origin—now also preserved in the Museo delle Civiltà in Rome (fig. 66).[15] A textual description of the mask appeared with an engraving in the *Musaeum metallicum*, Aldrovandi's posthumous work that was edited and published in 1648 by Bartolomeo Ambrosini, the naturalist in charge of the Studio Aldrovandi between 1632 and 1657.[16] The context of the work is important. It is a monumental compilation of more than a thousand pages on the mineral realm, divided into four books. Its topic is the realm of the "underworld"—metals and petrified liquids that are present in soil and subsoil—conceived in all its complexity: from salt to shells to lead, clay, silver, alabaster, and marble. Aldrovandi (edited by Ambrosini) explored the physical characteristics of each element, the etymologies of their names, the differences they manifest across the globe, and their use to make artifacts and tools. The materia prima is definitely considered as having an effect on the artistic quality of the object.

Long before gathering his museum, Aldrovandi had trained in classical antiquity. His *Delle statue antiche*, published in 1556, is a fantastic promenade through the fragments of the ancient statuary still visible in Rome, with a superlative attention to their materials.[17] In addition to his focus on materials, Aldrovandi continuously tried to identify what the statues represent. *Delle statue antiche* includes the description of one of the most renowned bronze sculptures of the Greco-Roman repertoire. It was found in the Casa dei Conservatori: "In un'altra camera piu a dentro è una statua ignuda di bronzo asisa sopra un sasso rozzo di bronzo medesimamente: e sta in atto di volersi cavare del pie una spina" (In another room, further inside, there is a bronze nude statue seated on a rough stone, also of bronze: the figure is in the act of trying to remove a thorn from his foot).[18] We will shortly return to the statue admired by the young Aldrovandi—the famous Spinario.

If this early work attests to Aldrovandi's attention to the material and the making, it is in the pages of the posthumous *Musaeum metallicum* that the materia prima becomes the ordering criterion for the textual and visual representation of the artifact. In the part dedicated to the "terra figlina et arcilla," that is, to the clays and earths that can be employed in pottery and ceramics, one reads that the types of earth found in Italy are not the same as those found in Spain or Portugal, which, in turn, are different from those found in China. The engravings that accompany the Latin text clearly illustrate the difference between a pot made from "tierra ispense" and the rougher "vasos lusitanos," as well as a magnificent Chinese porcelain, whose brilliance and abundance the text celebrates (fig. 67). Based on the work of the Portuguese Jesuit Alvaro Semedo (1585–1658), the *Musaeum metallicum* presents the porcelain as evidence of a tireless production that from "a single city in the province of Jiangxi [*in Kiamsi Provincia Chinae . . . in una tantum villa*—we now know that this was the city of Jingdezhen] is distributed both to the realm [of China] and the world [*& toti Regno, & universo Orbi distribuatur*]."[19] In this case, as well, Portuguese, Spanish, and Chinese pots are discussed alongside objects from the Greek or Roman traditions, such as the famous Lucerne clay lamps.

FIGURE 67 | *Vas Porcellanicum,*
in Ulisse Aldrovandi, *Musaeum*
*metallicum in libros iv distributum*
(Bologna: Marcus Antonius Bernia,
1648), 231. Bologna, Biblioteca
Universitaria. © Alma Mater
Studiorum Università di Bologna—
Biblioteca Universitaria di Bologna.
Any other reproduction is prohibited
with any medium.

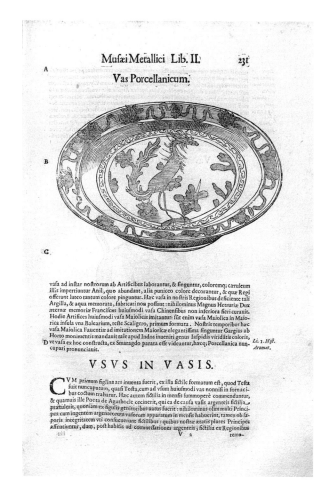

The description of the Mixtec turquoise mask appears in the fourth book of the
*Musaeum metallicum.* After discussing the use of small stones, particularly for the dec-
oration of buildings, the text relies on the authority of Leon Battista Alberti's *De re*
*aedificatoria* (published in 1485) to recall that the term *pavement* comes from the Latin
term *pavo,* meaning "peacock," since floors made out of stones share the feathery char-
acteristic of that magnificent bird.[20] Aldrovandi (as edited by Ambrosini) remarks that in
Italy, there are a great number of temples whose pavements are decorated with a mosaic
technique (he uses the term *musaic*) and alludes to the Greek term for this technique: *asa-*
*roton* (ἀσάρωτον), described by Pliny the Elder in his *Natural History.*[21] The word means
literally "that which has not been swept," since the small stones of the mosaic pavement
evoke the crumbs and other remains left on the floor after a meal.[22] The second term that
the text puts forward to introduce the Mixtec mask is *Lithostrata*: literally a type of pav-
ing that could refer to mosaic. But, in this case, the term may be also used to refer to a
specific location, as we will see shortly.

## Larua Indica varijs lapillis exornata inſtar Lithoſtroti.

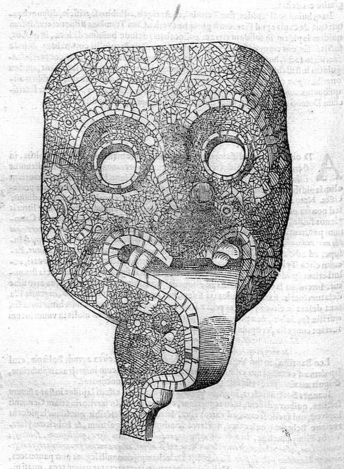

At this point in the text and in the middle of a seemingly philological—and, more pre-cisely, etymological—discussion, the turquoise mask from Mexico unexpectedly comes into play. Here text and image take two divergent albeit related paths. The text that runs from pages 549 to 551 is interrupted by the engraving on page 550 (fig. 68). That is, having introduced the reader, on page 549, to the section on mosaic technique, the book pres-ents the engraving titled *Larva indica* (Indian specter or Indian mask). After observing this completely unexpected type of object, the reader then immediately returns, on the following page, to the world of mosaic pavements in the Greek and Roman tradition, to be suddenly transported, once more, to another space with the following paragraph: "But it is worth noting that Gómara, in his *Histories of the Indies*, writes that these masks from the Indies were undoubtedly made of wood and then decorated with small stones of different colors in such a way that they admirably rival the work of the *lithostroton*. For this reason, for the pleasure of the reader we show an image of the mask."[23]

We can thus identify three key moments in the "representation" of the object. First, on page 549, the text discusses the technique used in the Greco-Roman world to make decorated pavements. Second, on page 550, the engraving of the Mixtec mask occupies the space of an entire page, following with relative fidelity the very characteristics of the object, including the exact placement of the mosaic tesserae. At the same time, the title of the image turns to the analogical method and describes the object as "Larva Indica varijs lapillis exornata instar Lithostroti" (Indian mask decorated with various stones like [*instar*: in the manner of] the *Lithostroton*). Finally, on page 551, the text on the Indian mask exceeds the analogical method. The artifact is not only similar to but rivals (*aemu-lentur*) the work of the *lithostroton*.

But what did "in the manner of the Lithostroton" mean to a reader of the time? As mentioned, the Latin term *lithostroton* derives from the Greek λιθόστρωτος and was used to refer to pavements made of mosaic or stone.[24] However, following the Gospel of John 19:13, this term also indicated a specific site in Jerusalem, the Gabbatha, which in Aramaic alludes to the place Pilate was said to have condemned Jesus. By describing the Mix-tec mask as *Larva indica* (Indian mask) and reading it on the basis and in the direction of the *Lithostroton* (a stone pavement associated with a specific place in Jerusalem), the *Museum metallicum* grafts the "Indian mask" onto an antiquity shared with that antipo-dean part of the *orbi universum*. The American object becomes an important device that reactivates antiquity by a journey around the world and, one might say, through time. Passing through the *Lithostroton* of Jerusalem and the dawn of Christianity, the descrip-tion of the Indian mask puts in place the coordinates of a fully vital, universal antiquity.

Spinari of the Indies

In the case of the *Musaeum metallicum*, the "montage" method is neither simple analogy nor causal thinking. As gears or mechanical pieces, the objects (in all their dimensions, that is, form, size, material, and so forth) also entail a type of ekphrasis that juxtaposes, makes collide, and connects. The idea of observing the artifacts, especially those coming from Mexico, in order to bring forth a memory of the antiquity of the world, conceived now as single and multiple, is common to other authors who were simultaneously confronted with the great problem of how to describe and translate the novelty of those objects, while redefining the breadth of the concept of antiquity itself.

Let us look at the case of Lorenzo Pignoria (1571–1631), the antiquarian from Padua who in 1615 published a profusely illustrated supplement to the *Immagini degli Dei* (originally published in 1556) by Vincenzo Cartari, one of the most important works of Renaissance mythography.[25] In his contribution titled *Discorso intorno le Deità dell'Indie Orientali, et Occidentali, con le loro figure tratte da gl'originali* (Discourse on the gods of the East and West Indies, with their figures traced from the originals)—whose sources and implications still remain insufficiently explored—the Paduan antiquarian established a dialogue between the "gods" of Mexico, Japan, India, and China and the gods of Egypt, Greece, and Rome. Interestingly, this dialogue was almost exclusively based on the objects' characteristics, as observed by the author or as described in the rich correspondence that Pignoria maintained with collectors of the period.

The pages that Pignoria devotes to Quetzalcóatl are of particular interest for our discussion on the reactivation of antiquity through the observation and display of artifacts. Here too, as in the case of Aldrovandi, text and image complement each other, while simultaneously taking distinct paths (fig. 69). Before the engraving, Pignoria explains, "Now, this Quetzalcóatl was also called Topilczin, that is, my very beloved son, and they say that he was born with the use of reason and that he was the first to begin to invoke the Gods and make sacrifices to them, with his own blood, that he drew from his person with thorns [as] in other ways already had the people of our world, the Bellonarii, the Gauls of the mother of the Gods and others who scattered blood: but this one [Quetzalcoatl Topiltzin] was much older, although a disciple of the same school."[26] In the text, Quetzalcóatl is presented as a rational man, in his manifestation as Topiltzin, which Pignoria translates as "my beloved son" (in Nahuatl, lit., our beloved son). The engraving presents us with a triumphant Quetzalcóatl-Topiltzin, standing and in profile. A discreet reference to the act of sacrifice appears in the sharply pointed object represented to the right: comparing it with the image of the Codex Ríos—now considered to be the "original" on which Pignoria based his representations of the Mesoamerican gods—we can see that this is precisely the "thorn" mentioned in the text (fig. 70).[27] In his commentary,

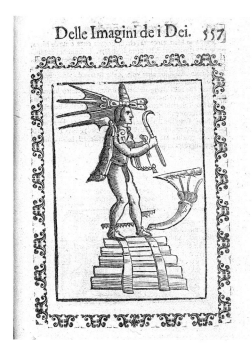

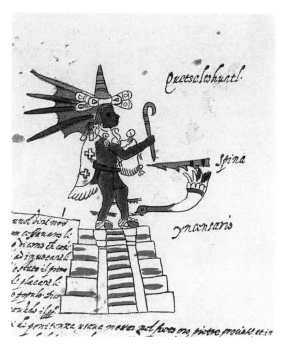

FIGURE 69 | *Quetzalcóatl*, in Lorenzo Pignoria, "Delle imagini degli dei indiani," in Vincenzo Cartari, *Le vere e noue imagini de gli Dei delli antichi di Vincenzo Cartari… Cauate da' marmi, bronzi, medaglie, gioie, & altre memorie antiche* (Padua, 1626), 557. Courtesy of the Getty Research Institute Open Access program.

FIGURE 70 | *Quetzalcóatl-Topiltzin*, in the Codex Ríos, ca. 1565. From the facsimile *Il Manoscritto messicano vaticano 3738, detto il Codice Rios*, 1900 (Rome: Danesi, 1900). Washington, DC, Smithsonian Library.

Pignoria insists on the sacrificial act that allows him to put Quetzalcóatl not only in dialogue with the "gentility of our world" and specifically with the Bellonarii (the Roman priests of the goddess of war, Belona) but also to assert that the Mexican "man-god" was at the same time "much more ancient" (*forte più antico*) than the Romans and a "disciple of the same school." This seems to suggest the idea that both Topiltzin and the Bellonarii had inherited their beliefs from a common originary thought.

However, what is most striking in Pignoria's text is the detail that Quetzalcóatl-Topiltzin "si cavava dalla persona con Spine" (used a thorn to draw [the sacrificial blood] from himself). Sixteenth-century sources often describe the Mesoamerican practices of self-sacrifice, carried out with cactus or maguey thorns.[28] But it is possible that, in 1615, European readers of this description would not so much have appreciated its verisimilitude from an anthropological point of view, as they would have immediately thought of another "beloved young man" coming from Greco-Roman antiquity who was not drawing blood out with a thorn but who was taking a thorn out of his foot—the famous

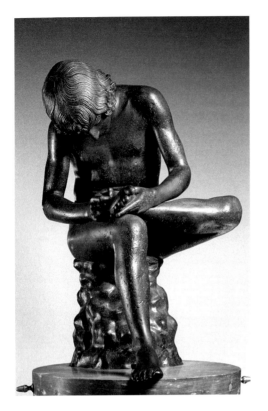

FIGURE 71 | Spinario, first century BCE. Bronze. Rome, Capitoline Museum. © Roma Sovrintendenza Capitolina ai Beni Culturali, Musei Capitolini.

Spinario. The celebrated sculpture was known from a Roman copy of the orginal Greek and was on display in Rome in the Palazzo dei Conservatori (fig. 71). As we have seen above, Aldrovandi described it in 1557 in his *Delle statue antiche* ("a bronze statue of a nude boy seated on a rough rock: he is in the act of trying to pull a thorn from his foot"). This was a true icon of classical antiquity, frequently copied during the Renaissance (by Holanda, for instance).[29] It was resignified from the early Christian period onward as an allegory of the conversion of a pagan, who on removing the thorn is freed from ignorance and acknowledges the imminent arrival of the Redeemer.[30] In 1401, in the famous panel Filippo Brunelleschi presented to the competition for the doors on the north of the Florence Baptistery, the artist inserted a Spinario on the lower left, probably in a figural key: by making him a witness to the sacrifice of Isaac, a liminal moment par excellence for the Christian typological interpretation of the Old and New Testaments.

The idea that Pignoria describes Quetzalcóatl-Topiltzin in a sort of "counter-analogy" to the Spinario—one is removing the thorn to free himself from ignorance while the other used it for self-sacrifice—might seem conjecture and speculation. However, we have additional archival evidence, which comes not from Padua, Bologna, Rome, or Florence but from New Spain. In the Florentine Codex and in the Durán Codex—both compiled in New Spain around the 1570s and 1580s, the first by the Franciscan Bernardino de Sahagún, the second by the Dominican Diego Durán—the Nahua painters (*tlacuiloque*) decided to represent Quetzalcóatl in an astonishing, and astonishingly similar, way: neither standing nor triumphant but seated and making the self-sacrificial gesture with a maguey thorn (figs. 72 and 73). Quetzalcóatl is represented in both images by means of the same new iconography—one that we could call the Spinario of the Indies.

It remains to demonstrate how an image of the Roman Spinario could have arrived in New Spain to be then reinterpreted in the personification of Quetzalcóatl. But we

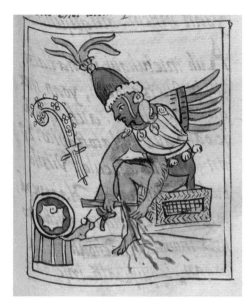

FIGURE 72 | *Quetzalcóatl*, in the Florentine Codex, ca. 1570. Painted manuscript on paper. Florence, Biblioteca Mediceo-Laurenziana, MS Med. Palat. 218, fol. 211r. Su concessione del Ministero della Cultura. Any other reproduction is prohibited with any medium.

FIGURE 73 | *Quetzalcóatl*, in Diego Durán, *Historia de las Indias*... (the Durán Codex), ca. 1570–80. Madrid, Biblioteca Nacional de España, MSS. Micro/908, MSS–495, fol. 248v. Photo: Biblioteca Nacional de España.

know for certain that copies of the statue were widely circulating in Europe at the time, in particular between Rome and the Iberian territories. Margarita of Austria in Mechelen owned at least two reproductions made after the original: one bronze and the other marble; the latter was then inherited by Mary of Hungary, who brought it to Cigales (Valladolid).[31] The statue also traveled in drawings (by Holanda, who brought it to Lisbon, and by Jan Gossaert, who brought it to the Netherlands). The statue was widely reproduced in engravings as part of the compilations of ancient statues from Rome published throughout the sixteenth century. Marco Dente's engraving is particularly interesting as the Spinario is represented in profile (fig. 74). Made prior to 1527, it later enjoyed wide circulation through the *Speculum Romanae Magnificentiae* (completed in 1573).[32] It is possible to imagine that this specific engraving arrived in Spain through the Spaniard Antonio Salamanca, who worked in Rome together with the Frenchman Antonio Lafreri.[33] From Spain, the engraving of the Spinario probably left for New Spain, where it would be reinterpreted in a Mesoamerican key by the *tlacuiloque* who worked with Sahagún or Durán. And on a more methodological level, let us remark that other examples of the reinterpretation and reuse of pagan antiquities in a Mesoamerican key are numerous, including at the famous Casa del Deán, in Puebla, where Ovid's *Metamorphosis* was combined with Mesoamerican references.[34]

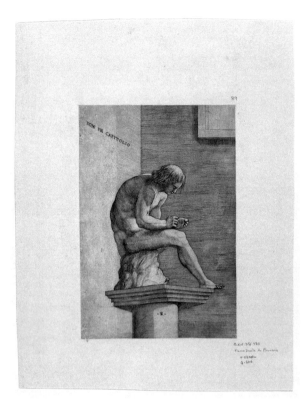

FIGURE 74 | Marco Dente, *Man Removing a Thorn from His Foot*, in Antonio Lafreri, *Speculum Romanae Magnificentiae*, ca. 1573. Engraving. New York, The Metropolitan Museum of Art © The Metropolitan Museum of Art, New York.

FIGURE 75 | opposite | *Pantheon of Gods*, in the Florentine Codex, ca. 1570. Painted manuscript on paper. Florence, Biblioteca Mediceo-Laurenziana, MS Med. Palat. 218, fol. 10r. Su concessione del Ministero della Cultura. Any other reproduction is prohibited with any medium.

The black skin of Quetzalcóatl as represented in the Florentine Codex and the Durán Codex requires further attention. While it can be undoubtedly associated with the body painting used in the pre-Hispanic period, the color of these Spinari of the Indies reminds us also of the bronze statue described by Aldrovandi, that is, the Spinario of the Palazzo dei Conservatori.[35] By this "bronzification" of a pre-Hispanic reference, the *tlacuiloque* of the Florentine Codex and the Durán Codex may have produced both the antiquarianization of the world prior to the conquest—that is to say, its elevation to the rank of proofs of a past civilization—as well as its estrangement. In the Florentine Codex, this same mechanism may be at work in the famous series that opens the manuscript (fig. 75). Dedicated to the representation of the Nahua pantheon, the antiquarianization of the "gods" is made visible not only through the captions that accompany them (Huitzilopochtli is described as "another Hercules," Tezcatlipoca as "another Jupiter," for example) but also by the material aspect of these "gods." Both their posture and their color, in fact, seem to allude precisely to the statues of Greco-Roman antiquity made not only of bronze but also of marble and other fine stones. Black, white, or green, the Nahua gods have taken the colors of Greco-Roman sculptures. It is not simply the imitation of Greco-Roman

Vitzilobuchtli      otro hercules

Tezcatlipaca. otro iupiter.

Capitulo primero. fo. 1.

¶ Capitulo tercero. fo. ibidem.

Paynal. vicario de vitzilobuchtli.

Tlaloc tlamacazqui. dios de las pluuias.

Capitulo segundo.      fo. ibidem.

Capitulo quarto      fo. 2.

10

sacrality and its representations, however, but also a reactivation of pre-Columbian history thought in tandem with classical references.[36]

## Between Our Two Feet . . .

From Mexico, Bologna, or Padua, a great variety of authors—the *tlacuiloque* working with Sahagún and Durán, Aldrovandi, Cospi, and Pignoria (as well as the Inca De la Vega, from Spain)—seem to have contributed simultaneously to the dynamic display of a new artistic world. These together with all the experiments studied in this book happened right before the closure analyzed by Benjamin Schmidt: the construction, between 1660 and 1730, of a peculiar exoticism that arose from an imaginary of European harmony, after decades of internal wars.[37] When Michelangelo, according to Holanda, saw in the human-made objects manufactured thoughout the entire world—the artifacts of the antipodes—something that concerned him as a painter; when Anghiera defined civilization tout court via the artistry created in the New World, which, in turn, demonstrated how that creative potential had been endowed to all humans without exceptions; when Las Casas claimed that the humanity of the "Indians" was art based; when the supposedly despicable idols coming from overseas were, in fact, displayed as sublime handmade forms; when feather painting brought something new to the art of painting, worldwide; or when the Nahua *tlacuiloque* revisited the classical Spinario or the contrapposto figure to think their own history and art history anew, they all found novel ideas to demonstrate that artistry—as intrinsically inscribed in thoughtful materiality—and humanity—as intrinsically creative and indestructible—cannot ever be approached as exotic.

Yet, not everybody, even in the sixteenth century, participated in those same experiments and in that same revolution in thought studied in this book. Actually, many of the authors I discuss in *A New Antiquity* remained unpublished for a long time, faced open criticism, and were officially censored.[38] How can we still contend, therefore, that it was a "revolution in thought"? A comparison may help us here.

In his groundbreaking *De revolutionibus orbium celestium* (1543), Copernicus, while mathematically demonstrating the heliocentric system ("in medio vero omnium residet sol"), wittingly acknowledged that, for those living on the terrestrial globe, geocentrism was still inevitably a way to make the universe visible: "For us who are borne by the earth, the sun and the moon pass by and the stars return on their rounds, and again they drop out of sight."[39] We could parallel this reflection with what was going on at the same time in the field of art theory. While thinkers, such as Anghiera, Dürer, Holanda, Las Casas, Guevara, and the other authors we studied in this book, were pointing to the revolution in thought produced by the "antipodean objects"—the universalization of the human

artistic potential with the subsequent decentralization of Europe and its classical past as the only sources of artistic excellence—many still looked at the artistic globe from Europe, picturing all the rest as peripheral.

Yet, the revolution was ongoing.

Copernicus's heliocentric demonstration opened up the possibility to devise completely different relationships among planets in the solar system. The revolution in thought studied in this book opens up the possibility of another history of art history, where "antipodean objects" prompted a configuration that is still *today* central to any reflection about the artistic act, about what it means to be an artist, and about what is to be human—with the difference that if, for Copernicus, the sun was stationary at the center of its system, the antipodean objects moved all around the terrestrial globe, producing a potentially infinite number of artistic and theoretical configurations.

My sense is that the revolution in thought triggered by the antipodean objects can be liberating for many new generations of students and scholars in the field of art history, including European art history. At stake is to demonstrate that European art history is also made of the antipodean artifacts. If substantial work has been done, in the last few years, to study how the writing of history, in the Renaissance, was impacted by the experience of the New World, this book has opened the path to the study of how the writing of art history, as well, was reshaped by the artifacts seen or coming from the New World— and by their observation and description.[40] In other words, that impact can no longer be restricted to a few pages of a survey or to a chapter of an anthology. That is precisely why I wrote this book. To develop this argument certainly demands indefatigable archival research. But it also requires an indispensable assumption about one's own position. A brief "prophecy" (actually, more a statement of fact) by Leonardo da Vinci is inspiring in this sense. In a short text written around 1508, he describes the hemispheres: "Degli emisferi che sono infiniti e da infinite linee sono divisi in modo che ciascun homo n'a una d'esse line intra l'un piede e l'altro" (Of hemispheres which are infinite and which are divided by an infinite number of lines, so that everyone always has one of these lines between their two feet).[41] Leonardo's passage can be a motto for early modern art history, including that of Europe, where the antipodean objects *continuously* cross our two feet—and our two eyes, as well as across our writing, thinking, and teaching.

In this sense, let us take it as a good omen.

# Notes

Translations are mine unless otherwise indicated.

## INTRODUCTION

1. Las Casas, *Apologética*, book 3, chap. 55, ed. O'Gorman, 1:340.

2. Ostapkowicz, "Integrating the Old World." Before 1517, Cardinal Francisco Jiménez de Cisneros's collection included a beaded object seemingly arrived from Hispaniola in 1316.

3. Vandenbroeck, "Amerindian Art and Ornamental Objects," 107.

4. "Joyas que Hernán Cortés envió a España" (1526) 1: doc. 62. See also Russo, "Cortés's Objects," 15 and 23n91.

5. Xeres, *Verdadera relación de la conquista*, 165. See also Lothrop, *Inca Treasure*, 50.

6. Here and throughout the book, I use the term *artifact* neither to signal the cultural importance of these objects (versus their supposedly autonomous artistic relevance) nor to point to their supposed factitious nature. I use *artifact* in its most etymological sense, as *arte factus* (made with art).

7. Hernando Pizarro's letter was transcribed by Fernández de Oviedo y Valdés. A modern edition was published as Pizarro, *Carta a los magníficos señores oidores de la audiencia*.

8. "Real Cédula," quoted in Parker, *Emperor*, 357n48. Two months later, in March 1534, Hernando Pizarro brought to Charles V in Toledo some of the salvaged artifacts: "Dos vasixas de oro e una de plata e un retablo de ymagenes e una caña de mahiz de oro e un atambor pequeño guarnecido de oro," "Real Cédula," chap. 3, 129.

9. "Real Cédula," chap. 3, 128.

10. Calepino, *Latinae atque adeo etiam graecae linguae Dictionarium*, n.p. This might be a quotation from Rudolf Agricola's *De inventione dialectica* (written in 1479, published in 1515). Covarrubias will rework this definition in his *Tesoro* in 1611: "Arte: Latine ars, quae sic definitur, ars est recta ratio rerum faciendarum, y assi toda cosa que no lleva su orden, razon, y concierto, dezimos que esta hecha sin arte: es nombre muy general de las artes liberales, y las mecanicas . . ." (fol. 65r). The *Vocabolario degli Accademici della Crusca* in 1612 will also point to the relationship between *art* and *reason*: "Arte è un'abito cavato dalla esperienza, di poter operare con ragione" (80).

11. On the sumptuous display of treasures, regalia, and religious spectacles, see Johnson, "Aztec Regalia."

12. "Unas carátulas hechas de huesos de pescado, á manera puesto de aljófar, y unos cintos de lo mismo fabricado por artificio admirable." Las Casas, *Historia de las Indias*, book 1, chap. 78, ed. Millares Carlo, 1:332. See also Las Casas, *Apologética*, book 3, chap. 61, ed. O'Gorman, 1:586.

13. On Columbus's library, see Kimmel, *Librarian's Atlas*, and Wilson-Lee, *Catalogue of Shipwrecked Books*.

14. Oviedo y Valdés, *Historia general y natural de las Indias*, book 2, chap. 7, ed. Perez de Tudela Bueso, 117:30.

15. Dürer, *Schriftlicher Nachlaß*, 1:48 (August 27, 1520). I will discuss this passage in both chapters 4 and 5. For a different take on Dürer's wording in his diary, see Feest, "Dürer et les premières évaluations." See also Greenblatt, "Resonance and Wonder," 53, and Hess, "Marvelous Encounters."

16. On Dürer and Columbus, see M. McDonald, *Ferdinand Columbus*. On Erasmus and Columbus, see Wilson-Lee, *Catalogue of Shipwrecked Books*, 206.

17. D. MacDonald, "Collecting a New World," 656. On Mechelen's court, where Charles V was raised by his adored aunt Margaret, see Parker, *Emperor*, esp. chap. 1 ("Young Charles").

18. On Erasmus: Preserved Smith, quoted in Parker, *Emperor*, 15; on Dürer: Hess, "Marvelous Encounters," 163. Wilson-Lee, on the contrary, writes that Dürer might have "illustrated a translation of *Hieroglyphica* made by his friend Wilibald Pirkheimer with images not unlike the sacred Aztec discs that he saw at Brussels" (*Catalogue of Shipwrecked Books*, 206). Dürer's drawing is today at the British Museum (https://www.britishmuseum.org/collection/object/P_1932-0709-2).

19. Horodowich and Markey, *New World in Early Modern Italy*.

20. Bandello, *Novelle*, pt. 1, novel 23, ed. Laterza and Figli, 2:19. Chiericati was returning from Portugal, where he had been sent the year before by Leon X to visit the court of Emanuel (Cachey, introduction to *First Voyage*, xvi).

21. On the history of the Codex Vindobonensis I, see Anders, Jansen, and Perez, *Origen e historia de los reyes Mixtecos*.

22. Markey, "Feather Painting of Moctezuma."

23. Anania, *Universal fabrica del mondo*, book 4, 8. Anania discusses here pictographic writing as "imagini in luogo di lettere" and describes a manuscript: "Mostrommi queste imagini frà Alonso Ferrea canonico regolare, huomo mathematico e persona di qualità, sopra un cuoio d'animale cosi acconcio, che pareva carta Turchesca, dalle quali s'intendeno pingendo, come noi scriviamo; pingeano molto aggrabatamente con olio di Cian, che resiste alle pioggie." The "oil of Cian" is oil made of chia seeds (*Salvia*

*hispanica*). Anania must have read López de Gómara's observations (*Historia generale delle Indie Occidentali*, chap. 103), though the Spanish chronicler refers there to the painting of gourds, not manuscripts (thanks to Davide Domenici for this precision). Therefore, Anania personally saw Mexican pictographic manuscripts and feather painting (*Universal fabrica del mondo*, book 4, 7v). See Russo, "*Questa macchina mondiale*."

24. "Hum Ecce Homo, tamanho como hum quarto de papel de marca mayor de estranho feitio e materia. Era de penas de' passaros, tão finas nas côres, e por tal ordem postas, que ficavaõ mostrando muy ao natural a imagem do Christo noquelle passo, e esta imagem foi mandada em grande presente a S. A. das Indias de Castella." Francisco Monclaro, "Relaçaõ da viagem," 493. The original document of 1575 is quoted and discussed by Marcocci, *Invenzione di un impero*. See also Rappaport and Cummins, *Beyond the Lettered City*. Queen Catarina of Austria hoped that the American object had the power to convert the African king ("para o Monomo-tapa se se convertesse," Monclaro, "Relação da viagem," 493).

25. Monclaro, "Relação da viagem," 493.

26. Russo, "Multilingual Dialogues."

27. The bibliography available today on the *Wunderkammern*, the wonder cabinets or cabinets of curiosities, is impressive. See, in particular, the pioneer work of Lugli, *Naturalia et mirabilia*; Falguières, *Chambres de merveilles*; Yaya, "Wonders of America"; Feest, "Vienna's Mexican Treasures." For a transcultural perspective on collecting, see Bleichmar and Mancall, *Collecting Across Cultures*.

28. Göttler and Mochizuki, *Nomadic Object*. See, in particular, Mochizuki's introduction, where she proposes the interesting concept of a "global republic of objects" (6).

29. On the impact of the New World on the Old, see the pioneer works of Elliot, *Old World and the New*; Greenblatt, "Resonance and Wonder"; and Grafton, Shelford, and Siraisi, *New Worlds, Ancient Texts*.

30. Markey, *Imagining the Americas*; D. MacDonald, "Collecting a New World"; Holohan,

"Collecting the New World"; Russo, "Cortés's Objects."

31. Shelton, "Cabinets of Transgression," 203, retaking Ryan's argument in "Assimilating New Worlds." See also Bujok, "Ethnographica"; Göttler, "'Indian Daggers with Idols'"; and Göttler, "Extraordinary Things."

32. On ethnography, see Rubiés's substantial scholarship, in particular *Travel and Ethnology*. On the relationship between artifact and "human science," see Falguières, "Inventeurs des choses." On global lives, see Gerritsen and Riello, *Global Lives of Things*.

33. Kubler, *Esthetic Recognition of Ancient Amerindian Art*, especially the chapter "Salvaging Amerindian Antiquity."

34. Bleichmar, "The Cabinet and the World." On the collecting of Americana, see the major oeuvre by Christian Feest.

35. On the display of pre-Columbian artifacts in national museums, see Achim, *From Idol to Antiquity*.

36. Hall, "The West and the Rest."

37. Battisti, *Antirinascimento*; see also Cole and Wood, review of Battisti, *L'Antirinascimento*.

38. Pagden, *Fall of the Natural Man*, 1, and Wood, *History of Art History*, 11.

39. "Donde la calidad de la tierra o la costumbre que en ella se usaba a tener oficios no los constreñía, por su recreación o por su curiosidad cosas por arte y tan polidas y sotiles hacían, que mostraban no menos que muy claramente ser de ingenio vivísimos y sotilísimos." Las Casas, *Apologética*, book 1, chap. 61, ed. O'Gorman, 1:316 and 325, respectively.

40. Kristeller, "Modern System of the Arts"; Wittkower and Wittkower, *Born Under Saturn*; Kurz and Kris, *Legend, Myth and Magic*. On the history of aesthetics, see the monumental oeuvre by Władysław Tatarkiewicz. I further discuss the impact of the artifacts of the New World on the shifting frontiers between the liberal and mechanical arts in Russo, "Artistic Humanity."

41. The mosaic disk is attributed to "Mexica lapidary *artists*" (emphasis mine), in Pillsbury, Potts, and Richter, *Golden Kingdoms*, 265 (no. 219).

42. Abu-Lughod, *Before European Hegemony*; Sallmann, *Grand désenclavement du monde*. See also Normore, "Re-assessing the Global Turn," and Brottom, *Renaissance Bazaar*.

43. Mack, *Bazaar to Piazza*; Schmidt Arcangeli and Wolf, *Islamic Artefacts*; Nagel, "Some Discoveries of 1492."

44. Rodini, "Mobile Things," and Rodini, *Gentile Bellini's Portrait*.

45. Mack, *Bazaar to Piazza*, chap. 4. "Islamicized" designs were also produced in the workshops of the major Italian courts. Jardine looks at artistic commissions and the circulation of objects under this perspective of bravura consumerism (*Worldly Goods*).

46. Bisaha, *Creating East and West*, esp. chap. 2 ("The New Barbarian"). See also Farago, "Desiderata for the Study."

47. Tommasino, *Venetian Qur'an*.

48. Commerce with North Africa had a long story. Fairs of northern Castile had been fueled by African gold and trade goods (Phillips and Phillips, *Worlds of Christopher Columbus*, 54–55). The Castilians had the monopoly in the commerce of the shell *caurí* (*cypraea moneta*) from the Canary Islands to Guinea and Sudan in exchange for gold (Rumeu de Armas, *España en el Africa Atlántica*, 1:448) and, later, enslaved people (Bassani, *African Art and Artifacts*). On medieval precedents, see Santana Simões, "Symbolic Importance of the 'Exotic,'" and Santos Lopes, *Da descoberta ao saber*. On sub-Saharan exchanges and circulation of materials in the thirteenth and fourteenth centuries (from Seville to Paris), see Guérin, "Exchange of Sacrifices." On Portuguese travels and depictions, see Cattaneo, "European Medieval and Renaissance Cosmography."

49. Abulafia, *Discovery of Mankind*. See also Martin, *Renaissance Meteorology*, and Martin, *Subverting Aristotle*.

50. Wey-Gómez, *Tropics of Empire*, 87.

51. Christopher Columbus, quoted in Phillips and Phillips, *Worlds of Christopher Columbus*, 106.

52. Pina, "Relação do Reino do Congo," chap. 57, 148, quoted and discussed by Fromont, *Art of Conversion*, 128.

210

53. "Neste Reyno do Conguo se fazem huns panos de palma de pello como veludo & delles com lavores como catim velutado tam fermosos que a obra delles se nom faz melhor feyta em Italia; & em toda a outra Guinee nom ha terra em que saybam fazer estes panos senom neste Reyno do Conguo." Pacheco Pereira, *Esmeraldo de situ orbis*, book 3, chap. 2, 84.

54. "Mays sotis cohares de marfim e milhor lavradas que em nenhua parte & asim fazem esteiras de palma a que ells chamom bicas muito fermosas & boas." Ibid., book. 1, chap. 33, 56. Earlier we read, "Nesta terra fazem humas esteiras de palma muito fermosas & asy collares de marfim" (ibid., 55). The same "extremely well-carved" ivories, along with clothes of rare beauty (*di rara bellezza*) will later join the collections of Rudolf II in Prague, Manfredo Settala in Milan, or Ferdinando Cospi in Bologna. On the ivory listed in Rudolf II's 1607 inventory, see Bassani, *African Art and Artifacts*, 13 p. 7.

55. "Pano de palma muito fino, e delgado, com lavores altos, e baixos, a maneira que acerca de nos hé a tecedura de cetim aveludado." João de Barros, *Asia*, vol. 1, book, 3, chap. 9, quoted in Bassani, "Note on Kongo," 83.

56. "Admirandum sane, tantam apud Barbaros vigere artem nostre crispatae Holosericae superantem." Terzago, *Musaeum Septalianum*, 131, quoted in Bassani, *African Art and Artifacts*, 152n502.

57. "Tot muneribus ornatus Praefectus et donis a Goathanario refertys, tunicam interulam Aphricana arte consutam, nobilibus coloribus variegatam, facta versura induit insigniter." Scillacio, *De insulis*, 6.2.19, ed. Symox et al., 170. In the same account, Scillacio uses "mira arte" and "artificio miro" to refer to the Taino artifacts.

58. See, for instance, Leloup and Patou, *Dogon*, 186–87, fig. 4. On Mande trade networks, see Menzel, "Textile Trades in West Africa," 89–91.

59. Fernandes, *Códice Valentim Fernandes*: "Em Serra Lyoa som os homens muyto sotijs muy engeniosos fazem obras de marffim muy maravilhosas de ver de todallas cousas que lhes mandam fazer—a saber huus fazem colheyros outros saleyros outros punhos pela dagas e qualquer

outra sotileza" (111); "Os homens desta terra som muy sotijs negros de arte manual—a saber—de saleyros de marfim e colhares. E assi qualquer obra que lhes debuxam os cortam em marffim" (115); "Fazem nesta terra muytos artificios manuals de ferro . . . fazem coisas sotijs de marfim, como colheres, saleyros e manilhas" (98).

60. "Som homens muyto sotijs de trabalho de suas mãos em coser e texer e outras muytas cousas." Ibid., 81.

61. In paleontology, the artistic act is a guiding principle to define humans and its relatives. See the great chapter on Neanderthal art, titled "Beautiful Things," in Wragg Skyes, *Kindred*, 239–64. Children's literature also presents art as embedded in the birth of humanity; see the beautiful books by Bright and Bailey, *When We Became Human*, and Gerstein, *First Drawing*.

62. Wallerstein, *European Universalism*. This imperial universalism completely diverges from the universalism of a Saint Paul as studied by Badiou and Brassier in *Saint Paul*. For a fine analysis of the entanglements between false hegemonic universalism and normativity, especially regarding women, see Khader, *Decolonizing Universalism*.

63. Headley, *Europeanization of the World*.

64. The period that I study precedes the one analyzed by Schmidt in *The Invention of the Exotic*. I will return to Schmidt's precise thesis in the conclusions.

65. On how Christendom transfigured into Europe, see Wood, "Discourse of the Idol."

66. See the critical edition and introduction of Piccolomini, *Europe*.

67. Gruzinski, *Conversations avec un métis*.

68. Nagel and Wood, *Anachronic Renaissance*.

69. Momigliano, "Ancient History and the Antiquarian," esp. 289–92. According to Momigliano, antiquarians were thought of as "imperfect historians who helped to salvage relics of the past too fragmentary to be the subject of proper history" (292n2).

70. Ibid. See also Schnapp, *Historie universelle des ruines*; Anderson and Rojas, *Antiquarianisms*; and Marcocci, *Globe on Paper*, esp. chapter 1.

71. Deswarte-Rosa, *Ideias e imagens*, esp. 17–22.

72. The distinction between *ancient* and *old* will be retaken by Vasari. Wood defines Vasari's treatement of this distiction, however, as "confusing" (*History of Art History*, 85).

73. See the critical analysis of the Hobbesian/Rousseauian paradigms in Graeber and Wengrow, *Dawn of Everything*.

74. A series of original efforts to address the topic has been magisterially reunited by Grant and Price, "Decolonizing Art History."

CHAPTER 1

1. The bibliography on the global turn in art history is vast. Some publications have been particularly important: Elkins, *Is Art History Global?*; Elkins, *Art and Globalization*; Joselit, "Roundtable: The Global Before Globalization," 3–19; Savoy, *Globalization of Renaissance Art*; Cassid and D'Souza, *Art History in the Wake*; Gerritsen and Riello, *Global Lives of Things*; and Kaufmann, *Circulation in the Global Art History*. See also Allerstorfer and Leisch-Kiesl, *Global Art History*. Here, Allerstorfer rightly identifies the impact of the 1986 International Congress of the History of Art on the global turn (for the proceedings, see Lavin, *World Art*).

On the tension between political/economic globalization and artistic experimentation, see Wilson and Vanhaelen, "Making Worlds," 108 and 113. Several exhibitions have contributed to address the abundant experimentation that accompanied the early modern globalization; see Gruzinski, *Planète métisse*, and Russo, Wolf, and Fane, *Images Take Flight*.

2. On how the global approach has renewed the parameters of history, see Conrad, *What Is Global History?* On art history, see the intervention by Farago, "Global Turn in Art History," 305. For a critical history of the discipline, see Belting, *End of Art History?*, and the recent synthesis by Wood, *History of Art History*.

3. A concise bibliographic panorama on what could be called the Holanda problem is provided by Nascimento, "Da pintura antiga de Francisco de Holanda," 37–50. Nascimento rightly highlights the long-standing negative impact of the early twentieth-century art

historians Hans Tietze, Ernest Steinmann, and Julius von Schlosser and the crucial rupture produced by Robert Klein's pioneer vision on Holanda's novelty. Summers's *Michelangelo and the Language of Art* shifted the discussion about Holanda's dialogues from their accuracy to the cultural milieu that is reflected in their language. Holanda's treatise is listed as "Italian theory" in Elkins and Williams, *Renaissance Theory*, 315.

4. Farago, "Global Turn in Art History," 308.

5. Schapiro, "Style," quoted in Wood, *History of Art History*, 370.

6. Russo, "Artistic Humanity," 352–63, esp. 357–58. On the distinct argument that *ingenio* was used by some missionaries as evidence that the American population was ready to be Christianized, see Domenici, "Missionary Gift Records on Mexican Objects."

7. Carrier, *World Art History*, 58. Carrier acknowledges the impact of Elkins's *Stories of Art* on his project (xvii) and, specifically, Elkins's advice to avoid a single voice "in the current climate of multiculturalism, postcolonial studies, pluralism, and relativism" (58). For a bold critic of world art history, see the excellent contribution by Juneja, "Alternative, Peripheral or Cosmopolitan?," 81–107. On *Bildtheorie*, see Belting, *Anthropology of Images*, and Bredekamp, *Image Acts*.

8. On otherness as a topic in early modern art, see Stoichita, *Darker Shades*. Stoichita coins the term "iconosphere of difference" to name the construction of European identity against supposedly racial others (14). Holanda offers an interesting counterpoint to this assumption.

9. Wallerstein, *European Universalism*.

10. Sloterdijk, *In the World Interior of the Capital*. See also Ramachandran, *Worldmakers*, esp. chap. 4.

11. On this painting, see Gschwend and Lowe, *Global City*.

12. António de Holanda's other miniature with a "view of Lisbon" is illustrated in ibid., 13.

13. Ibid., 24–25. Unknown Netherlandish master, *View of the Rua Nova dos Mercadores*, 1570–1619. Oil on canvas. London, Kelmscott Manor Collection, The Society of Antiquaries of London.

14. See also Francisco de Holanda's own drawing of the city of Lisbon, including the ships and their masts, in *Da fábrica que falece à cidade de Lisboa* (1571), Lisbon, Biblioteca da Ajuda, MS 51-III-9, fols. 8v–9r.

15. On the comparison and complementarity between Seville and Lisbon, see Góis, *Urbis Olisiponis descriptio*, book 1, translated in Ruth, *Lisbon in the Renaissance*.

16. Pacheco Pereira, *Esmeraldo de situ orbis*, 1506, book 3, chap. 2, 84.

17. Lowe, "Texteis da África Ocidental," esp. cat. nos. 30, 32.

18. Salvadore, *African Prester John*, esp. chap. 7 ("A Tale of Three Cities, 1527–1539"). See Marcocci, *Consciência de um império*, esp. chap. 5 ("A Etiópia censurada"). The humanist Damião de Góis later published a defense of Zaga Saab in which he registers his own thoughts, titled *Fides, religio, moresque Aethiopum*. See also Marcocci, "Gli umanisti italiani," 307–66.

19. Álvares, *Verdadeira informação das Terras do Preste*, chap. 134. My thanks to Matteo Salvadore for the precise reference. In Góis's *Fides, religio, moresque Æthiopum*, Zaga Saab refers to sacred books that he had brought and lost during the trip ("in itinere"), although that could have happened once he was in Portugal, as he remained there so long and the court frequently moved in those years.

20. Gschwend and Beltz, *Elfenbeine aus Ceylon*. See also Biedermann, "Diplomatic Ivories."

21. Saunders, *Social History of Black Slaves*, 23.

22. See Gschwend and Lowe, *Global City*, 63, fig. 46.

23. Holanda, *Da fabrica que falece a cidade de Lisboa*, 4: "In these days the people of Lisbon were still gentiles and pagans . . . they adored idols, as I myself saw when I was young, in the plinth of the idol Asclepius." For the reconstruction of the key moments of Holanda's life in and after Rome, I rely on the substantial and brilliant scholarship of Sylvie Deswarte-Rosa and on the 2013 essay by Oliveira Caetano, "Francisco de Hollanda."

24. Deswarte-Rosa, "Contribution à la connaissance," 427.

25. Deswarte-Rosa, "Viagem a Itália."

26. The letters are archived under "Correspondência diplomática de D. Pedro Mascarenhas Embaixador del Rey D. João 3º à Corte de Roma," 49-IX-36, Palacio Nacional da Ajuda, Lisbon. I found the reference to this collection of documents in Deswarte-Rosa, "Francisco de Holanda à Bologne," 26. I have then consulted the catalogue compiled by Maria da Conceição Carvalho Geada at the Palacio de Ajuda, thanks to the librarians' assistance. Several letters have been published in *Corpo diplomatico portugués*, with the reference to Manicongo, in vol. 3, 48.

27. João de Castro, quoted in Deswarte-Rosa, *Ideias e imagens*, 42–46.

28. See Cândida Caixeiro, "Estela indiana com inscrição em sânscrito."

29. On Holanda's family, see Oliveira Caetano, "Francisco de Hollanda," 11–12.

30. After completing it in the late 1570s, Holanda offered the book to Philip II. Deswarte-Rosa proposes that the manuscript was completed after the disaster of Alcácer Quibir (1578) and that this episode is evoked in the representation of the Apocalypse ("'De aetatibus mundi imagines,'" *Monuments et mémoires*). Today the book is held in Madrid, Biblioteca Nacional de España, DIB/14/26.

31. Throughout, I usually cite the King James Version of the Bible.

32. Deswarte-Rosa, "*De aetatibus mundi imagines*," *Felix Austria*. See also Deswarte-Rosa, introduction to Deswarte-Rosa and Saramago, *Edades del mundo*.

33. According to Deswarte-Rosa, the patrons of the *De aetatibus mundi imagines* are King John III and Queen D. Catarina, with the support of Infante Dom Luis (Deswarte-Rosa, personal communication with the author, January 2022).

34. "Que a terra seja outrosi redonda se prova porque os signos y as estrellas não nacem y se poem igualmente a todollos homens em todallas partes." Nunes, *Tratado da sphera*, n.p.

35. Holanda would have realized "a fusion between theology and cosmography" (Deswarte-Rosa, introduction to Deswarte-Rosa and Saramago, *Edades del mundo*, 81).

36. See, for instance, the image of the Creation in the fifteenth-century French manuscript of the *Miroir historial de Vincent de Beauvais*, Bibliothèque nationale de France (hereafter BNF), MS fr. 308, fols. 16v and 24v.

37. See De Sousa Leitão, *Pedro Nunes*, 158–59.

38. According to Bruno Haas, in Holanda's image, the celestial spheres and the terrestrial globe are in a space of commensurability thanks to a common metric (introduction to "Mittelalterliche Bildgeometrie Einleitung"). My reading of the Earth in full light is in dialogue with but differs from Haas's proposal.

39. Deswarte-Rosa and José Saramago, *Edades del mundo*, fig. III (commentary).

40. Holanda, *Da pintura antiga*, chap. 34, ed. González García, 155–56. Based on my interpretation of the original Portuguese, I adapt here Sedgwick Wohl's translation in Holanda, *On Antique Painting*, 126–27. Note, in particular, my choice of "will be seen" to translate "se descubrirá," instead of Wohl's "will be revealed," which carries Christian implications. In the following chapter, Holanda writes, "The painting of the image or thing that we intend to paint is made up of light, which is first, and of shade, which is next. . . . Great experience and knowledge go into this shade and into the boldness with which it has to be applied . . . for wherever their shadow passes, it exempts nothing and covers everything. . . . A device that an elegant master occasionally employs is to make one figure completely illuminated by daylight, and right next to it, on the same level, another one completely darkened by the shadow that the first casts on him. . . . At times (such as when a sudden light is produced by some ray) the shadow needs to be much deeper in order to allow the light to be brighter and to remain more definite and absolute."

41. Deswarte-Rosa borrows Giovan Paolo Lomazzo's expression "intellectual portrait" (in his *Idea del Tempio della Pittura*, 1590) to comment on Holanda's theory of portraiture ("Do tirar polo natural," 18–35, 32).

42. Sloterdijk, *In the World Interior of the Capital*, 22–23.

43. The risks and payoffs of this physical expansion were exemplified precisely by the hazardous circumnavigation by the ship *Victoria*, which successfully returned to its starting point, although without its commander, Magellan. Juan Sebastián de Elcano took over as commander and completed the voyage.

44. On the treatise, see Lousa, *Do pintor como génio*. Even today, there are few studies that address both parts of the treatise. Elena Calvillo posits that Holanda's task in both *Da pintura antiga* and in the *Álbum das antigualhas* (1538–60) was that of a courtly translator of ancient texts (such as Vitruvius and Pliny) and monuments ("No Stranger in Foreign Lands," 112–45).

45. Holanda, *On Antique Painting*, chap. 3, trans. Wohl, 74.

46. Holanda, *Da pintura antiga*, ed. González García, 55.

47. Klein, "Francisco de Hollanda," 6–9. On Vasari's *disegno* as an intellectual and practical faculty and a "conceptual basis for appreciating the arts," see Rubin, *Giorgio Vasari*, 2.

48. Holanda, *On Antique Painting*, chap. 11, trans. Wohl, 11.

49. On the literary function of "Holanda's Michelangelo" in the "Dialogues in Rome," see Agoston, "Male/Female."

50. Holanda, *On Antique Painting*, trans. Wohl, 180.

51. But that does not matter since it is rather the "psychological verisimilitude of the fictive voice of Michelangelo" to carry the power of these assertions (Agoston, "Michelangelo as Voice," 135–68 [with a discussion of Klein's and Eugenio Battisti's ideas]).

52. Holanda, *On Antique Painting*, trans. Wohl, 189. According to Deswarte-Rosa, Holanda saw the "Belle" of Avignon in his way back from Rome to Lisbon (personal communication with the author, January 2022).

53. Holanda, *On Antique Painting*, trans. Wohl, 192. I added "entire" to Wohl's translation, and I translate *officio* as "trade" instead of "occupation."

54. Ibid., 92.

55. A thorough discussion of Alberti's demonstration can be found in Williams, *Art Theory*, 57–61.

214

56. Nicolaus Cusanus, *De ludo globi*, quoted in Bouwsma, "Renaissance Discovery of Human Creativity," 17–34. Bouwsma also quotes important passages by Giannozzo Manetti, *De dignitate hominis* (published in 2019 as *On Human Worth and Excellence*, edited and translated by Brian P. Copenhaver).

57. See the map of the Ptolemaic world still in Milan in 1510 and included in a manuscript of the *Cosmographia* (Paris, BNF, MS lat. 4801, fol. 74r, http://archivesetmanuscrits.bnf.fr/ark:/12148 /cc636763).

58. A partial historical overview of the term *world* in the sixteenth and seventeenth centuries is proposed by Ramachandran, *Worldmakers*, 10–11. Holanda's *Da pintura antiga* complicates this overview.

59. Holanda, *Da pintura antiga*, chap. 13, trans. Wohl, 94–95. Based on my interpretation of the original Portuguese, I slightly adapt Wohl's translation here and in the following excerpts; I translate "antigo" with "ancient" instead of "antique."

60. Holanda, *Da pintura antiga*, ed. González García, 55. In the manuscript of his Spanish translation of 1563, Manuel Denis makes a marginal note to that sound passage where Holanda declares that painting cannot be learned but is embedded in humankind: "El pintar no se aprende mas nasce" (*Libro de la pintura antigua*, Madrid, Real Academia de Bellas Artes de San Fernando, MS 361-3, page not numbered).

61. Holanda, *On Antique Painting*, trans. Wohl, 94.

62. Ibid.

63. Ibid., 94–95.

64. Ibid., 95. I provide an explanation of my translation of *conversados* as "encountered and became conversant [with ancient painting]" in the following section of this chapter.

65. Holanda had clearly in mind the world of Alexander the Great, whom he represents with a globe in one of the illustrations of *De aetatibus mundi imagines* (no. LXVI).

66. See, for instance, Xeres, *Verdadera relación de la conquista de Perú*. Cummins (*Toasts with the Inca*, chap. 1) refers to dictionaries that include the term: Domingo de Santo Tomás, *Lexicón*

(1560), Diego de Torres Rubio, *Arte de lengua Quichua* (1619); *Vocabulario y phrasis* (1586); and Ludovico Bertonio, *Vocabulario de la lengua Aymara* (1612). See also Ziolkoski, "Acerca de algunas funciones," 11–24.

67. Titu Cusi Yupanqui, *An Inca Account of the Conquest of Peru*, quoted in D'Altroy, *Incas*, 319.

68. Cummins thought that "in none of the texts is there a mention of *vasos* or anything like them" and that "in the records of Inca gold and silver objects first collected and sent to Spain, there is hardly any mention of *vasos, queros, aquillas*, or any other drinking cup, Spanish or Quechua" (*Toasts with the Inca*, 35).

69. Feest, "Mexico and South America in the European Wunderkammer," 237–44. For existing beakers, see Pillsbury, "Imperial Radiance," 33–44.

70. Nagel, "Some Discoveries of 1492."

71. Interpretations of New World societies in terms of the Old Testament were so frequent that material discrepancies between their artifacts would not have constituted a problem. On Holanda's exploration of Jewish antiquities in a Christian key, see Pereda, "Antigüedades judías y piedad cristiana," 2–15.

72. See Caso, "Explicación del reverso del Codex Vindobonensis," 9–46. For a more recent bibliography, see Jansen, "Vienna Codex."

73. On later intertwinements of different genealogical representations, see Russo, "Renacimiento vegetal," 5–39.

74. Markey, *Imagining the Americas*, 13.

75. According to Anders, Jansen, and Perez, Johann Albrecht Widmanstetter, former secretary of Clement VII, owned it between 1537 and 1557 (*Origen e historia de los reyes mixtecos*). Thanks to Alex Nagel for pointing me to this information.

76. Stéphane Toussaint has called this pristine condition a "barbarous wisdom" ("Alexandrie à Florence," 985). On the perfection of the origins of art, see also the discussion of Vasari by Wood, who quotes a passage from the "Preface to The Lives": "You can easily see that art had not just gotten started in those times, on the contrary for from the perfection of those works it would

seem to be closer to the zenith than to the beginning" (*History of Art History*, 82).

77. Deswarte-Rosa, "Prisca pictura," and Deswarte-Rosa, *Ideias e imagens*, esp. 22. The term echoes the Ficinian *prisca theologia*.

78. For Spanish, see Denis, *De la pintura antiga*, 57: "Aquellas gentes han sido conversadas en otros tiempos." For French, see Deswarte-Rosa, "Antiquité et Nouveau Mondes," 63: "Ces peuples y étaient versés à une autre époque." For English, see Holanda, *On Antique Painting*, trans. Wohl, 95: "These people were already civilized in another time."

79. Galliccioli, *Fraseologia bibblica*, 120.

80. Where the original Greek of the verse had "associated with men," the Latin version used "conversatus est," meaning that God's revelation happened through *conversation* with humans. Adams, *Baruch and the Epistle of Jeremiah*, 114. Although Jerome excluded it from the Vulgate, the Book of Baruch was considered part of the Bible during the fourth session of the Council of Trent (April 1546).

81. Quotations of this verse frequently appeared in Christian theological texts, where Baruch's prophecy is interpreted as "foretelling Jesus' earthly appearance." Adams lists the Church Fathers' citations from the Book of Baruch (ibid., appendix 1).

82. Pereira, "A Fé de Francisco de Holanda." On how Europeans used this guiding principle to divide people between those who are irrational and those who are rational, see Pagden, *Fall of the Natural Man*, esp. chap. 2.

83. Thanks to Fernando Pereira for this perspective (personal communication with the author, August 2022).

84. Holanda, *Da pintura antiga*, "Quarto Diálogo," ed. González García, 310.

85. "Ha muitos que afirmam mil mentiras, e uma é dizer que os pintores eminentes sñao stranhos e de conversação incomportabel e dura . . . os pintores não são em alguma manueira desconversais por soberba." Holanda, *Da pintura antiga*, "Primeiro Diálogo," ed. González García, 230 (with clarifications at notes 621 and 624).

86. On the educative force, see Sousa, "View of the Artist," esp. 47.

87. Wey-Gómez, *Tropics of Empire*, 74. "They believed that the sea from then on was all parceled and unassailable" (João de Barros, quoted by ibid., 133). For Columbus's opponents at the royal junta, Atlantic Africa discoveries were "exceptions to the theory of the five zones"; they disputed "the possibility of finding more dry land—much less inhabited land—in the direction of the torrid and southern temperate zones" (134). Amerigo Vespucci wrote to Lorenzo de' Medici from Seville (1500): "It appears to me, most excellent Lorenzo, that by this voyage of mine the opinion of the majority of the philosophers is confuted, who assert that no one can live in the Torrid Zone because of the great heat, for in this voyage I found it to be the contrary" (quoted in Pohl, *Amerigo Vespucci*, 81).

88. Friedman, "Cultural Conflicts," 69.

89. Here again, Holanda offers an interesting counterpoint to the materials analyzed by Stoichita, in particular, his analysis of the nudity associated with African people (*Darker Shades*, 49–50). Interestingly, Stoichita also points to the fact that in the representation of Christian salvation and damnation, the bodily differences do not count anymore: Black and white evils will all be punished, and Black and white righteous will all be saved (57).

90. On metalworks "offered" to Sapa Inca from the coast, see Cummins, *Toasts with the Inca*. On Inca rulership and production, see D'Altroy, *Incas*. On collecting, see Pillsbury and Trever, "Martínez Compañón and His Illustrated 'Museum.'" I thank Joanne Pillsbury for the suggestion that the golden artifacts collected in Cajamarca may have come from Chan Chan, which had been recently conquered by the Incas.

91. Anghiera, *De orbe novo*, "Third Decade," book 4, 75, ed. Mazzacane and Magioncalda, 1:353.

92. Surekha Davies addresses this map as an intersection between woodcutting and cannibalism in *Renaissance Ethnography*, 121–23.

93. Boyd Goldie, *Idea of the Antipodes*, 9.

94. Markey, *Imagining the Americas*, 82. Ulisse Aldrovandi, the contemporary Italian naturalist, mentions Cavalieri's collection in his travel

216

journal. See Serra, "Ulisse Aldrovandi americanista," 111.

95. Paolo Giovio, quoted in Pigafetta, *First Voyage Around the World*, 126.

96. Alberti, *Historie di Bologna*, quoted and translated in Domenici and Laurencich-Minelli, "Domingo de Betanzos' Gifts," 171. See also Donattini, "Mondo portato a Bologna." Some objects can be traced to these days.

97. Russo, *Untranslatable Image*.

CHAPTER 2

1. Holanda, *Da pintura antiga*, ed. González García, 87.

2. Holanda, *On Antique Painting*, trans. Wohl, 94.

3. Benjamin, "Task of the Translator," 157: "thus transplants the original into an—ironically—more ultimate domain." On the relevance of this passage, see Russo, introduction to *Untranslatable Image*.

4. Holanda, *On Antique Painting*, trans. Wohl, 192.

5. "Preciosarum multarum rerum argumenta." Anghiera, *Opus Epistolarum*, Ep. 131. I quote from the 1670 edition of his letters, which were first published in 1530. Hereafter, "OE, Ep." will refer to the letter, followed by the number. Anghiera himself had prepared them for publication. See Heidenheimer, *Petrus Martyr Anglerius*, and J. López de Toro's introduction to Anghiera, *Epistolario*.

6. The reference to the antipodes will continue in OE, Eps. 134, 135, 140, 142, 144, 146, 158, 181.

7. Crow, *Intelligence of Art*.

8. Miller, *History and Its Objects*, 1.

9. Hernández Castelló, "El II conde de Tendilla."

10. Based on OE, Ep. 42, Anghiera's biographers have stated that he worked for Francesco Negro. But this is probably an error of the editor of the 1530 edition, repeated in the edition of 1670, as the name of the governor of Rome in 1487 was Giovanni Alimento Nigro (or de' Nigro). I thank Miles Pattendon for pointing me to the right name. Nigro was Milanese and may

have known Anghiera for many years. Francesco Pescennio Negro was an important humanist at the time, and this may be the source of the error in the recipient's name in the *Opus Epistolarum*.

11. Beer, "Roman 'Academy,'" and Bianca, "Pomponio Leto." On Leto's archaeological trips, see D'Onofrio, *Visitiamo Roma*, 271–91 (excerpta). On Leto's objects, see Magister, "Pomponio Leto collezionista di antichità."

12. Schraven, "Founding Rome Anew."

13. Borghesi, "Chronology," 42. See also Hughes, "Pico della Mirandola," and Dorez and Thuasane, *Pic de la Mirandole*. On the complexity of the relationships between the Accademia and the curia, see Beer, "Roman 'Academy.'" Extradited by Pio II in 1468, Leto returned to Rome in 1470 to enjoy strong connections with the papal curia. However, the group's activities combining pagan readings and the celebration of the mass in church events (largely attended by the clergy) must have been under scrutiny.

14. Pattenden, "Governor and Government," 259. The governor's right "to prosecute all criminal matters occurring within 40 miles of the city walls" was instituted in 1473 by Sixtus IV (261). On Nigro, see Del Re, *Monsignor Governatore*, 68. On the governor of Rome as "chief and president of the court . . . president of the public spectacles," see Moroni, *Dizionario di erudizione storico-ecclesiastica*, 32:5.

15. Respectively, Cassirer, "Giovanni Pico della Mirandola," 325; Pico, *Oration*, 117; Cassirer, "Giovanni Pico della Mirandola," 331. Cassirer suggestively synthesizes Pico's philosophical invention vis-à-vis the scholastic: "The scholastic thesis: '*Essentiae rerum sunt immutabiles*' may hold for all other beings; but with Pico it does not hold for man" (331–32). Franco Bacchelli tracks the origins of this passage in Plato's *Protagoras* ("Cos'ha veramente detto l'umanesimo filosofico"). See also Pico and Biondi, *Conclusiones nongentae*, thesis XIV.

16. Anghiera describes the improvised society that emerged in the military camps as harmonious and "international": "Our camps are like the city dreamed in the Republic by Plato" (OE, Ep. 73).

17. Anghiera first used the expression in his letter to Ascanio Sforza, November 1, 1493 (OE, Ep. 138). He will later explicitly say "novum, ut ita dixerim, terrarium orbem" (the new terrestrial orb as I have called it) ("First Decade," translated in Eatough, *Selections from Peter Martyr*, 145 and comment on 280). The lexical election of *de orbe novo* as a "new orb, or sphere" and not *de mundo novo* (a new word), as it is often translated (even capitalized), is a meaningful innovation vis-à-vis medieval geography (Castilla, "*Homo viator, homo lector*," 107–8).

18. See Mariéjol, *Un lettré italien*, chap. 5 ("L'enseignement de Pierre Martyr"). Anghiera's labor as instructor is less a phase of his life (as argued in Cro, "'Princeps' y la cuestión del plagio," 36) than a life commitment.

19. Pennesi, *Pietro Martire d'Anghiera*, 18n4. A 1502 document related to Queen Isabel calls Anghiera "maestro de los caballeros de su corte en las artes liberales" (quoted in ibid., 18n2).

20. Wilson-Lee, *Catalogue of Shipwrecked Books*, 40–41, 134. Ferdinand Columbus eventually collected Pietro Martire's works (Arbolí y Faruardo, *Biblioteca Colombina*, 109–14). On Columbus's cosmographic practices, from his library, see Kimmel, "Early Modern Iberia," and Kimmel, *Librarian's Atlas*, chap. 1.

21. "Admiror in etate tam tenera ingenii tale acumen, in tam insigni principe eam humanitatem colo." OE, Ep. 47. See also Eps. 44 and 63.

22. In 1490, Leto published Sallust with a commentary (see Brown and Kaster, *Catalogus Translationum et Commentariorum*, 8:291–92).

23. Correspondence with Fajardo shows how his mentor's early advice eventually matures in a more on a par correspondence between coevals. His former pupil, the now experienced governor of Murcia, received Anghiera's geopolitical analyses on the Mediterranean, from details on the ongoing tensions in the Spanish possessions in Italy to the preparations for an important embassy he would shortly undertake on behalf of the kings (Eps. 217, 220, 223, 225, 231). Letters to Fajardo on Mexico comprise OE, Eps. 623, 650, 665, and 717.

24. Ruffo da Forlí had been bishop of Forlimpopoli and Bertinoro, collector in Portugal, and apostolic *nuncius* at the court of the Spanish king of Naples. In 1523 he was appointed apostolic administrator of the diocese of Cádiz. Anghiera cultivated a correspondence with Ruffo through three decades (see, in particular, OE, Eps. 132, 137, 326, and 747ff.). His "Sixth Decade" is dedicated to him. Ruffo had seen the objects that arrived in 1520 and wrote a fond letter to Chieregato. See Bataillon, "Premiers Mexicains."

25. See the incunabula by Otino della Luna or the early sixteenth-century books by Giovanni Tacuino, printed in Venice *mira arte*.

26. On the Flemish tapestries, see OE, Ep. 182; on the Egyptian architecture, OE, Ep. 234; on Tripoli, OE, Ep. 442.

27. Russo, "Multilingual Dialogues."

28. Cicero, *De oratore*, esp. book 2, 35 and 58.

29. Vélez, "Genius, as *ingenium*," 1. See also the thorough study of this "capacious umbrella term" in Marr et al., *Logodaedalus*, esp. 9. Beer, "Roman Academy," 193.

30. In an earlier letter to Ruffo, dated 1522, Anghiera already pointed to how, at the court, one admired the acuity embedded in the admirable ways precious jewels were made—"munera illa preciosa miris modis laborata . . . acumen admiratus es." OE, Ep. 763.

31. Marr et al., *Logodaedalus*, esp. chap. 2 (for a study of the Italian "industria").

32. Rubinstein, "History of the Word *politicus*," 46. The meaning of *politicus* drastically changed with the impact of Machiavelli and anti-Machiavellianism: it came to denote "cunning, and altogether amoral conduct based on expediency, deceitfulness" (54).

33. Becker, "The Civic and the Domestic."

34. In "Civic Humanism," Moulakis reconstructs the concept based on Garin's *Umanesimo italiano* and Baron's *Crisis of the Early Italian Renaissance*. See also Skinner, *Foundations of Modern Political Thought*, vol. 2, and Skinner, *Visions of Politics*.

35. In his political treatise *De institutione rei-publicae* (completed by 1494, printed in 1520), Francesco Patrizi, commenting upon Aristotle's

218

*Politics* (1338ab), wrote an apology of *some* of the arts (architecture, painting, sculpture, and metal or ivory engraving): "Pictura, Sculptura, ac Caelatura, artes sunt peregregiae, & ad disciplinam literarum proxime accedunt, adeo ut nulla ex parte civili viro poenitendae esse videantur" (fol. 18). On Patrizi's reference to Aristotle, see Klein, *Esthétique de la technè*, 105.

36. In a 1521 letter to Charles V's chancelor Mercurino de Gattinara, Anghiera states that the subtlety and durability of the buildings seen and the ornamental clothes worn by the people met by Cortés proved that the people were "gente politica" (OE, Ep. 715). Egidio da Viterbo employs the term *civile* in Italian, and in 1522, the Venetian ambassador in Spain Gasparo Contarini makes a very clear distinction between civilization and the "costume ferino" (wild beast custom) of human sacrifice (see Benzoni, *Cultura italiana*, 8, 14–15).

37. Judith N. Shklar, quoted by Pagden, *Languages of Political Theory*, 2.

38. Bénat Tachot contends that there is a divide between the descriptions of the ethical qualities and those of the making processes ("*Ingenio* ou *industria*"). I am arguing here that the two are instead closely tied in Anghiera.

39. M. McDonald, *Ferdinand Columbus*, 43–45.

40. Eatough, "Peter Martyr's Account."

41. Parker, *Emperor*, 17.

42. The *De Nuper* excerpted a variety of sources, including Juan Díaz's narration of Grijalba's expedition, which had been published in Venice in 1520, along with de Ludovico de Varthema's *Itinerario*.

43. On Zorzi, see Horodowich, *Venetian Discovery of America*, 41–58; Almagià, "Intorno a quattro codici."

44. Anghiera's *De nuper* will be printed at the end of *Praeclara Ferdina[n]di Cortesii de noua maris oceani*, Savorgnan's Latin translation of Cortés's Second and Third Letters, and illustrated with the famous maps.

45. Eatough, "Peter Martyr's Account." The handbook is also the first text where Anghiera openly criticizes the inhumane treatment of the inhabitants of the islands (406).

46. Ibid., 415, 420, respectively.

47. Russo, "Cortés's Objects."

48. See chapters 4 and 5 for commentary on Dürer's famous passage.

49. Feest points out that from the seventy-three artifacts from Mexico listed in Margaret of Austria's 1523 inventory, at least fourteen came from the 1519 shipment ("Vienna's Mexican Treasures," 34, and "Héritage des cabinets d'art," 197).

50. See, in particular, Kubler, "Salvaging Amerindian Antiquity," 43, and Shelton, "Cabinets of Transgression," 195. Ruffo's 1520 letter from Valladolid to Chiericato shares the same tone of astonishment (reprinted in Bataillon, "Premiers Mexicains envoyés").

51. "Si quid unquam honoris humana ingenia in huiuscemodi artibus sunt adepta, principatum iure merito ista consequentur. Aurum gemmasque non admiror quidam, qui industria quove studio superet opus materiam stupeo." Anghiera, *De orbe novo*, "Fourth Decade," 9.2, ed. Mazzacane and Magioncalda, 1:506. I follow here the translation by Eatough, "Peter Martyr's Account," 415. On this passage, see also Feest, "Dürer et les premières évaluations."

52. See Parker, *Emperor*, 107 and chap. 5 (on Adrian's handling of the Revolt of Comuneros during Charles V's absence).

53. "Habent nanque argutissimos omnium artium opifices." Anghiera, *De orbe novo*, "Fifth Decade," 3.124, ed. Mazzacane and Magioncalda, 2:592.

54. Ribera had become fluent in Nahuatl and could explain the contents of the maps that intrigued (*allicio*) the observers who inspected (*inspicio*) them. See Russo, *Untranslatable Image*, 40–41.

55. "Nullum est animal quadrupes, nulla volucris, piscis nullus, ad eorum artificibus semel visus, cuius imaginem non diducant ad vivum." Anghiera, *De orbe novo*, "Fifth Decade," 10.24, ed. Mazzacane and Magioncalda, 2:694.

56. "¿Qué más grandeza puede ser que un señor bárbaro como éste tuviese contrahechas de oro y plata y piedras y plumas, todas las cosas que debajo del cielo hay en su señorío, tan al natural lo de oro y plata, que no hay platero en el mundo que mejor lo hiciese, y lo de

las piedras que no baste juicio comprender con qué instrumentos se hiciese tan perfecto, y lo de pluma, que ni de cera ni en ningún bordado se podría hacer tan maravillosamente?" Cortés, "Segunda carta," edition Gayangos, 109. I translate *contrahechas* as "made after," although the vast literature on the term alerts us to the variety of its meanings in early modern art theory (see Parshall, "Imago Contrafacta," and McTighe, *Representing from Life*, 29–34).

57. According to Forcellini, this Latin locution is found in Cicero, although in the negative form "*neque . . . ad vivum reseco*" meaning "not to take it in too strict a sense" (*Totius Latinitatis*, 4:535). See also Kusukawa, "*Ad vivum*."

58. Kusukawa, "*Ad vivum*," 109, see also 94 (reference to Erasmus), 110 (reference to Gessner). On later developments of this expression, especially in seventeenth-century Dutch theory, see Swan, "*Ad vivum*."

59. In fact, the expression will be increasingly used "even when the viewer had no direct knowledge or memory of the depicted object" (Kusukawa, "*Ad vivum*," 112). For the interesting case of Aldrovandi referring to images of the New World made "ad vivum"—including of people never seen—see Markey, "Aldrovandi's New World Natives."

60. The mask has been thoroughly studied and photographed by McEwan et al., *Turquoise Mosaics*.

61. "Larvam vidimus perpulchre formatam: ea interiori parte sui est contexta tabella, desuper minutissimis confecta lapillis tali iunctura compactis ut fallere ungues possint et unus ac idem esse lapillus videatur oculis lucidis ex ea qua diximus specula fieri materia, auribusque aureis faciem illius duae ab utroque tempora traversant zonae virides . . . " Anghiera, *De orbe novo*, "Fifth Decade," 10.26, ed. Mazzacane and Magioncalda, 2:694.

62. Elizabeth Boone notes that the long straps of the British Museum mask suggest that "it would have been worn by a deity impersonator" (personal communication to McEwan, quoted in McEwan et al., *Turquoise Mosaics*, 67n50). On the deity's impersonator, called in Nahuatl

*ixiptla*, which was often a victim personifying the deity before being sacrificed, see the discussion and bibliography provided in Russo, "Plumes of Sacrifice."

63. Reconstruction by Cro, "Princeps y la cuestión del plagio," 48–49.

64. Frommel, "Chiostri di S. Ambrogio."

65. Freiberg, *Bramante's Tempietto*.

66. "Propterea quomodo sive domos, mira arte laboratas videbant, sive alia quaecumque, ad eorum usum pertinentia, fabricarent maxima nostros detenuit admiratio; sed fluvialibus quibusdam durissimis lapidibus, praecutis, omnia apud illlos diduci certum est." Anghiera, *De orbe novo*, "First Decade," 1.28, ed. Mazzacane and Magioncalda, 1:45.

67. Anghiera, *De orbe novo*, "First Decade," 2.3, translated by Eatough in *Selections from Peter Martyr*, 50–51.

68. Interestingly, Nebrija's 1511 edition of the *Oceani decas* employs the word "magalius," a Latin term coming from the edifications of a neighborhood in Cartago to refer to the houses, while the 1516 edition will use "tugurius," meaning huts. See Cro, "Princeps," 61, 211n66. The passage appears in ibid., 151; it can be compared with the version in Anghiera, *Selections from Peter Martyr*, translated by Eatough in *Selections from Peter Martyr*, 137.

69. "In uno certo loco vetteno doe statue de ligno: eli stavano sopra a doi bisse: pensarono fossero soi idoli. Ma erano poste solum per bellezza." *Paesi novamente ritrovati*, chap. 92 ("Como lo Admirante trovo le Isole di li Canibali").

70. "lacunaribus harundineis versicoloribus superinductis, mira arte intertextis," Anghiera, *De orbe novo*, "First Decade," 2.17, translated by Eatough in *Selections from Peter Martyr*, 57.

71. This translation, probably compiled and edited by Ramusio, appeared in Venice in 1534. See Horodowich, *Venetian Discovery of America*, chap. 2.

72. "Domos habent sphaericas, ex diversis trabibus constructas, palmarum foliis, aut quareundam herbarum textura contextas, a pluvia tutissimas. Trabium fixarum terrae ita coëunt

cuspides, ut castrenses aemulenter papiliones. Ferro carent. Ex fluvialibus quibusdam lapidibus fabrilia formant instrumenta. Lectos habent pensiles, gosampinis quibusdam lodicibus, ad trabes deductis funibus, lodici alligatis. Funes ex gosampio uel herbis quibusdam sparto tenacioribus contorquent." OE, Ep. 156.

73. For example: "Est haec gens, mi Pomponi, (ut ajunt) seminuda, fere invalida . . . nostro tamen more domos habent lapidibus constructas." OE, Ep. 185.

74. Zabughin, *Giulio Pomponio Leto*, 193, and Bracke, "Ms. Ottob," 298n24.

75. "Potest & nudis natura dictare, ut ingenium ad bonas artes inducant, quandoquidem vestibus indutum, neminem creaverit unquam." OE, Ep. 206.

76. When invited to lecture in Salamanca in 1488, Anghiera was asked by Lucio Marineo Siculo to improvise a lecture on Juvenal's second *Satire*; the result was an enormous success (OE, Ep. 57). The third satire is addressed in another one of his letters (OE, Ep. 10).

77. Anghiera, *De orbe novo*, "First Decade," transcription and English translation by Eatough in "Peter Martyr's Account," 415n75.

78. "Cognitum enim est illos aurum, in quantum est aurum, non magnifacere sed tanti illud aestimare, quanti artificis manus in formam cuique gratam diducere aut conflare didicerit. Quis rude marmor aut ebur incultum comprat magno? Nullus equidem sed si phidiae aut praxitelis dextra fabrefactum in comatam nereidem, aut hamadriadem pulchre formatam prodierit, nusquam emptores deerunt." Anghiera, *De orbe novo*, "First Decade," 3.5, transcription and English translation by Eatough in *Selections from Peter Martyr*, 61.

79. The "princely traveler of the Renaissance" will enthusiastically comment on the painting of Van Eyck or the "modo tudescho" (Chastel, *Cardinal Louis d'Aragon*, 60 [on Van Eyck], 131 [on the "German mode"]). Ludovico will also meet Margarita of Austria (52). Chastel proposes that Ludovico's interest in Breton folklore may have been informed by his knowledge of New World mythology (165).

80. Ludovico of Aragon had traveled with Queen Giovanna of Aragon after the death of her husband, King Ferdinand II.

81. The passages on the *zemes* are from Anghiera, *De orbe novo*, "First Decade," 9.10 and 9.24, translated by Eatough in *Selections from Peter Martyr*, 103 and 109.

82. Anghiera, *De orbe novo*, "First Decade," 5.12, translated by Eatough in *Selections from Peter Martyr*, 80–81.

83. See the notice on the scholarly website of the University of Windsor, "Spanish Republic of Letters," http://cdigs.uwindsor.ca/srl/node/379. Elisio also authored treatises on thermal baths. His *Libellus de mirabilibus civitatis putheolorum et locorum vicinorum* (Naples, 1475) was translated and republished through the following centuries.

84. Polain, *Catalogue des livres imprimés*, 4:105 (notice 1398).

85. Ostapkowicz, "Either a Piece of Domestic Furniture." The author discusses Las Casas's passages on *duhos* in the *Apologética*.

86. "Nullus enim est qui parare sibi novi aliquid, quo sua tellus careat, non delectetur, cum hominibus cunctis sit a natura tributum, ut novis rebus studeant et alliciantur." Anghiera, *De orbe novo*, "First Decade," 8.6, translated by Eatough in *Selections from Peter Martyr*, 96.

87. According to Isidore of Seville, *De differentiis verborum*, quoted in Silvestri, *Lat. cunctus*, 8: "Cuncti omnes sunt si modo iuncti et simul faciunt aliquid. Aliter omnes dicuntur, non cuncti."

88. Quoted in Freund, *Wörterbuch der lateinischen Sprache*, 1:1091. See also Lewis, Freund, and Short, *Latin Dictionary*. Known as the *Lexicon of Festus*, the *De verborum significatione* is a ninth-century compilation of Festus's epitome of the grammarian Flaccus made by Paul the Deacon for the library of Charlemagne. See Irvine, *Making of Textual Culture*, 314.

89. *Cunctus* appears in the *Carmen Arvale* and is present in almost all the classical authors writing in Latin (Salluste, Horace, Ovid, Tacitus, Lucretius, Caesar, Catullus, or Seneca). See *Lexilogos*, the website compiling several Latin dictionaries, https://www.lexilogos.com

/english/latin_dictionary.htm. According to Calonghi, it denotes "tutti come un solo uomo" (https://outils.biblissima.fr/fr/collatinus-web).

90. "Et vocavit Adam nomen uxoris suæ, Heva: eo quod mater esset cunctorum viventium" (Gen. 3:20). For the Hebrew original, I thank Seth Kimmel.

91. Respectively, Hamp, "On the Phonology and Morphology of the Lat. *Cunctus*," 169, and Silvestri, *Lat. cunctus.* esp. 5, 6, and 8 ("una totalità che si caratterizza in quanto espressione di una visione unitaria e complessiva delle sue parti . . . non una totalità indistinta, ma la pluralità delle parti costituenti").

92. Garin, *Umanisti, artisti, scienziati*, 117. For Ficino, see, for instance, a passage from *Theologia Platonica* , book 14, chap. 8, fol. 136v: "Cuncti denique *homines* excellentissimos animos atque optime de humano genere meritos in hac vita ut divinos honorant" (emphasis mine).

93. This was Pico's conviction; see Cassirer, "Giovanni Pico," 326. On the use of *cunctus* to name the plurality of a whole's constitutive parts, see also Giovanni Ruffo da Forlì's epigram, published at the beginning of Anghiera's *Oceani decas* (1516); in this case, Ruffo used the term to express geographical outreach ("all the places with no exception").

94. Respectively, Grafton, *New Worlds, Ancient Texts*, 54–55, and Gruzinski, *Images at War*, 16.

95. Gerbi, "Oviedo and Italy," 53–54; Cro, "Italian Humanism," esp. 56; Rubiés, "Travel Writing," 159–61. On Anghiera's impact on Montaigne, see Cro, *Noble Sauvage*, esp. 14–30.

96. According to Maravall, the emergence of the New World urged thinkers to set themselves free from antiquity, creating a progressive vision of history (*Antiguos y modernos*).

97. For a good summary of the debate and its recent developments, see Summit, "Renaissance Humanism." See also Giustiniani, "Homo, Humanus."

98. Garin, *Pensiero pedagogico dell'umanesimo*, and Grafton and Jardine, *From Humanism to the Humanities*, xix, 16, and 116n45.

99. Grafton and Jardine, *From Humanism to the Humanities*, 3.

100. For a review of Copenhaver's translation of Pico's *Oration*, see Grafton, "Thinking Outside the 'Pico Box.'"

101. "Solos namque illos esse homines, re ipsa judico, qui virtutibus pollent, caeteros nomine tantum, re autem animalia bruta, ut quique appetitu regitur vario, diversa censeo." OE, Ep. 82. Francesco Patrizi da Siena, *De regno* (composed between 1481 and 1484 and dedicated to Alonso de Aragona, King of Calabria), has a chapter titled "De humanitate": "Humanitas quidem est benevolentia ac dexteritas erga omnes homines permista" (I found Patrizi's reference in Toussaint, *Humanismes, Antihumanismes*, 53n12, but I quote from Patrizi's, *De regno* edition of 1582, 372.

102. Toussaint, *Humanismes, Antihumanismes*, 29.

## CHAPTER 3

1. "Opifices sunt ubique argutissimi." Anghiera, *De orbe novo*, "Fourth Decade," 5.32, ed. Mazzacane and Magioncalda, 1:478.

2. On how these terms referred to the medieval artist, see Fricke, "*Artifex* and *Opifex*."

3. Alberti's *De re aedificatoria* played a key role in the Renaissance to fix the Vitruvian triad; see Krautheimer, "Alberti and Vitruvius."

4. In his Italian commentary to Vitruvius, Daniele Barbaro refers to the architecture of Hispaniola (Falguières, "Inventeurs des choses").

5. Huntington Library, San Marino, MS HEM-HM 177. On the history of the Huntington manuscript, see Myers, *Fernández de Oviedo's Chronicle*, 271n7 and 284n4, and more recently, Teglia Alonso, "Claroscuros del archivo colonial," on the relationships between the manuscript and the printed version.

6. Anghiera, *De orbe novo*, "Fourth Decade," 9.35, ed. Mazzacane and Magioncalda, 1:510.

7. On Oviedo's visual training, see Gerbi, "Oviedo and Italy." García Sáiz reconstructs an extraordinary panorama of the artists and artworks that Oviedo must have seen in Italy ("Acerca de los conocimientos pictóricos"). Gansen bases "Framing the Indies" on this still-unsurpassed bibliography.

222

8. Oviedo openly refers to Cesariano's Italian edition of Vitruvius. See Turner, "Libros del alcaide," 177, and the loci found by Gerbi, "Oviedo and Italy," 164.

9. Bénat Tachot, "*Ingenio* ou *Industria*."

10. Oviedo y Valdés, *Historia general y natural de las Indias*, book 42, chap. 11, ed. Perez de Tudela Bueso, 120:144.

11. Wallerstein, *European Universalism*. See my discussion of what I call two "antithetical universalisms" in the introduction to this book.

12. Las Casas, *Apologética*, book 1, chap. 78, ed. O'Gorman, 1:332.

13. Las Casas's father had a bakery on the corner of calles de la Fruta (today Rivera) and Carpintería (today Cuna) (Pérez Fernández, *Cronología documentada de los viajes*, 69). I reconstruct the walkable distance from that corner to the church of Saint Nicolás of Bari. See also Alonso, *Diccionario histórico de las calles de Sevilla*.

14. Cómez, *Sinagogas de Sevilla*, 32–37. Cómez characterizes the Judería as already "disappeared" in 1410 (40).

15. Montero de Espinosa and Collantes de Terán, *Relación histórica de la Judería de Sevilla*, 123.

16. "Guayças, que eran unas carátulas hechas de pedrería de huesos de pescado, à manera puesto de aljófar, y unos cintos de lo mismo fabricado por artificio admirable." Las Casas, *Historia de las Indias*, ed. Millares Carlo, 1:123. On *guaizas*, especially those made of shell and stone, see Mol, *Costly Giving*.

17. Las Casas, *Apologética*, book 3, chap. 48, ed. O'Gorman, 1:259.

18. In the introduction to his excellent critical edition of Las Casas's *Apologética*, Edmundo O'Gorman dates the work between 1555 and 1559 (1:xxxv). On the debate concerning the dating of the *Apologética*, see Hanke, *All Mankind Is One*; Wagner and Parish, *Life and Writings*; Clayton, *Bartolomé de Las Casas*, 447.

19. Méchoulan, *Antihumanisme*. On the debate, see Bentancor, *Matter of Empire*, chap. 2.

20. Sánchez Manzano, "Apologia."

21. As is well known, portions of the *Historia de las Indias* reappear in the *Apologética*, yet,

the author often refers to Hispaniola as the place from where he is writing. Perhaps he affirmed so, even once in Spain, to add testimonial value to his argument?

22. Las Casas's position regarding the autonomy between the Old World and the New is both nuanced and reinforced in the *Historia de las Indias*.

23. Manrique, "Las Casas," 328.

24. Kubler, "Salvaging Amerindian Antiquity," 49, and Colmenares, "De-idolizing."

25. Las Casas, "Apologética Historia Sumaria," autograph manuscript, Madrid, Biblioteca de la Real Academia de la Historia, MS 9/4809.

26. Williams, *Art, Theory, and Culture*, esp. 22.

27. "La multitud y diversidad de los oficios y oficiales que hay, no fácilmente se hallara quien todos y cuán primos y sutiles o delicados sean, los recite y encaraciéndolos según debería, los cuente, y no solamente un oficial sabe con primos y sutileza hacer un oficio, pero muchos ellos saben y usan muchos como si uno solo supiese u cada uno perfectamente." Las Casas, *Apologética*, book 3, chap. 62, ed. O'Gorman, 1:320.

28. This reconstruction of Las Casas's life and travels relies on the magisterial effort by Pérez Fernández in *Cronología documentada de los viajes*. Motolinía, *Carta al Emperador*, 162: "y [Las Casas] se hartó y tornó a vaguear." See also Pérez Fernández, "Bartolomé de las Casas y los esclavos negros"; Clayton, *Bartolomé de Las Casas*; Orique, *To Heaven or to Hell*, chap. 1.

29. Pérez Fernández, *Cronología documentada de los viajes*, 75 (on Las Casas eventually referring in *Historia de las Indias* to the people who most contributed "the tyrannies made to the Indians," including "my own father"). On the enslavement of Africans in Spain at the time and Las Casas's experience with slavery in Seville, see Clayton, *Bartolomé de Las Casas*, 138.

30. Parish, *Las Casas*, quoted by Cárdenas Bunsen, *Escritura y derecho canónico*, 15. Cárdenas Bunsen considers that Las Casas's training in canon law informed the juridical style and content of all his writings.

31. Mira Caballos, *Gran armada colonizadora*, 294.

32. Las Casas writes that he extensively cultivated "pan de la tierra," meaning the manioca to make *pan cazabe* (*Apologética*, book 1, chap. 9, ed. O'Gorman, 1:51).

33. Pérez Fernández, *Cronología documentada de los viajes*, 138 (based on Las Casas, *Historia de las Indias*). The numbers are different in Mira Caballos, *Gran armada colonizadora*.

34. Pérez Ferández, *Cronología documentada de los viajes*, 162–81. See also Clayton, *Bartolomé de Las Casas*, 49–50. Among other evidence, Las Casas affirms that he traveled to the Eternal City along sections of the ancient Roman road system.

35. As seen in chapter 2, books 1–3 of Anghiera's "First Decade" were sent in manuscript form to Ascanio Sforza in 1494; books 4–9 were dedicated to Ludovico de Aragona in 1501 and printed in Italian translation in 1504 and 1507.

36. Las Casas, *Historia de las Indias*, book 3, chap. 4, ed. Millares Carlo, 3:441; Pérez Fernández, *Cronología documentada de los viajes*, 212. On the sermon, see Seed, "Are These Not Also Men?"

37. "Atónitos, a muchos como fuera de sentido, a otros más empedernidos y algunos algo compungidos, pero a ninguno, a lo que yo después entendí, convertido." Las Casas, *Historia de las Indias*, book 3, chap. 4, ed. Millares Carlo, 1:442.

38. See Clayton, *Bartolomé de Las Casas*, 423.

39. The title was common to bishops but not with the adjective "universal." See Clayton, *Bartolomé de Las Casas*, 109 (quoting Alvaro Huerga).

40. Las Casas's total faith in Anghiera is attested in passages such as: "A ninguno se debe dar más fe que a Pedro Mártir que escribió en latín sus Décadas, estando en aquellos tiempos en Castilla" (*Historia de las Indias*, prologue, ed. Millares Carlo, 3:442).

41. Las Casas, *Historia de las Indias*, book 2, chap. 44; book 3, chap. 70; book 3, chap. 103; ed. Millares Carlo, 2:352; 3:66; 3:183; Pérez Fernández, *Cronología documentada de los viajes*, 271.

42. Parker, *Emperor*, 344.

43. "Un presente de cosas tan ricas y por tal artificio hechas y labradas, que parecía ser sueño y no artificiadas por mano de hombre." Las Casas, *Historia de las Indias*, book 3, chap. 121, ed. Millares Carlo, 3:245.

44. Las Casas, *Apologética*, book 3, chap. 133, ed. O'Gorman, 1:695.

45. Pérez Fernández, *Cronología documentada de los viajes*, 734.

46. Ibid., 555.

47. Ibid., 631 and 633.

48. Ibid., 678.

49. On Carmona, see Pérez Fernández, "Bartolomé de las Casas y los esclavos negros." The other friars were Fray Rodrigo de Ladrada, Fray Luis Cáncer, and Fray Jordán de Piamonte (Pérez Fernández, *Cronología documentada de los viajes*, 717).

50. On Las Casas's "conversion" in Portugal, see Lampe, "Las Casas and African Slavery," also based on Pérez Fernández, "Bartolomé de las Casas y los esclavos negros," and Clayton, *Bartolomé de las Casas*, esp. 421–22.

51. See the fine analysis of Las Casas's chapters on Africa in the *Historia de las Indias* (book 1, chaps. 15 and following) by Gruzinski, *Machine à remonter le temps*, chap. 11. The *Apologética*, however, is still full of negative judgments toward the "negros," whose bodies Las Casas associates with dirtiness (see Nava Román, "Del blanqueamiento de Quetzalcoatl," 31n3).

52. Pérez Fernández reconstructs all of Las Casas's itinerary from Lisbon to Aranda de Duero by land, according to Villuga's *Repertorio* (*Cronología documentada de los viajes*, 719).

53. Marado, *Arquitetura conventual e cidade medieval*, 74–75. In the Middle Ages, the convent could provide indulgences to those who visited for the celebration of Saint Peter Martyr (held in April or June). The sepulcher of Saint Gil de Santarém was the object of frequent peregrinations to the Convento da Graça. More research needs to be done based on the documents of the Arquivo Nacional da Torre do Tombo (https://digitarq.arquivos.pt/details?id=4411915).

54. Las Casas, *Historia de las Indias*, book 1, chap. 19, ed. Millares Carlo, 1:104–11.

55. On Holanda in Santarém, see Serrão, "Hóspede ilustre," 385.

56. Oliveira Caetano, "Francisco de Hollanda," 11.

57. Serrão, "Hóspede ilustre," 392.

58. Vases of different provenance in space and time became at the center of Nicolas Claude Fabri de Pereisc's Mediterranean atlas and antiquarian method; see Miller, *Pereisc's Mediterranean World.*

59. Teresa Soley, personal communication with the author.

60. João de Castro, quoted in Deswarte-Rosa, *Ideias e imagens*, 37–47. Deswarte-Rosa proposes that for his *Creation of the Animals*, in the *De aetatibus imagines*, Holanda was inspired by João de Castro's description of a waterspout in his *Roteiro*. Since Holanda was at work on that particular drawing in Santarém in 1547, one can hypothesize that he had Castro's descriptions in mind. On Castro, see Chichorro, "D. João de Castro e o universalismo."

61. Among other loci, see the celebration of the temples of Peru in Las Casas, *Apologética*, book 3, chap. 131, ed. O'Gorman, 1:685–87.

62. Las Casas seems to have extensively used the Biblioteca Colombina, by then deposited in the Dominican convent of Saint Paul in Seville. Pérez Fernández, *Cronología documentada de los viajes*, 835.

63. León-Portilla, introduction to Las Casas, *Brevísima*, viii.

64. At the end of the sixteenth century, for instance, the Franciscan chroniclers Gerónimo de Mendieta and Juan de Torquemada had access to a copy in the Dominican convent of Mexico. See Hanke, *Bartolomé de Las Casas*, 5n2, and O'Gorman, "Estudio preliminar," xxxv.

65. The term *artífice* was not in a position of inferiority vis-à-vis "artist" (as the difference artistan/artist seems to imply). Covarrubias defined *artista* as "el mecánico que procede por reglas y medidas en su arte, y da razón de ella" (*Tesoro*, fol. 93v).

66. According to Cárdenas Bunsen, "the *Apologética Historia Sumaria* . . . is a historicization of the exercise of prudence based on the demonstration of institutions of the *Ius Gentium*" (*Escritura y derecho canónico*, 21). On art

and prudence, see Summers, *Judgement of Sense*, chap. 12.

67. "Buen uso y ejercicio de razón, y la virtud y hábito intelectual subjectado en la razón práctica, que es la prudencia de que hablamos." Las Casas, *Apologética*, book 3, chap. 40, ed. O'Gorman, 1:215. See O'Gorman, "Estudio preliminar," esp. xxxi.

68. O'Gorman, "Estudio preliminar," lxvii.

69. According to Hanke, however, the bull also opened a "wedge for a more aggressive papal program in the affairs of the Indies"—a fact that explains why Charles V asked the pope to revoke it ("Pope Paul III," 73). Parker believes that the failure of the Algiers campaign made the emperor change his mind and promulgate the New Laws in 1542 (*Emperor*, 358–62, esp. 361).

70. Pérez Fernández, *Cronología documentada de los viajes*, 729–34 ("tiene un valor general de relación entre todos los pueblos").

71. "Todas las naciones del mundo son hombres, y de todos los hombres y de cada uno dellos es una no más la definición, y ésta es que son racionales . . . todo el linaje de los hombres es uno." Las Casas, *Apologética*, book 3, chap. 48, ed. O'Gorman, 1:257–58. Covarrubias defines *razón* after Calepino's entry: "[facultas], qua una a caeteris animantibus homo secernitur" (*Tesoro*, 1).

72. Las Casas, *Apologética*, book 3, chap. 42, ed. O'Gorman, 1:220–25.

73. Ibid., book 3, chap. 47, ed. O'Gorman, 1:250.

74. On Garcés's printed text, see the critical edition by Laird, "Humanism and the Humanity"; on the bull and its relationship to art, see Russo, "Recomposing the Image."

75. Domenici, "Missionary Gift Records," 97.

76. Bentancor, *Matter of Empire*, 139. Bentancor brilliantly analyzes the differences between Sepúlveda's and Las Casas's Aristotelianism (see esp. 142).

77. When I refer to the holograph manuscript, it is Las Casas, "Apologética Historia Sumaria," Madrid, Biblioteca de la Real Academia de la Historia, MS 9/4809. In the modern edition, O'Gorman added a title to this chapter: "Second

requisite of the perfect society of the Indians: artisans. Hispaniola and Caribbeans," in Las Casas, *Apologética*, book 3, chap. 61, ed. O'Gorman, 1:316. See my comments above on the editor's decision to add titles and on the biased use of *artisan*.

78. Las Casas, *Apologética*, book 3, chaps. 59 and 60, ed. O'Gorman, 1:306–15.

79. "The goldsmith must have a very sharp chisel with which he can engrave figures of many kinds on amber, hard stone, marble, emerald, sapphire and pearl." Neckam, *De nominibus utensilium*, 142.

80. See Trench, *Materials and Techniques*.

81. The admiration of artworks made with the simplest materials is also present in Pliny's *Natural History* (see Wood, *History of Art History*, 61).

82. Bazin, *Loom of Art*, 29.

83. According to Covarrubias, *labor* could refer to woven and needle-embroidered fabrics: "Hacer labor, y labrar, y labrandera, se dize de la ocupación de las mugeres en telas, y las labores que hazen en ellas con la aguja" (*Tesoro*, 510v).

84. Joanna Ostapkowicz, personal communication with the author, 2018 and 2021.

85. Covarrubias interestingly devotes a long entry to *aljofar* in his *Tesoro* underlining the artistry required to work these pearls: "Es la perla menudica que se halla dentro de las conchas que se crian, y se llaman madre de perlas . . . reformando los artifices las dichas perlas, las igualan, y las ajustan de manera que tengan un grandor y una redondez" (49r–v).

86. Las Casas, *Historia de las Indias*, book 1, chap. 57, ed. Millares Carlo, 1:272. Scillacio says that the belts offered to Columbus were twelve: "Balteos supra duodecim mira arte fulgentes (nonnulli enim auri crustilis distingueantur bambacio intertexto artificio miro" (*De insulis* 6.2.19, ed. Symox et al., 170).

87. On postcontact belts, see Ostapkowicz, "'Made with . . . admirable artistry.'"

88. Russo, "Cortés's Objects."

89. Sauer, *Early Spanish Main*, and D'Esposito and Jacobs, "Auge y ocaso."

90. Holanda, *Da pintura antiga*, ed. González García, 192. See chapter 1 in the present book.

91. See, in particular, Russo, "Contemporary Art from New Spain," and Russo, *Untranslatable Image*, chap. 4.

92. Here, Las Casas's correction of a minor typographical error matters. After having misspelled *brosdado* for embroidery, he promptly struck through the word and wrote *broslado*. He did not want to leave any doubt about the right translation of *opere plumario* as embroidered with a needle. In fact, he writes "according to the master of histories [Petrus Comestor, the twelfth-century theologian] in a certain language of Egypt feather means needle" (fol. 202v).

93. Las Casas, *Apologética*, book 3, chap. 133, ed. O'Gorman, 1:695. Las Casas will develop his argument on the unjust spoilage of the treasures of Peru in his 1563 text, *De thesauris* (which is translated by Losada García in Las Casas, *Tesoros*).

94. Vetter, *Plateros indígenas*, 69.

95. Although this information is part of the main body, Las Casas decided to place it first, erasing the beginning of the following sentence ("Apologética," manuscript, fol. 213v).

96. On the Peruvian sources of Las Casas, see López-Ocón, "Fuentes peruanas."

97. An excellent overview on the history of the mine is provided by Lane, *Potosí*.

98. One example will suffice: "De noche cómo los cerros están llenos de infinitas luminarias por la lumbre que resulta y sale por los agujeros de aquellas hornillas, o más propios albahaqueros" (Las Casas, *Apologética*, book 3, chap. 65, ed. O'Gorman, 1:342), and "Para aprovecharse del metal hacían unas formas de barro, del talle y manera que es un albahaquero en españa . . . de noche hay tantas dellas por todos los campos y collados que parecen luminarias" (Cieza de León, *Primera parte de la crónica*, chap. 109).

99. Tereygol and Cruz, "Metal del viento." See also Lane, *Potosí*, 47.

100. Lane, *Potosí*, 35, 32n20 (for a reference to a 1548 document on Indian resettlements).

101. "Habrá cuatro años que . . . se descubrió una boca de infierno, por la cual entran cada año dende el tiempo que digo gran cantidad

226

de gente, que la codicia de los españoles sacrifica a su Dios, y es una mina de plata que llaman Potosí. Y para que vuestra alteza entiende que ciertamente es boca del infierno que para tragar ánimas ha permitido Dios que se haya descubierto esta tierra, pintaré aquí algo de ella." Fray Domingo de Santo Tomás to Bishop Fray Bartolomé de las Casas, General Archives of the Indies (AGI), patronato 252, ramo 22, reprinted in Vargas, *Fray Domingo de Santo Tomás*, 87–108. I found the reference to, and fine analysis of, this document in López-Ocón Cabrera, "Andinología, lascasismo y humanismo cristiano," chap. 3 (esp. 98–100).

102. As Lane writes, "The crucial refining sector was almost entirely in native Andean hands during Potosí's first boom" (*Potosí*, 50). There is even evidence of early Indigenous-Spanish partnership.

103. Anghiera, *De thesauris*, quoted in Bentancor, *Matter of Empire*, 146.

CHAPTER 4

1. Las Casas reports this twice in the *Apologética* (book 2, chap. 37, and book 3, chap. 64, ed. O'Gorman). Motolinía uses the same expression but without any critical distance. The Franciscan affirms: "Andan mirando como monas todo para contrahacer todo cuanto ven hacer" (*Historia de las Indias*, ed. Serna Arnaiz, Castaniz Prado, 86) and "esta gente son como monas, que lo que unos hacer, luego lo contrahacen los otros" (*Memoriales*, chap. 59, ed. O'Gorman, 238). The colonialist topos of depicting Indigenous people as tricksters is related and yet differs from the medieval and Renaissance metaphor of the artist as capable of imitating Nature, of being a *scimia* (monkey) of Nature. On this metaphor and an elaboration of Ernst Robert Curtius's work on the subject in medieval history, see Ginzburg, "De l'artiste considéré comme faux-monnayeur."

2. Abdulrazak Gurnah, "As if there isn't enough to go around," video of telephone interview, accessed May 1, 2023, https://www.youtube.com/watch?v=cyzEzDz7uJA.

3. I retake here the formula of Shklar, quoted by Pagden in the introduction to *The Languages of Political Theory* and commented on in my second chapter.

4. Las Casas, *Apologética* , book 3, chap. 132, ed. O'Gorman, 2:690.

5. "Yo he visto casi infinitos dellos; unos eran de oro, otro de plata, otros de cobre, otros de barro, otros de palo, otros de masa, otros de diversas semillas. Unos hacían grandes, otros mayores, otros medianos, otros pequeños, otros chequitos y otros más chequitos." Las Casas, *Apologética*, book 3, chap. 121, ed. O'Gorman, 2:139. The "infinity of idols" is stressed also in chap. 133.

6. Bernand and Gruzinski, *De l'idôlatrie*.

7. A 1496 sermon delivered by Savonarola in the Florence Cathedral denounced the new idols that had entered Christian paintings: the beauty of the contemporary Florentine youth, used by the artists as models of the saints (Nagel, *Controversy of Renaissance Art*, 14). Nagel demonstrates that even before the Reformation the question of idolatry mattered in all the debates about the relationships between arts and religion. See Lockwood, "Luther on Idolatry," 134.

8. David Freedberg calls it "the calculated orchestration of iconoclasm" (*Iconoclasts and Their Motives*, 27).

9. Cole and Zorach point to how "the concept of the idol tended to heighten sensitivity to the materiality of the objects it confronted" (*Idol in the Age of Art*, 10). Farago and Parenteau remark how idols could yet be regarded "as signs of the subtle creative power of the human imagination . . . as evidence of the artist's unlimited ability to invent things out of his imagination" ("Grotesque Idol," 107). See also Farago, "Reframing the Baroque."

10. "Muchos ídolos de oro, que aunque era baxo y de poca cosa, sublimábanlo de arte, que en todas las Islas de Santo Domingo, y en Jamaica y aún en Castilla hubo gran fama de ello." Díaz del Castillo, *Historia Verdadera*, 13.

11. Alberti, *De pictura*, book 1.

12. "Por tal artificio hechas y labradas, que parecía ser sueño y no artificiadas por mano de hombre . . . solo la hechura y hermosura suya se

pudiera vender muy cara." Las Casas, *Historia de las Indias*, book 3, chap. 121, ed. Millares Carlo, 3:245–46.

13. Holanda, *Da pintura antiga*, ed. González García, 192.

14. See *sublimar* and *sublime* in Real Academia Española, *Corpus diacrónico del Español*, https://corpus.rae.es/cordenet.html. Covarrubias attests: "Sublimar: ensalçar" (sublimate: to elevate) (*Tesoro*, fol. 34v).

15. See the excellent studies published in Van Eck, *Translations of the Sublime*.

16. This passage of Boileau's *Traité du Sublime* (1674) is quoted and translated by Doran, *Theory of the Sublime*, 104. Doran credits Boileau as the crucial actor "to the emergence of the sublime as a critical concept" (100).

17. Burke, *Philosophical Enquiry*. See Doran, *Theory of the Sublime*, chap. 6.

18. "Vamos adelante a los grandes oficiales de labrar y asentar la pluma, y pintores y entalladores muy sublimados que por lo que ahora hemos visto la obra que hacen, tendremos consideración en lo que entonces labraban; que tres indios hay ahora en la Ciudad de México tan primísimos en su oficio de entalladores y pintores, que se dicen Marcos de Aquino y Juan de la Cruz y el Crespillo, que si fueran en el tiempo de aquel antiguo o afamado Apeles, o de Michael Angel, o Berruguete, que son de nuestros tiempos, también les pusieran en el número de ellos." Díaz del Castillo, *Historia Verdadera*, 169–70.

19. Peterson, "Creating the Virgin of Guadalupe," 585–86.

20. Peterson has a different reading of Díaz del Castillo's passage, which she considers an appraisal of "the indigenous mastery of fine arts" just referencing "the familiar classical canon" (ibid., 588). This canon, however, is also impacted by the mention of what the artificers "used to make."

21. Fricke, *Fallen Idols*, 70.

22. Bernard of Clairvaux, *Apologia* 12.29, quoted by Pranger, *Bernard of Clairvaux*, 337.

23. About Bernard's passage, Umberto Eco brilliantly notes, "How paradoxical was the disdain of this man who was nonetheless able to analyze so well the things that he did not want

to see" (*Arte e bellezza*, 28). On *pulchritudo*, see Konstan, *Beauty*, 152–69.

24. Ginzburg, *Occhiacci di legno*, 140. Ginzburg also inquires into the relationship between Bernard and Origenes.

25. Rubin, *Giorgio Vasari*, esp. 256 and 279.

26. Bandello, *Novelle*, pt. 1, novel 23, ed. Laterza and Figli, 2:19.

27. Cortés, "Second Letter," 106.

28. On Cortés's strategic use of the discourse of idolatry, see Gruzinski, *Images at War*.

29. The destruction of idols was a *passage obligé* in the life of saints or saints-to-be, "a premise of sanctity" (Fricke, *Fallen Idols*, 71).

30. Cortés, "Second Letter," 107.

31. Greenspahn, "Syncretism and Idolatry."

32. "Ídolos, de maravillosas grandeza y altura, y de muchas labores y figuras esculpidas, así en la cantería como en el maderamiento." Cortés, "Segunda carta," edition Gayangos, 106 , trans. by Pagen in "Second Letter," 105–6.

33. Among others, in the inventory of the items shipped by Cortés in 1519, we read: "Una cabeza de oro con el rostro de piedra verde con sus orejas y caracoles menuditos," "una rueda de oro grande con una figura de monstruos en medio y labrada toda de follajes," "una mitra de pedrería azul con una figura de monstruo en el medio de ellas, y enforrada en un cuero que parece en las colores martas con un plumaje pequeño" (see Russo, "Cortés's Objects").

34. The early Christian scholar Origen would have rather called these "images" not "idols," the former being reproductions of natural things, the latter being creations of what does not exist in nature; he, however, condemned them both (Ginzburg, *Occhiacci di legno*, 139–40).

35. Cortés, "Segunda carta," edition Gayangos, 107.

36. For a good overview, see Spear, "Di sua mano." See also Glasser, *Artists' Contracts*, and Rizzo, *Il lessico filologico*. One of the first instances where the reference to the hand signals the artist's caliber is in a crucifix made by Giunta Pisano in San Domenico, Bologna, as early as 1250 (Ashcroft, *Albrecht Dürer*, 1:78n2).

37. Leonardo da Vinci, quoted by Williams, *Raphael*, 42n88.

228

38. The 1502/3 will of Francesco Pugliese lists works "di mano di Sandro Botticello," reprinted in Polizzotto, "Arte del ben," 73. See also Sansovino, *Venetia città nobilissima*.

39. Sullivan, "Alter Apelles," 1165.

40. Lomazzo, *Trattato dell'arte*. See also Armenini, *De' veri precetti* (1586), quoted in Nagel, *Controversy of Renaissance Art*, 259.

41. Quoted in Spear, "Di sua mano," 80, 83.

42. "Hoperazione di mano." Cennino Cennini, quoted in Nagel, *Controversy of Renaissance Art*, 56. "La mano tanto più all'intelletto obbedisse quanto piú sublimi le idee erano." Filippo Baldinucci, quoted in Williams, *Raphael*, 70n217.

43. Las Casas, *Apologética*, book 3, chap. 63, ed. O'Gorman, 1:327.

44. Dufour Bozzo, Calderoni Masetti, and Wolf, *Mandylion*.

45. Belting, *Likeness and Presence*, 208.

46. On the relevance of dreams and visions in the production of images, see Schmitt, "Culture de l'imago."

47. Fricke, *Fallen Idols*.

48. Wolf, review of Nagel and Wood, *Anachronic Renaissance*, 139.

49. Ibid., 138. See Nagel and Wood, *Anachronic Renaissance*, esp. chap. 12, "Acheiropoieton and Author."

50. Dürer, *Schriftlicher Nachlaß*, 1:48 (August 27, 1520).

51. Ibid., 1: doc. 58. For the English translation, I use the one published in Belting, *Likeness and Presence*, doc. 42C, where *künstlich* is translated as "artistic" (553).

52. Feest, "Dürer et les premières évaluations." See also, more recently, Feest, "From Calicut to America."

53. On Dürer's therapeutic art theory and practice, see Merback, *Perfection's Therapy*, esp. 286n32 (on Christ's healing miracles).

54. Sullivan has criticized the insistence on the Christ-like features of this portrait and inscribed it in the humanist debate about creativity, especially in relationship to Pliny's account of Apelles exceptional painting. For her discussion of the specific detail of Dürer's hand ("although empty of the implements used to create paintings . . . a learned hand"), see "Alter Apelles," 1168, 1174.

55. Merback, *Perfection's Therapy*.

56. Bernard Prévost has devoted particular attention to the weaving and knotting involved in Amazonian feather art ("Ars plumaria").

57. The text appears on fols. 126v–150 of *Historie del signor D. Fernando Colombo*. José Juam Arrom translated the text into Spanish and titled it *Relación de las antigüedades de los indios*. See Pané, *Relación acerca*.

58. Las Casas, "Apologética Historia Sumaria," autograph manuscript, Madrid, Biblioteca de la Real Academia de la Historia, MS 9/4809, fol. 395 bis v. I have explored the history of this term and its resonances in Arabic, in Russo, "'These Statues.'"

59. Alberti, *On Painting and Sculpture*, 120–21.

60. Carabell, "Image and Identity," esp. 90–93. The quotation comes from Michelangelo, "Lettera a Varchi," quoted in Barocchi, *Trattati d'arte*, 1:522–23.

61. Hirst, "Michelangelo in Rome," 590.

62. Minter, "Discarded Deity," 450.

63. For the *çemi*, see the evidence that resins' inlays were "'refreshed' periodically" (Ostapkowicz et al., "'Treasures . . . of Black Wood,'" 957.

64. Sutherland Minter associates the rejection rather to the reforms of cardinal conduct promoted by Alexander VI in 1497. Interestingly, this rejection seems to have generated in Michelangelo a new conscience about the need to be recognized as an artist, including having more control on the fate of his works ("Discarded Deity," 454–58).

65. Adorno, "Felipe Guaman Poma de Ayala," and León-Llerena, "Historia, lenguaje y narración," 58–61.

66. León-Llerena, "Historia, lenguaje y narración," 140.

67. Trever, "Idols, Mountains, and Metaphysics."

68. On the colonial project of destroying *huacas*, see León-Llerena, "Historia, lenguaje y narración," 207.

69. See, for instance, Guaman Poma, *Nueva Corónica*, Copenhagen, Royal Library, GKS 2232 4°, fols. 579 and 596.

70. De Marees, *Beschryvinge ende historische verhael*, 17.

71. Cook, "Before the Fetish."

72. Smith and Tuckey, *Narrative of an Expedition*, 381–82.

73. Dutch wide-brimmed hats, furthermore, were themselves indicators of global dynamics; see Brook, *Vermeer's Hat*.

74. Piazza, *La conciencia oscura*, esp. 10–26.

75. On Don Carlos's trial, see Lopes Don, *Bonfires of Culture*, and Lopes Don, "1539 Inquisition."

76. Lopes Don, *Bonfires of Culture*, 147.

77. I base my reading of the trial's transcription on the modern edition of the *Proceso Inquisitorial*.

78. Ibid., 51.

79. Molina, *Vocabulario*, 117.

80. "El cerro de Cho[o]llolan, que está hecho a mano, dicen que fue obra de gigantes, y que lo quisieron subir tan alto que se les cayó en tres pedazos. . . . Llaman los naturales [a] este cerro *Tlachihualtepetl*, que quiere decir en la lengua Mexicana cerro hecho a mano, y ansí parece ser obra fabricada por mano de hombres, porque fue hecha de ladrillo y adobes, muy grande y grueso." Muñoz Camargo, *Descripción de la ciudad*, 116.

81. Sahagún, *Psalmodia Christiana*, 233, quoted by Bierhorst, *Nahuatl-English Dictionary*, 326.

82. *Proceso Inquisitorial*, 51.

83. Ibid., 54.

84. Ibid., 79.

85. Ibid., 103.

86. Pérez Fernández, *Cronología documentada de los viajes*, 511.

87. One of the rare examples of the act of idol making is a miniature in a London *Bible Moralisée* (British Library, MS Harley 1527) portraying the silversmith Demetrius with a hammer, listening to Saint Paul preach in Athens (Camille, *Gothic Idol*, 28, fig. 18).

88. When the text of the *Vulgata* was transcribed, the chapters' sequence was changed to: 13, 14, 12, 15, and 16. A fine textual analysis of the appendix is made by Johansson, "Estrategias discursivas," although the image is not discussed.

I first presented my reading of this painting in "Artistic Vitality, Universal Humanity." Thomas Cummins includes a discussion of the image in "Sacrifice and Idolatry."

89. I am using here the English translation from 1582 published in *The Holy Bible* (Glasgow, 1820).

90. Thanks to Leonardo López Lujan for his help in identifying these iconographical elements, which are associated to several "deities."

91. Haskell and Penny, *Taste and the Antique*, 148. Haskell and Penny remind us that the first drawing of the Apollo Belvedere is found in the Codex Escurialensis, a sketchbook that arrived in Spain before 1509.

92. This idea originated from a conversation with Patrice Giasson, who pointed out to me that the idols' arms could instead be depicted here in the process of being made out of different woodblocks, as is the case in Christian religious sculpture.

93. Williams, *Art, Theory, and Culture*.

94. "The artist did it, therefore it is not a God" (*el oficial fue el que le hizo, y assi no es Dios*). Acosta, *Historia natural y moral*, 323.

95. Marion, *God Without Being*, 12. See also Kennedy, "Semantic Field."

96. Marion, *God Without Being*, 12.

97. Ibid., 17.

98. Ibid., 24.

99. An amateur video taken in the 1970s, before the reconstruction and reassembling of the temple of Sanjūsangen-dō, resonates with Frois's movement through the text (https://www.youtube.com/watch?v=FF2P150Vwfg, accessed May 1, 2023).

100. Frois, *Historia de Japam*, 20–21. I have excerpted this passage.

101. Nicholas of Cusa, quoted in De Certeau, "Gaze of Nicholas of Cusa," 12.

102. Ibid., 14.

103. This experience is opposed to that of an all-seeing icon, such as those described by Nicholas of Cusa in his *De visione dei sive De icona*. Brini proposes in French the interesting terms of *omnivoyant* and *omnivoyure* to differenciate the all-seeing power of the icon from the desired

230

all-seeing experience of the modern subject ("De l'omnivoyant à l'omnivoyure").

104. My reading differs from Walter S. Melion's interpretation of Frois's visit to the shrine of Amida. While Melion posits that the site was recognized by Frois as "a suitable locus of meditation," this only would point to "a cross cultural awareness" ("Introduction," 48). In other words, the theoretical impact that an aesthetic experience in Kyoto would have on Jesuit image theory is not discussed by Melion.

105. Mendes Pinto, *Travels of Mendes Pinto*, 223–24.

106. "In uno certo loco vetteno doe statue de ligno: eli stavano sopra a doi bisse: pensarono fossero soi idoli. Ma erano poste solum per bellezza." *Paesi novamente ritrovati*, chap. 92 ("Como lo Admirante trovo le Isole di li Canibali").

107. Here again, my reflections are inspired by Brini, "De l'omnivoyant à l'omnivoyure," even though the author more classically defines the advent of a modern subject in relationship to the invention of perspective, and not to the observation of the infinite variety of "idols."

108. Bernand and Gruzinski, *De l'idôlatrie*.

109. Ibid. For a criticism of the inclination, in modern scholarship, to interpret Mesoamerican cultures as overreligious, see Giasson, "Tlazolteotl."

110. "Bien sabían ellos que los ídolos eran obras suyas y muertas y sin deidad, mas los tenían en reverencia por lo que representaban y porque los habían hecho con muchas ceremonias, especialmente los de palo." De Landa, *Yucatan Before and After the Conquest*, 48. We know today that this text is not autograph and that many hands could have collaborated. I have slightly changed Gates's English translation (47).

111. "En el rico despojo se hallaron muchas pieças de oro y plata de notable labor y costa, principalmente un Idolo de oro, que peso 30 libras, cosa maravillosa, y que hace perder los estribos a los que no saben que cosa es la riqueza de la India, y las grandezas que aquellos Bárbaros tienen en servicio de la vanidad de sus Idolos. Tenia este Idolo extraordinaria figura: porque le servian de ojos dos finísimas y grandes

esperaldas, y en el el pecho tenia embutido un rubi muy rico, tan grande como una castaña." Ribadeneyra, *Historia general de la Yndia oriental*, 75.

112. Rubiés, "Theology, Ethnography, and the Historicization," 586 and 594, respectively.

CHAPTER 5

1. On the later historiographic construction of the term *Renaissance*, see Wood, *History of Art History*, esp. 243–48.

2. Ashcroft, *Albrecht Dürer*, 1:77.

3. As seen in the previous chapter, Sullivan analyzes Dürer's self-portrait in light of Celtis's poem ("Alter Apelles").

4. On the translation of *ager*, see the entry in Lewis, Freund, and Short, *Latin Dictionary*.

5. Spitz, *Conrad Celtis*. Celtis is extensively discussed by Wood, *Forgery, Replica, Fiction*.

6. Dekker, "Globes in Renaissance Europe," 3:149. Dekker proposes that "humanism materialized" in the globes (3:158).

7. Spitz, *Conrad Celtis*, 11–15.

8. Rybcka, "Influence of the Cracow Intellectual Climate."

9. "Omne quippe humanae uitae praesidium ingenio eius est paratum: cultus agrorum ususque frugum, artificum sollertia, prouentus artium, commoditates uitae humanae." Apuleius, *De mundo*, 359, trans. Boys-Stones, accessed April 13, 2023, http://individual.utoronto.ca/gbs/demundo/texts.html. For coherence in the present book, I use "ingenuity" in place of "ingeniousness."

10. Quoting a document written by the grandmother Queen Isabella, soon after Charles's birth, Parker underscores "how much hope surrounded the birth of a grandson, who would inherit so many and such great kingdoms and lordships" (*Emperor*, 6).

11. That same year of 1500, Celtis edited and published the *Germania* by Tacitus, where he read that "Germani sunt indigenae," the Germans are the "indigenous" inhabitants of the land (Spitz, *Conrad Celtis*, 100). See also Wood, *Forgery, Replica, Fiction*. Two years later, Celtis authored a text where he reimagined Germany

as the center of the world. Willibald Pirckheimer spoke of Germany as "the navel of all Europe" (*totius Europae umbilico*) (quoted in Pietchotki, *Cartographic Humanism*, 232, see also 26–67).

12. Dürer, *Schriftlicher Nachlaß*, 1:48 (August 27, 1520). On the salt cellars, see Bassani, *African Art*, 114. Dürer is quoted and discussed by Preston-Blier, "Capricious Arts," 21.

13. Vasari, *Vite*, Edition Torrentiniana, accessed May 29, 2023, http://memofonte.acca demiadellacrusca.org/vite_1550.asp.

14. Ibid.

15. Rubin, *Giorgio Vasari*, 193.

16. "Di che si ha obligo, se è così lecito dire, alla rovina di Roma, perciò che essendosi i maestri sparsi in molti luoghi, furono le bellezze di queste arti comunicate a tutta l'Europa." Vasari, *Vite*, Edition Torrentiniana, accessed May 4, 2023, http://memofonte.accademiadellacrusca .org/vite_1550.asp.

17. On organic metaphors to address physical displacement in Vasari and other Italian treatises, see Kim, *Traveling Artist*.

18. "Dopo il disfacimento di Europa e delle nobili arti e scienze elle cominciassero a *rinascere, a crescere, a fiorire* e finalmente siano venute al colmo della loro perfezzione . . . così nobili arti, delle quali non solo la Toscana, ma tutta l'Europa se ne abbellisce, vedendosi quasi in ogni parte l'opere de' toscani artefici e de' lor o discepoli risplendere." Vasari, *Vite*, Edition Giuntina, accessed May 4, 2023, http://memofonte .accademiadellacrusca.org/vite_1568.asp.

19. Williams, *Art Theory*, 71.

20. Rubin, *Giorgio Vasari*, 214. See also Déotte, "Alberti, Vasari, Leonardo."

21. Instead, Vasari obtained the institutionalization of the Florentine Accademia del Disegno, approved in 1563 by Cosimo I de' Medici (Rubin, *Giorgio Vasari*, 212). *Disegno* as the "conceptual basis for appreciating the arts" is discussed by Rubin (2).

22. Lia Markey proposes that the very structure of the Guardaroba Nuova was impacted by the presence of Americana (*Imagining the Americas*, chap. 3).

23. Ibid., 42.

24. Heikamp and Anders, *Mexico and the Medici*.

25. Markey, *Imagining the Americas*, 34–35.

26. Guercio, *Art as Existence*.

27. Interestingly, the term "a manera de *indios*" (in the fashion of the Indians) was used at the time to refer to golden jewels with no hallmarks. For example, "labrado de manera de yndios syn senal nj marca alguna," in "Audencia Canarias," 1537, Archivo General de Indias, *Justicia*, 693, fol. 72v. I thank Gabriel de Ávilez Rocha for pointing me to this document and for sending me his transcription. He analyzes the source in "Empire from the Commons," esp. 176–77.

28. An interesting reflection on the Vasarian model for Latin American arts is Mundy and Hyman, "Out of the Shadow of Vasari."

29. Guevara's *Comentarios de la pintura* was written between 1560 and 1563, though it remained unpublished until the end of the eighteenth century. I quote both from the eighteenth-century edition and from the early seventeenth-century manuscript kept today at the Prado, MS 8. On the history of the document, see Dueñas, "Manuscrito del *Comentario*."

30. See the documentation in Vergara, *Patinir*.

31. Julius von Schlosser makes only a furtive reference to the *Comentarios*, characterizing Guevara's work as "die merkwürdige Geschichte der antike Malerei" (the strange history of ancient painting) (*Die Kunstliteratur*, 247).

32. Guevara, *Comentarios*, 230.

33. Ibid., 247.

34. "Abbatté e destrusse talmente le statue, le pitture, i museici e gli stucchi maravigiosi che se ne perdè, non dico la maiestá sola, ma la forma e l'essere stesso." Vasari, *Vite*, Edition Torrentiniana, accessed May 4, 2023, http://memofonte .accademiadellacrusca.org/vite_1550.asp.

35. On the term "four parts of the world" and its implications, see Gruzinski, *Quatre parties du monde*.

36. "V. M. . . . habiendo traido y juntado de diversas naciones una masa de buenos ingenios y habilidades, que obliga a los naturales de España à estudiar y trabajar tanto." Guevara, *Comentarios*, 3.

37. Ibid., 5.

38. Vasari also speaks on how "la unione nella pittura é una discordanza di colori diversi accordati insieme." Vasari, *Vite*, Edition Torrentiniana, accessed May 4, 2023, http://memofonte.acca demiadellacrusca.org/vite_1550.asp.

39. Covarrubias, *Tesoro*, fol. 560.

40. Guevara, *Comentarios*, 15–16.

41. See Horn, *Jan Cornelisz Vermeyen*, fig. A32. See also Vermeyen, *Der Kriegszug Kaiser Karls V. gegen Tunis*.

42. "Célebres son las paredes de la Iglesia de Monreal en Sicilia, así en abundancia como en arte; pero creo que à todo lo que de la antigüedad ha sobrado, vence lo que hay en Palermo en una Iglesia del Castillo viejo, llamado San Pedro el Viejo, lo qual yo miré con gran atención el año de 35 viniendo de la jornada de Tunez, adonde llevé a algunos de la nación a verlo, como cosa maravillosa." Guevara, *Comentarios*, 103. For the distinction Vasari makes between old ("vecchi e non antichi") and the truly ancient Greeks, see *Vite*, proemio: "da San Silvestro in qua furono poste in opera da un certo residuo dé Greci, i quali piú tosto tignere che dipingere sapevano" and "Abbandonando le maniere vecchie, ritornarono a imitare le antiche." (Vasari, *Vite*, Edition Torrentiniana, accessed May 4, 2023, http:// memofonte.accademiadellacrusca.org/vite_1550 .asp). As seen in chapter 1, the Vasarian distinction, which Wood characterizes as "confusing" (*History of Art History*, 85), may come from Holanda, who, on the contrary, had been very clear about its significance.

43. "Esta suerte de Pintura y el declarar por ella sus conceptos, parece haber imitado los Indios occidentales, y del Nuevo orbe, especialmente los de la Nueva España: ahora sea que por antigua tradición les vega de los Egipcios, lo qual podría haber sido, hora sea que los naturales de estas dos naciones concurriesen en uas mismas imaginaciones." Guevara, *Comentarios*, 235–36. The bibliography on the Mesoamerican art of pictography is extensive. A thorough discussion and bibliography can be found in Boone, *Stories in Red and Black*.

44. "Tienen figuradas en pintura las Jornadas que los vasallos de vuestra V.M. y ellos hicieron en la conquista de México y otras partes." Guevara, *Comentarios*, 235.

45. The *Lienzo de Tlazcala* is today lost (a facsimile of a late nineteenth-century copy was published by Alfredo Chavero in 1892). Copies of the *Lienzo* were circulating in the sixteenth century. There is a version of the *Lienzo* in the Casa de Colón of Valladolid (Ballesteros Gaibrois, "Lienzo de Tlaxcala"), which is today considered by several scholars to be a nineteenth-century copy. On the Lienzo, see Romero de Terreros, "Cosas que fueron."

46. A document from the *cabildo* of Tlaxcala states that in 1552 "a painting of Cortés's arrival in Tlaxcala and the war of conquest is to be prepared for presentation to the emperor"; quoted by Asselbergs, "Conquest in Images," 92. See also the work of Travis Kranz.

47. The *Battle of Tunis* by Vermeyen is interestingly similar to the scenes of the *Lienzo*: the cartoons were completed just a few years before, and a tapestry was made after the cartoons in the Real Alcázar of Sevilla (Asselbergs, "Conquest in Images," 92–93).

48. Chuchiak, "*In Servitio Dei*," 614.

49. It could be worth investigating the possible familial relationship between one of de Landa's peers in the Yucatan, Hernando de Guevara, and Felipe de Guevara. Hernando de Guevara signs with de Landa a document to the Council of the Indies supporting several appointments in the Yucatan (including that of Lorenzo de Bienvenida as the first bishop) and urging a bolder presence of Yucatan functionaries in the *Audiencia* of New Spain, as well as defining the Franciscan privileges in the Christianization process ("Fr. Diego de Landa, Fr. Francisco de Navarro y Fr. Hernando de Guevara al Consejo de Indias, 3 abril 1559," 1:83–88).

50. "Todo esto debemos à esos barbaros de Godos, los quales ocupando las provincias llenas entónces de todas las buenas artes, no se contenaron solo con arruinar los edificios, estatuas, y semejantes cosas, pero también se ocuparon con sumo cuidado en quemar librerias insignes, no dexando papel à vida." Guevara, *Comentarios*, 247.

51. The inventory was published by Dueñas, "Manuscrito del *Comentario*." 369: "Otro lienzo

de dos baras de ancho y bara y quarta de alto de pluma q*ue* es un triunpho y tanbien esta. Guarnecido."

52. Guevara, *Comentario*, fol. 95.

53. "Es de notar la extraña devoción que los dichos Indios á todo género de Pintura tienen. . . . Justo es tambien concederles haber traido á la Pintura algo de nuevo y raro, como es la pintura de las plumas de aves, variando ropas, encarnaciones y cosas semejantes, con diversidad de colores de plumas que por allá cria la naturaleza, y ellos con su industria escogen, dividen, apartan y mezclan." Ibid., 237.

54. The term *Indian* to refer to an inhabitant of the New World functions in Guevara (and in many sixteenth-century sources) in a way similar to that of the term *India* in modern sources on India, as "an imagined ingredient with material vestiges here, important in the survival technique of the fabrication of a hybrid identity" (Spivak, *Aesthetic Education*, 50).

55. Ibid., 178, and Pliny the Elder, *Naturalis historia*, book 35, chap. 36.

56. On *metatechné*, see Williams, *Art, Theory, and Culture*. See also my dialogue with Williams's ideas in the first chapter of this book, and Russo, "Artistic Humanity."

57. I want to thank here the sinologists Paize Keulemans, Dorothy Ko, Jonathan Hay, Claudia Pozzana, and Alessandro Russo for helping me to understand Ricci's text. The punctuation in Chinese is Keulemans's. See also Giles and Ricci, *Translations from the World Map*, 8, and Huang, *Li Madou*.

58. Archivo General de la Nación, Mexico City, *Indios*, 5 (64), fol. 87v.

59. We cannot assume that Juanes Cuiris and Iuan Bautista refer to the same journeyman. In fact, in this document, the name of Juan Cuiris is part of a request signed by other officials, including a Bautista Cuirixan. See López Sarrelangue, *Nobleza indígena*, 250–53.

60. The two engravings have been found by Clara Bargellini in Miroslav, *Prints After Giulio Clovio*, 106–9. Anders mentions that the two works appear in the inventories of the holdings of the Treasury of Rudolph II in Prague dated 1600 ("Artes menores," 45). Estrada de Gerlero

hypothesizes that these two images were given to Rudolph II by his cousin and brother-in-law Philip II, first passing through Spain ("Mass of Saint Gregory" 102–5).

61. López Sarrelangue, *Nobleza indígena*, 255.

62. Witcombe explains that in the sixteenth-century practice, "neither the inventor of the idea or the image, nor the engraver or woodcutter who reproduced it could sustain any legal action related to artistic rights" (*Copyright in the Renaissance*, 58). Witcombe mentions the collaboration between Thomassin and Turpin, precisely for the etchings of the Virgin Mary and Jesus—made after Clovio's work (200–206).

63. Vasari, *Vite*, Edition Giuntina, accessed May 29, 2023, http://memofonte.accademia dellacrusca.org/vite_1568.asp. The etchings could be based on two miniatures by Clovio mentioned by Bradley, *Life and Works of Giulio Clovio*, 335–36: "In the Galleria Borghese are two miniatures, a Madonna and a Head of Christ, without doubt by Clovio."

64. Della Rena, *Descrizione dell'America*, quoted in Heikamp and Anders, *Mexico and the Medici*, 15.

65. Eichberger, "Naturalia and Artefacta."

66. Maximilian I was also the dedicatee, in 1507, of the first map featuring the name America (D. MacDonald, "Collecting a New World," 653).

67. He was also working, with Burgkmaier, on *Maximilian's Triumphal Arch*, where several "men from Calicut," actually the New World, appear dressed in feathers. Massing, "Quest for the Exotic." Dürer wrote in his diary that he collected exotic bird species that were offered to him during his trip to the Netherlands.

68. On the history of restoration work on Parmigianino's *Cupid*, see Wald, "Parmigianino's 'Cupid Carving His Bow.'" I am grateful to Christian Feest for the information on Heintz and to Paulus Reiner and Francesca Del Torre Scheuch for bibliographical guidance.

CONCLUSIONS

1. Legati, *Museo Cospiano*; on Giuseppe Maria Mitelli and Cospi, see Russo, "Curator's Eyes."

234

2. According to Bredekamp, the term *machinamenta* "tries to establish a conceptual order within a mass of objects that have been brought together" (*Nostalgie de l'antique*, 57).

3. For a detailed criticism of the concept of exoticism as self-evident historical category, see Russo, "Dopo l'esotismo."

4. Laurencich-Minelli and Filippetti, "Per le collezioni americaniste," 211. In the catalogue of the Cospi Museum, there is clear mention of "Messico," "Brasile," and "Groenlandia," together with a more ambiguous reference to "Indian" or "from the Indies." On these categories, see the works of Keating and Markey and Bleichmar. On Eisenstein, see Tega, *Antichità del mondo*.

5. My thanks to Patrice Giasson for this suggestive idea. Let us recall that unlike the Cospi Museum, the panels of the *Mnemosyne Atlas* were composed of photographic reproductions of the artifacts and so did not depend on their arrangement on shelves. The bibliography on Aby Warburg's method is extensive, but see, in particular, Didi-Huberman, *Atlas ¿Cómo llevar el mundo a cuestas?*

6. *Inventario semplice*, 13–14.

7. Ibid., 16. A large part of the Cospi collection is now split between the Museo Civico in Bologna (http://www.flickr.com/photos/curiositas/sets/72157625742785461) and the Museo delle Civiltà in Rome.

8. Ostapkowicz, "Integrating the Old World into the New."

9. The essay by Brizzolara, Medica, and Morigi Govi, "Ferdinando Cospi e l'antico," is an exception to the above.

10. Acosta uses this metaphor in his *Historia natural y moral de las Indias*. See, for instance, book 1, chap 6, ed. O'Gorman, 28: "A todas partes del mundo la tierra y el agua se están abrazando y dando entrada la una a la otra" (And in all parts of the world, the land and the sea seem to embrace each other).

11. Vega el Inca, *Comentarios reales de los Incas*, book 1, chap. 1, 9–11.

12. See the ode that Carlo Cesare Malvasia composed in 1677 for the catalogue of the Cospi Museum. A year after the *Museo Cospiano* (1677), Malvasia would publish a book solely dedicated to the artists of the Bologna region, *Felsina pittrice*.

13. Dante's sculpture—in the center of Mitelli's engraving—appears in the Cospi Museum as "Testa ritratto di Dante" (A portrait head of Dante). The shelves also housed a "Scorazza di Dante a squame" (a breastplate of [having belonged to?] Dante) and a "Scacco di Dante e sua impresa" (chess set with Dante's coat of arms). *Inventario semplice*, 22–23.

14. Webb, *Ekphrasis, Imagination and Persuasion*.

15. Keating and Markey, "Indian Objects," 209–13.

16. Aldrovandi, *Musaeum metallicum*, and Findlen, *Possessing Nature*, 25.

17. Aldrovandi, *Delle statue antiche*, 140. On the importance of the material—in particular, marble—see Gallo, "Ulisse Aldrovandi."

18. Aldrovandi, *Delle statue antiche*, 193. On the efforts at identification, see Stenhouse, "Visitors, Display, and Reception," 425.

19. Aldrovandi, *Musaeum metallicum*, 229–30. The reference to Alvaro Semedo's book, *Imperio de la China*, published in Spanish in 1642, allows us to attribute this part of the *Musaem metallicum* to Bartolomeo Ambrosini, who added the reference at the editing stage.

20. Were the paved roads of the ancient Roman cities also a memento of this technique? I thank Patrice Giasson for a picture of the cardo of Roman Bologna, made of trachyte stones.

21. Pliny the Elder, *Naturalis historiae*, book 36, chap. 60, ed. Mayhoff and Von Jan, 5:383.

22. This scene is represented in the exceptional Roman mosaic preserved in the Château de Baudry in Switzerland.

23. "Sed mirandum est, quod Gomara, in Historijs Indicis, recitat, nimirum ab Indis larvas, seu personas ex ligno fabrefieri, deinde lapillis variorum colorum exornari, ut perbellè lithostroton æmulentur. Quamobrem in gratiam Lectoris iconem huius Larvæ exhibemus." Aldrovandi, *Musaeum metallicum*, 551. Aldrovandi could have had access to the Italian translation by Agustín de Cravaliz (López de Gómara, *Historia generale delle Indie Occidentali*). See Keating and Markey, "Indian Objects," 10.

24. The translation of Aldrovandi's text in the essay by Keating and Markey emphasizes the technical aspect of the *lithostroton* as "tessellated work" ("Indian Objects," 9–10). The term, however, may have here also geographical, historical, and sacred resonance.

25. Pignoria, "Seconda parte delle imagini." On Pignoria, see in particular Seznec, "Essai de mythologie compare," and Mason, *Lives of Images*, 132.

26. "Hora questo Quetzalcoatl fu chiamato ancora Topilczin, cioè mio molto amato figliuolo, e dicono, che nascesse con l'uso di ragione, & che fosse'l primo, che cominciasse ad invocar li Dei, e far loro sacrificii, co'l suo sangue medesimo, che si cavava dalla persona con spine, & in alter maniere, haveva giá la Gentilitá del nostro Mondo, i Bellonarii, i Galli della madre degli Dei, & altri si fatti che spargevano sangue; ma questi fu forte piú antico, tutto che discepolo della medesima scuola." Pignoria, "Seconda parte delle imagini," xv.

27. My thanks to David Colmenares for the exact reference to the Codex Ríos.

28. Aguirre Molina, "Ritual del autosacrificio," esp. 101.

29. Holanda, *Album dos desenhos das Antigualhas.*

30. Mouriki, "Theme of the 'Spinario.'"

31. The bronze example is today at the Kunsthistorisches Museum in Vienna (see Haag, Eichberger, and Gschwend, *Women*); the marble one is cited by Di Dio and Coppel, *Sculpture Collections in Early Modern Spain*, 38.

32. My thanks to Madeleine Viljoen for pointing me to the engraving by Marco Dente da Ravenna (1490–1527).

33. Parshall, "Antonio Lafreri's *Speculum*." On Salamanca, see Deswarte-Rosa, "Gravures de monuments antiques."

34. Gruzinski, *Aigle et la sybille.*

35. Nava Román, "Dolor negro en la piel."

36. I have developed this idea in dialogue with Salvatore Settis's inspiring *Il futuro del classico* and for the article "Parlare al presente" I wrote for his coedited volume *Recycling Beauty.*

37. Schmidt recognizes this new exoticism as closely related to the independence of Holland (granted in Westfalia) and the decline of the Dutch imperial project (the Dutch West India Company declared bankruptcy in 1674).

38. Similarly, Marcocci has called the group of early modern historians writing in a global perspective, a "minority line" (*Globe on Paper*, 9). On the relationship of Holanda with the Inquisitorial censor, see Pereira, "A Fé de Francisco de Holanda," and Deswarte Rosa, "Malitia temporis."

39. Copernicus, quoted by Dekker, "Globes in Renaissance Europe," 3:159.

40. See, in particular, Gruzinski, *Machine à remonter le temps*; Cañizares-Esquerra, *How to Write the History*; Subrahmanyam, "On Early Modern Historiography"; and, more recently, Marcocci, *Globe on Paper.*

41. Leonardo da Vinci, *Codex Atlanticus*, 362, http://codex-atlanticus.it.

# Bibliography

PRIMARY SOURCES

Acosta, José de. *Historia natural y moral de las Indias.* 1590. Edited by Edmundo O'Gorman. 3rd ed. Mexico City: FCE, 2006.

Alberti, Leon Battista. *De pictura,* 1436. English edition: *On Painting and on Sculpture: The Latin Texts of De Pictura and De Statua.* Edited and translated by Cecil Grayson. London: Phaidon, 1972. French edition: *La peinture.* Translated by Thomas Golsenne and Bertrand Prévost. Paris: Seuil, 2004.

Aldrovandi, Ulisse. *Delle statue antiche.* In Lucio Mauro, *Le antichità de la città di Roma.* Venice: Por Giordano Ziletti, 1556.

———. *Musaeum metallicum in libros iv distributum . . . Bartolomeo Ambrosinus composuit.* Bologna: Marcus Antonius Bernia, 1648.

Alonso, Manuel. *Diccionario histórico de las calles de Sevilla.* Seville: Ayuntamento, 1993.

Álvares, Francisco. *Verdadeira informação das Terras do Preste.* 1540. Lisbon: Imprensa Nacional, 1889.

Anania, Lorenzo de. *La universal fabrica del mondo.* Naples, 1573.

Anghiera, Pietro Martire de. *De orbe novo decades: I–VIII.* Edited by Rosanna Mazzacane and Elisa Magioncalda. 2 vols. Genova: Università di Genova, Facoltà di lettere, Dipartimento di archeologia, filologia classica e loro tradizioni, 2005.

———. *Epistolario.* Edited and translated by José López De Toro. 4 vols. Madrid: Góngora, 1953–57.

———. *Opus Epistolarum.* Alcalà: In aedibus M. de Eguia, 1530. Reprinted and edited by Fernando Pulgar. Amsterdam: Typis Elzevir, 1670.

———. *Selections from Peter Martyr.* Edited and translated by Geoffrey Eatough. Turnhout: Brepols, 1998.

Apuleius. *De mundo.* English translation by George Boys-Stones. University of Toronto individual web page of George Boys-Stones. Accessed April 13, 2023. http://individual.utoronto.ca/gbs/demundo/texts.html.

Arbolí y Farando, Servando, ed. *Biblioteca Colombina: Catálogo de sus libros impresos.* 7 vols. Seville: Biblioteca Colombina, 1888–1948.

Ashcroft, Jeffrey. *Albrecht Dürer: Documentary Biography.* 2 vols. New Haven: Yale University Press, 2017.

Bandello, Matteo. *Novelle.* 1554. Bari: Laterza et Figli, 1910.

Boileau, Nicolas. *Traité du sublime.* Paris: Denys Thierry, 1674.

Calepino, Ambrogio. *Latinae atque adeo etiam graecae linguae dictionarium.* Basel, 1538.

"Carta de Felipe II a Wanli." 1580. Transcribed by Carmen Hsu. "Dos cartas de Felipe II al emperador de China." *eHumanista* (2004): 194–209.

Cicero, Marcus Tullius. *De oratore, Books 1 and 2.* Translated by E. W. Sutton. London: W. Heinemann, 1979.

Cieza de Leon, Pedro. *Primera parte de la crónica del Perú.* Seville: Martín Montesdoca, 1553.

*Corpo diplomatico portugués.* Vol. 3. Lisbon: Tipografia da Academia Real das Sciencias, 1868.

Cortés, Hernán. "Second Letter." In *Letters from Mexico*, translated by Anthony Pagden, 47–159. London: Yale University Press, 1986.

———. "Segunda carta." In *Cartas y relaciones*, edited by Pascual de Gayangos, 51–157. Paris: Imprenta Central de los Ferrocarriles, 1866.

Covarrubias, Miguel de. *Tesoro de la lengua castellana o española.* Madrid: Luis Sánchez, 1611.

De Marees, Pieter. *Beschryvinge ende historische verhael, vant Gout koninckrijck van Gunea.* Amsterdam: C. Claesz, 1602.

Denis, Manuel. *De la pintura antiga por Francisco de Holanda.* 1563. Facsimile ed. Madrid: Ratés, 1921.

Díaz del Castillo, Bernal. *Historia Verdadera de la conquista de la Nueva España.* 1568. Madrid: En la imprenta del Reino, 1632.

Di Dio, Kelley H., and Rosario Coppel. *Sculpture Collections in Early Modern Spain.* London: Taylor and Francis, 2016.

Diego de Landa. *Relación de las cosas de Yucatán.* 1560. Mexico City: Porrúa, 1959.

Dürer, Albrecht. *Schriftlicher Nachlass.* Edited by Hans Rupprich. 3 vols. Berlin: Deutscher Verein für Kunstwissenschaft, 1956–69.

Ficino, Marsilio. *Theologia Platonica.* 1482. Venice: Pederzano, 1525.

"Fr. Diego de Landa, Fr. Francisco de Navarro y Fr. Hernando de Guevara al Consejo de Indias, 3 abril 1559." In *Documentos para la historia de Yucatán*, vol. 1, *1550–60*, edited by France V. Scholes, 83–88. Mérida: Compañía Tipográfica Yucateca, 1936.

Frois, Luis. *Historia de Japam.* 1585. Edited by José Wicki. Lisbon: Presidencia do Conselho de Ministros, 1981.

Galliccioli, Giambattista. *Fraseologia bibblica ovvero Dizionario latino italiano della Sacra Biblia.* Venice: Appresso Francesco Sassoni, 1773.

Góis, Damião de. *Fides, religio, moresque Aethiopum sub imperio preciosi Joannis.* Louvain: Rutger Ressen, 1540.

———. *Urbis Olisiponis descriptio.* Évora, 1554.

Guevara, Felipe de. *Comentarios de la pintura que escribió Don Felipe de Guevara, Gentil-hombre de boca del Señor Emperador Carlos Quinto, Rey de España: Se publican por la primera vez con un discurso preliminar y algunas notas de Don Antonio Ponz.* Madrid: Don Geronimo Ortega, 1788.

Holanda, Francisco de. *Album dos desenhos das Antigualhas.* 1537–40. Lisbon: Livros Horizonte, 1989.

———. *Da fabrica que falece a cidade de Lisboa.* 1571. Madrid: Vergilio Correia, 1929.

———. *Da pintura antiga.* Edited by Angel González García. Lisbon: Imprenta Nacional Casa da Moeda, 1984.

——— [Hollanda]. *On Antique Painting.* Translated by Alice Sedgwick Wohl. University Park: Penn State University Press, 2013.

"Joyas que Hernán Cortés envió a España desde México inventariadas por Cristóbal de Oñate" (1526). In *Documentos Cortesianos*, edited by José Luís Martínez, 1:412–15 (doc. 62). Mexico City: Fondo de Cultura económica: 1990.

Landa, Diego, de. *Relación de las cosas de Yucatán.* 1566. English translation: *Yucatan Before and After the Conquest: The Maya.* Translated by William Gates. New York: Dover, 1978.

Las Casas, Bartolomé de. *Apologética historia sumaria.* Completed ca. 1557. Edited by Edmundo O'Gorman. 2 vols. Mexico City: UNAM, 1967.

———. *Brevísima relación de la destruyción de las Indias.* Madrid: EDAF, 2004.

238

———. *Historia de las Indias.* Edited by Agustín Millares Carlo. 2 vols. Mexico City: Fondo de Cultura Economica, 1965.

———. *Los tesoros del Perú.* Translated and edited by Ángel Losada. Madrid: Consejo Superior de Investigaciones Científicas, 1958.

Legati, Lorenzo. *Museo Cospiano annesso a quello del famoso Ulisse Aldrovandi.* Bologna: Giacomo Monti, 1677.

*Lienzo de Tlaxcala,* facsimile edition. In Alfredo Chavero, *Homenaje a Cristóbal Colón: Antigüedades mexicanas.* Mexico City: Oficina Tipográfica de la Secretaría de Fomento, 1892.

Lomazzo, Giovan Paolo. *Idea del tempio della pittura.* Milan: Pontio, 1590.

———. *Trattato dell'arte della pittura.* Milan: Pontio, 1584.

López de Gómara, Francesco. *La historia generale delle Indie Occidentali.* Translated by Agustín de Cravaliz. Rome: Valerio and Luigi Dorici, 1556.

Malvasia, Cesare. *Felsina pittrice: Vite de pittori bolognesi.* Bologna: Per l'erede di Domenico Barbieri, 1678.

Manetti, Giannozzo. *On Human Worth and Excellence.* Edited and translated by Brian P. Copenhaver. The I Tatti Renaissance Library. Cambridge: Harvard University Press, 2019.

Mendes Pinto, Fernão. *Peregrinaçam.* 1614. English translation: Fernão Mendes Pinto, *The Travels of Mendes Pinto.* Translated by Barbara Catz. Chicago: University of Chicago Press, 1989.

Molina, Alonso de. *Vocabulario en Lengua castellana y méxicana.* Mexico City: Antonio de Espinosa, 1571.

Monclaro, Francisco. "Relaçaõ da viagem que fizeram os Padres da Companhia de Jesus com Francisco Barreto na Conquista do Monomotapa no anno de 1569." *Boletim da Sociedade de Geografía de Lisboa,* ser. 4, 1 (1883): 492–508.

Moroni, Gaetano. *Dizionario di erudizione storico-ecclesiastica.* Vol. 32. Venice: Typ. Emiliana, 1845.

Motolinía, Toribio de. *Carta al Emperador.* 1555. Edited by José Bravo Ugarte. Mexico City: Editorial Jus, 1949.

———. *Memoriales o libro segundo de las cosas de la Nueva España y de los naturales de ella.* Edited by Edmundo O'Gorman. Mexico City: Universidad Nacional Autónoma de México-Instituto de Investigaciones Históricas, 1971.

Muñoz Camargo, Diego. *Descripción de la ciudad y provincia de Tlaxcala.* San Luis Potosi: El Colegio de San Luis, 2000.

Neckam, Alexander. *De nominibus utensilium.* In Urban Tigner Holmes Jr., *Daily Living in the Twelfth Century: Based on the Observations of Alexander Neckam in London and Paris.* Madison: University of Wisconsin Press, 1964.

Nunes, Pedro. *Tratado da sphera: Con a theorica do Sol et da Lua.* Lisbon: Per Germão Galharde, 1537.

Oviedo y Valdés, Gonzalo Fernández de. *Historia general y natural de las Indias.* Edited by Juan Perez de Tudela Bueso. Vols. 117–21 (5 vols.). Madrid: Ediciones Atlas, 1959.

Pacheco Pereira, Duarte. *Esmeraldo de situ orbis.* 1506. Commemorative ed. Lisbon: Imprensa Nacional, 1892.

*Paesi novamente ritrovati per la navigatione di Spagna in Calicut: Et da Albertutio Vesputio fiorentino intitulato Mondo Novo, novamente impresso.* Milan, 1519.

Pané, Ramón. *Relación acerca de las antigüedades de los indios.* Ca. 1496. Edited by José Juan Arrom. Mexico City: Siglo Veintiuno, 2008.

Patrizi, Francesco. *De institutione reipublicae libri nouem.* Edited by Jean Savigny. Paris, 1518.

———. *De regno et regis institutione libri 9.* Paris: Giles Gourbin, 1582.

Piccolomini, Aeneas Silvius. *Europe, ca. 1400–58.* Edited by Nancy Bisaha. Translated by Robert Brown. Washington, DC: Catholic University of America Press, 2013.

Pico della Mirandola, Giovanni. *Oration on the Dignity of Man: A New Translation and*

*Commentary*. Edited by Francesco Borghesi and Massimo Riva. New York: Cambridge University Press, 2016.

Pico, della M. G., and Albano Biondi. *Conclusiones nongentae: Le novecento tesi dell'anno 1486*. Florence: Leo S. Olschki editore, 1995.

Pigafetta, Antonio. *The First Voyage Around the World, 1519–1522: An Account of Magellan's Expedition*. Edited by Theodore J. Cachey. Toronto: University of Toronto Press, 2019.

Pignoria, Lorenzo. "Seconda parte delle imagini degli Dei Indiani." In Vincenzo Cartari. *Le vere e noue imagini de gli Dei delli antichi di Vincenzo Cartari*, i–lxiii. Padua: Pietro Paolo Tozzi, 1615.

Pina, Rui de. "Relação do Reino do Congo." 1492. Reprinted as Rui de Pina, *O Cronista Rui de Pina*. Edited by Carmen M. Radulet. Lisbon: Commizzão National, 1992.

Pizarro, Hernando. *Carta a los magníficos señores oidores de la audiencia real de su majestad que residen en la ciudad de Santo Domingo del dos de noviembre de 1533*. Lima: Colección de libros y documentos referentes a la historia del Perú, 1920.

Pliny the Elder. *Naturalis historiae libri XXXVI*. Edited by Carolus Mayhoff and Ludwig Von Jan. Vol. 5. Biponti [Zweibrücken]: Ex typographia Societatis, 1783.

*Proceso Inquisitorial del cacique de Tetzcoco*. 1539. Edited by Luis González Obregón. Mexico: Gobierno del Distrito Federal y Congreso Internacional de Americanistas, 2009.

"Real Cédula disponiendo el empleo del Tesoro conducido por Hernando Pizarro." *Libro primero de Cabildos de Lima*. Paris: Paul Dupont, 1900.

Ribadeneyra, Antonio de San Román. *Historia general de la Yndia oriental*. Valladolid: Luis Sánchez, 1603.

Sansovino, Francesco. *Venetia cittá nobilissima*. Venice: Jacomo Sansovino, 1581.

Scillacio, Nicoló. *De insulis meridiani atque indici nuper inventis*. 1494. Reprinted in *Italian Reports on America, 1493–1522: Accounts by Contemporary Observers*. Edited by Geoffrey Symcox, Luciano Formisano, Theodore J. Cachey, and John C. McLucas. Turnhout: Brepols, 2002.

Semedo, Alvarez, Manuel F. Sousa, and Juan Sanchez. *Imperio De La China Publicado Por Manuel De Faria I Sousa*. Madrid: impresso por Juan Sanchez a costa de Pedro Coello, 1642.

Terzago, Paolo Maria. *Musaeum Septalianum*, Dertonae: Typis filiorum qd. Elisei Violæ, 1664.

Vasari, Giorgio. *Le vite de' piu eccellenti pittori, scultori e architettori nelle redazioni del 1550 e 1568*. Edited by Rosanna Bettarini and Paola Barocchi. Florence: Studio per Edizioni Scelte, 1966–87. Online editions by Accademia della Crusca-Fondazione Memofonte: Edition Torrentiniana (Florence: Lorenzo Torrentino, 1550), http://memofonte .accademiadellacrusca.org/vite_1550 .asp; Edition Giuntina (Florence: Giunti, 1568), http://memofonte.acca demiadellacrusca.org/vite_1568.asp.

Vega el Inca, Garcilaso de la. *Comentarios reales de los Incas*. Lisbon: Pedro Craesbeeck, 1609.

Villuga, Pedro Juan. *Repertorio de todos los caminos*. Medina de Campo: Pedro de Castro, 1546.

Vinci, Leonardo da. *Codex Atlanticus*, 1478–1519. http://codex-atlanticus.it.

*Vocabolario Degli Accademici Della Crusca*. Venice: Giovanni Alberti, 1612.

Xeres, Francisco de. *Verdadera relación de la conquista del Perú*. 1534. Madrid, 1891.

SECONDARY SOURCES

Abulafia, David. *The Discovery of Mankind: Atlantic Encounters in the Age of Columbus*. New Haven: Yale University Press, 2009.

Abu-Lughod, Janet L. *Before European Hegemony: The World System, A.D. 1250–1350*.

240

New York: Oxford University Press, 1989.

Achim, Miruna. *From Idol to Antiquity: Forging the National Museum of Mexico*. Lincoln: University of Nebraska Press, 2017.

Adams, Sean A. *Baruch and the Epistle of Jeremiah*. Leiden: Brill, 2014.

Adorno, Rolena. "Felipe Guaman Poma de Ayala: An Andean View of the Peruvian Viceroyalty, 1565–1615." *Journal de La Société Des Américanistes* 65 (1978): 121–43.

Agoston, Laura Camille. "Male/Female, Italy/ Flanders, Michelangelo/Vittoria Colonna." *Renaissance Quarterly* 58, no. 4 (2005): 1175–219.

———. "Michelangelo as Voice Versus Michelangelo as Text." *Journal of Medieval and Early Modern Studies* 36, no. 1 (2006): 135–68.

Aguirre Molina, Alejandra. "El ritual del autosacrificio en Mesoamérica." *Anales de Antropología* 38, no. 1 (2004): 85–109.

Allerstorfer, Julia, and Monika Leisch-Kiesl, eds. *Global Art History: Transkulturelle Verortungen von Kunst und Kunstwissenschaft*. Bielefeld: Transcript, 2017.

Almagià, Roberto. "Intorno a quattro codici fiorentini e ad uno ferrarese dell'erudito veneziano Alessandro Zorzi." *La Bibliofilia* 30 (1936): 313–47.

Anders, Ferdinand. "Las artes menores." *Artes de México* 137 (1970): 4–45.

Anders, Ferdinand, Maarten Jansen, and Jimenez G. A. Perez. *Origen e historia de los reyes Mixtecos: Libro explicativo del llamado Codice Vindobonensis*. Mexico City: Fondo de Cultura Económica, 1992.

Anderson, Benjamin, and Felipe Rojas, eds. *Antiquarianisms: Contact, Conflict, Comparison*. Oxford: Joukowsky Institute, 2017.

Asselbergs, Florine G. L. "The Conquest in Images: Stories of Tlaxcalteca and Quauhquecholteca Conquistadors." In *Indian Conquistadors: Indigenous Allies in the Conquest of Mesoamerica*, edited by Laura E. Matthew and Michael R.

Oudijk, 65–101. Norman: University of Oklahoma Press, 2007.

Bacchelli, Franco. "Cos'ha veramente detto l'umanesimo filosofico." Conference at the IIS Archimede, San Giovanni in Persiceto (Bologna), 2018. Accessible on https://www.youtube.com/watch?v= 8jVd65zzjss.

Badiou, Alain, and Ray Brassier. *Saint Paul: The Foundation of Universalism*. Stanford: Stanford University Press, 2009.

Ballesteros Gaibrois, Manuel. "El Lienzo de Tlaxcala de la Casa de Colón de Valladolid." In *Cuadernos Prehispánicos* 5 (1977): 5–17.

Barocchi, Paola. "Lettera di G. B. Adriani a G. Vasari." In Giorgio Vasari, *Le vite de' pi u eccellenti pittori, scultori e architettori nelle redazione del 1550 e 1568*, edited by Rosanna Bettarini and Paola Barocchi, 232–35. Florence: Studio per Edizioni Scelte, 1987.

———. *Trattati d'arte del cinquecento: Fra manierismo e controriforma*. 3 vols. Bari: Laterza, 1962.

Baron, Hans. *The Crisis of the Early Italian Renaissance: Civic Humanism and Republican Liberty of Classicism and Tyranny*. Princeton: Princeton University Press, 1955.

Bassani, Ezio. *African Art and Artifacts in European Collections*. London: British Museum, 2000.

———. "A Note on Kongo High-Status Caps in Old European Collections." *RES: Anthropology and Aesthetics* 5, no. 1 (1983): 74–84.

Bataillon, Marcel. "Les premiers Mexicains envoyés en Espagne par Cortès." *Journal de la Société des Americanistes* 48 (1959): 135–40.

Battisti, Eugenio. *L'antirinascimento*. Milan: Feltrinelli, 1962.

Bazin, Germain. *The Loom of Art*. New York: Simon and Schuster, 1962.

Becker, Anna. "The Civic and the Domestic in Aristotelian Thought." In *Gendering the Renaissance Commonwealth*, 13–48.

Cambridge: Cambridge University Press, 2020.

Beer, Susanna de. "The Roman 'Academy' of Pomponio Leto: From an Informal Humanist Network to the Institution of a Literary Society." In *The Reach of the Republic of Letters: Literary and Learned Societies in Late Medieval and Early Modern Europe*, edited by Arjan van Dixhoorn and Susie Speakman Sutch, 1:181–218. Leiden: Brill, 2008.

Belting, Hans. *An Anthropology of Images: Picture, Medium, Body*. Princeton: Princeton University Press, 2014.

———. *The End of Art History?* Chicago: University of Chicago Press, 1987.

———. *Likeness and Presence: A History of the Image Before the Era of Art*. Chicago: University of Chicago Press, 1996.

Bénat Tachot, Louise. "*Ingenio* ou *industria*: La ligne de partage des eaux." In "Sguardi incrociati sull'oggetto etnografico," special issue, *Thule: Rivista Italiana di Studi Americanistici* (Perugia), nos. 16/17 (2004): 147–75.

Benjamin, Walter. "The Task of the Translator." 1923. In *Illuminations*, 69–82. Translated by Harry Zohn. Edited and introduced by Hannah Arendt. New York: Harcourt Brace Jovanovich, 1968.

Bentancor, Orlando. *The Matter of Empire: Metaphysics and Mining in Colonial Peru*. Pittsburgh: University of Pittsburgh Press, 2017.

Benzoni, Maria Matilde. *La cultura italiana e il Messico: Storia di un'immagine da Temistitan all'indipendenza (1519–1821)*. Milan: Unicopli, 2004.

Bernand, Carmen, and Serge Gruzinski. *De l'idôlatrie: Une archéologie des sciences réligieuses*. Paris: Seuil, 1990.

Bianca, Concetta. "Pomponio Leto e l'invenzione dell'Accademia Romana." In *Les académies dans l'Europe humaniste: Idéaux et pratiques*, edited by Marc Deramaix, Perrine Galand-Hallyn, Ginette Vagenheim, and Jean Vignes, 25–56 (no. 441). Geneva: Droz, 2008.

Biedermann, Zoltán. "Diplomatic Ivories: Sri Lankan Caskets and the Portuguese-Asian Exchange in the Sixteenth Century." In *Global Gifts: The Material Culture of Diplomacy in Early Modern Eurasia*, edited by Zoltán Biedermann, Anne Gerritson, and Giorgio Riello, 88–118. Cambridge: Cambridge University Press, 2017.

Bierhorst, John. *A Nahuatl-English Dictionary and Concordance to the Cantares Mexicanos: With an Analytic Transcription and Grammatical Notes*. Stanford: Stanford University Press, 1985.

Bisaha, Nancy. *Creating East and West: Renaissance Humanists and the Ottoman Turks*. Philadelphia: University of Pennsylvania Press, 2010.

Bleichmar, Daniela. "The Cabinet and the World: Non-European Objects in Early Modern European Collections." *Journal of the History of Collections* 33, no. 3 (November 2021): 435–45.

Bleichmar, Daniela, and Peter C. Mancall, eds. *Collecting Across Cultures: Material Exchanges in the Early Modern Atlantic World*. Philadelphia: University of Pennsylvania Press, 2011.

Boone, Elizabeth H. *Stories in Red and Black: Pictorial Histories of the Aztecs and Mixtecs*. Austin: University of Texas Press, 2000.

Borghesi, Francesco. "Chronology." In Pico della Mirandola, *Oration on the Dignity of Man*, 37–44.

Bouwsma, William J. "The Renaissance Discovery of Human Creativity." In *Humanity and Divinity in Renaissance and Reformation*, edited by John W. O'Malley, Thomas M. Izbicki, and Gerald Christianson, 17–34. Leiden: Brill, 1993.

Boyd Goldie, Matthew. *The Idea of the Antipodes*. New York: Routledge, 2009.

Bracke, Wouter. "The MS Ottob. lat. 1982: A Contribution to the Biography of Pomponius Laetus?" *Rinascimento* 2, no. 29 (1989): 293–99.

242

Bradley, John William. *The Life and Works of Giulio Clovio*. Amsterdam: G. W. Hissink, 1971.

Bredekamp, Horst. *Image Acts: A Systematic Approach to Visual Agency*. Berlin: De Gruyter, 2017.

———. *La nostalgie de l'antique: Statues, machines et cabinets de curiosités*. Paris: Diderot éditeur Arts et Sciences, 1996.

Bright, Michael, and Hannah Bailey. *When We Became Humans*. Lake Forest: Words Pictures, 2019.

Brini, Jean. "De l'omnivoyant à l'omnivoyure." *Journal français de psychiatrie* 2, no. 16 (2002): 8–10. http://www.cairn.info /revue-journal-francais-de-psychiatrie -2002–2-page-8.htm.

Brizzolara, Anna Maria, Massimo Medica, and Cristiana Morigi Govi. "Ferdinando Cospi e l'antico." In Tega, *Antichità del mondo*, 51–86.

Brook, Timothy. *Vermeer's Hat: The Seventeenth Century and the Dawn of the Global World*. London: Profile, 2010.

Brottom, Jerry. *The Renaissance Bazaar: From the Silk Road to Michelangelo*. Oxford: Oxford University Press, 2010.

Brown, Virginia, James Hankins, and Robert A. Kaster. *Catalogus Translationum et Commentariorum: Mediaeval and Renaissance Latin Translations and Commentaries, Annotated Lists and Guides*. 8 vols. Washington, DC: Catholic University of America Press, 2011.

Bujok, Elke. "Ethnographica in Early Modern Kunstkammern and Their Perception." *Journal of the History of Collections* 2, no. 1 (2009): 17–32.

Burke, Edmund. *A Philosophical Enquiry into the Origin of Our Ideas of the Sublime and Beautiful*. Cambridge: Cambridge University Press, 2014.

Cachey, Theodore J. Introduction to Pigafetta, *First Voyage*, ix–xxxvi.

Calvillo, Elena. "No Stranger in Foreign Lands: Francisco de Hollanda and the Translation of Italian Art and Theory." In *Trust and Proof: Translators in Renaissance Print Culture*, edited by Andrea Rizzi, 112–45. Leiden: Brill, 2017.

Camille, Michael. *The Gothic Idol: Ideology and Image-Making in Medieval Art*. Cambridge: Cambridge University Press, 1989.

Cândida Caixeiro, Mariana. "Estela indiana com inscrição em sânscrito e a Lenda de Elefanta." In *Tapeçarias de D. João de Castro*, edited by José Francisco da Mota Sampaio Brandão. Lisbon: CNCDP, 1995.

Cañizares-Esquerra, Jorge. *How to Write the History of the New World*. Stanford: Stanford University Press, 2001.

Carabell, Paula. "Image and Identity in the Unfinished Works of Michelangelo," *Res: Anthropology and Aesthetics* 32 (1997): 83–105.

Cárdenas Bunsen, José Alejandro. *Escritura y derecho canónico en la obra de fray Bartolomé de las Casas*. Madrid: Iberoamericana, 2011.

Carrier, David. *A World Art History and Its Objects*. University Park: Penn State University Press, 2008.

Caso, Alfonso. "Explicación del reverso del Codex Vindobonensis." *Memoria de El Colegio nacional* 5, no. 5 (1950): 9–46.

Cassid, Jill H., and Aruna D'Souza, eds. *Art History in the Wake of the Global Turn*. Williamstown: Clark Art Institute, 2014.

Cassirer, Ernst. "Giovanni Pico della Mirandola: A Study in the History of Renaissance Ideas." *Journal of the History of Ideas* 3, no. 3 (1942): 123–44.

Castilla, Carlos. "*Homo viator, homo lector*: Escritura, lectura y representación en las Décadas de Pedro Mártir de Anglería." *Revista Telar* 11–12 (2016): 94–113.

Catlos, Brian A., and Sharon Kinoshita, eds. *Can We Talk Mediterranean? Conversations on an Emerging Field in Medieval and Early Modern Studies*. New York: Palgrave Macmillan, 2017.

Cattaneo, Angelo. "European Medieval and Renaissance Cosmography: A Story of Multiple Voices." *Asian Review of World Histories* 4, no. 1 (2016): 35–81.

Chastel, André. *Le Cardinal Louis D'Aragon: Un voyageur princier de la Renaissance*. Paris: A. Fayard, 1986.

Chichorro, Federica. "D. João de Castro e o universalismo da cultura portuguesa." Publication of the Universidade católica portuguesa, 1996, 87–103. http://www4 .crb.ucp.pt/Biblioteca/rotas/rotas/fred erica%20chichorro%2087a103%20p.pdf.

Chuchiak, John. "*In Servitio Dei*: Fray Diego de Landa: The Franciscan Order, and the Return of the Extirpation of Idolatry in the Colonial Diocese of Yucatán, 1573–1579." *Americas* 61, no. 4 (2005): 611–46.

Clayton, Lawrence A. *Bartolomé de las Casas: A Biography*. Cambridge: Cambridge University Press, 2012.

Cole, Michael, and Christopher Wood. Review of Battisti, *L'Antirinascimento*. *Art Bulletin* 95, no. 4 (December 2013): 251–55.

Cole, Michael Wayne, and Rebecca Zorach, eds. *The Idol in the Age of Art: Objects, Devotions and the Early Modern World*. Farnham: Ashgate, 2009.

Colmenares, David Horacio. "De-idolizing Artifacts in the *Apologética Historia Sumaria* by Bartolomé de las Casas." Unpublished paper shared by the author.

Cómez, Rafael. *Sinagogas de Sevilla*. Seville: Diputación de Sevilla, Servicio de Archivo y Publicaciones, 2015.

Conrad, Sebastian. *What Is Global History?* Princeton: Princeton University Press, 2016.

Cook, Alexandra. "Before the Fetish: Artifice and Trade in Early Modern Guinea." PhD diss., Columbia University, 2022.

Cro, Stelio. "Italian Humanism and the Myth of the Noble Savage." *Annali d'Italianistica* 10 (1992): 48–68.

———. *The Noble Sauvage. Allegory of Freedom*. Waterloo: Wilfrid Laurier University Press, 2006.

———. "La 'Princeps' y la cuestión del plagio del 'De Orbe Novo.'" *Cuadernos para Investigación de la Literatura Hispánica* 28 (2003): 15–240.

Crow, Thomas. *The Intelligence of Art*. Chapel Hill: University of North Carolina Press, 2000.

Cummins, Thomas B. F. "Sacrifice and Idolatry in Pre-Columbian America: 'Because the worshipping of abominable idols is the cause and the beginning of all evil.'" In *Sacrifice and Conversion in the Early Modern World*, edited by Maria Berbara, 23–57. Florence: I Tatti—The Harvard University Center for Italian Renaissance Studies, 2022.

———. *Toasts with the Inca*. Ann Arbor: University of Michigan Press, 2002.

D'Altroy, Terence. *The Incas*. Malden: Wiley-Blackwell, 2015.

Daston, Lorraine, and Katharine Park. *Wonders and the Order of Nature: 1150–1750*. New York: Zone, 2001.

Davies, Surekhka. *Renaissance Ethnography and the Invention of the Human*. New York: Cambridge University Press, 2016.

De Boer, Wietse, Karl A. E. Enenkel, and Walter Melion, eds. *Jesuit Image Theory*. Leiden: Brill, 2016.

De Certeau, Michel. "The Gaze Nicholas of Cusa." *Diacritics* 17, no. 3 (1987): 2–38.

Dekker, Elly. "Globes in Renaissance Europe." In *The History of Cartography*, vol. 3, *Cartography in the European Renaissance*, part 1, edited by David Woodward, 3:135–73. Chicago: University of Chicago Press, 2007.

Del Re, Niccolò. *Monsignor Governatore di Roma*. Rome: Istituto di studi romani, 1972.

Déotte, Jean-Louis. "Alberti, Vasari, Leonardo: From *disegno* as Drawing to *disegno* as Projective Milieu." *Appareil* (2009). https://doi.org/10.4000/appareil.604.

De Sousa Leitão, Henrique, ed. *Pedro Nunes (1502–1578): Novas terras, novos mares e o que mays he; Novo ceo e novas estrellas*. Lisbon: Biblioteca Nacional Portugal, 2002.

D'Esposito, Francesco, and Auke P. Jacobs. "Auge y ocaso de la primera sociedad minera de América: Santo Domingo 1503–1520." *Nuevo Mundo Mundos*

244

*Nuevos* (2015). https://doi.org/10.4000 /nuevomundo.67723.

Deswarte-Rosa, Sylvie. "Antiquité et nouveau mondes: A propos de Francisco de Holanda." *Revue de l'art*, no. 6863 (1985): 55–72.

———. "Contribution à la connaissance de Francisco de Holanda." *Arquivos do Centro Cultural Português* 7 (1974): 421–29.

———. "Les 'De aetatibus mundi imagines' de Francisco de Holanda." *Monuments et mémoires de la Fondation Eugène Piot* 66, no. 1 (1983): 67–190.

———. "Les *De aetatibus mundi imagines* de Francisco de Holanda entre Lisbonne et Madrid." In *Felix Austria: Lazos familiares, cultura política y mecenazgo artístico entre las cortes de los Habsburgo*, edited by Bernardo J. García García, 245–82. Madrid: Fundación Carlos de Amberes, 2016.

———. "Do tirar polo natural (1549) de Francisco de Holanda." In *Do tirar polo natural: Inquérito ao retrato português / Inquiry to the Portuguese Portrait*, edited by Andrea Cardoso, 18–35. Lisbon: Museu Nacional de Arte Antiga, 2018.

———. "Francisco de Holanda à Bologne, Pâques 1540: Les Portugais et Bologne durant la première moitié du cinquecento." In *Da Bologna all'Europa: Artisti bolognesi in Portogallo (XVI–XIX secolo)*, edited by Micaela Antonucci and Sabine Frommel, 21–70. Bologna: Bologna University Press, 2017.

———. "Les gravures de monuments antiques d'Antonio Salamanca, à l'origine du *Speculum Romanae Magnificentiae*." *Annali di Architettura*, no. 1 (1989): 47–62.

———. *Ideias e imagens em Portugal na época dos descobrimentos: Francisco de Holanda e a teoria da arte.* Lisbon: DIFEL, 1992.

———. Introduction to Deswarte-Rosa and Saramago, *Edades del mundo*.

———. "Malitia temporis, Francisco de Holanda face à la censure: Textes et images." In *Pensar história da arte:*

*Estudos de homenagem a José-Augusto França*, edited by Pedro Flor, 113–26. Lisbon: Esfera do Caos Editores, 2016.

———. "Prisca pictura e antiqua novitas Francisco de Holanda e a taxonomia das figuras antigas." *ARS* (Sao Paulo) 4, no. 7 (January 2006): 14–27.

———. "A viagem a Itália de Francisco de Holanda (1538–1540)." In *Os descobrimentos portugueses e a Europa do Renascimento*, edited by Exposição Europeia de Arte, Ciência e Cultura, 61–65. Lisbon: Comissariado da XVII E.A.C.C., 1983.

Deswarte-Rosa, Sylvie, and José Saramago. *Las edades del mundo: Estudio iconográfico del "De aetatibus mundi imagines."* Barcelona: BiblioGemma, 2007.

Didi-Huberman, Georges. *Atlas ¿Cómo llevar el mundo a cuestas?* Madrid: Museo Nacional Centro de Arte Reina Sofía, 2010.

———. *Confronting Images: Questioning the End of a Certain Art History*. University Park: Penn State University Press, 2005.

Domenici, Davide. "Missionary Gift Records on Mexican Objects in Early Modern Italy." In Horodowich and Markey, *New World in Early Modern Italy*, 86–102.

Domenici, Davide, and Laura Laurencich-Minelli. "Domingo de Betanzos' Gifts to Pope Clement VII in 1532–33: Tracking the Early History of Some Mexican Objects and Codices in Italy." *Estudios de cultura Náhuatl* 47 (2014): 169–209.

Donattini, Massimo. "Il mondo portato a Bologna: Viaggiatori, collezionisti, missionari." In *Storia di Bologna: Cultura, istituzioni culturali, Chiesa e vita religiosa*, vol. 3, *Bologna nell'età moderna (secoli xvi–xviii)*, edited by Adriano Prosperi, 537–682. Bologna: Bologna University Press, 2008.

D'Onofrio, Cesare. *Visitiamo Roma nel Quattrocento: La città degli umanisti.* Rome: Romana Società Editrice, 1989.

Doran, Robert. *The Theory of the Sublime from Longinus to Kant*. Cambridge: Cambridge University Press, 2015.

Dorez, Léon, and Louis Thuasne. *Pic de la Mirandole en France (1485–1488)*. Paris: E. Leroux, 1897.

Dueñas, Elena Vázquez. "Los comentarios de la pintura de Felipe de Guevara / Commentaries on Painting by Felipe de Guevara." Special issue, *Anales de historia del arte* (2010): 365–76.

———. "El manuscrito del 'Comentario de la pintura y pintores antiguos' de Felipe de Guevara en el Prado." *Boletín del Museo del Prado* 27, no. 45 (2009): 33–43.

Dufour Bozzo, Colette, Anna Rosa Calderoni Masetti, and Gerhard Wolf. *Mandylion: Intorno al sacro volto, da Bisanzio a Genova*. Milan: Skira, 2004.

Eatough, Geoffrey. "Peter Martyr's Account of the First Contacts with Mexico." *Viator* 30 (1999): 397–421.

Eco, Umberto. *Arte e bellezza nell'estetica medievale*. Milan: La nave di Teseo, 2016.

Eichberger, Dagmar. "Naturalia and Artefacta: Dürer's Nature Drawings and Early Collecting." In *Dürer and His Culture*, edited by Dagmar Eichberger and Charles Zika, 212–16. Cambridge: Cambridge University Press, 1998.

Elkins, James, ed. *Art and Globalization*. University Park: Penn State University Press, 2010.

———, ed. *Is Art History Global?* London: Routledge, 2007.

———. *Stories of Art*. New York: Routledge, 2002.

Elkins, James, and Robert Williams. *Renaissance Theory*. New York: Routledge, 2009.

Elliott, John H. *The Old World and the New, 1492–1650*. Cambridge: Cambridge University Press, 1970.

Estrada de Gerlero, Elena Isabel. "Mass of Saint Gregory." In *Painting a New World: Mexican Art and Life, 1521–1821*, edited by Donna Pierce, Gomar R. Ruiz, and Clara Bargellini, 102–5. Denver: Frederick and Jan Mayer Center for Pre-Columbian and Spanish Colonial Art, Denver Art Museum, 2004.

Falguières, Patricia. *Les chambres de merveilles: Le rayon des curiosités*. Paris: Bayard, 2003.

———. "Les inventeurs des choses: Enquêtes sur les arts et la naissance d'une science de l'homme dans les cabinets du XVIè siècle." In *Histoire de l'art et anthropologie*, edited by David Freedberg, Paris: INHA / musée du quai Branly ("Les actes"), 2009. http://journals.openedition.org/actesbranly/94.

Farago, Claire. "Desiderata for the Study of Early Modern Art of the Mediterranean." In Catlos and Kinoshita, *Can We Talk Mediterranean?*, 49–64.

———. "The Global Turn in Art History: Why, When, and How Does It Matter?" In Savoy, *Globalization of Renaissance Art*, 299–313.

———. "Reframing the Baroque: On Idolatry and the Threshold of Humanity." In *Rethinking the Baroque*, edited by Hellen Hills, 99–142. Farnham: Ashgate, 2011.

Farago, Claire J., and Carol K. Parenteau. "Dürer et les Premières Evaluations Européennes de l'Art Mexicain." In *Destins croisés, cinq siècles de rencontres avec les Amérindiens*, edited by Joëlle Rostkowski and Sylvie Devers, 107–11. Paris: UNESCO, 1992.

———. "The Grotesque Idol: Imaginary, Symbolic and Real." In Cole and Zorach, *Idol in the Age of Art*, 105–31.

Feest, Christian. "The Collecting of American Indian Artifacts in Europe, 1493–1750." In *America in European Consciousness, 1493–1750*, edited by Karen Ordahl Kupperman, 324–60. Chapel Hill: University of North Carolina Press, 1995.

———. "Dürer et les premières évaluations européennes de l'art mexicain." In *Destins croisés: Cinq siècles de rencontres avec les amérindiens*, edited by Joëlle Rostkowski and Sylvie Devers, 107–19. Paris: UNESCO—Albin Michel, 1992.

———. "From Calicut to America." In *Albrecht Dürer: His Art in Context*, edited by Jochen Sander, 367–75. Munich: Prestel, 2013.

246

———. "L'héritage des cabinets d'art et de curiosités, objets mexicains du XVIe siècle dans les musées européens." In *Les Aztèques: Trésors du Mexique ancien*, edited by S. Purini, M. Lambrecht, and M. Ruyssinck, 197–99. Brussels: Musées Royaux d'Art et d'Histoire Roemer-und Pelizaeus-Museum Hildesheim, 1987.

———. "Mexico and South America in the European Wunderkammer." In *The Origins of Museums*, edited by Arthur MacGregor and Oliver Impey, 237–44. Oxford: House of Stratus, 1985.

———. "Vienna's Mexican Treasures: Aztec, Mixtec, and Tarascan Works from 16th Century Austrian Collections." *Archiv für Völkerkunde* 44 (1990): 1–6.

Findlen, Paula. *Possessing Nature: Museums, Collecting, and Scientific Culture in Early Modern Italy*. Berkeley: California University Press, 1994.

Forcellini, Egidio. *Totius Latinitatis Lexicon*. 6 vols. Prati: Typis Aldinianis, 1860–79.

Freedberg, David. *Iconoclasts and Their Motives*. Maarssen: Gary Schwartz, 1985.

Freiberg, Jack. *Bramante's Tempietto*. Cambridge: Cambridge University Press, 2014.

Freund, Wilhelm. *Wörterbuch der Lateinischen Sprache*. Leipzig: Wolfenbüttel, 1834.

Fricke, Beate. "Artifex and Opifex—The Medieval Artist." In *A Companion to Medieval Art: Romanesque and Gothic in Northern Europe*, edited by Conrad Rudolph, 45–70. Hoboken: Wiley-Blackwell, 2019.

———. *Fallen Idols, Risen Saints: Sainte Foy of Conques and the Revival of Monumental Sculpture in Medieval Art*. Turnhout: Brepols, 2015.

Friedman, John B. "Cultural Conflicts in Medieval World Maps." In *Implicit Understandings*, edited by Stuart B. Schwartz, 64–95. Cambridge: Cambridge University Press, 1995.

Frommel, Christoph Luitpold. "I chiostri di S. Ambrogio e il cortile della Cancelleria a Roma: Un confronto stilistico." In *Arte lombarda* 79, no. 4 (1986): 9–18.

Fromont, Cecile. *The Art of Conversion: Christian Visual Culture in the Kingdom of Kongo*. Chapel Hill: University of North Carolina Press, 2017.

Gallo, Daniela. "Ulisse Aldrovandi, *Le statue di Roma* e i marmi romani." *Mélanges de l'École française de Rome: Italie et Méditerranée* 104, no. 2 (1992): 479–90.

Gansen, Elizabeth. "Framing the Indies: The Renaissance Aesthetics of Gonzalo Fernández de Oviedo (1478–1557)." *Colonial Latin American Review* 28, no. 2 (2019): 130–51.

García Sáiz, María Concepción, "Acerca de los conocimientos pictóricos de Gonzalo Fernández de Oviedo." In *América y la España del siglo XVI*, edited by Gonzalo Fernández de Oviedo y Valdés, Fermino del Pino-Díaz, and Francisco de Solano, 73–85. Madrid: C.S.I.C. Inst. Fernández de Oviedo, 1982.

Garin, Eugenio. *Il pensiero pedagogico dell'umanesimo*. Florence: Coedizioni Giuntine Sansoni, 1958.

———. *L'umanesimo italiano: Filosofia e vita civile nel rinascimento*. Bari: Laterza et Figli, 1952.

———. *Umanisti, artisti, scienziati: Studi sul rinascimento italiano*. Pisa: Edizioni della Normale, 2021.

Gerbi, Antonello. "Oviedo and Italy." In *Nature in the New World: From Christopher Columbus to Gonzalo Fernández De Oviedo*, translated by Jeremy Moyle, 145–200. Pittsburgh: University of Pittsburgh Press, 2010.

Gerritsen, Anne, and Giorgio Riello. *The Global Lives of Things: The Material Culture of Connections in the Early Modern World*. London: Routledge, 2015.

Gerstein, Mordicai. *The First Drawing*. New York: Little, Brown, 2013.

Giasson, Patrice. "Tlazolteotl, deidad del abono: Una propuesta." *Estudios de Cultura Náhuatl* 32 (2001): 135–57.

Giles, Lionel, and Matteo Ricci. *Translations from the Chinese World Map of Father*

*Ricci*. London: Royal Geographical Society, 1919.

Ginzburg, Carlo. "De l'artiste considéré comme faux-monnayeur." *Po&sie* 142, no. 4 (2012): 147–61.

———. *Occhiacci di legno: Nove riflessioni sulla distanza*. Milan: Feltrinelli, 2011.

Giustiniani, Vito R. "Homo, Humanus, and the Meanings of 'Humanism.'" *Journal of the History of Ideas* 46, no. 2 (1985): 167–95.

Glasser, Hannelore. *Artists' Contracts of the Early Renaissance*. New York: Garland, 1977.

Göttler, Christine. "Extraordinary Things: 'Idols from India' and the Visual Discernment of Space and Time." In Göttler and Mochizuki, *Nomadic Object*, 35–73.

———. "'Indian Daggers with Idols' in the Early Modern Constcamer: Collecting, Picturing and Imagining 'Exotic' Weaponry in the Netherlands and Beyond." *Netherlands Yearbook for History of Art / Nederlands Kunsthistorisch Jaarboek Online* 66, no. 1 (2016): 80–111.

Göttler, Christine, and Mia M. Mochizuki, eds. *The Nomadic Object: The Challenge of World for Early Modern Religious Art*. Leiden: Brill, 2018.

Graeber, David, and David Wengrow. *The Dawn of Everything: A New History of Humanity*. New York: Farrar, Straus and Giroux, 2017.

Grafton, Anthony. "*Historia* and *Istoria*: Alberti's Terminology in Context." *I Tatti Studies: Essays in the Renaissance* 8 (1999): 37–68.

———. "Thinking Outside the 'Pico Box.'" *New York Review*, November 5, 2020.

Grafton, Anthony, and Lisa Jardine. *From Humanism to the Humanities: Education and the Liberal Arts in Fifteenth and Sixteenth-Century Europe*. Cambridge: Harvard University Press, 1986.

Grafton, Anthony, April Shelford, and Nancy Siraisi, eds. *New Worlds, Ancient Texts: The Power of Tradition and the Shock of Discovery*. Cambridge: Belknap Press of Harvard University Press, 2002.

Grant, Catherine, and Dorothy Price, eds. "Decolonizing Art History." Special issue, *Art History* 43, no. 1 (February 2020).

Greenblatt, Stephen. "Resonance and Wonder." In *Exhibiting Cultures: The Poetics and Politics of Museum Display*, edited by Ivan Karpe and Steven Lavine, 42–56. Washington, DC: Smithsonian Institution Press, 1991.

Greenspahn, Frederick E. "Syncretism and Idolatry in the Bible." *Vetus Testamentum* 54, no. 4 (2004): 480–94.

Gruzinski, Serge. *L'aigle et la sibylle: Fresques indiennes du Mexique*. Paris: Imprimerie Nationale, 1994.

———. *Conversation avec un métis de la Nouvelle-Espagne*. Paris: Fayard, 2021.

———. *Images at War: Mexico from Columbus to Blade Runner (1492–2019)*. Durham: Duke University Press, 2001.

———. *La machine à remonter le temps: Quand l'Europe s'est mise à écrire l'histoire du monde*. Paris: Fayard, 2018.

———, ed. *Planète métisse*. Paris: Musée du Quai Branly-Actes Sud, 2008.

———. *Les quatre parties du monde: Histoire d'une mondialisation*. Paris: Éditions de la Martinière, 2004.

Gschwend, Annemarie Jordan, and Johannes Beltz. *Elfenbeine aus Ceylon: Luxusgüter für Katharina von Habsburg (1507–1578)*. Zurich: Museum Rietberg, 2010.

Gschwend, Annemarie Jordan, and Kate J. P. Lowe. *The Global City: On the Streets of Renaissance Lisbon*. London: Paul Holberton, 2015.

Guercio, Gabriele. *Art as Existence: The Artist's Monograph and Its Project*. Cambridge: MIT Press, 2009.

Guérin, Sarah M. "Exchange of Sacrifices: West Africa in the Medieval World of Goods." In *Re-assessing the Global Turn in Medieval Art History*, edited by Christina Normore and Carol Symes, 97–124. Amsterdam: ARC, Amsterdam University Press, 2017.

Haag, Sabine, Dagmar Eichberger, and Annemarie Jordan Gschwend, eds. *Women: The Art of Power; Three Women from the*

248

*House of Habsburg*. Vienna: Kunsthis-
torisches Museum, 2018.

Haas, Bruno. Introduction to the "Mittelalter-
liche Bildgeometrie Einleitung."
Presentation held in Dresden, Germany,
November 23–26, 2016.

Hall, Stuart. "The West and the Rest: Discourse
and Power." In *Formations of Modernity*,
edited by Bram Gieben and Stuart Hall,
275–332. Cambridge: Polity, 1992.

Hamp, Eric P. "On the Phonology and Morphol-
ogy of Lat. *Cunctus*." *American Journal of
Philology* 94, no. 2 (1973): 169–70.

Hanke, Lewis. *All Mankind Is One: A Study of
the Disputation Between Bartolomé de las
Casas and Juan Ginés de Sepúlveda in 1550
on the Intellectual and Religious Capacity
of the American Indians*. DeKalb: North-
ern Illinois University Press, 1994.

———. *Bartolomé de Las Casas: Pensador
político, historiador, antropólogo*. Bue-
nos Aires: Universidad de Buenos Aires,
1968.

———. "Pope Paul III and the American Indi-
ans." *Harvard Theological Review* 30, no.
2 (1937): 65–102.

Hanks, William. *Converting Words*. Berkeley:
University of California Press, 2010.

Haskell, Francis, and Nicholas Penny. *Taste
and the Antique: The Lure of Classical
Sculpture, 1500–1600*. New Haven: Yale
University Press, 1981.

Headley, John M. *Europeanization of the World:
On the Origins of Human Rights and
Democracy*. Princeton: Princeton Uni-
versity Press, 2016.

Heidenheimer, Heinr. *Petrus Martyr Anglerius
und sein Opus epistolarum: Ein Beit-
rag zur Quellenkunde des Zeitalters der
Renaissance und der Reformation*. Berlin:
Seehagen, 1881.

Heikamp, Detlef, and Ferdinand Anders. *Mexico
and the Medici*. Florence: EDAM, 1972.

Hernández Castelló, M. Cristina. "El II conde
de Tendilla como representante de los
Reyes Católicos en Italia: Su paso por
Bolonia, Florencia, Roma y Nápoles."
In *El imperio y las Hispanias de Trajano
a Carlos V: Clasicismo y poder en el arte
español*, edited by Sandro de María and
Manuel Parada López de Corselas, 261–
70. Bologna: Bologna University Press,
2014.

Hess, Peter. "Marvelous Encounters: Albrecht
Dürer and Early Sixteenth-Century
German Perceptions of Aztec Culture."
*Daphnis* 33, nos. 1/2 (2004): 161.

Hirst, Michael. "Michelangelo in Rome: An
Altar-Piece and the 'Bacchus.'" *Burling-
ton Magazine* 123, no. 943 (1981): 581–93.

Holmes, Urban T., and Alexander Neckam. *Daily
Living in the Twelfth Century: Based on
the Observations of Alexander Neckham
in London and Paris*. Madison: Univer-
sity of Wisconsin, 1982.

Holohan, Kate Elizabeth. "Collecting the New
World at the Spanish Habsburg Court,
1519–1700." PhD diss., New York Univer-
sity, 2015.

Horn, Hendrik J. *Jan Cornelisz Vermeyen: Painter
of Charles V and His Conquest of Tunis;
Paintings, Etchings, Drawings, Cartoons
and Tapestries*. Doornspijk: Davaco,
1989.

Horodowich, Elizabeth. *The Venetian Discov-
ery of America: Geographic Imagination
and Print Culture in the Age of Encoun-
ters*. Cambridge: Cambridge University
Press, 2018.

Horodowich, Elizabeth, and Lia Markey, eds.
*The New World in Early Modern Italy,
1492–1750*. Cambridge: Cambridge Uni-
versity Press, 2018.

Huang, Shijian. *Li Madou Shi Jie D Tu Yan Jiu*.
Shanghai: Shanghai gu ji chu ban she,
2004.

Hughes, Philip Edgcumbe. "Pico della Miran-
dola, 1463–1494: A Study of an
Intellectual Pilgrimage." *Philosophia
Reformata* 23, no. 3 (1958): 118–21.

*Inventario semplice di tutte le materie esattamente
descritte che si trovano nel museo Cos-
piano: Non solo le notate nel libro gia
stampato e composto dal Sig. Lorenzo
Legati, ma ancora le aggiunteui in copia*

*dopo la fabrica.* Bologna: Giacomo Monti, 1680.

Irvine, Martin. *The Making of Textual Culture: "Grammatica" and Literary Theory, 350–1100.* Cambridge: Cambridge University Press, 2006.

Jansen, Marten. "Vienna Codex." In *The Oxford Encyclopedia of Mesoamerican Culture,* edited by David Carrasco, 313–14. Oxford: Oxford University Press, 2001.

Jardine, Lisa. *Worldly Goods: A New History of the Renaissance.* New York: W. W. Norton, 1996.

Johansson, Patrick. "Las estrategias discursivas de Sahagún en una refutación en náhuatl del libro I del Códice florentino." *Estudios de Cultura Náhuatl* 42 (2011): 139–65.

Johnson, Carina. "Aztec Regalia and the Reformation of Display." In Bleichmar and Mancall, *Collecting Across Cultures,* 83–98.

Joselit, David. "Roundtable: The Global Before Globalization." *October* 133 (2010): 3–19.

Juneja, Monica. "Alternative, Peripheral or Cosmopolitan? Modernism as a Global Process." In Allerstorfer and Leisch-Kiesl, *Global Art History,* 79–108.

Kaufmann, Thomas DaCosta. *Circulation in the Global Art History.* Edited by Catherine Dossin and Béatrice Joyeux-Prunel. Farnham: Ashgate, 2016.

Keating, Jessica, and Lia Markey. "Indian Objects in Medici and Austrian-Habsburg Inventories." *Journal of the History of Collections* 23, no. 2 (2011): 283–300.

Kennedy, Charles A. "The Semantic Field of the Term 'Idolatry.'" In *Uncovering Ancient Stones: Essays in Memory of H. Neil Richardson,* edited by Lewis M. Hopfe, 193–204. Winona Lake: Eisenbrauns, 1994.

Khader, Serene J. *Decolonizing Universalism: A Transnational Feminist Ethic.* New York: Oxford University Press, 2019.

Kim, David Young. *The Traveling Artist in the Italian Renaissance.* New Haven: Yale University Press, 2014.

Kimmel, Seth. "Early Modern Iberia, Indexed: Hernando Colón's Cosmography." *Journal of the History of Ideas* 82, no. 1 (2021): 1–28.

———. *The Librarian's Atlas.* Chicago: University of Chicago Press, forthcoming.

Klein, Robert. *L'estétique de la techné: L'art selon Aristote et les théories des arts visuels au XVIème siècle.* Paris: Institut National d'Histoire de l'Art, 2017.

———. "Francisco de Hollanda et les secrets de l'art." *Colóquio: Revista de arte e letras* 11 (1960): 6–9.

Klein, Robert, and Henri Zerner. *Italian Art, 1500–1600.* Evanston: Northwestern University Press, 1989.

Konstan, David. *Beauty: The Fortunes of an Ancient Greek Idea.* Oxford: Oxford University Press, 2017.

Kranz, Travis B. "The Tlaxcalan Conquest Pictorials: The Role of Images in Influencing Colonial Policy in Sixteenth-Century Mexico." PhD diss., University of California, Los Angeles, 2001.

Krautheimer, Richard. "Alberti and Vitruvius." In *Studies in Western Art: Acts of the Twentieth International Congress of the History of Art,* vol. 2, *The Renaissance and Mannerism,* edited by Millard Meiss, 42–52. Princeton: Princeton University Press, 1963.

Kristeller, Paul O. "The Modern System of the Arts: A Study in the History of Aesthetics, Part I." *Journal of the History of Ideas* 12, no. 4 (1951): 496–527.

Kubler, George. *Esthetic Recognition of Ancient Amerindian Art.* New Haven: Yale University Press, 1991.

———. "Salvaging Amerindian Antiquity Before 1700." In *Esthetic Recognition,* 41–83.

Kurtz, Otto, and Ernst Kris. *Legend, Myth, and Magic in the Image of the Artist: A Historical Experiment.* New Haven: Yale University Press, 1934, repr. 1979.

250

Kusukawa, Sachiko. "'Ad Vivum' Images and Knowledge of Nature in Early Modern Europe." In *Ad Vivum*, edited by Thomas Balfe, Joanna Woodall, and Claus Zittel, 89–121. Leiden: Brill, 2019.

Laird, Andrew. "Humanism and the Humanity of the Peoples of the New World: Fray Julián Garcés, *De habilitate et capacitate gentium*, Rome 1537; A Study, Transcription and Translation of the Original Imprint in the John Carter Brown Library." *Studi Umanistici Piceni* 34 (2015): 183–225.

Lampe, Armando. "Las Casas and African Slavery in the Caribbean: A Third Conversion." In *Bartolomé de las Casas, O.P.: History, Philosophy, and Theology in the Age of European Expansion*, edited by David Thomas Orique, O.P., and Rady Roldán-Figueroa, 421–36. Leiden: Brill, 2018.

Lane, Kris. *Potosi: The Silver City That Changed the World*. Oakland: University of California Press, 2021.

Laurencich-Minelli, Laura, and Alessandra Filippetti. "Per le collezioni americaniste del Museo Cospiano e dell'Istituto delle Scienze: Alcuni oggetti ritrovati a Bologna." *Archivio per l'Antropologia e la Etnologia Firenze* 113 (1983): 207–25.

Lavin, Irving, ed. *World Art: Themes of Unity in Diversity; Acts of the XXVIth International Congress of the History of Art*. University Park: Penn State University Press, 1986.

Leloup, Hélène, and Agnès Patoux. *Dogon*. Paris: Musée du Quai Branly, 2011.

León-Llerena, L. M. "Historia, lenguaje y narración en el manuscrito de Huarochirí." PhD diss., Princeton University, 2011.

León-Portilla, Miguel. Introduction to Las Casas, *Brevísima relación de la destrucción de las Indias*.

Lewis, Charlton T., William Freund, and Charles Short. *A Latin Dictionary Founded on Andrews' Edition of Freund's Latin Dictionary*. Oxford: Clarendon Press, 1966.

Lockwood, Michael A. "Luther on Idolatry: A Lutheran Response to Contemporary False Belief." PhD diss., Concordia Seminary, St. Louis, 2013.

Lopes Don, Patricia. *Bonfires of Culture: Franciscans, Indigenous Leaders, and Inquisition in Early Mexico, 1524–1540*. Norman: University of Oklahoma Press, 2010.

———. "The 1539 Inquisition and Trial of Don Carlos of Texcoco: Religion and Politics in Early Mexico." *Hispanic American Historical Review* 88, no. 4 (2008): 573–606.

López-Ocón Cabrera, Leoncio. "Andinología, lascasismo y humanismo cristiano." PhD diss., Facultad Latinoamericana de Ciencias Sociales Sede Ecuador, 1987.

———. "Las fuentes peruanas de la Apologética Historia." In *Obras completas de Fray Bartolomé de las Casas*, edited by Ramón Hernándes, O.P., and Lorenzo Galmés, O.P., 261–82. Madrid: Alianza Editorial, 1992.

López Sarrelangue, D. E. *La nobleza indígena de Pátzcuaro en la época virreinal*. Mexico City: Universidad Nacional Autónoma, 1965.

Lothrop, S. K. *Inca Treasure as Depicted by Spanish Historians*. Los Angeles: Southwest Museum, 1964.

Lousa, Teresa. *Do pintor como génio na obra de Francisco de Holanda*. Lisbon: Ediçães Ex-Libris, 2014.

Lowe, Kate J. P. "Texteis da África Ocidental na Lisboa renascentista: Descrição e padrões." In *A cidade global: Lisboa no Renascimiento*, edited by Annemarie Jordan Gschwend and Kate J. P. Lowe, 124–27. Lisbon: MNAA, 2017.

Lugli, Adalgisa. *Naturalia et mirabilia: Il collezionismo enciclopedico nelle Wunderkammern d'Europa*. Milan: Mazzotta, 1983.

MacDonald, Deanna. "Collecting a New World: The Ethnographic Collection of Margaret of Austria." *Sixteenth Century Journal* 33, no. 3 (2002): 649–63.

Mack, Rosamond E. *Bazaar to Piazza: Islamic Trade and Italian Art, 1300–1600*.

Berkeley: University of California Press, 2002.

Magister, Sara. "Pomponio Leto collezionista di antichità: Addenda." In *Antiquaria a Roma: Intorno a Pomponio Leto e Paolo II*, 51–121. Rome: Roma nel Rinascimento, 2003.

Manrique, Jorge Alberto. "Las Casas y el arte indígena." In *Una visión del arte y de la historia*, 323–33. Mexico City: UNAM / Instituto de Investigaciones Estéticas, 2001.

Marado, Catarina Almeida. *Arquitetura conventual e cidade medieval: A formação e os impactos dos sistemas urbanísticos mendicantes em Portugal (SÉC. XIII–XV)*. Coimbra: Imprensa da Universidade de Coimbra, 2018.

Maravall, José A. *Antiguos y modernos: La idea de progreso en el desarrollo inicial de una sociedad*. Madrid: Sociedad de Estudios y Publicaciones, 1966.

Marcocci, Giuseppe. *A consciência de um império*. Coimbra: Imprensa da Universidade de Coimbra, 2013.

———. *The Globe on Paper: Writing Histories of the World in Renaissance Europe and the Americas*. Oxford: Oxford University Press, 2020.

———. *L'invenzione di un impero: Politica e cultura nel mondo portoghese*. Rome: Carocci, 2011.

———. "Gli umanisti italiani e l'impero portoghese: Una interpretazione della *Fides, religio, moresque Æthiopum* di Damião de Góis." *Rinascimento* 45 (2005): 307–66.

Mariéjol, Jean H. *Un lettré italien à la cour d'Espagne (1488–1526): Pierre Martyr d'Anghera, sa vie et ses oeuvres*. Paris: Hachette, 1887.

Marion, Jean-Luc. *God Without Being*. Translated by Thomas A. Carlson. Chicago: University of Chicago Press, 2012.

Markey, Lia. "Aldrovandi's New World Natives in Bologna (or How to Draw the Unseen *al vivo*)." In Horodowich and Markey, *New World in Early Modern Italy*, 225–47.

———. "A Feather Painting of Moctezuma, Captured by a Sea Captain and Destined for a Medici." In *The Significance of Small Things: Essays in Honor of Diane Fane*, edited by Luisa Elena Alcalá and Ken Moser, 128–35. Madrid: Ediciones El Viso, 2018.

———. *Imagining the Americas in Medici Florence*. University Park: Penn State University Press, 2016.

Marr, Alexander, Raphaële Garrod, José R. Marcaida, and Richard J. Oosterhoff. *Logodaedalus: Word Histories of Ingenuity in Early Modern Europe*. Pittsburgh: University of Pittsburgh Press, 2019.

Martin, Craig. *Renaissance Meteorology: Pomponazzi to Descartes*. Baltimore: Johns Hopkins University Press, 2011.

———. *Subverting Aristotle: Religion, History, and Philosophy in Early Modern Science*. Baltimore: Johns Hopkins University Press, 2014.

Mason, Peter. *The Lives of Images*. London: Reaktion, 2001.

Massing, Jean M. "The Quest for the Exotic: Albrecht Dürer in the Netherlands." In *Studies in Imagery*, vol. 2, *The World Discovered*, 359–75. London: Pindar, 2007.

McDonald, Mark. *Ferdinand Columbus: Renaissance Collector (1488–1539)*. London: British Museum, 2005.

McEwan, Colin, Andrew Middleton, Caroline Cartwright, and Rebecca Stacey. *Turquoise Mosaics from Mexico*. London: British Museum, 2006.

McTighe, Sheila. *Representing from Life in Seventeenth-Century Italy*. Amsterdam: Amsterdam University Press, 2010.

Méchoulan, Henri. *L'antihumanisme de J. G. de Sepúlveda: Étude critique du "Democrates Primus."* Paris: Mouton, 1974.

Meggad, Amos. "'Right from the Heart': Indians' Idolatry in Mendicant Preaching in Sixteenth Century Mesoamerica." *History of Religions* 35, no. 1 (1995): 61–82.

Melion, Walter. "Introduction: The Jesuit Engagement with the Status and Functions of the Visual Image." In De Boer,

252

Enenkel, and Melion, *Jesuit Image The-ory*, 1–51.

Menzel, Brigitte. "Textile Trades in West Africa." *Textile Society of America Symposium Proceedings* 6, no. 11 (1990): 89–91. https://digitalcommons.unl.edu/tsa conf/611.

Merback, Mitchell B. *Perfection's Therapy: An Essay on Albrecht Dürer's Melencolia I.* New York: Zone, 2017.

Miller, Peter N. *History and Its Objects: Antiquar-ianism and Material Culture Since 1500.* Ithaca: Cornell University Press, 2017.

———. *Pereisc's Mediterranean World.* Cam-bridge: Harvard University Press, 2015.

Minter, E. S. "Discarded Deity: The Rejection of Michelangelo's Bacchus and the Artist's Response." *Renaissance Studies* 28, no. 3 (2014): 443–58.

Mira Caballos, Estéban. *La gran armada coloni-zadora de Nicolás de Ovando, 1501–1502.* Santo Domingo: Academia Dominicana de la Historia, 2014.

Miroslav, Begović. *Prints After Giulio Clovio.* Zagreb: Print and Drawings Depart-ment of the Croatian Academy of Arts and Sciences, 1998.

Mol, Angus. *Costly Giving, Giving Guaízas: Towards an Organic Model of the Exchange of Social Valuables in the Late Ceramic Age Caribbean.* Leiden: Side-stone, 2006.

Momigliano, Arnaldo. "Ancient History and the Antiquarian." *Journal of the Warburg and Courtauld Institutes* 13, nos. 3/4 (1950): 285–315.

Montero de Espinosa, Jose Mariá, and Antonio Collantes de Terán Sánchez. *Relación histórica de la Judería de Seville: Esta-blecimiento de la Inquisición en ella, su estinción* [sic] *y colección de los autos que llamaban de fé, celebrados desde su erec-ción.* [Seville]: Sociedad de Bibliófilos Andaluces, 1978.

Motolinía, Toribio de Benavente. *Historia de los indios de la Nueva España.* Edited by Mercedes Serna Arnaiz and Bernat Castany Prado. Madrid: Real Academia

Española and Centro para la Edición de los Clásicos Españoles, 2014.

Moulakis, Athanasios. "Civic Humanism." In *The Stanford Encyclopedia of Philosophy*, edited by Edward N. Zalta. Stanford: Stanford University, 2011. Revised December 13, 2011. https://plato.stan ford.edu/archives/win2018/entries /humanism-civic.

Mouriki, Doula. "The Theme of the 'Spinario' in Byzantine Art." *Deltion of the Christian Archaeological Society* 4, no. 6 (1970–72): 53–66.

Mundy, B. E., and A. M. Hyman. "Out of the Shadow of Vasari: Towards a New Model of the Artist in Colonial Latin America." *Colonial Latin American Review* 24, no. 3 (2015): 283–317.

Myers, Kathleen Ann. *Fernández de Oviedo's Chronicle of America: A New History for a New World.* Translated by Nina M. Scott. Austin: University of Texas Press, 2007.

Nagel, Alexander. *The Controversy of Renaissance Art.* Chicago: University of Chicago Press, 2011.

——— "Some Discoveries of 1492: Eastern Antiquities and Renaissance Europe." Lecture, Seventeenth Horst Gerson, University of Groningen, Groningen, Netherlands, November 14, 2013.

Nagel, Alexander, and Christopher Wood. *Anachronic Renaissance.* New York: Zone, 2011.

Nascimento, Cristiane. "Da pintura antiga de Francisco de Holanda: O encômio como género da prescrição e da arte." *Floema, caderno de teoria e história liter-aria* 1, no. 1 (2005): 37–50.

Nava Román, María del Rosario. "El color negro en la piel y su poder político-religioso en el mundo mesoamericano: Del Alti-plano Central a la Mixteca." Master's thesis, Universidad Nacional Autónoma de México, 2009.

———. "Del blanqueamiento de Quetzalcóatl a la invisibilidad del cuerpo pin-tado de negro." In *Estudiar el Racismo:*

*Afrodescendientes en México*, edited by María Elisa Velázquez, 29–73. Mexico City: INAH, 2019.

Normore, Christine, ed. *Re-assessing the Global Turn in Medieval Art History*. York: Arc Humanities Press, 2018.

Nowotny, Karl Anton. *Tlacuilolli: Style and Contents of the Mexican Pictorial Manuscripts*. Norman: University of Oklahoma Press, 2005.

O'Gorman, Edmundo. "Estudio Preliminar." In Las Casas, *Apologética historia sumaria*, 1:vii–lxxix.

Oliveira Caetano, Joaquim. "Francisco de Hollanda (1517–1584): The Fascination of Rome and the Times in Portugal." In Francisco de Holanda, *On Antique Painting*, trans. Wohl, 7–44.

Orique, David Thomas. *To Heaven or to Hell: Bartolomé de Las Casas's Confesionario*. University Park: Pennsylvania State University Press, 2018.

Ostapkowicz, Joanna. "'Either a Piece of Domestic Furniture of the Indians or One of Their Gods': The Study of Lucayan Duhos." *Journal of Carribean Archaeology* 15 (2015): 62–101.

———. "Integrating the Old World into the New: An 'Idol from the West Indies.'" *Antiquity* 91, no. 359 (2017): 1314–29.

———. "'Made with . . . Admirable Artistry': The Context, Manufacture and History of a Taíno Belt." *Antiquaries Journal* 93 (2013): 287–317.

Ostapkowicz, Joanna, Alex Wiedenhoeft, C. Bronk Ramsey, Erika Ribechini, Samuel Wilson, Christopher Bronk, and Tom Higham. "'Treasures . . . of Black Wood, Brilliantly Polished': Five Examples of Taíno Sculpture from the Tenth–Sixteenth Century Caribbean." *Antiquity* 85, no. 329 (September 2011): 942–59.

Pagden, Anthony. *The Fall of Natural Man: The American Indian and the Origins of Comparative Ethnology*. Cambridge: Cambridge University Press, 1982.

———. *The Languages of Political Theory in Early-Modern Europe*. Cambridge: Cambridge University Press, 1987.

Parish, Helen Rand. *Las Casas as a Bishop*. Washington, DC: Library of Congress, 1980.

Parker, Geoffrey. *Emperor: A New Life of Charles V*. New Haven: Yale University Press, 2019.

Parshall, Peter. "Antonio Lafreri's *Speculum Romanae Magnificentiae*." *Print Quarterly* 23, no. 1 (2006): 3–28.

———. "Imago Contrafacta: Images and Facts in the Northern Renaissance." *Art History* 16, no. 4 (1993): 554–79.

Pattenden, Miles. "Governor and Government in Sixteenth-Century Rome." *Papers of the British School at Rome* 77 (2009): 257–72.

Pennesi, Giuseppe. *Pietro Martire d'Anghiera e le sue relazioni sulle scoperte oceaniche*. Rome: Auspice il Ministero della pubblica istruzione, 1894.

Pereda, Felipe. "Antigüedades judías y piedad cristiana: Francisco de Holanda, de los *Desenhos* de El Escorial a las *Aetatibus mundi imagines*." *Reales sitios* 156, no. 40 (2003): 2–15.

Pereira, Fernando Antonio Baptista. "A fé de Francisco de Holanda." In *Arte e fé*, edited by Margarida Acciaiuoli, Francisco Caramelo, João Paulo Oliveira e Costa, and Teresa Meruje. Lisbon: University of Lisbon, 2016.

Pérez Fernández, Ignacio. *Bartolomé de las Casas, viajero por dos mundos*. Cuzco: Centro de estudios regionales andinos, 1998.

———. "Bartolomé de las Casas y los esclavos negros." In *Afroamericanos y el V Centenario*, edited by José Luis Cortés, 39–61. Madrid: Mundo Negro, 1992.

———. *Cronología documentada de los viajes, estancias y actuaciones de Fray Bartolomé de las Casas*. Puerto Rico: Centro de Estudios de los Dominicos del Caribe / Universidad Central de Bayamón, 1984.

Peterson, Jannette Favros. "Creating the Virgin of Guadalupe: The Cloth, the Artist, and Sources in Sixteenth-Century

254

New Spain." *Americas* 61, no. 4 (2005): 571–610.

Phillips, William D., and Carla R. Phillips. *The Worlds of Christopher Columbus*. Cambridge: Cambridge University Press, 2002.

Piazza, Rosalba. *La conciencia oscura de los naturales: Procesos de idolatría en la diócesis de Oaxaca (Nueva España), siglos XVI–XVIII*. Mexico City: El Colegio de México, 2016.

Piemontese, Angelo Michele. "Il corano latino di Ficino e i corani arabi di Pico e Monchates." *Rinascimento* 36 (1996): 227–73.

Pietchotki, Katharina. *Cartographic Humanism: The Making of Early Modern Europe*. Chicago: University of Chicago Press, 2021.

Pillsbury, Joanne. "Imperial Radiance." In Pillsbury, Potts, and Richter, *Golden Kingdoms*, 33–44.

Pillsbury, Joanne, Timothy Potts, and Kim N. Richter, eds. *Golden Kingdoms: Luxury Arts in the Ancient Americas*. Los Angeles: J. Paul Getty Museum and the Getty Research Institute, 2017.

Pillsbury, Joanne, and Lisa Trever. "Martínez Compañón and His Illustrated 'Museum.'" In Bleichmar and Mancall, *Collecting Across Cultures*, 235–53.

Pohl, Frederick. *Amerigo Vespucci, Pilot Major*. New York: Columbia University Press, 1944.

Polain, M. Louis. *Catalogue des livres imprimés au quinzième siècle des bibliothèques de Belgique*. 4 vols. Brussels: Société des Bibliophiles, 1932–78.

Polizzotto, Lorenzo. "Dell'Arte del Ben Morire: The Piagnone Way of Death, 1494–1545." *I Tatti Studies in the Italian Renaissance* 3 (1989): 27–87.

Pranger, Marinus B. *Bernard of Clairvaux and the Shape of Monastic Thought: Broken Dreams*. Leiden: Brill, 1994.

Preston-Blier, "Capricious Arts." In Cole and Zorach, *Idol in the Age of Art*, 16–21.

Prévost, Bernard. "L'ars plumaria en Amazonie pour une esthétique minoritaire." *Civilisations* 59, no. 2 (2011): 87–154.

Ramachandran, Ayesha. *The Worldmakers: Global Imagining in Early Modern Europe*. Chicago: University of Chicago Press, 2015.

Rappaport, Joanne, and Tom Cummins. *Beyond the Lettered City: Indigenous Literacies in the Andes*. Durham: Duke University Press, 2012.

Rizzo, Silvia. *Il Lessico filologico degli umanisti*. Rome: Edizioni di storia e letteratura, 1973.

Rocha, Gabriel de Avilez. "Empire from the Commons: Making Colonial Archipelagos in the Early Iberian Atlantic." PhD diss., New York University, 2016.

Rodini, Elizabeth. *Gentile Bellini's Portrait of Sultan Mehmed II: Lives and Afterlives of an Iconic Image*. London: I. B. Tauris, 2020.

———. "Mobile Things: On the Origins and the Meanings of Levantine Objects in Early Modern Venice." *Art History* 41, no. 2 (2018): 8.

Romero de Terreros, Manuel. "Cosas que fueron: Don Felipe de Guevara y el arte de los antiguos Mexicanos." *Excelsior*, March 30, 1936.

Rubiés, Joan-Pau. "Theology, Ethnography, and the Historicization of Idolatry." *Journal of the History of Ideas* 67, no. 4 (2006): 571–96.

———. *Travel and Ethnology in the Renaissance: South India Through European Eyes, 1250–1625*. Cambridge: Cambridge University Press, 2002.

———. "Travel Writing and Humanistic Culture: A Blunted Impact?" In *Bringing the World to Early Modern Europe*, edited by Peter Mancall, 131–68. Leiden: Brill, 2006.

Rubin, Patricia Lee. *Giorgio Vasari: Art and History*. New Haven: Yale University Press, 1995.

Rubinstein, Nicolai. "The History of the Word *Politicus* in Early Modern Europe." In

Pagden, *Languages of Political Theory*, 41–56.

Rumeu de Armas, Antonio. *España en el África Atlántica*. 2 vols. Madrid: C.S.I.C. Instituto de Estudios Africanos, 1956.

Russo, Alessandra. "An Artistic Humanity: New Positions on Art and Freedom in the Context of the Iberian Expansion, 1500–1600." *Res: Anthropology and Aesthetics* 65/66 (2014/15): 352–63.

———. "Artistic Vitality, Universal Humanity." Lecture presented as part of the Department of Latin American and Iberian Cultures (LAIC) Inaugural Lectures Series, Columbia University, September 2016.

———. "A Contemporary Art from New Spain." In Russo, Wolf, and Fane, *Images Take Flight*, 23–63.

———. "Cortés's Objects and the Idea of New Spain: Inventories as Spatial Narratives." *Journal of the History of Collections* 23, no. 2 (2011): 229–52.

———. "The Curator's Eye: Sebastiano Biavati, Custodian of a Heterogeneous Artistic World." In *The Significance of Small Things*, edited by Luisa Elena Alcalá and Ken Moser, 150–58. Madrid: Ediciones El Viso, 2018.

———. "Dopo l'esotismo: Per una storia contemporanea delle arti nella prima modernità." In *La scuola del mondo: Storie globali della collezione Farnese*, edited by Simone Verde, 43–51. Milan: Electa, 2023.

———. "Multilingual Dialogues Between Artifacts and Words in Early Modern Times." In *Art History Before English*, edited by Robert Brennan, C. Oliver O'Donnell, Marco M. Mascolo, and Alessandro Nova, 107–22. Rome: Officina libraria, 2021.

———. "Parlare al presente: Rinascite dell'arte Precolombiana / Speaking to the Present: Rebirths in Pre-Columbian Art." In *Recycling Beauty*, edited by Salvatore Settis and Anna Anguissola, 4–5, 314–21. Milan: Fondazione Prada, 2022.

———. "Plumes of Sacrifice: Transformations in Sixteenth-Century Mexican Feather Art." *Res: Anthropology and Aesthetics* 42, no. 1 (2002): 226–50.

———. "*Questa macchina mondiale*: Thresholds and Circulations Through Spanish Italy and the Iberian Americas in Lorenzo D'Anania's *La Universal Fabrica del Mondo* (Naples, 1573)." In *Spanish Italy and the Iberian Americas*, edited by Michael Cole and Alessandra Russo, New York: Columbia University, 2021. https://doi.org/10.7916/8fn7-dc47.

———. "Recomposing the Image: Presents and Absents in the *Mass of Saint Gregory*, Mexico, 1539." In *Synergies: Creating Art in Joined Culture*, edited by Manuela De Giorgi, Annette Hoffmann, and Nicole Suthor, 465–81. Florence: Kunsthistorisches Institut-Max Planck, 2012.

———. "El Renacimiento vegetal: Arboles de Jesé entre el Viejo Mundo y el Nuevo." *Anales del Instituto de Investigaciones Estéticas* 73 (1998): 5–39.

———. "'These Statues They Generally Called çemi': A New Object at the Crossroad of Languages." In *The Challenge of the Object / Die Herausforderung des Objekts*, edited by Ulrich Grossmann and Petra Krutisch, 45–49. Nuremberg: Verlag des Germanischen Nationalmuseums, 2013.

———. *The Untranslatable Image: A Mestizo History of Art of New Spain, 1500–1600*. Austin: University of Texas Press, 2014.

Russo, Alessandra, Gerhard Wolf, and Diana Fane, eds. *Images Take Flight: Feather Art in Mexico and Europe, 1400–1700*. Munich: Hirmer, 2015.

Ruth, Jeffrey S. *Lisbon in the Renaissance*. New York: Italica, 1996.

Ryan, Michael. "Assimilating New Worlds in the Sixteenth and Seventeenth Centuries." *Comparative Studies in Society and History* 23, no. 4 (1981): 519–38.

Rybcka, Eugeniusz. "The Influence of the Cracow Intellectual Climate." *Vistas in Astronomy* 9, no. 1 (1967): 165–69.

256

Sallmann, Jean-Michel. *Le grand désenclavement du monde, 1200–1600*. Paris: Payot, 2011.

Salvadore, Matteo. *The African Prester John and the Birth of Ethiopian-European Relations, 1402–1555*. Abingdon: Routledge, 2017.

Sánchez Manzano, María Asunción. "La Apología de Fray Bartolomé de las Casas: Estilo y composición." In *Apología o Declaración y defensa universal de los derechos del hombre y de los pueblos*, edited by Vidal Abril Castelló, lxxxi–lxxxviii. Valladolid: Consejería de Educación y Cultura, 2000.

Santana Simões, Catarina. "The Symbolic Importance of the 'Exotic' in the Portuguese Court in the Late Middle Ages." *Anales de Historia del Arte* 24 (2014): 517–25.

Santos Lopes, Marília dos. *Da descoberta ao saber: Os conhecimientos sobre África na Europa dos séculos XVI e XVII*. Viseu: Passagem Editores, 2002.

Sauer, Carl Ortwin. *The Early Spanish Main*. Cambridge: Cambridge University Press, 2008.

Saunders, A. *A Social History of Black Slaves and Freedmen in Portugal, 1441–1555*. Cambridge: Cambridge University Press, 1982.

Savoy, Daniel, ed. *The Globalization of Renaissance Art: A Critical Review*. Leiden: Brill, 2017.

Schapiro, Meyer. "Style." In *Anthropology Today*, edited by A. L. Kroeber, 257–311. Chicago: University of Chicago Press, 1953.

Schlosser, Julius von. *Die Kunstliteratur: Ein Handbuch zur Quellenkunde der neueren Kunstgeschichte*. Vienna: A. Schroll, 1924.

Schmidt, Benjamin. *The Invention of the Exotic: Geography, Globalism and Europe's Early Modern World*. Philadelphia: University of Pennsylvania Press, 2015.

Schmidt Arcangeli, Catarina, and Gerhard Wolf. *Islamic Artefacts in the Mediterranean World: Trade, Gift Exchange and Artistic Transfer*. Venice: Marsilio, 2011.

Schmitt, Jean-Claude. "La culture de l'imago." *Annales: Histoire, sciences sociales* 51, no. 1 (1996): 226–50.

Schnapp, Alain. *Une historie universelle des ruines*. Paris: Seuil, 2020.

Schraven, Minou. "Founding Rome Anew: Pope Sixtus IV and the Foundation of Ponte Sisto, 1473." In *Foundation, Dedication and Consecration in Early Modern Europe*, edited by Maarten Delbeke and Minou Schraven, 129–51. Leiden: Brill, 2012.

Seed, Patricia. "'Are These Not Also Men?': The Indian's Humanity and Capacity for Spanish Civilization." *Journal of Latin American Studies* 25, no. 3 (1993): 629–52.

Serra, Maurizio. "Ulisse Aldrovandi americanista e i suoi manoscritti: Le Antille." Laurea thesis, Università degli Studi di Bologna, 1985–86.

Serrão, Vitor. "Um hóspede ilustre na Santarém renascentista: Francisco de Holanda (1547–1549)." Special issue, *Revista Mátria* 21 (2021): 385–448.

Settis, Salvatore. *Il futuro del classico*. Turin: Einaudi, 2004.

Settis, Salvatore, and Anna Anguissola, eds. *Recycling Beauty*. Milan: Fondazione Prada, 2023.

Seznec, Jean. "Un essai de mythologie comparée au debut du XVIIe siècle." *Mélanges de l'école française de Rome* 48 (1931): 268–81.

Shelton, Anthony Alan. "Cabinets of Transgression: Renaissance Collections and the Incorporation of the New World." In *The Cultures of Collecting*, edited by John Elsner and Roger Cardinal, 177–203. London: Reaktion, 1994.

Silvestri, Domenico. *Lat. cunctus, itt. pankus*. Naples: Istituto Universitario Orientale, 1970.

Skinner, Quentin. *The Foundations of Modern Political Thought*. 2 vols. Cambridge: Cambridge University Press, 2012.

———. *Visions of Politics*. Cambridge: Cambridge University Press, 2002.

Sloterdijk, Peter. *In the World Interior of the Capital: Toward a Philosophy of Globalization.* Cambridge: Polity, 2013.

Smith, Christen, and James H. Tuckey. *Narrative of an Expedition to Explore the River Zaire, Usually Called the Congo: In South Africa in 1816, Under the Direction of Captain J.k. Tuckey, R.n.; To Which Is Added the Journal of Professor Smith and Some General Observations on the Country and Its Inhabitants.* London: J. Murray, 1816.

Sousa, Ronald W. "The View of the Artist in Francisco de Holanda's Dialogues: A Clash of Feudal Models." *Luso-Brazilian Review* 15 (1978): 43–58.

Spear, Richard E. "Di sua mano." *Memoirs of the American Academy in Rome: Supplementary Volumes* 1 (2002): 79–98.

Spitz, Lewis W. *Conrad Celtis: The German Arch-Humanist.* Cambridge: Cambridge University Press, 1957.

Spivak, Gayatri Chakravorty. *An Aesthetic Education in the Era of Globalization.* Cambridge: Harvard University Press, 2012.

Stenhouse, William. "Visitors, Display, and Reception in the Antiquity Collections of Late-Renaissance Rome." *Renaissance Quarterly* 58, no. 2 (2005): 397–434.

Stoichita, Victor. *Darker Shades: The Racial Other in Early Modern Art.* London: Reaktion, 2019.

Subrahmanyam, Sanjay. "On Early Modern Historiography." In *The Cambridge World History*, edited by Jerry H. Bentley et al., 425–45. Cambridge: Cambridge University Press, 2015.

Sullivan, Margaret A. "Alter Apelles: Dürer's 1500 Self-Portrait." *Renaissance Quarterly* 68, no. 4 (2015): 1161–91.

Summers, David. *The Judgement of Sense: Renaissance Naturalism and the Rise of Aesthetics.* Cambridge: Cambridge University Press, 1994.

———. *Michelangelo and the Language of Art.* Princeton: Princeton University Press, 1981.

Summit, Jennifer. "Renaissance Humanism and the Future of Humanities." *Literature Compass* 9/10 (2012): 665–78.

Sutherland Minter, Erin. "Discarded Deity: The Rejection of Michelangelo's *Bacchus* and the Artist's Response." *Renaissance Studies* 23, no. 3 (2014): 443–58.

Swan, Claudia. "*Ad vivum, naer het leven*, from the Life: Defining a Mode of Representation." *Word and Image* 11, no. 4 (1995): 353–72.

Tega, Walter, ed. *L'antichità del mondo*. Bologna: Editrice Compositori, 2002.

Teglia Alonso, Vanina M. "Claroscuros del archivo colonial: La escritura sobre la naturaleza de Fernández de Oviedo." *Huarte de San Juan: Geografía e Historia* 27 (2020): 267–90.

Tereygol, Florian, and Pablo Cruz. "Metal del viento: Aproximación experimental para la comprensión del funcionamiento de las wayras andinas." *Estudios atacameños* 48 (2014): 39–54.

Tommasino, Pier Mattia. *The Venetian Qur'an: A Renaissance Companion to Islam.* Philadelphia: University of Pennsylvania Press, 2018.

Toussaint, Stéphane. "Alexandrie à Florence: La Renaissance et sa *prisca theologia*." In *Alexandrie la divine*, edited by Charles Méla and Frédéric Möri, 971–90. Geneva: La Baconnière, 2014.

———. *Humanismes, Antihumanismes: De Ficin á Heidegger.* Paris: Les Belles Lettres, 2018.

Trench, Lucy. *Materials and Techniques in the Decorative Arts: An Illustrated Dictionary.* London: J. Murray, 2000.

Trever, Lisa. "Idols, Mountains, and Metaphysics in Guaman Poma's Pictures of Huacas." *Res: Anthropology and Aesthetics* 59, no. 1 (2011): 39–59.

Turner, Daymond. "Los libros del alcaide: La biblioteca de Gonzalo Fernández de Oviedo y Valdes." *Estudios dominicanos* 6, no. 32 (1977): 57–116.

Vandenbroek, Paul. "Amerindian Art and Ornamental Objects in Royal Collections, Brussels, Mechelen, Duurstede,

258

1520–1530." In *America, Bride of the Sun: 500 Years Latin America and the Low Countries*, 99–119. Ghent: Ministry of the Flemish Community, 1991.

Van Eck, Caroline A. *Translations of the Sublime: The Early Modern Reception and Dissemination of Longinus' Peri Hupsous in Rhetoric, the Visual Arts, Architecture, and Theater*. Leiden: Brill, 2012.

Vargas, José María. *Fray Domingo de Santo Tomás: Defensor y apóstol de los indios*. Santo Domingo: Editorial Santo Domingo, 1937.

Vélez, Posada. "Genius, as ingenium." In *Encyclopedia of Early Modern Philosophy and the Sciences*, edited by Dana Jalobeanu and Charles T. Wolfe, 1–8. Cham: Springer Nature Switzerland, 2020.

Vergara, Alejandro. *Patinir*. Madrid: Museo del Prado, 2007.

Vermeyen, J. C. *Der Kriegszug Kaiser Karls V. gegen Tunis: Kartons und Tapisserien*. Vienna: Kunsthistorisches Museum, 2000.

Vetter, Luisa. *Plateros indígenas en el Virreinato del Perú: Siglos XVI y XVII*. Lima: Buenaventura, 2008.

———. *Plateros y saberes andinos: El arte orfebre en los siglos XVI–XVII*. Cuzco: Centro de Estudios Regionales Andinos Bartolomé de Las Casas, 2016.

Wagner, Henry Raup, and Helen Rand Parish. *The Life and Writings of Bartolomé de Las Casas*. Albuquerque: University of New Mexico, 1967.

Wald, Robert. "Parmigianino's 'Cupid Carving His Bow,' History, Examination, Restoration." In *Parmigianino e il manierismo europeo: Atti del Convegno internazionale di studi Fornari Schianchi*, 165–81. Cinisello Balsamo: Silvana, 2003.

Wallerstein, Immanuel. *European Universalism: The Rhetoric of Power*. New York: New Press, 2006.

Webb, Ruth. *Ekphrasis, Imagination and Persuasion in Ancient Rhetorical Theory and Practice*. Farnham: Ashgate, 2009.

Wey-Gómez, Nicolás. *The Tropics of Empire: How Columbus Sailed South*. Cambridge: MIT Press, 2008.

Williams, Robert. *Art, Theory, and Culture in Sixteenth-Century Italy: From Techne to Metatechne*. Cambridge: Cambridge University Press, 2010.

———. *Art Theory: An Historical Introduction*. Malden: Wiley-Blackwell, 2004.

———. *Raphael and the Redefinition of Art in Renaissance Italy*. Cambridge: Cambridge University Press, 2017.

Wilson, Bronwen, and Angela Vanhaelen. "Making Worlds: Art, Materiality, and Early Modern Globalization." *Journal of Early Modern History* 23, nos. 2–3 (2019): 103–20.

Wilson-Lee, Edward. *The Catalogue of Shipwrecked Books: Young Columbus and the Quest for a Universal Library*. London: William Collins, 2019.

Witcombe, Christopher L. C. E. *Copyright in the Renaissance: Prints and the Privilegio in Sixteenth-Century Venice and Rome*. Leiden: Brill, 2004.

Wittkower, Rudolf, and Margot Wittkower. *Born Under Saturn: The Character and Conduct of Artists; A Documental History from Antiquity to the French Revolution*. New York: W. W. Norton, 1969.

Wolf, Gerhard. Review of Nagel and Wood, *Anachronic Renaissance*. *Art Bulletin* 94, no. 1 (2012): 135–40.

Wood, Christopher S. "The Discourse of the Idol." Paper given at two-part symposium "Images of Europe," European University Institute, Florence, October 2003 and March 2004.

———. *Forgery, Replica, Fiction: Temporalities of German Renaissance Art*. Chicago: University of Chicago Press, 2008.

———. *A History of Art History*. Princeton: Princeton University Press, 2019.

Wragg Skyes, Rebecca. *Kindred: Neanderthal Life, Love, Death, and Art*. London: Bloomsbury, 2020.

Yaya, Isabelle. "Wonders of America: The Curiosity Cabinets as a Site of

Representation and Knowledge." *Journal of the History of Collections* 20, no. 2 (2008): 173–88.

Zabughin, Vladimiro. *Giulio Pomponio Leto: Saggio Critico*. 3 vols. Grottaferrata: Tip. Italo-Orientale S. Nilo, 1910.

Ziolkoski, Mariusz. "Acerca de algunas funciones de los queros y los akillas." *Estudios latinoamericanos* 5 (1979): 11–24.

# Index

Italicized page references indicate illustrations. Endnotes are referenced with "n" followed by the endnote number.